OSCAR TUAZON
LIVE

2

DoPe Press Verlag der Buchhandlung Walther König, Köln

OSCAR TUAZON
LIVE

6

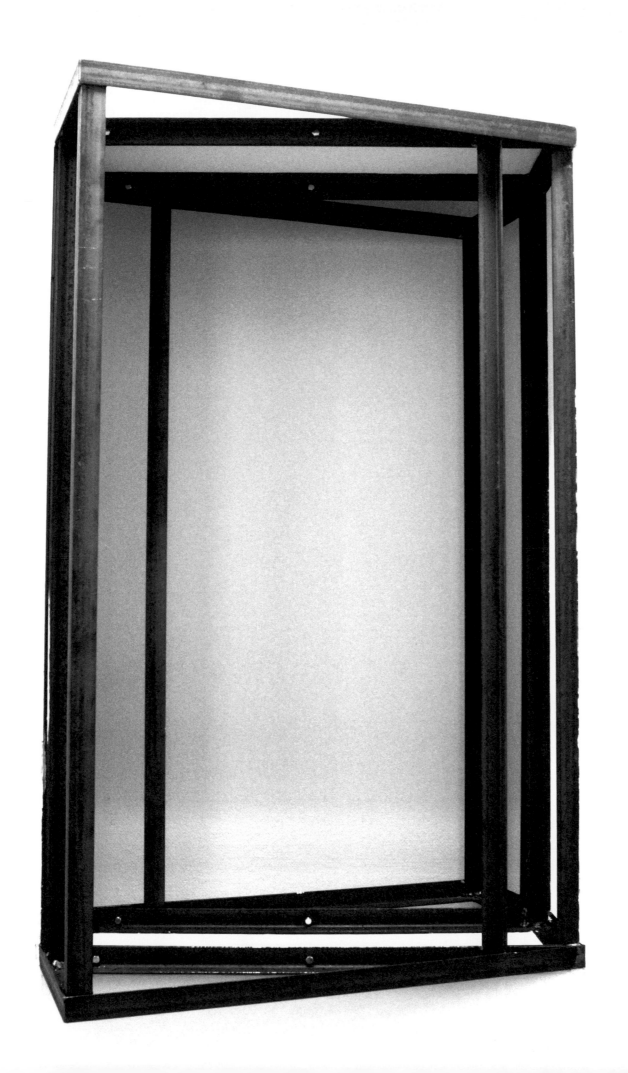

8

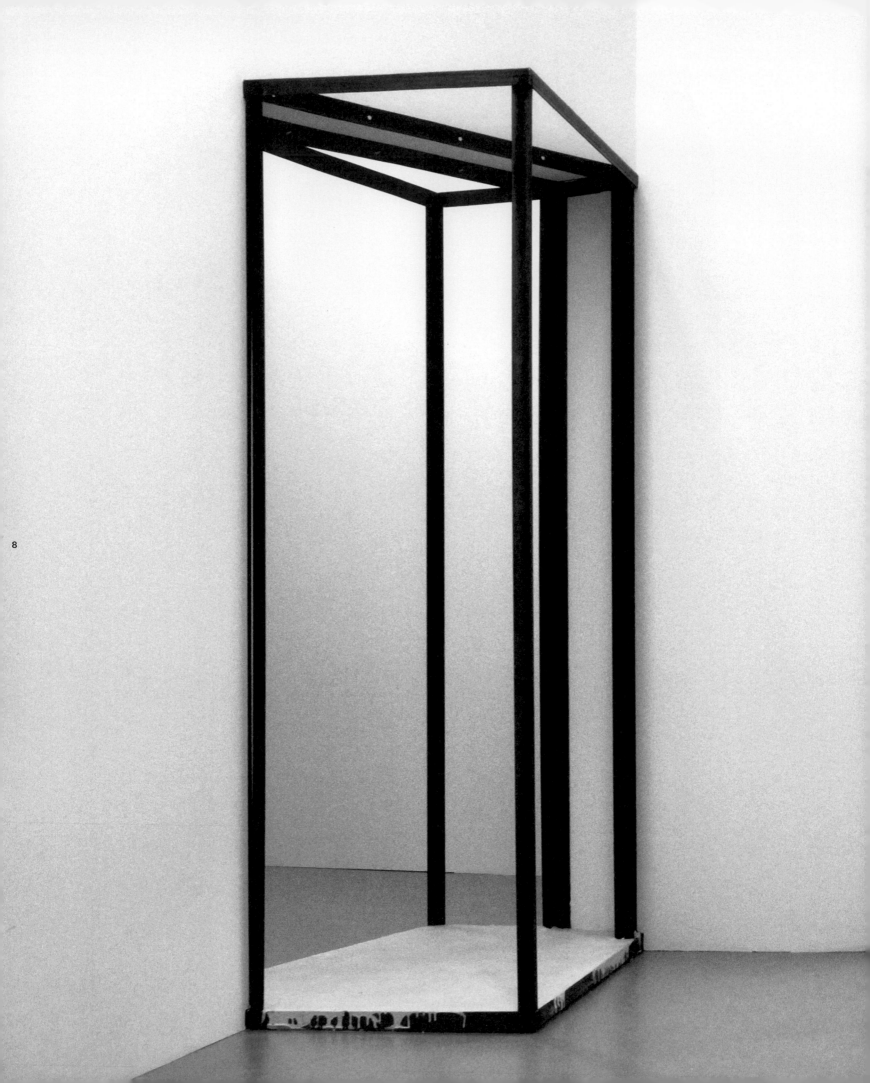

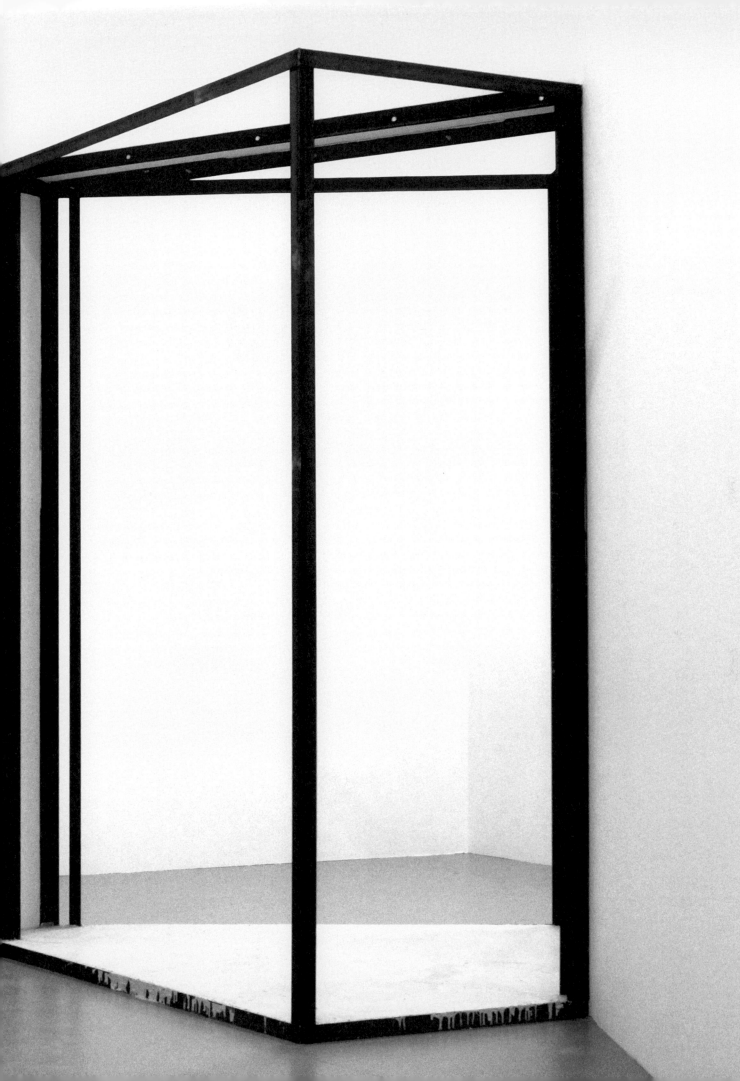

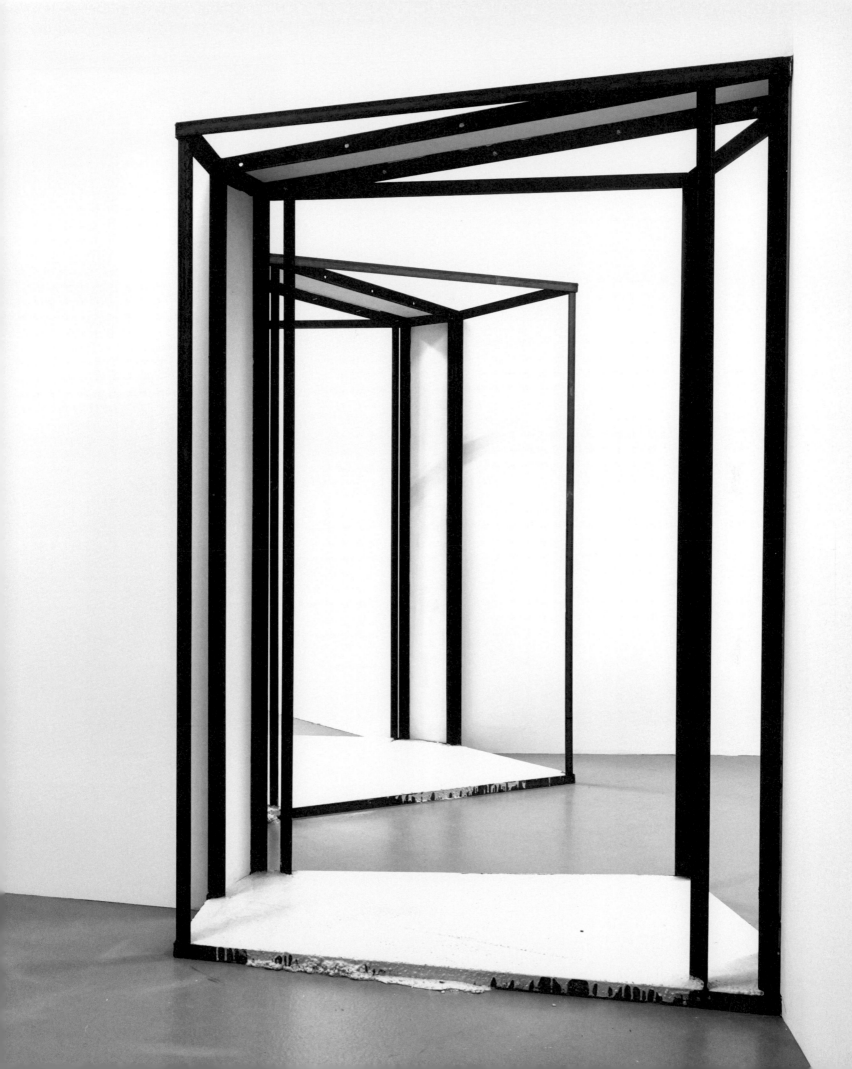

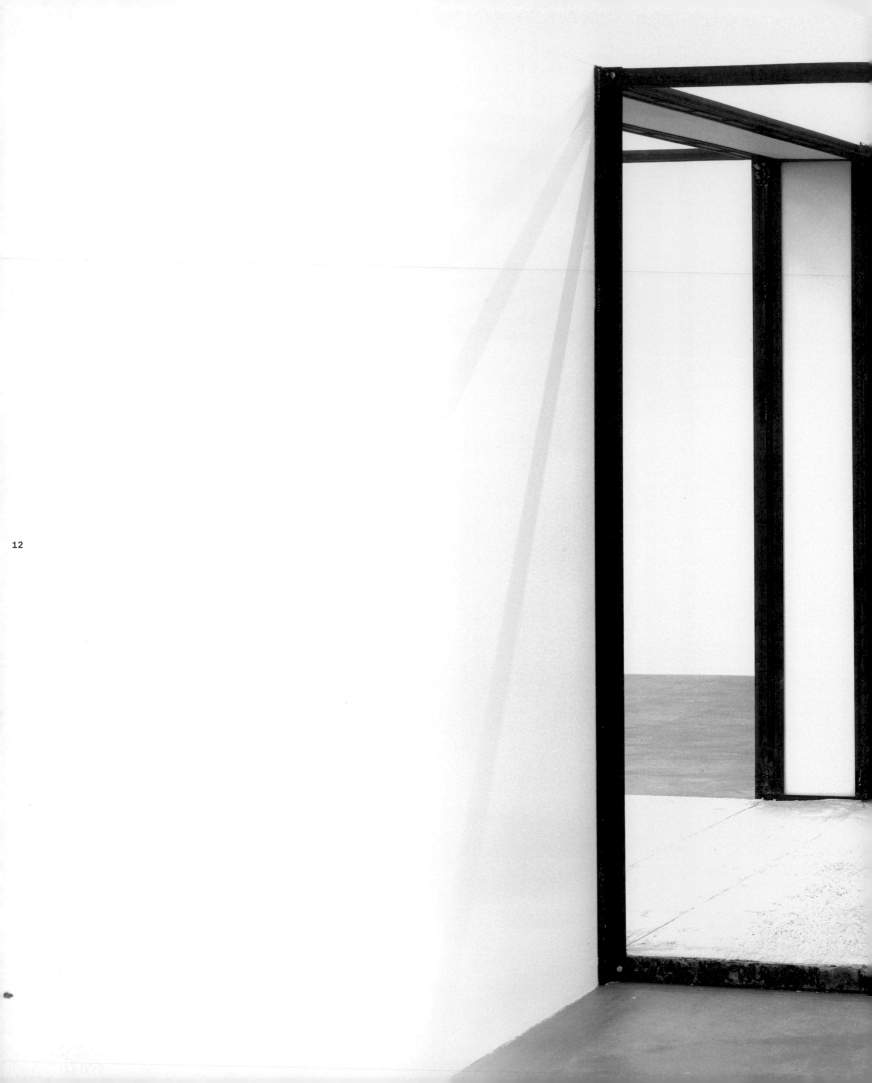

12

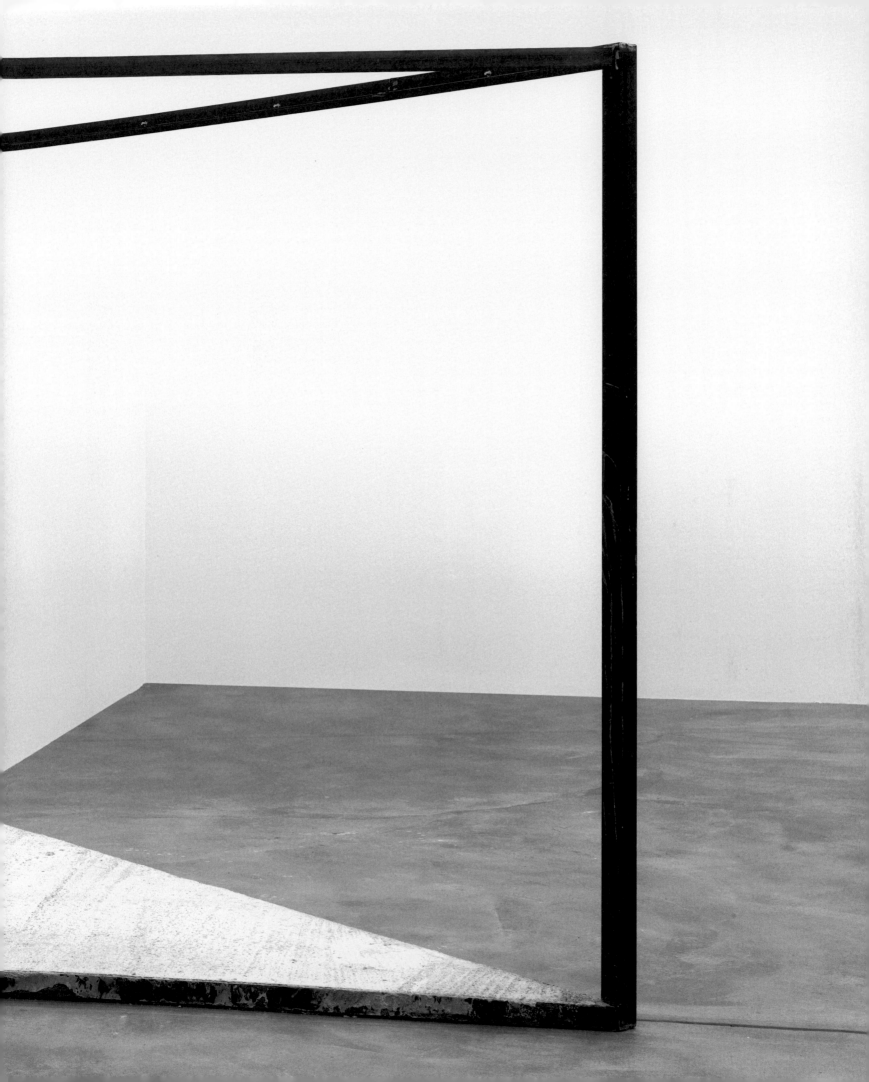

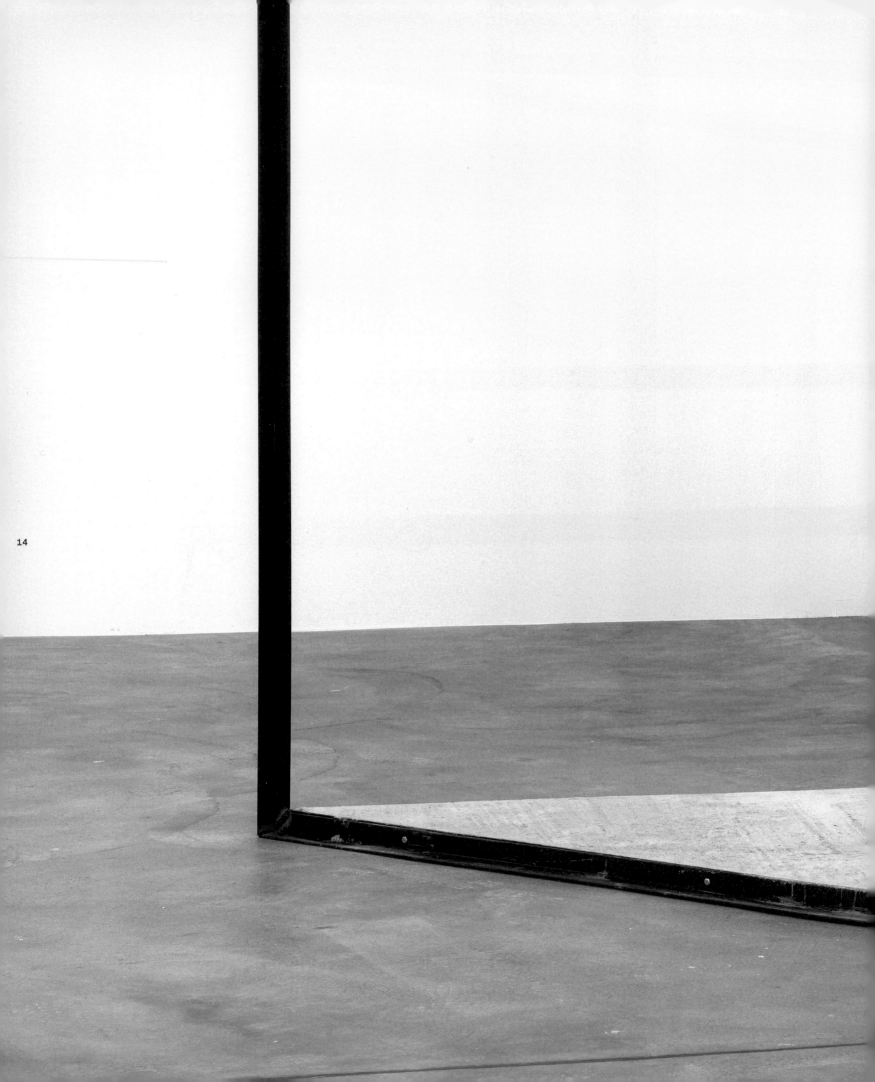

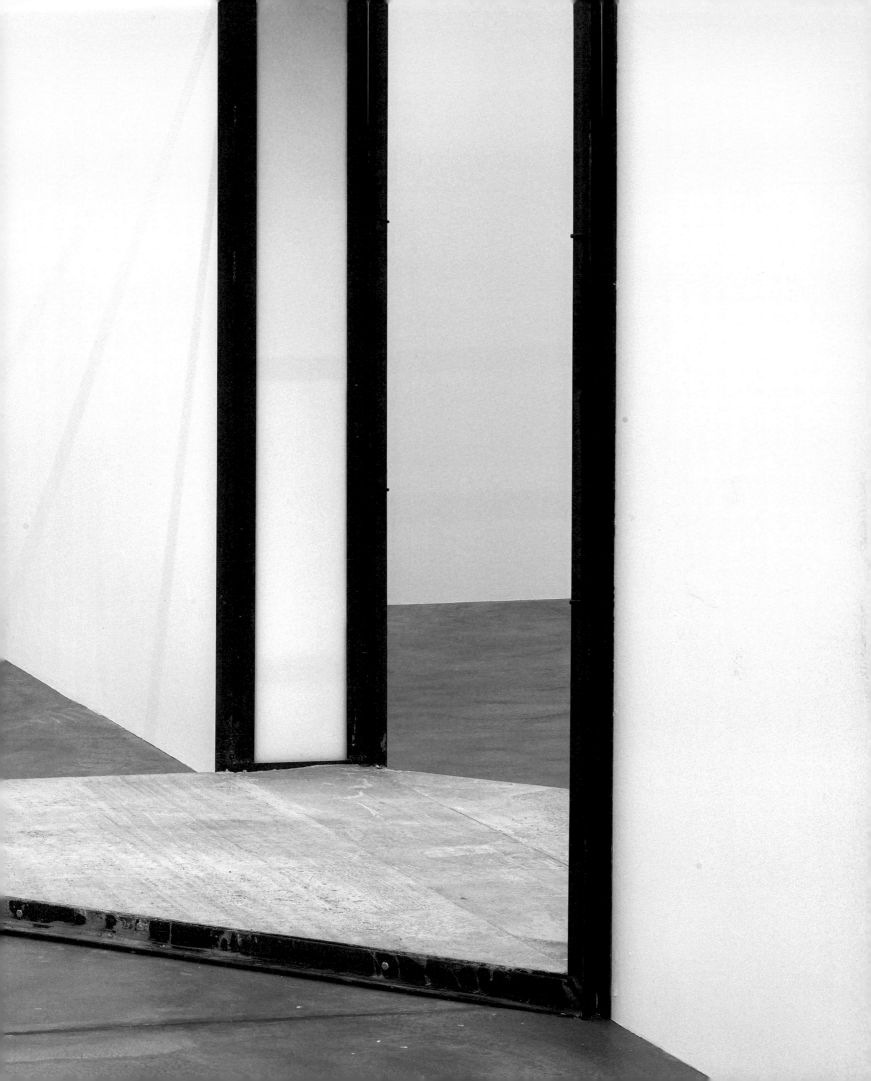

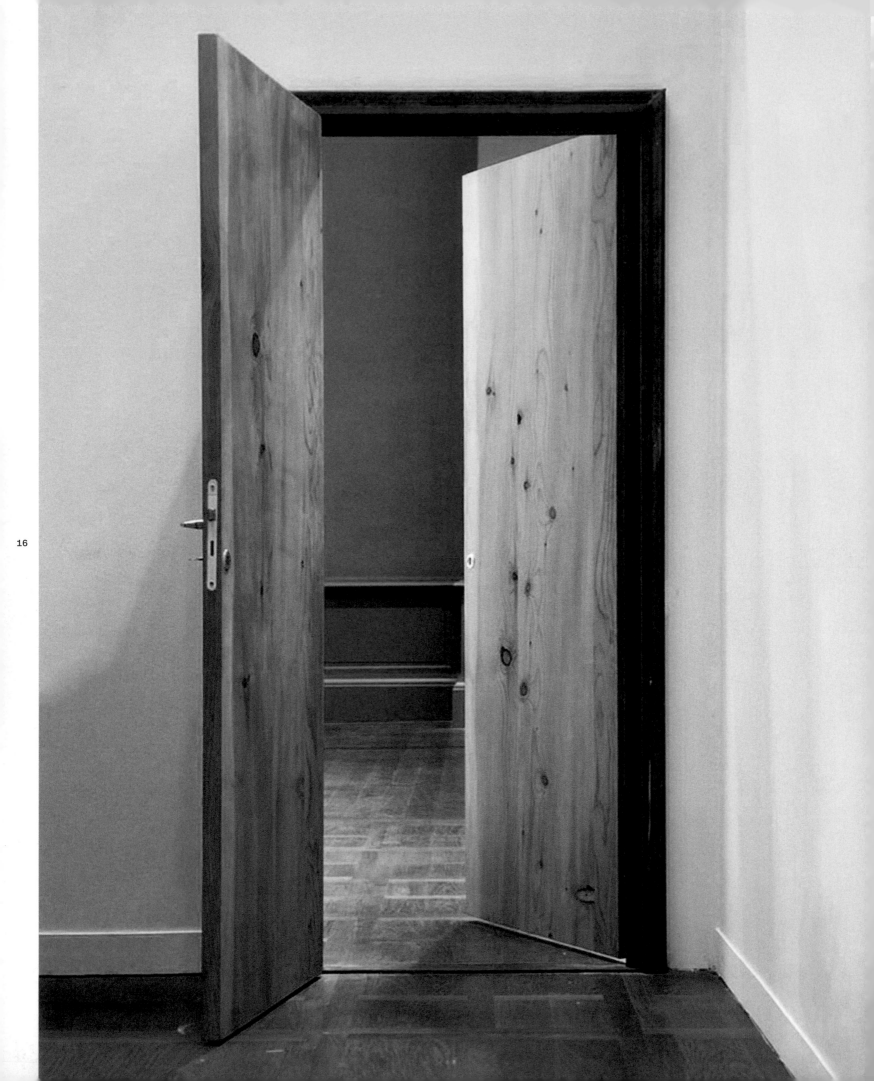

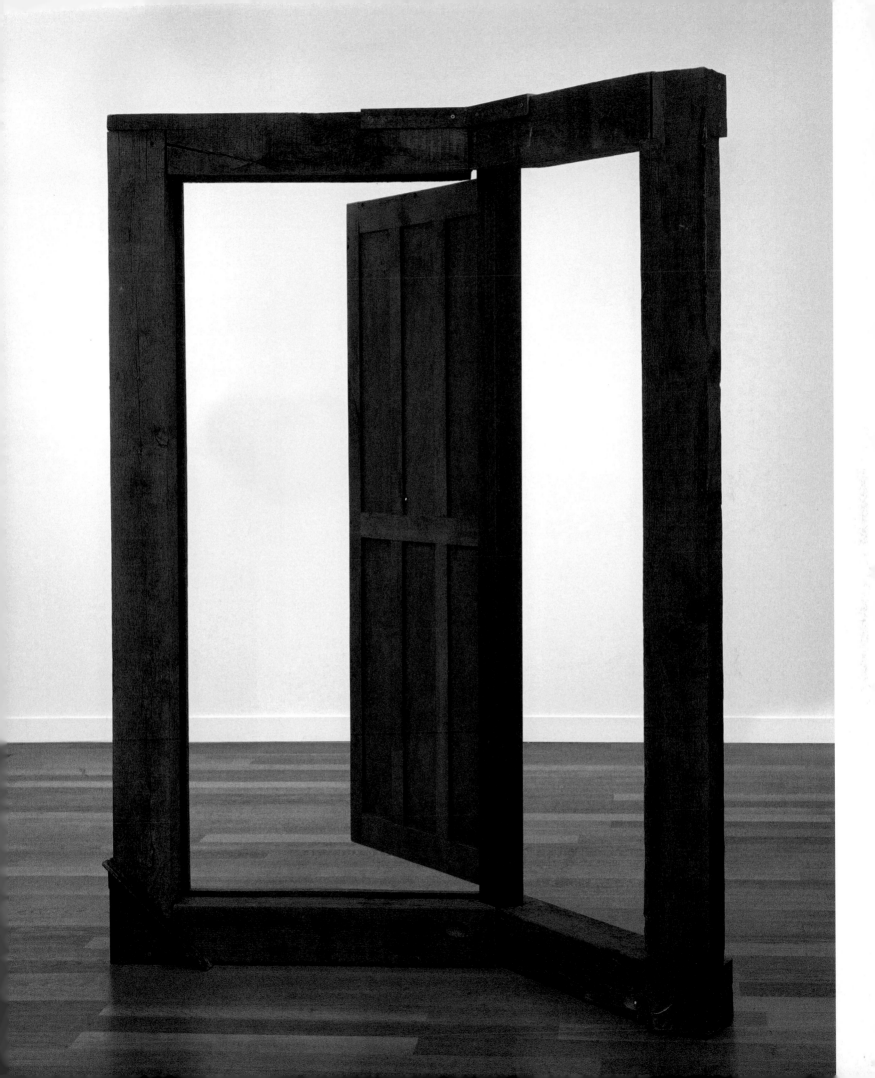

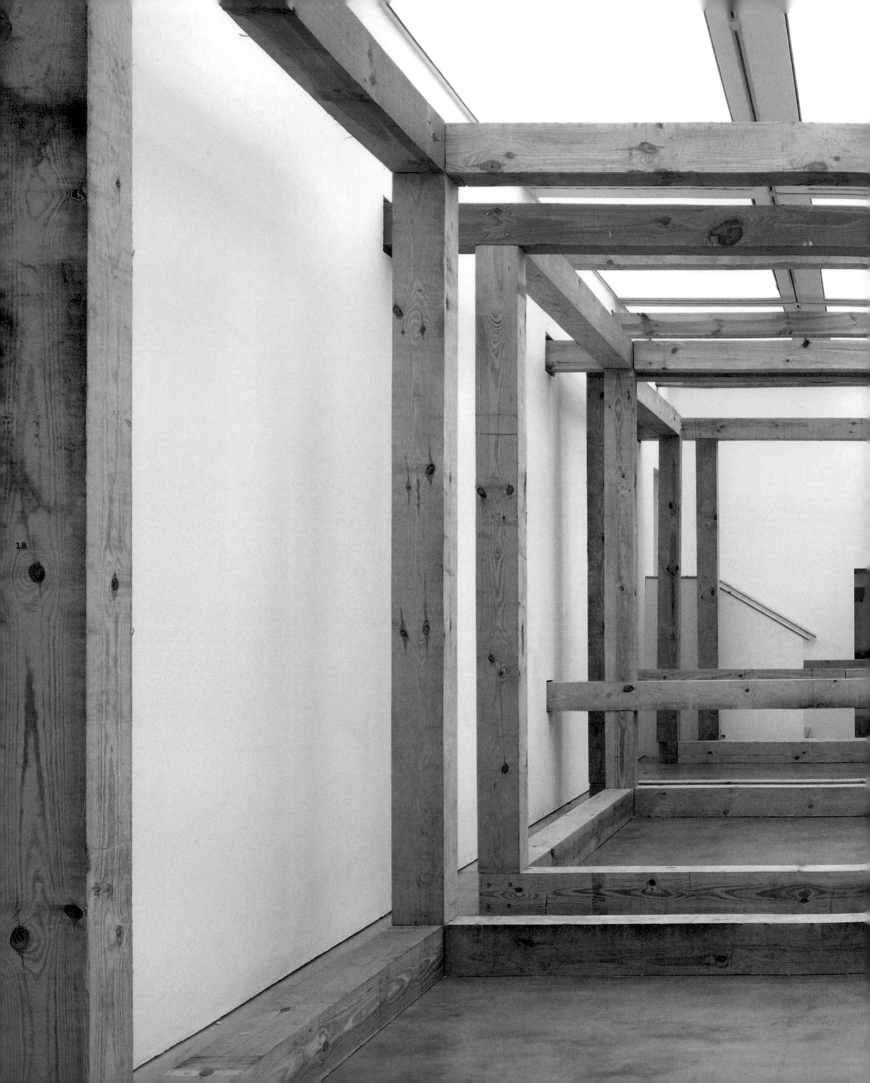

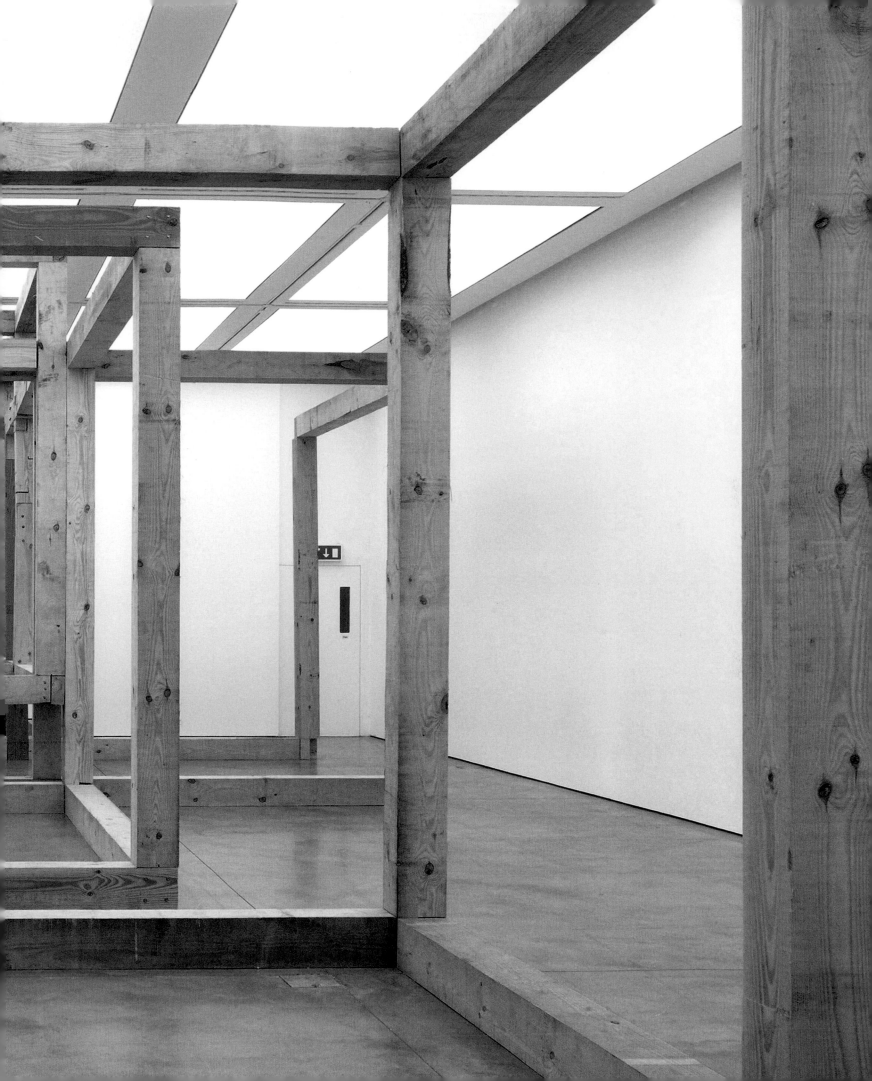

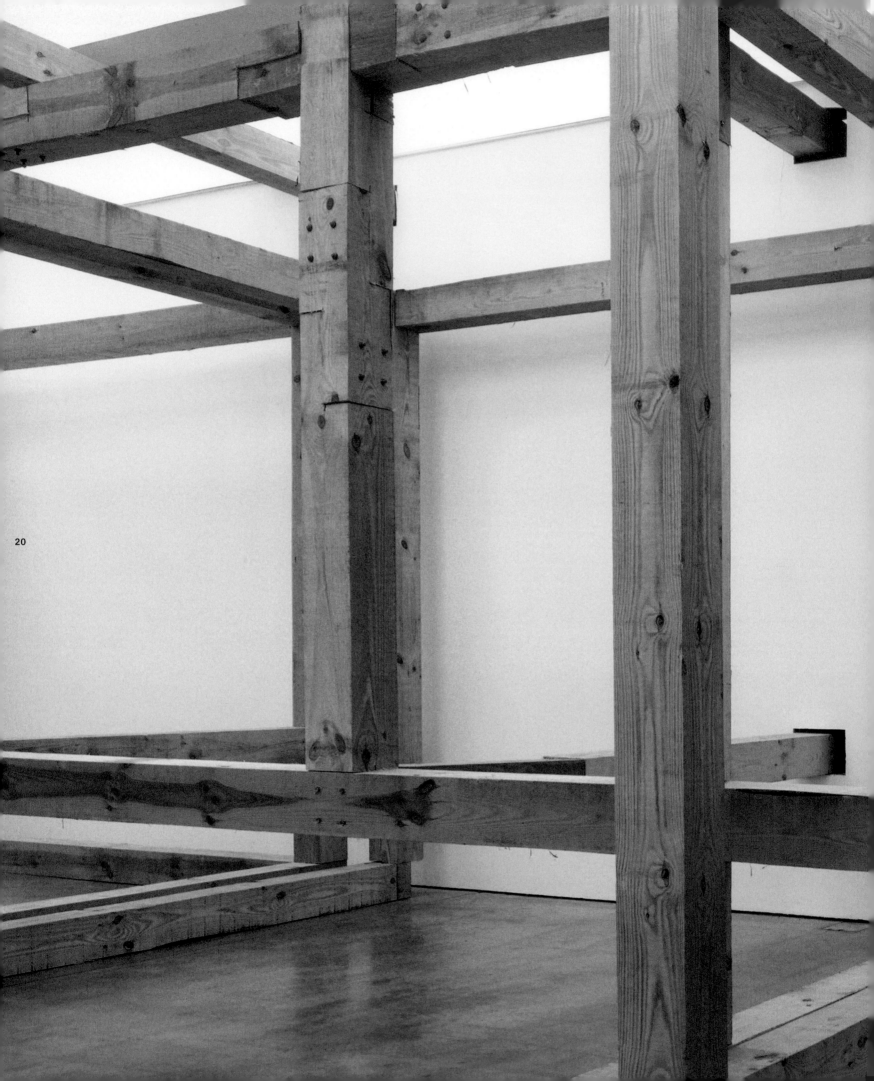

20

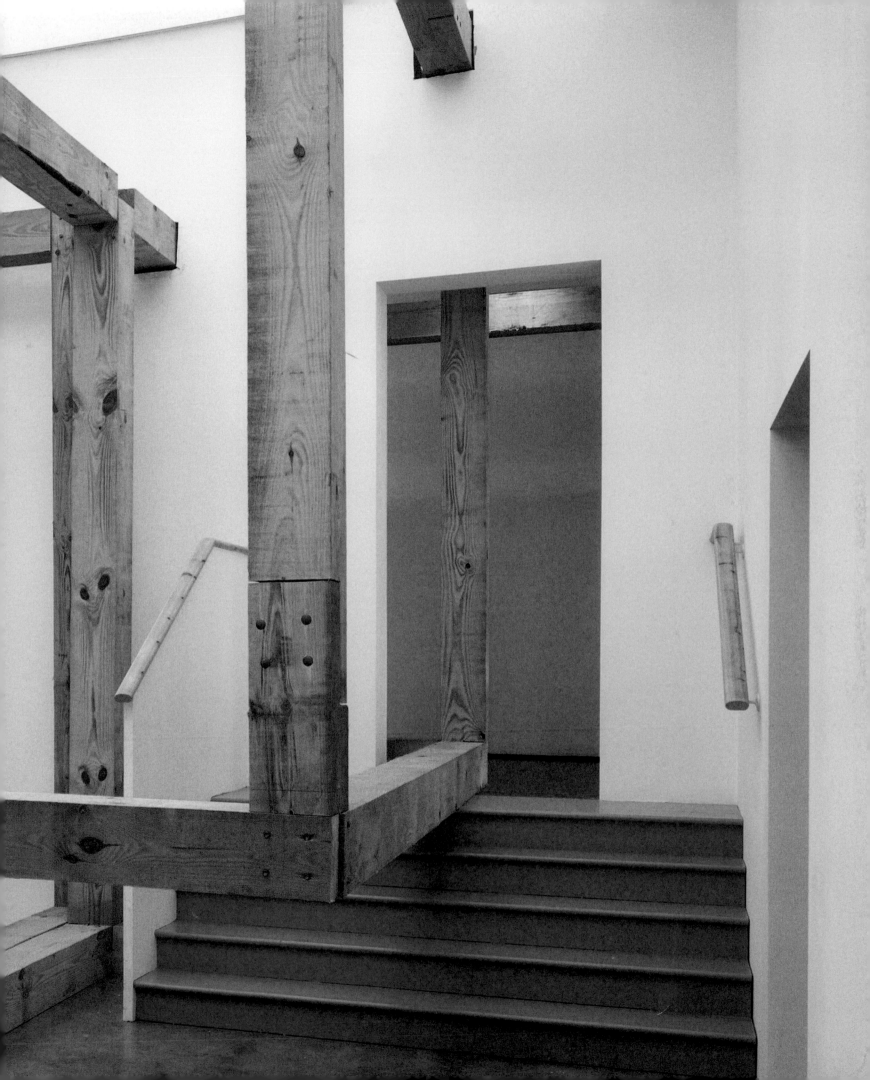

22

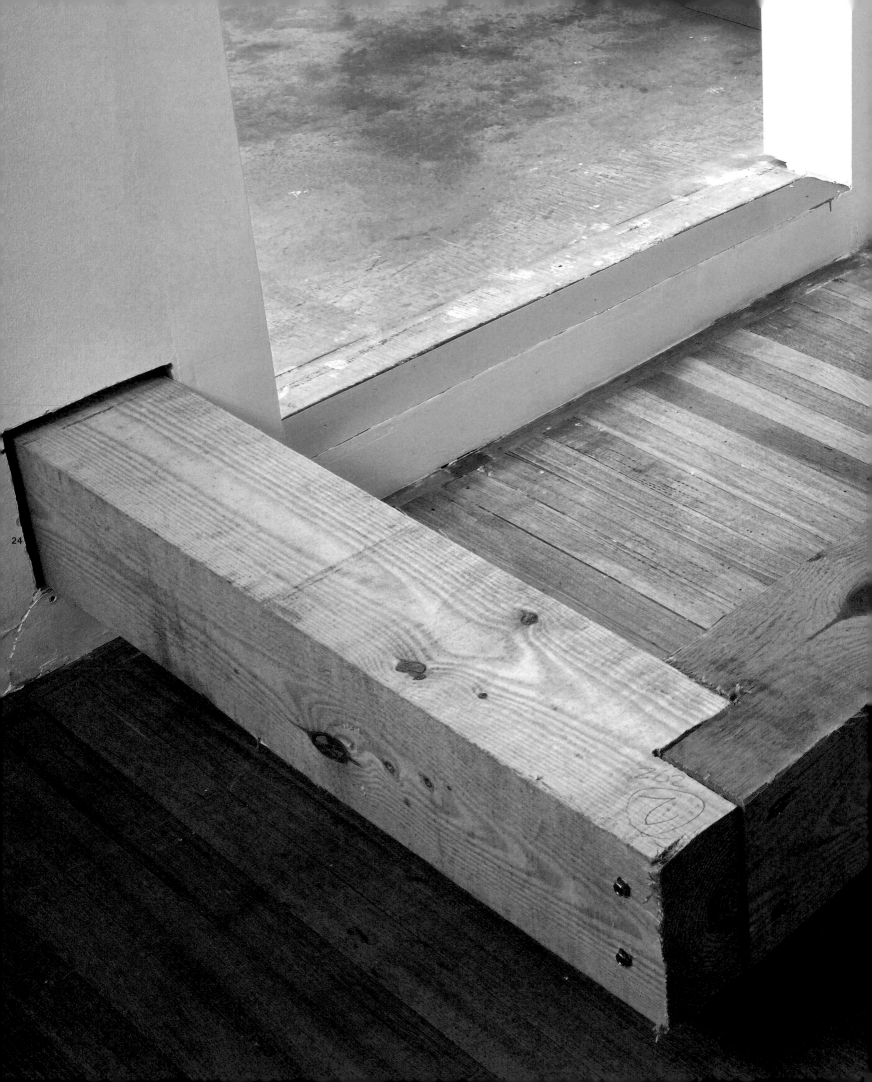

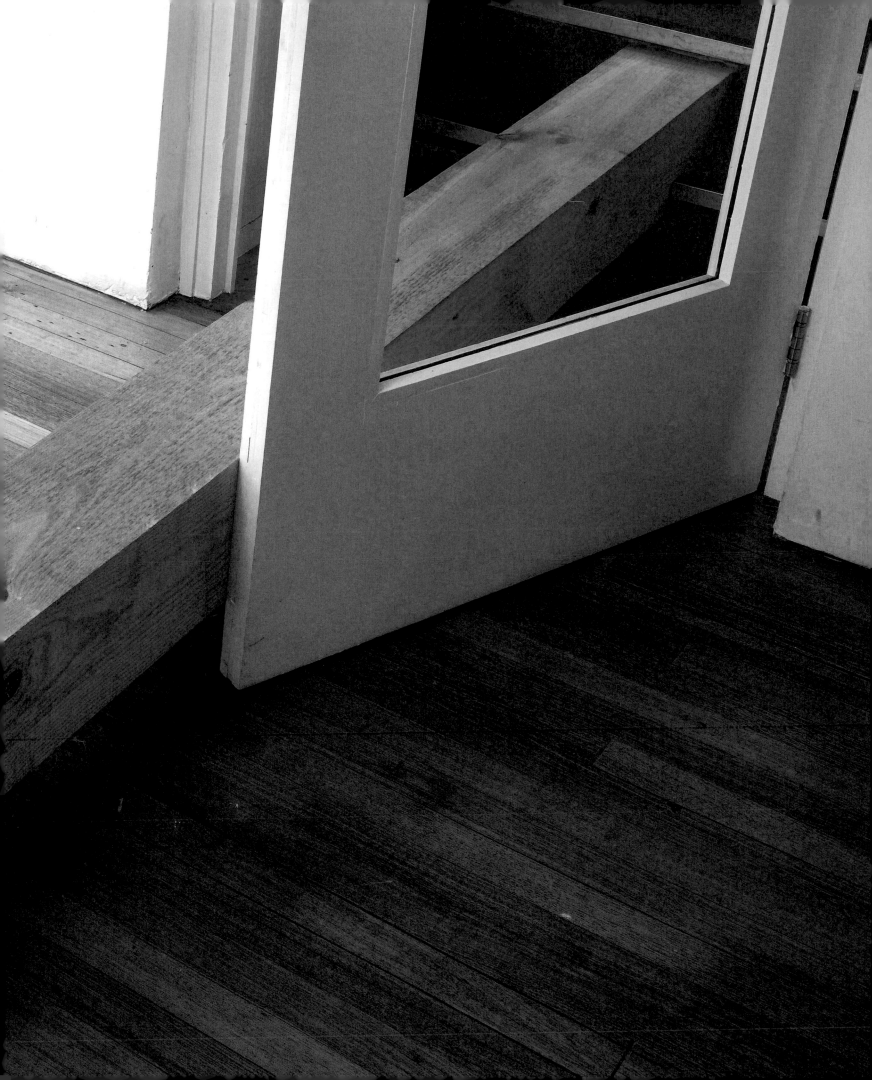

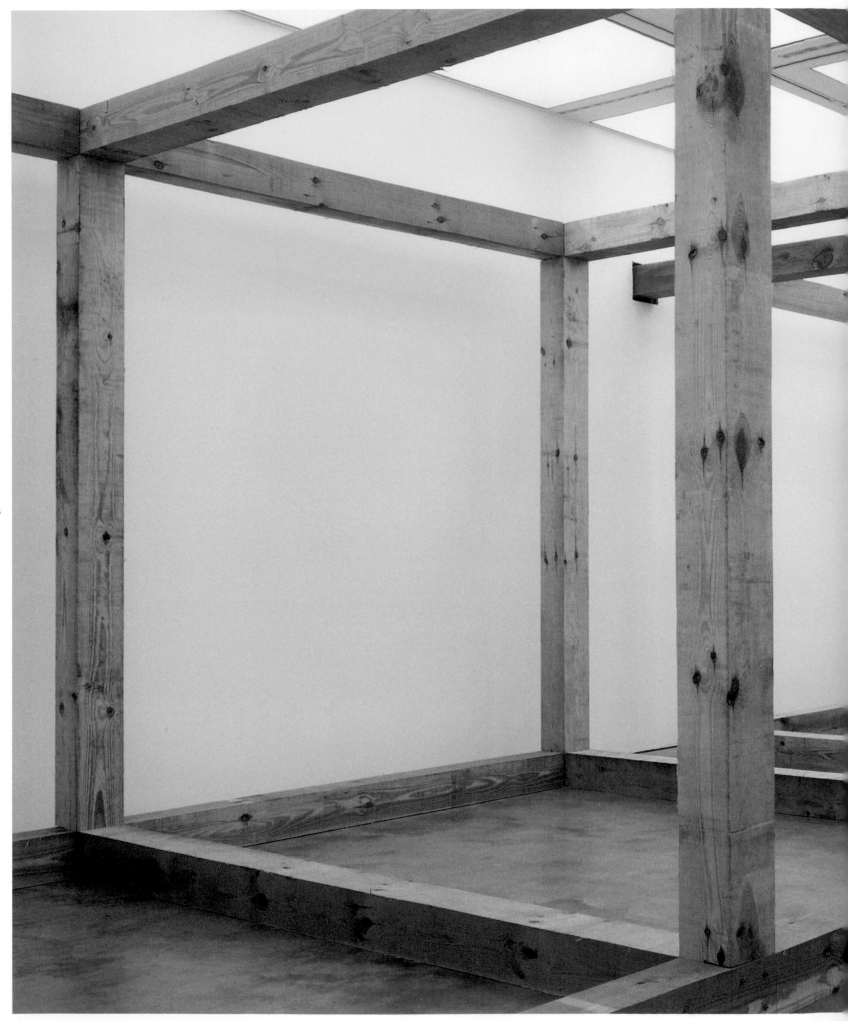

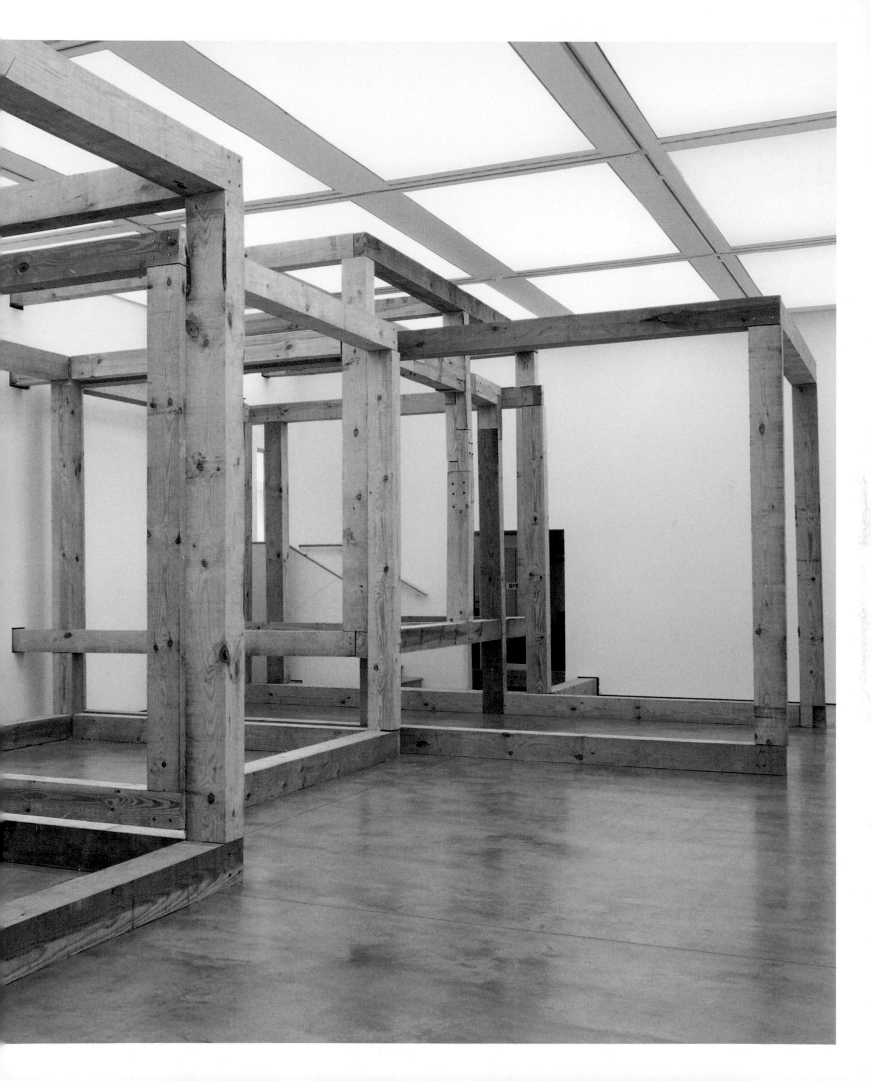

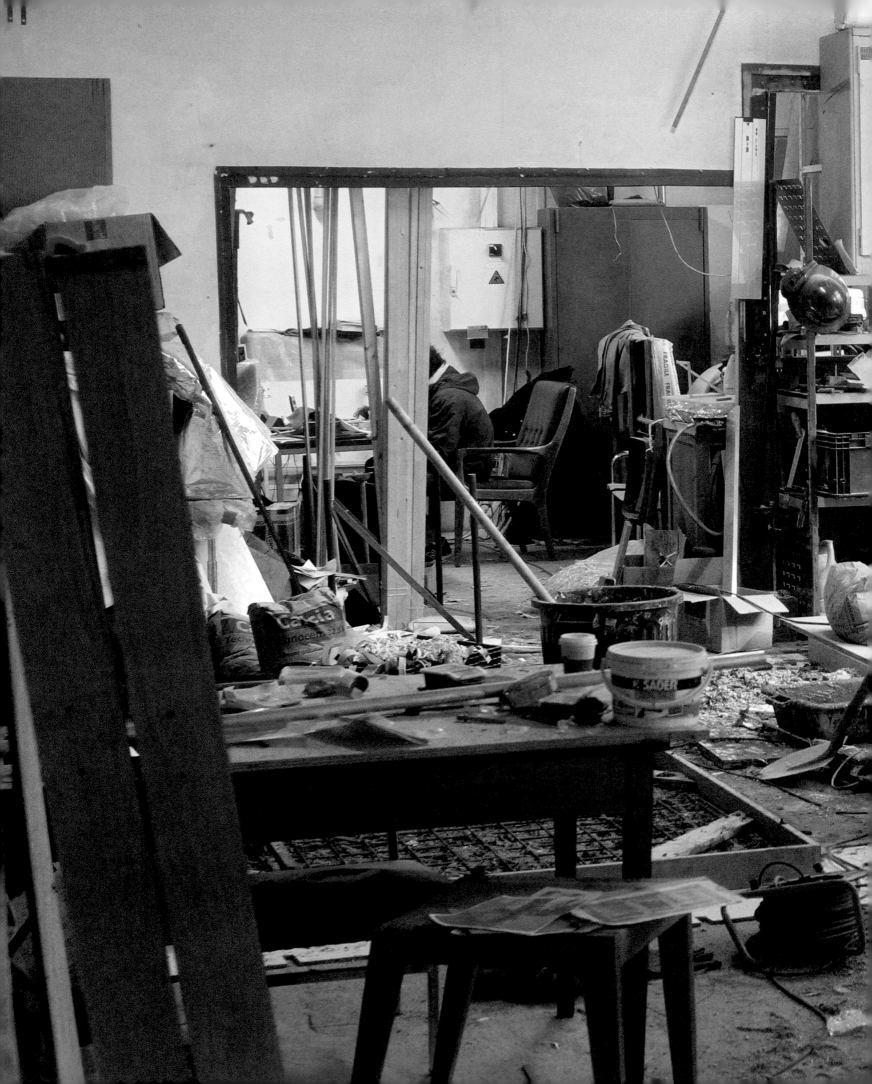

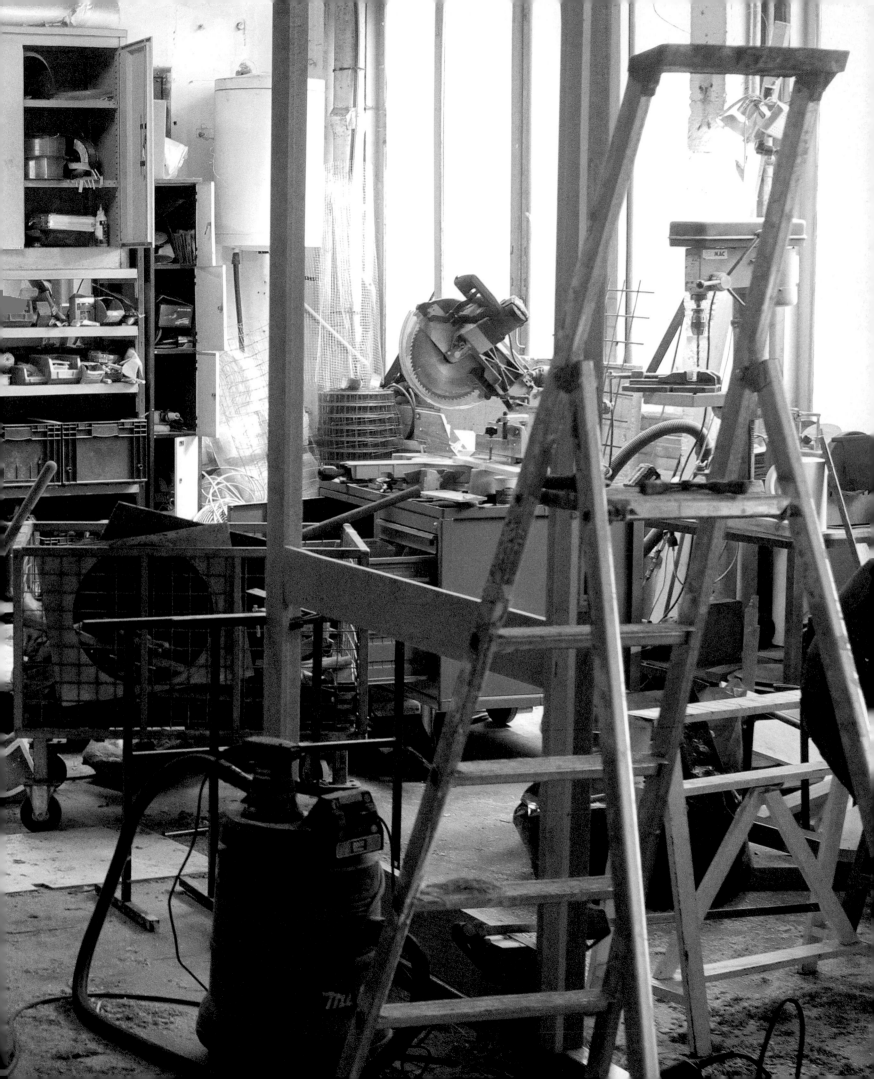

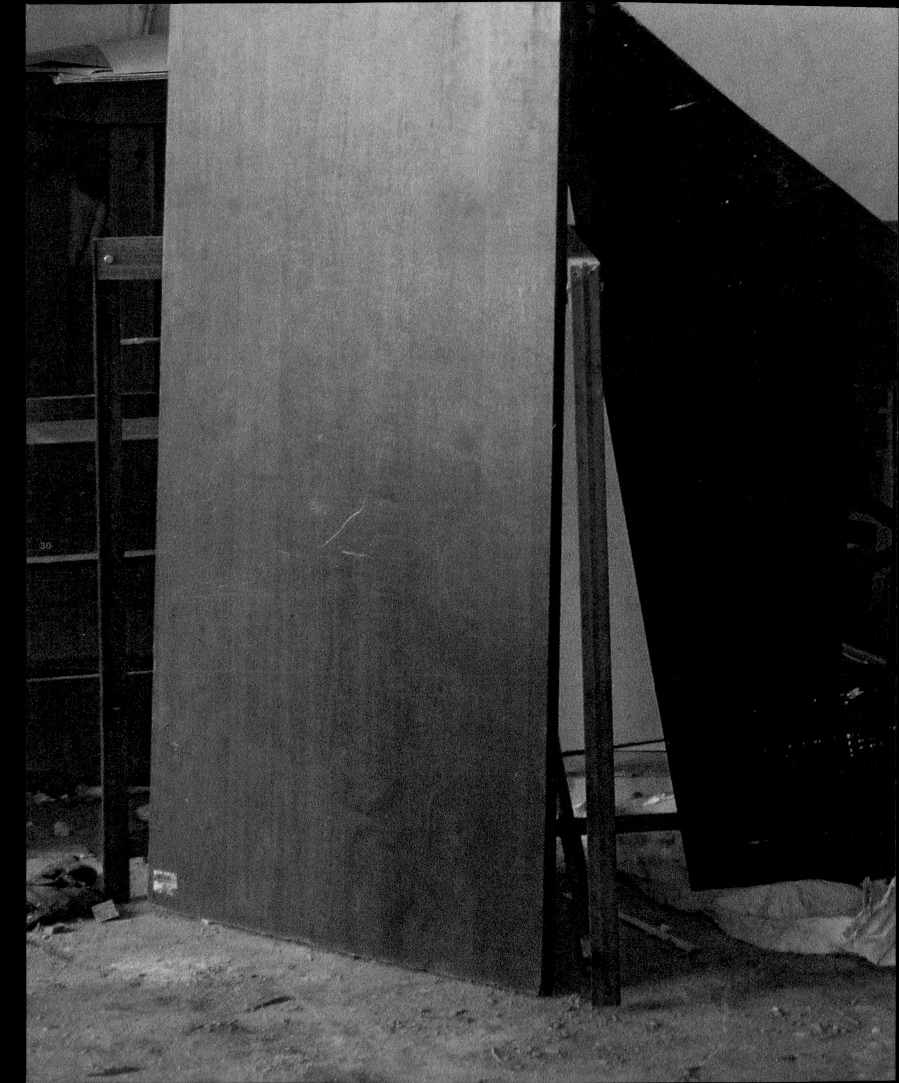

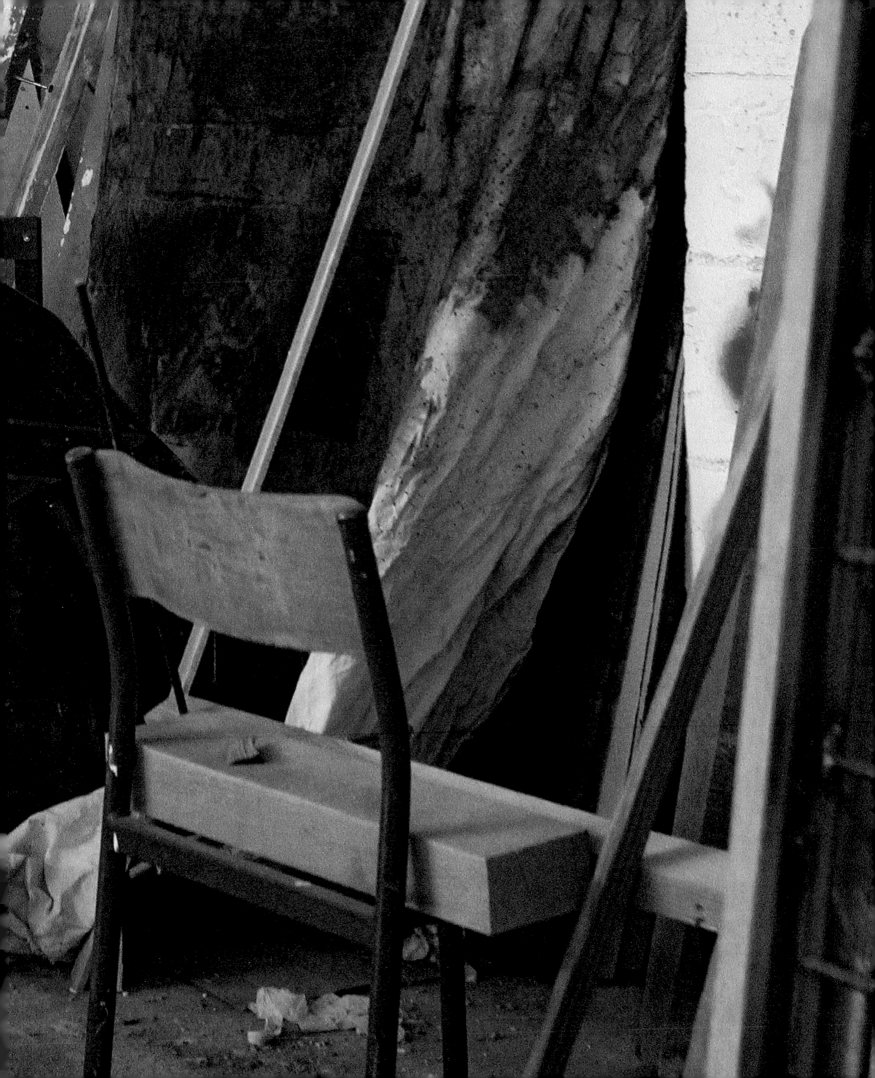

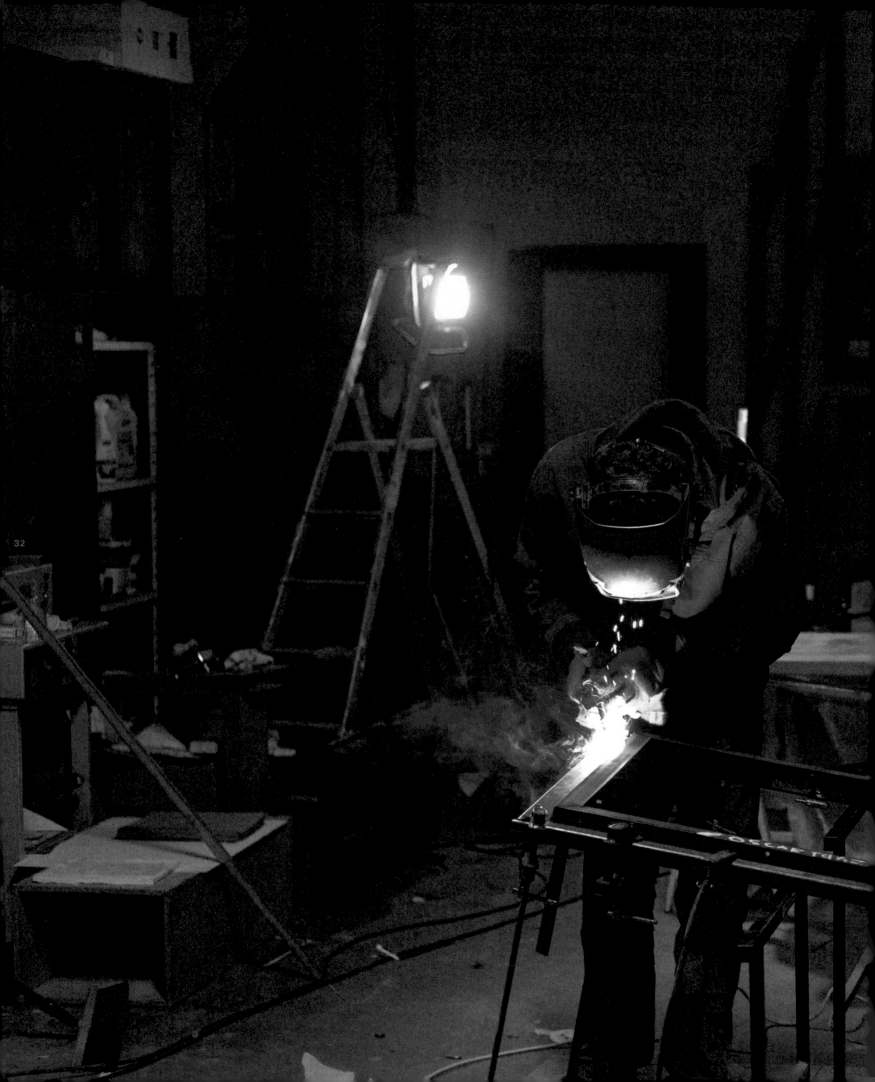

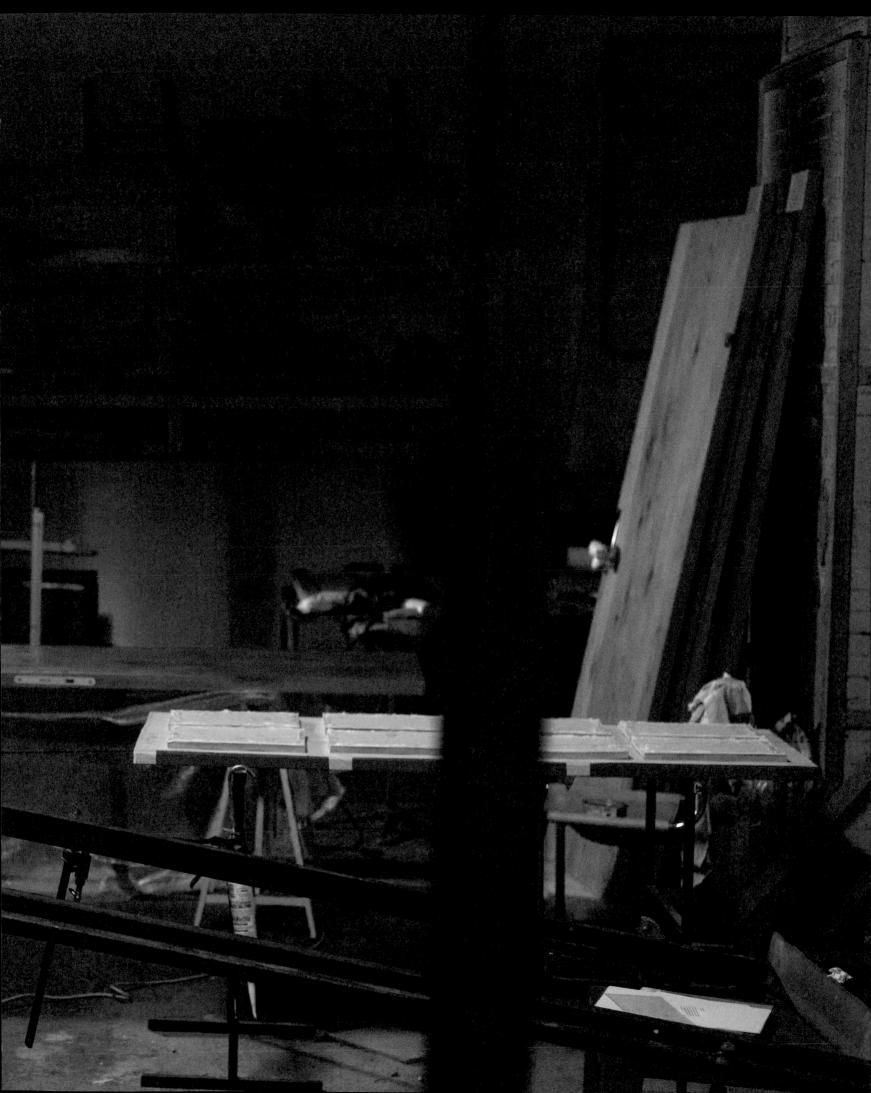

An artwork is a thing that can't stand on its own, a weak thing. A fragile thing. The work is inseparable from the space. The object needs a room; and yeah, the room needs an object. So in a very simplistic way it's hard to say where the work is actually located. It's disappearing into the space, it's becoming part of the building. Or it's absorbing the building into itself. That's a transaction. The work is fucking with the space. The work isn't subservient to the space, it's an equivalent. The work is fucking the space.

When I started making projects inside, I was very conscious of working in a room. I was adding something to the room. I was working in a room, in a building, I was doing a lot of renovations, remodel work, tearing out walls, framing doors, trying to make the space mine. I was an inhabitant, an occupant, a tenant. I paid for it. I did the work and stayed with it and got paid for it. I put money on it, lost some money on it so I had to stay with it. I stayed in the room with it. Moved in, lived there. That was the content of the work. The space made the work. The work couldn't exist without the space.

An artwork is an object that's not meant to be. That is the political of an artwork, the critical capacity of an artwork, being a thing in the world. A thing that hasn't existed. A thing that hasn't existed proposes new ways of being. Attractions. New desires, functions. A thing that proposes its own existence. A thing that proposes itself. An object that demands respect, a person. Fragmentary, incomplete, a dependent object, a projection, not a real thing, a potential thing. Unfinished, failed, a busted tool, discarded, absurd, impossible.

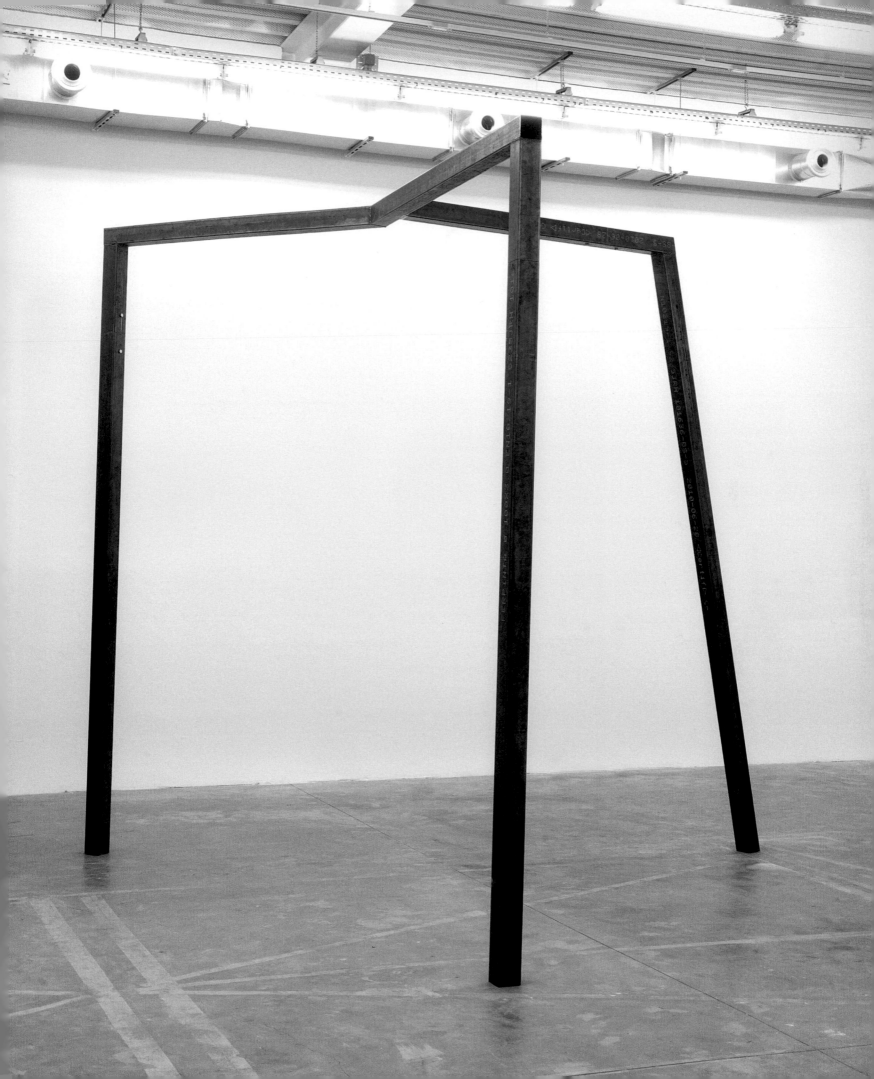

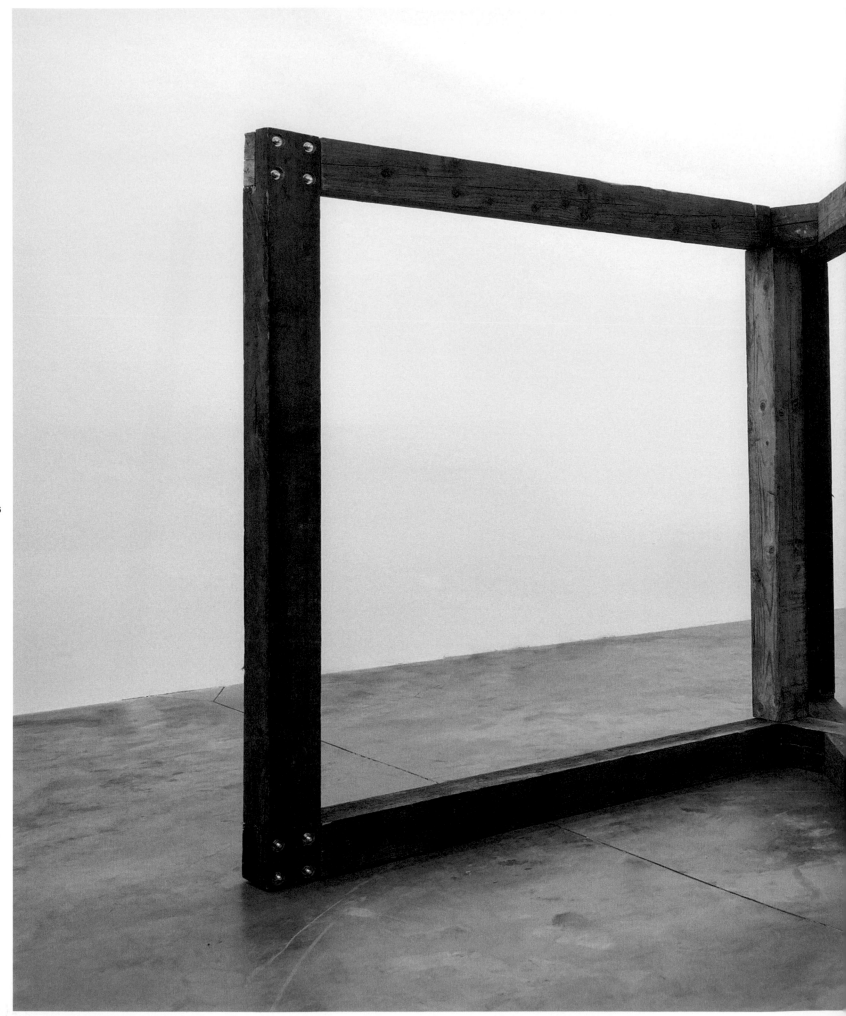

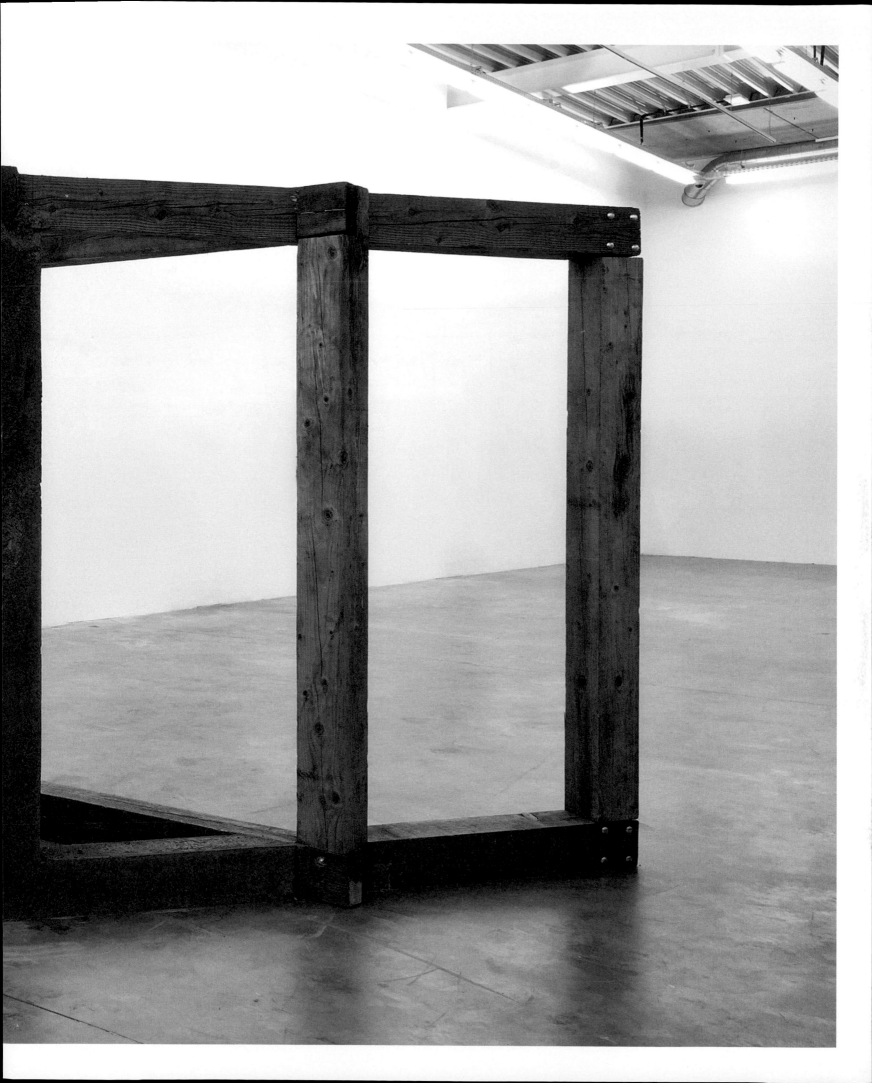

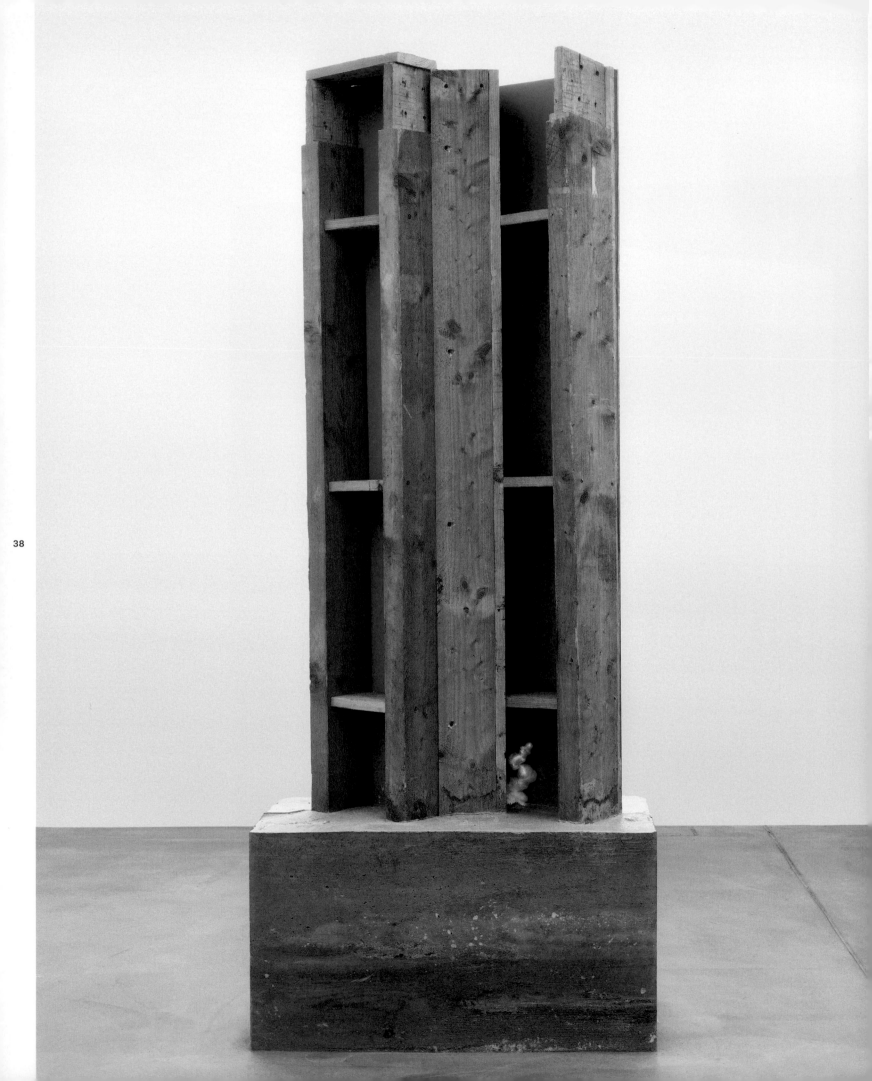

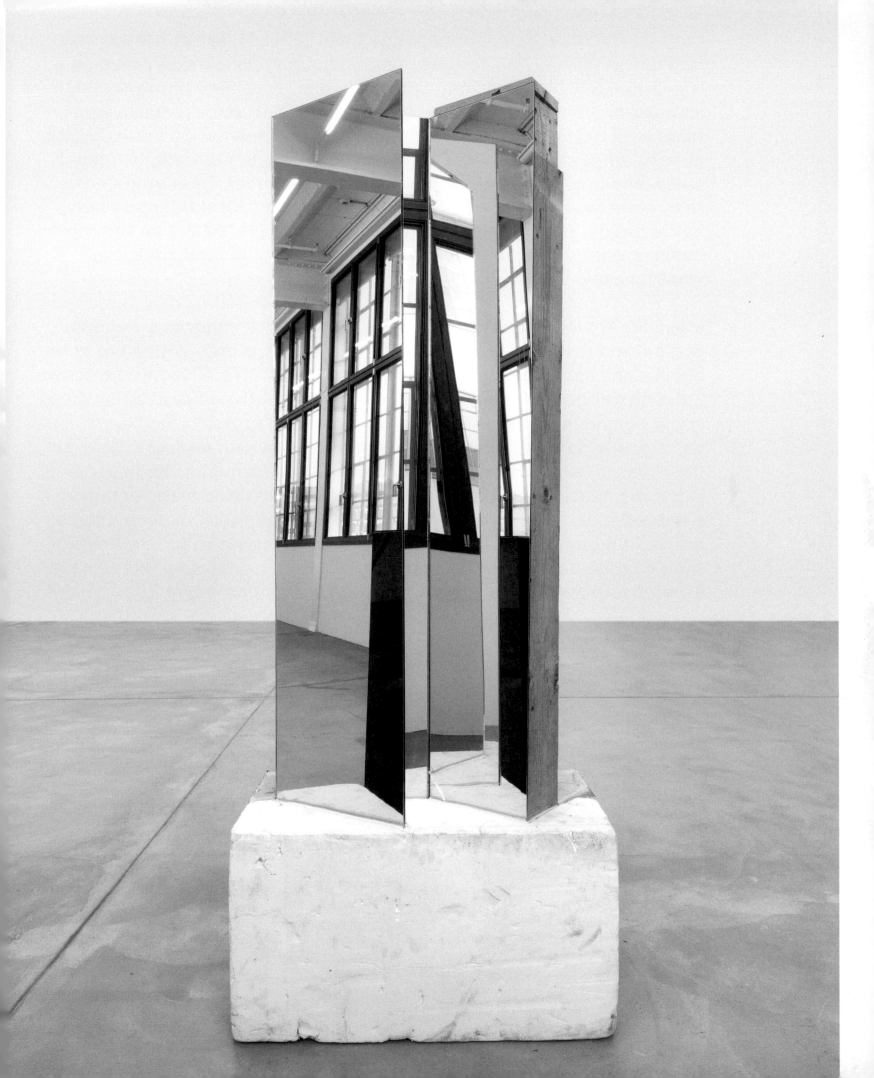

Dust on the floor, a pegboard pegged out, laid out, at least a day out, lath nailed laterally on centers, a man standing on a ladder, missing a leg, a man with carbide sand on both hands, a framing blade on a half inch worm drive post, dust on boards, dust-filled voids, boys, a wall filled with noise, floors, plaster on the boards, powder on cords, power chords, what's a wall? What's a man's advantage, standing in hand-cuffs, enhanced and handsome, what's a hand for? Steel stud construc-tion, aerated gypsum on felt, hot wax candy, unprotected and ready, hot n steady, steam, see, down on your knees, see, beads on the triple beam, cream, cabled in trees, whatever it is that a hand sees, see what I mean?

I feel like I'm looking into some black void of utter madness. I almost can't stand it. A man on the planet. I planned it, a man with a big prick, absurd and bandaged, give me the damn handcuffs. Give me the screw gun and get gone. Gimme a razor, a pair of straight-edge aviation snips, stand behind me to my left, close your eyes and protect your hands, we're gonna dance. Dust on the damn floor, down on all fours, flour on floorboards, words, fiber in slurry, fiber on the form boards, fine. Funny. Fabulous, fastidious, a fully-formed word. An enlisted man, a maniac, a fine woman down on the floor on all fours. Sensitive, explicit, interes-ted, it's gibberish. Gilt-edged grey plaster compressed in felt, floated, skim coated, hand troweled and wet polished, a reflective flat surface, beveled and abrupt, corrupted, a human substance, I love it.

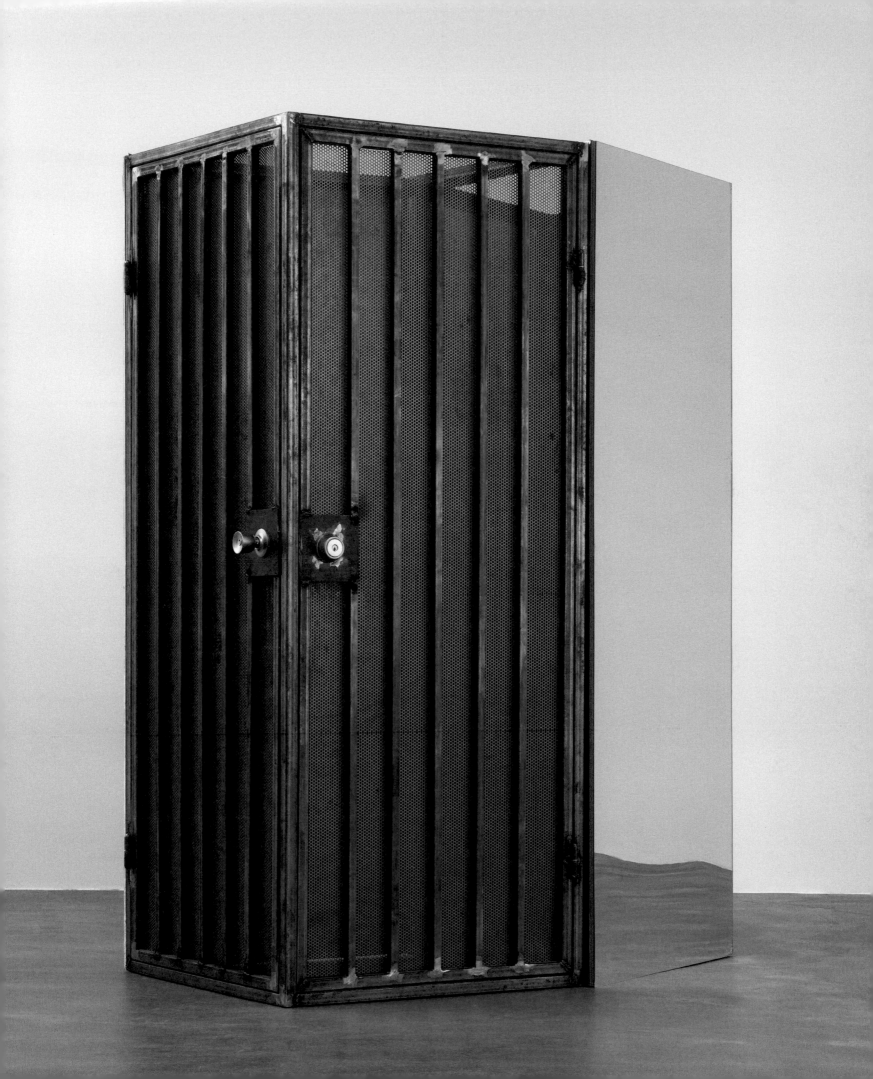

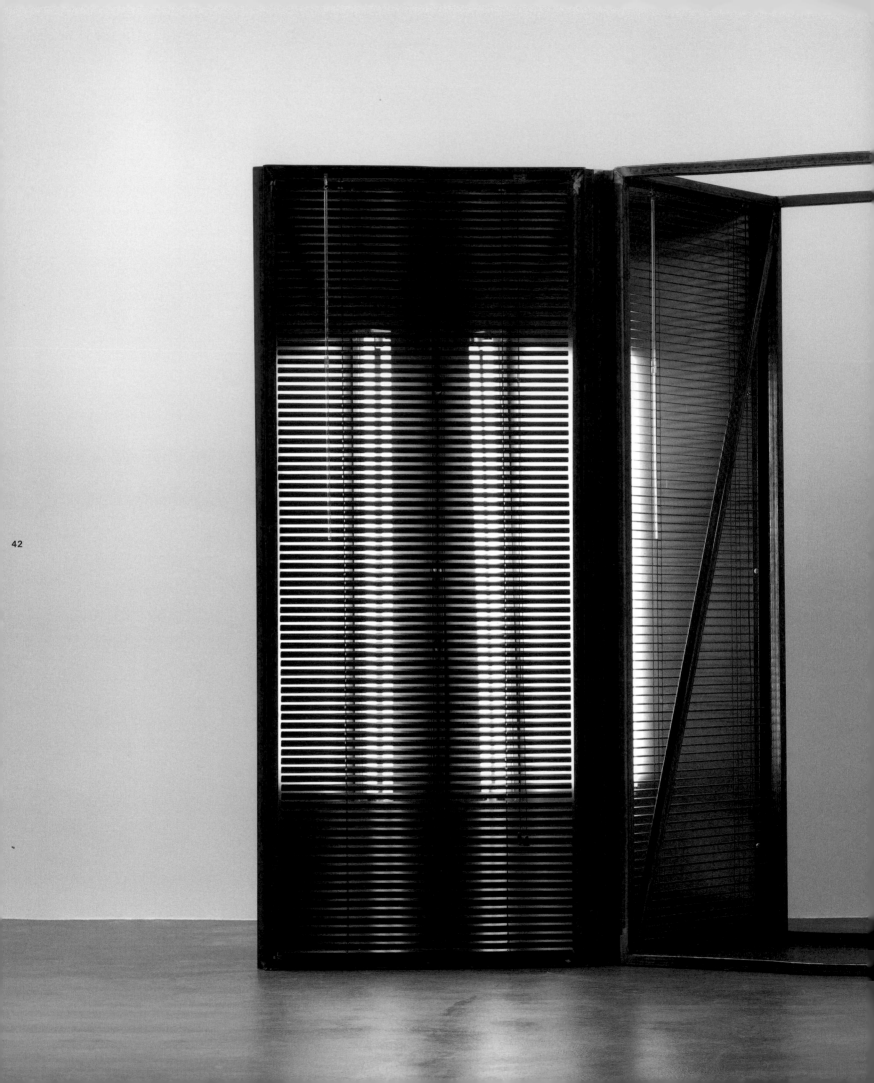

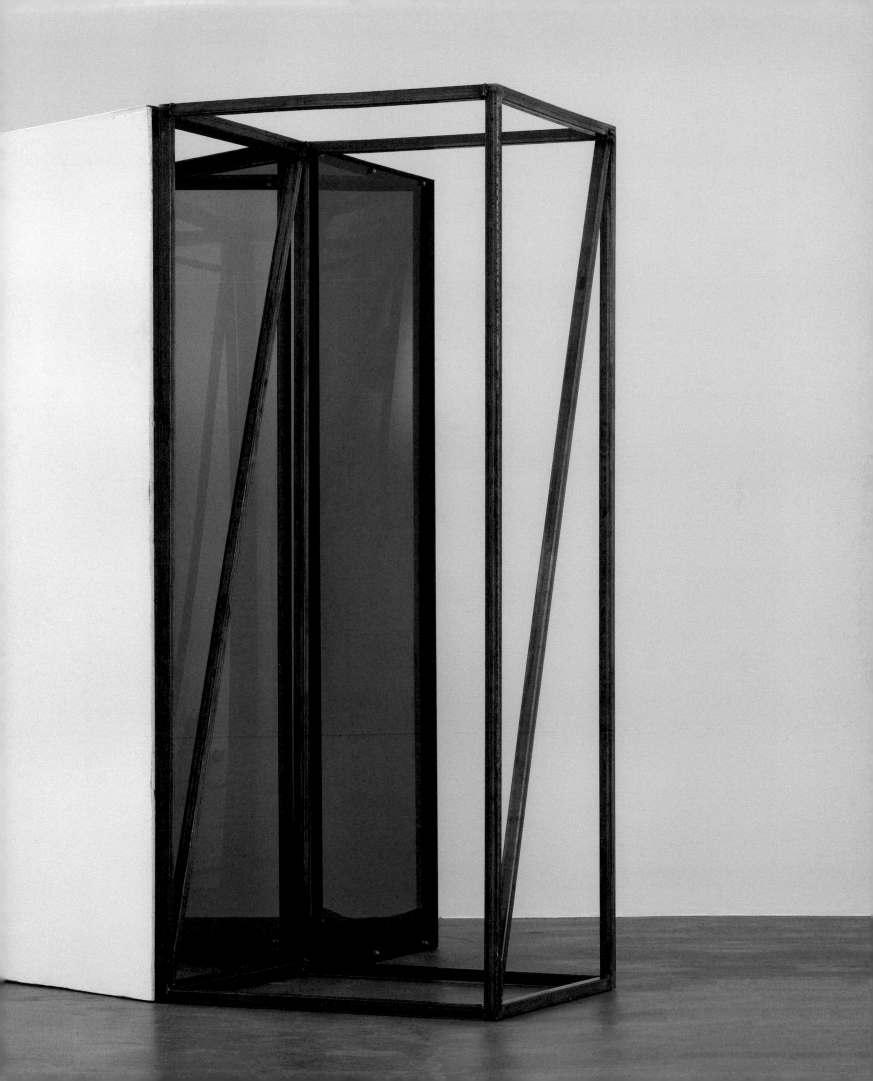

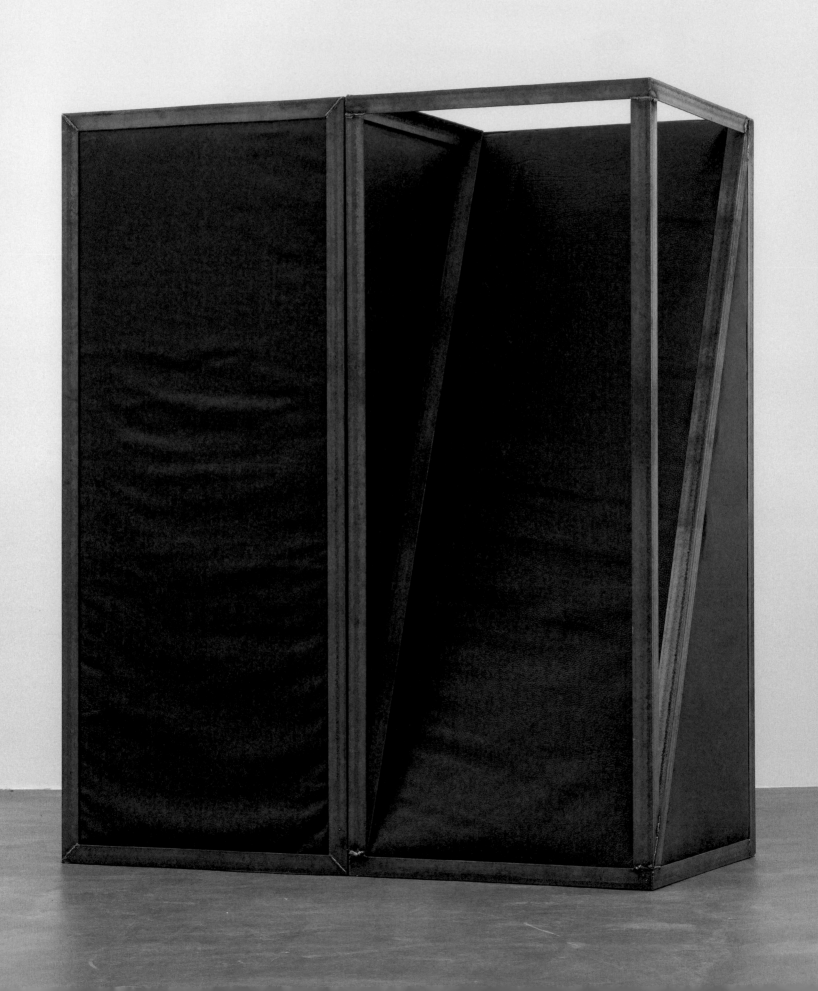

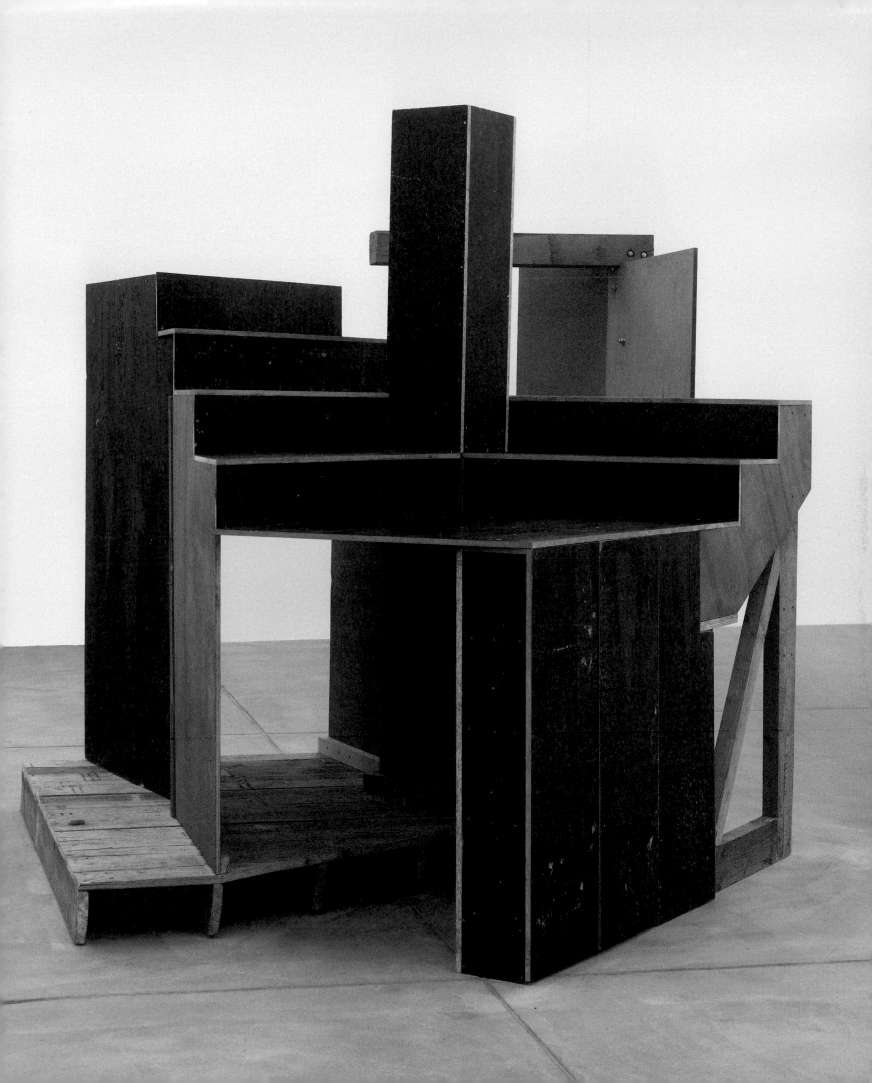

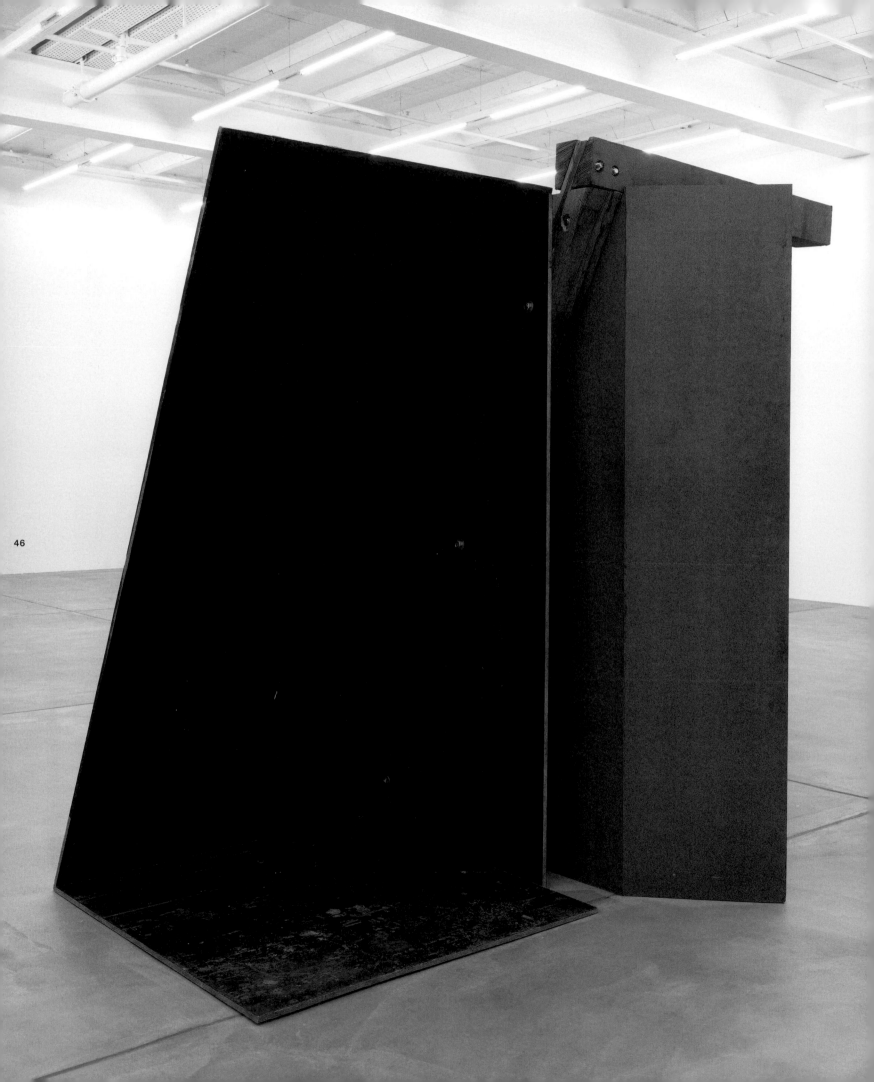

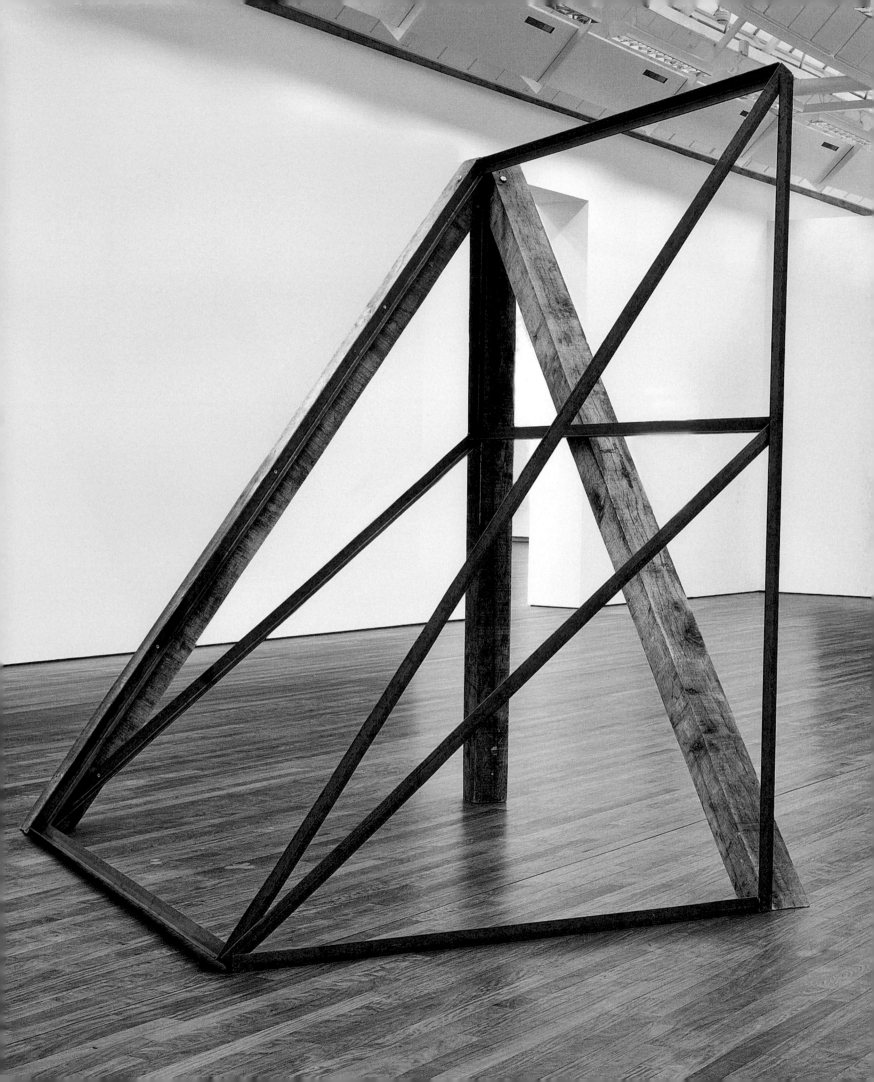

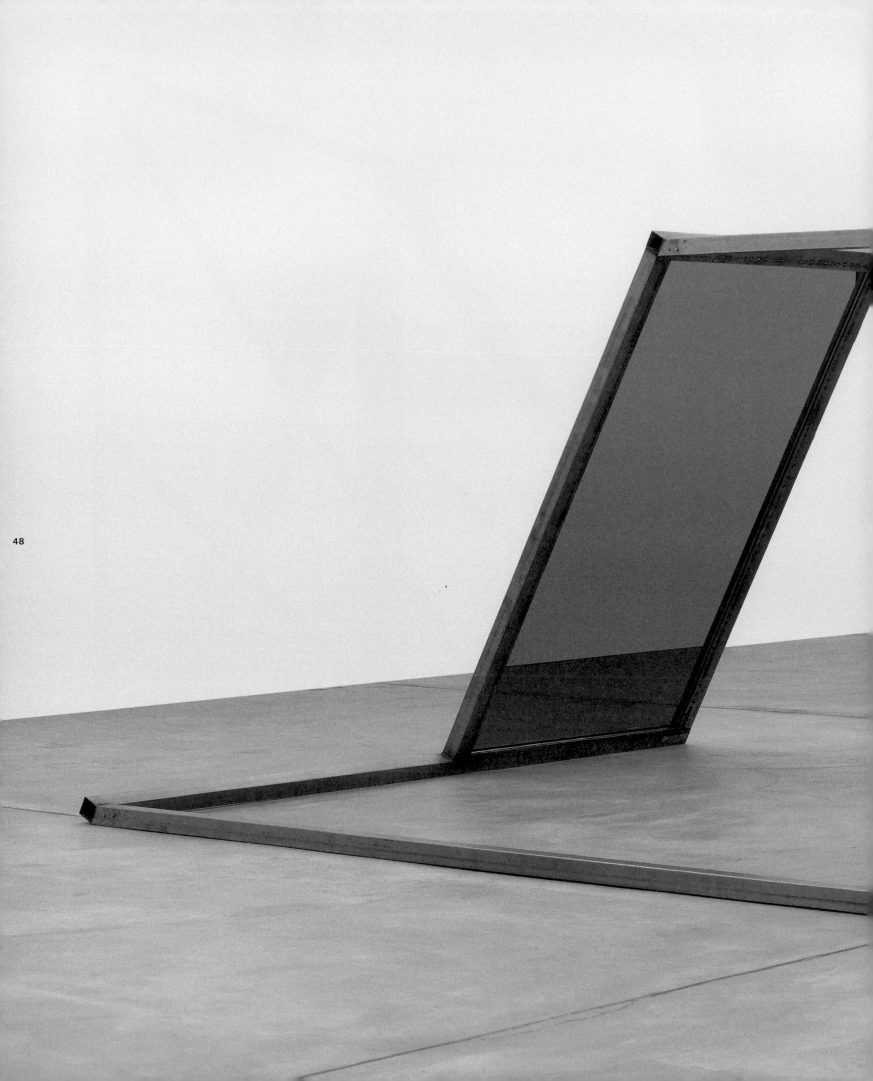

48

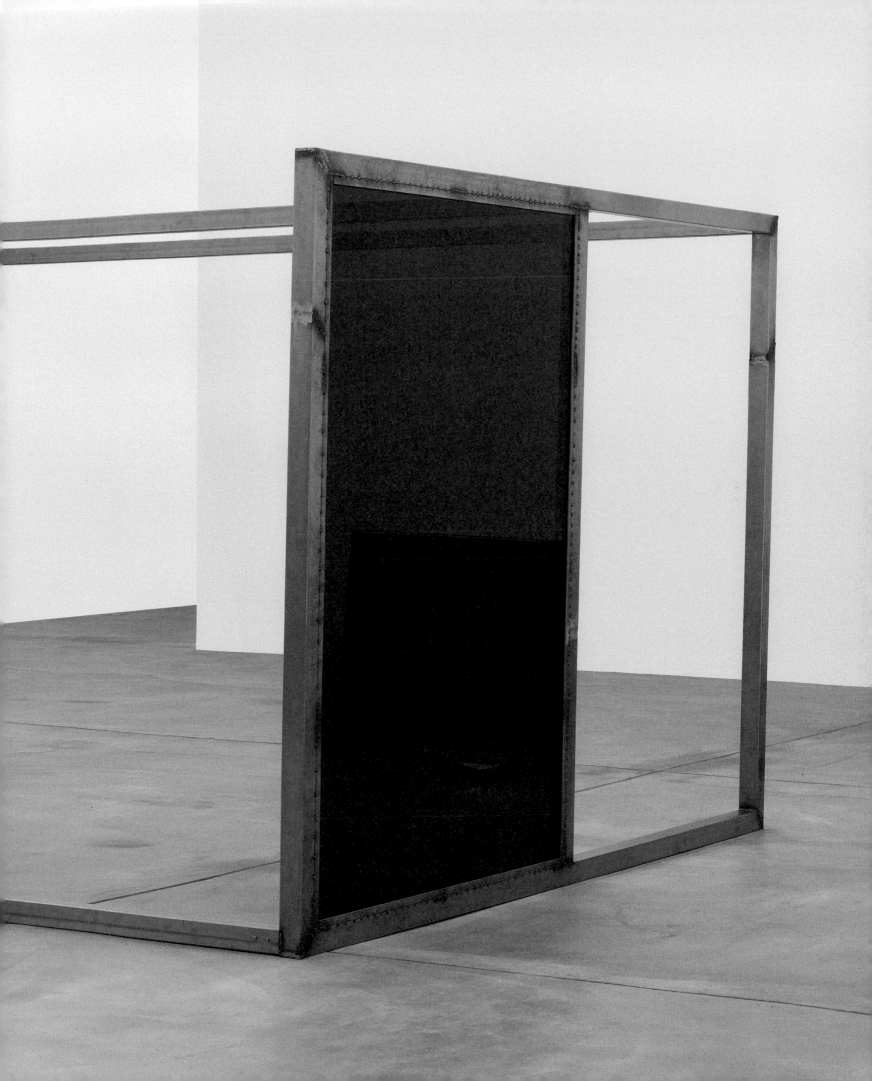

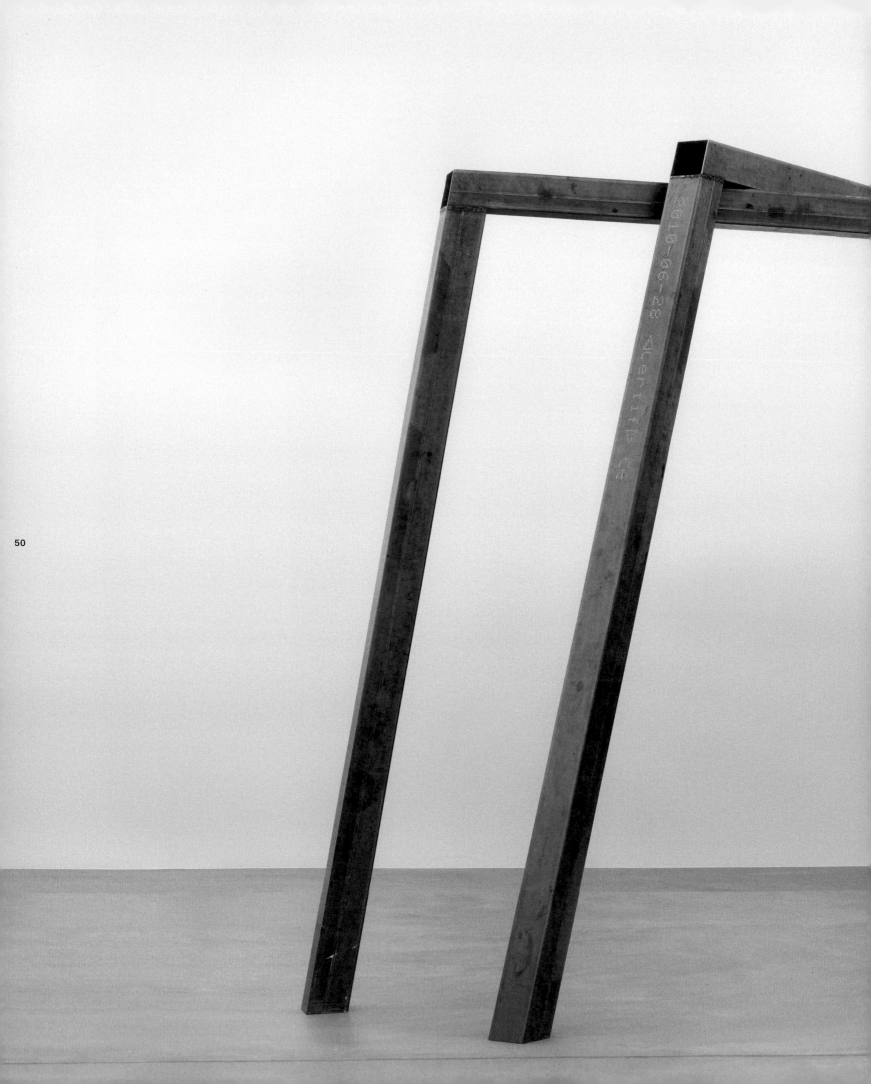

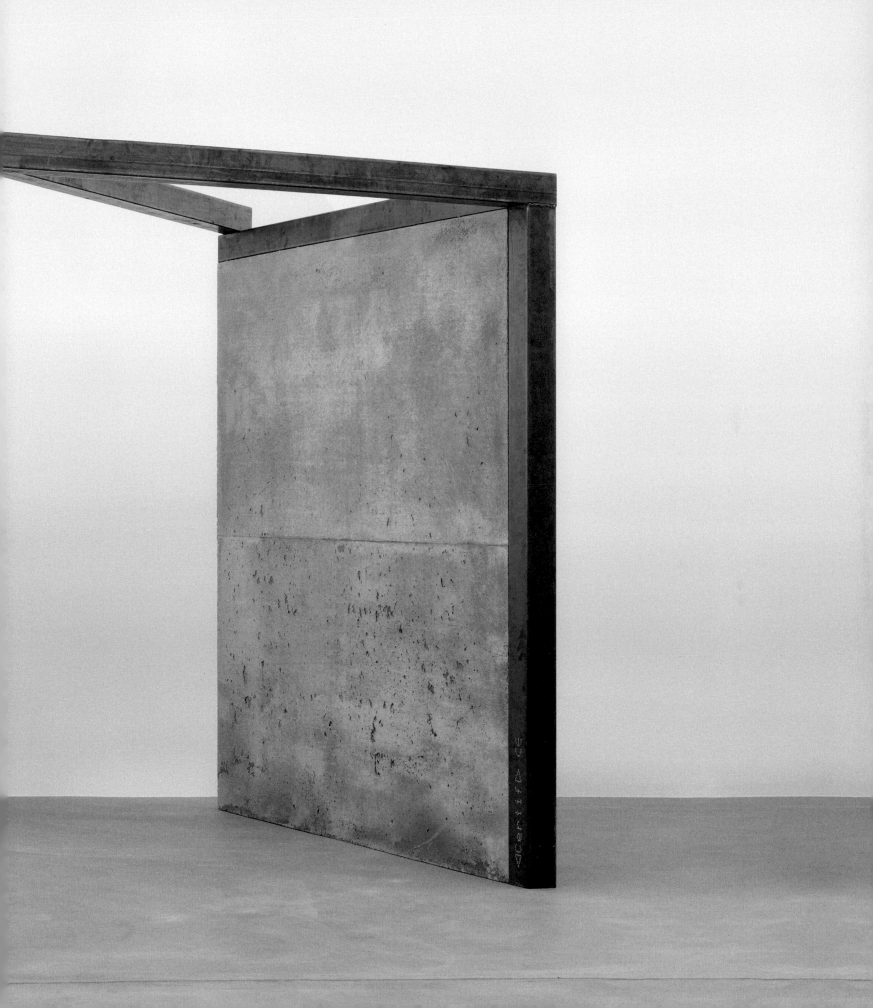

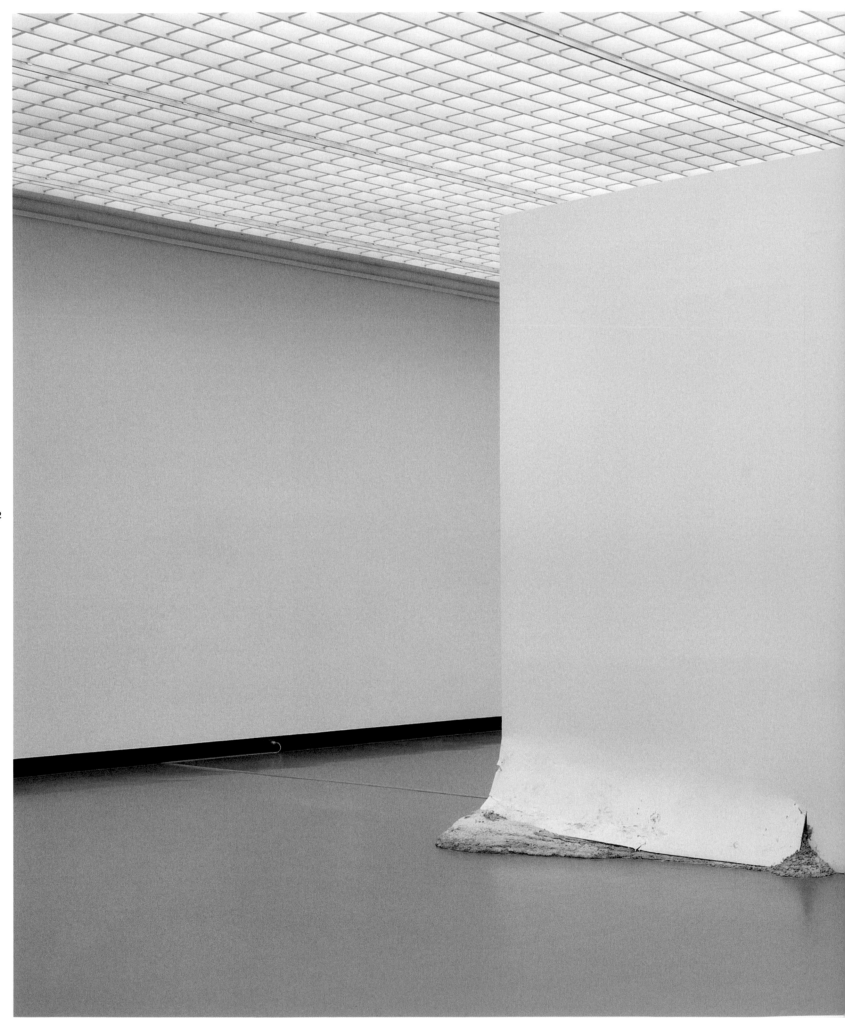

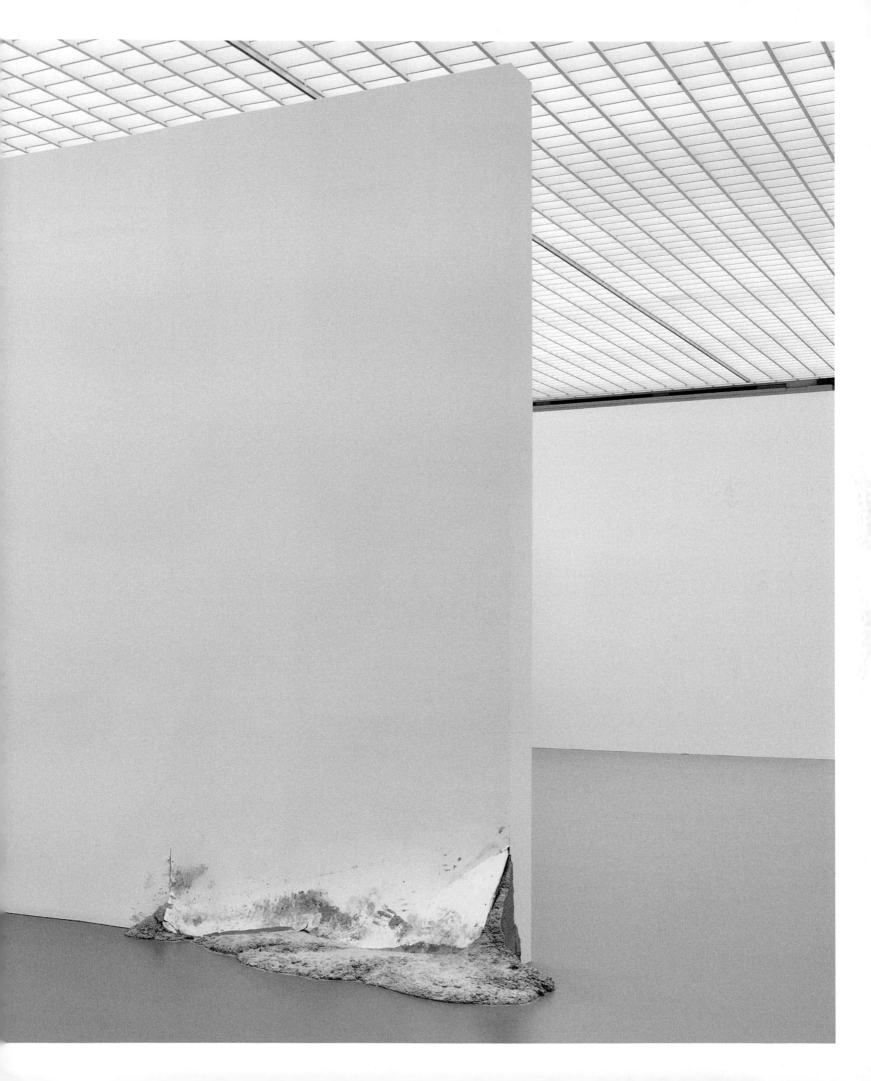

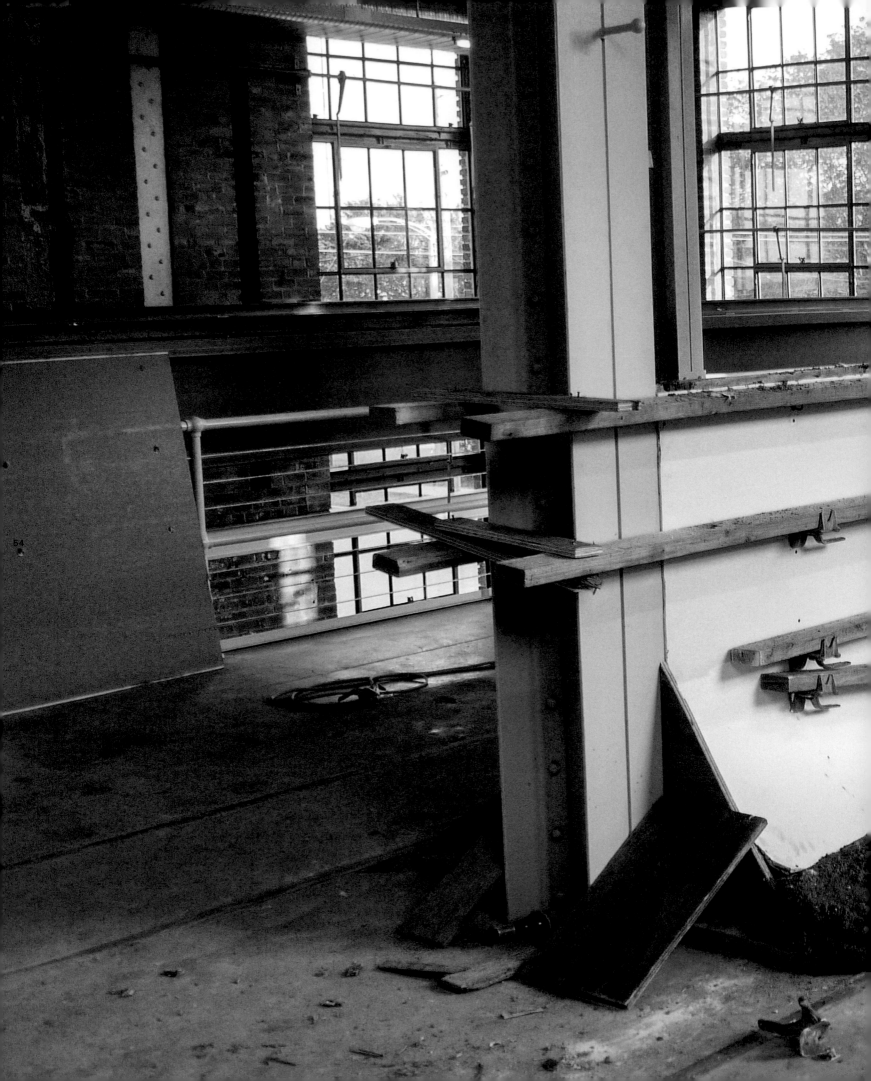

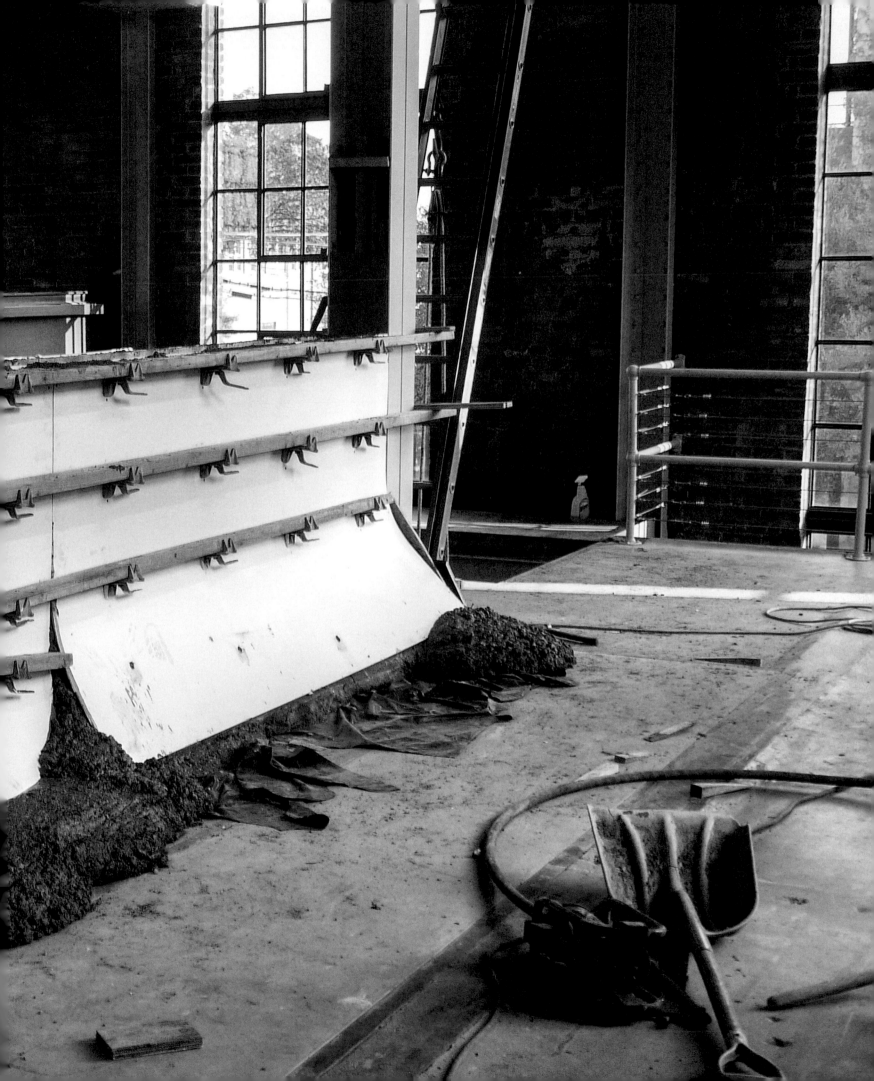

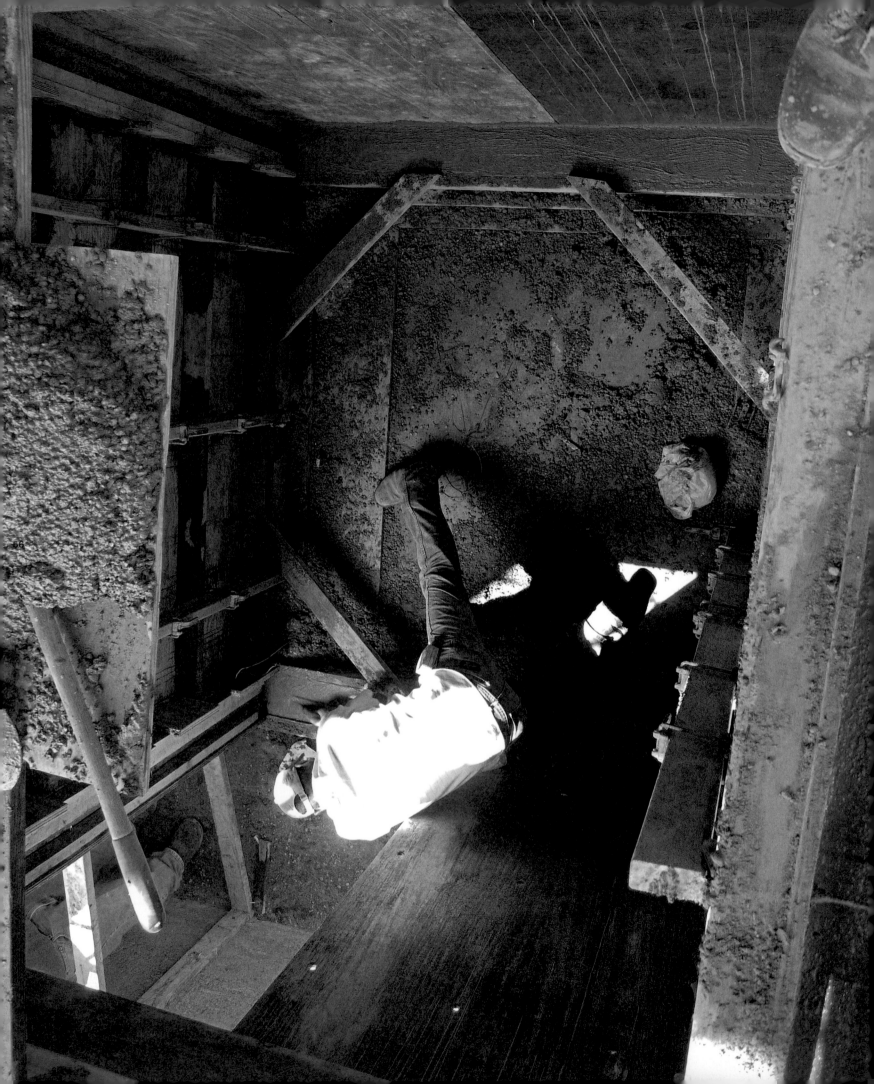

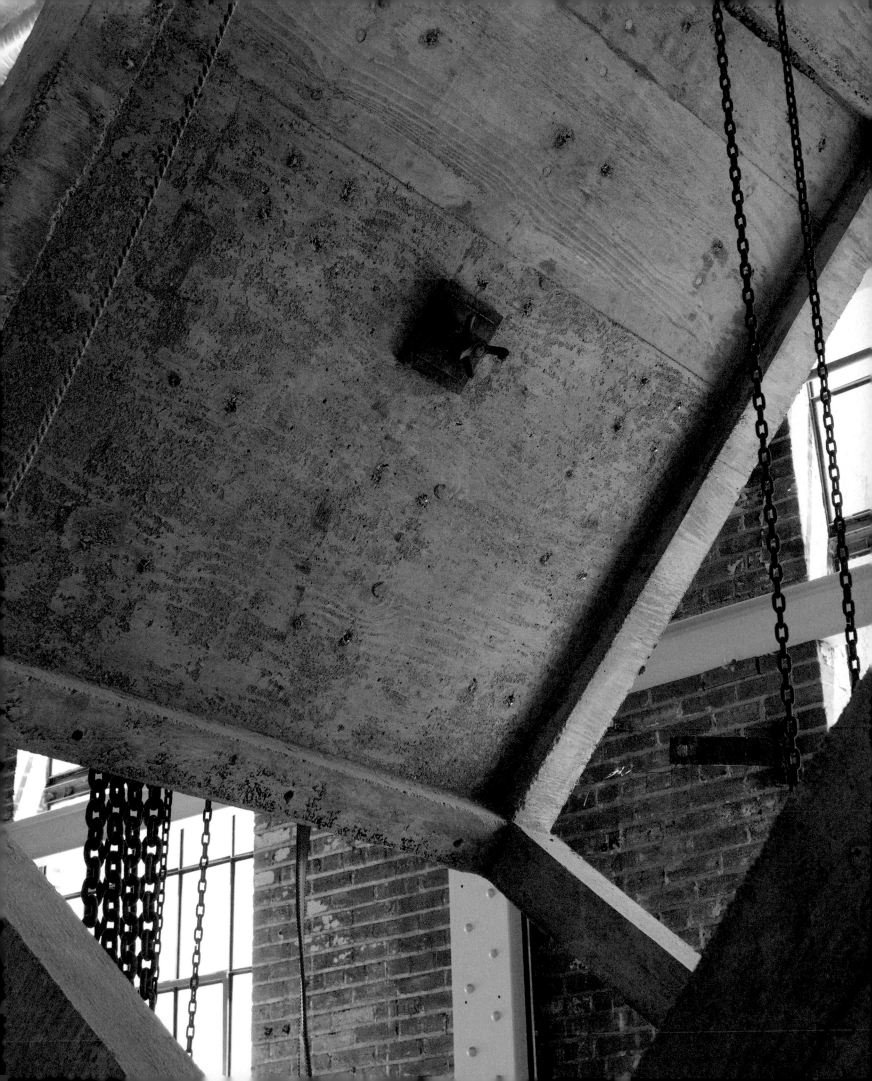

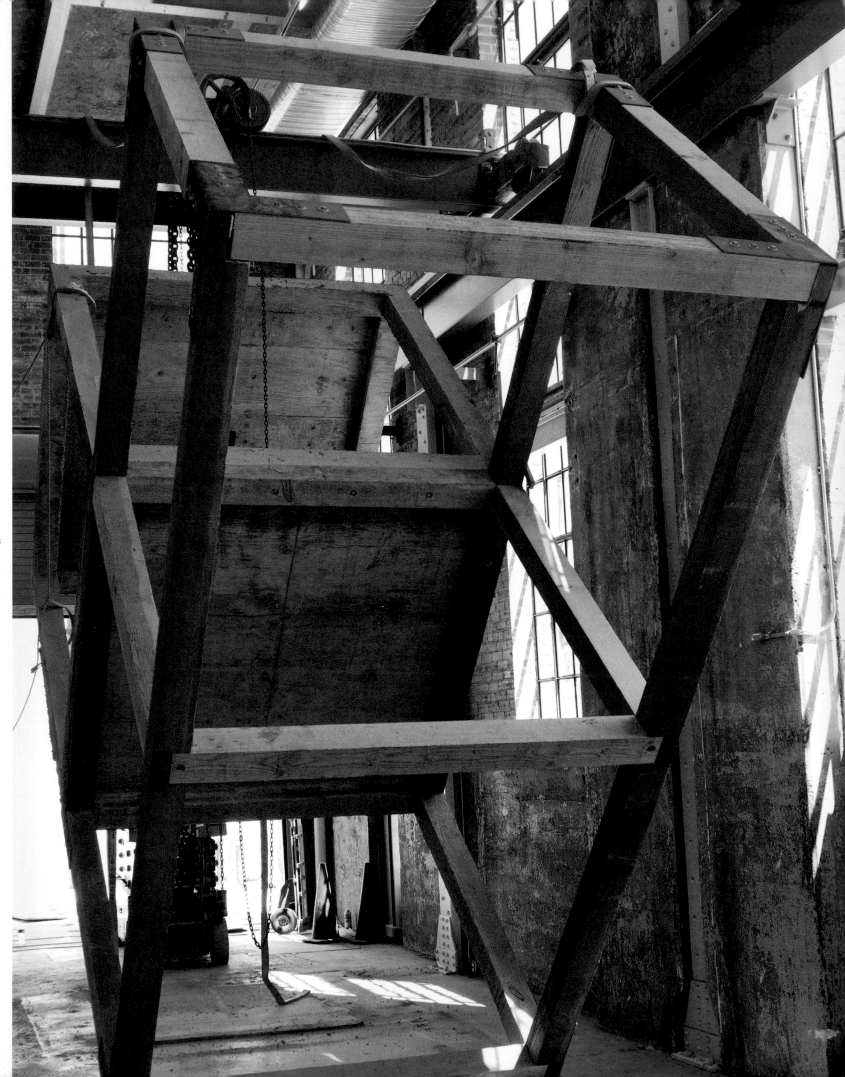

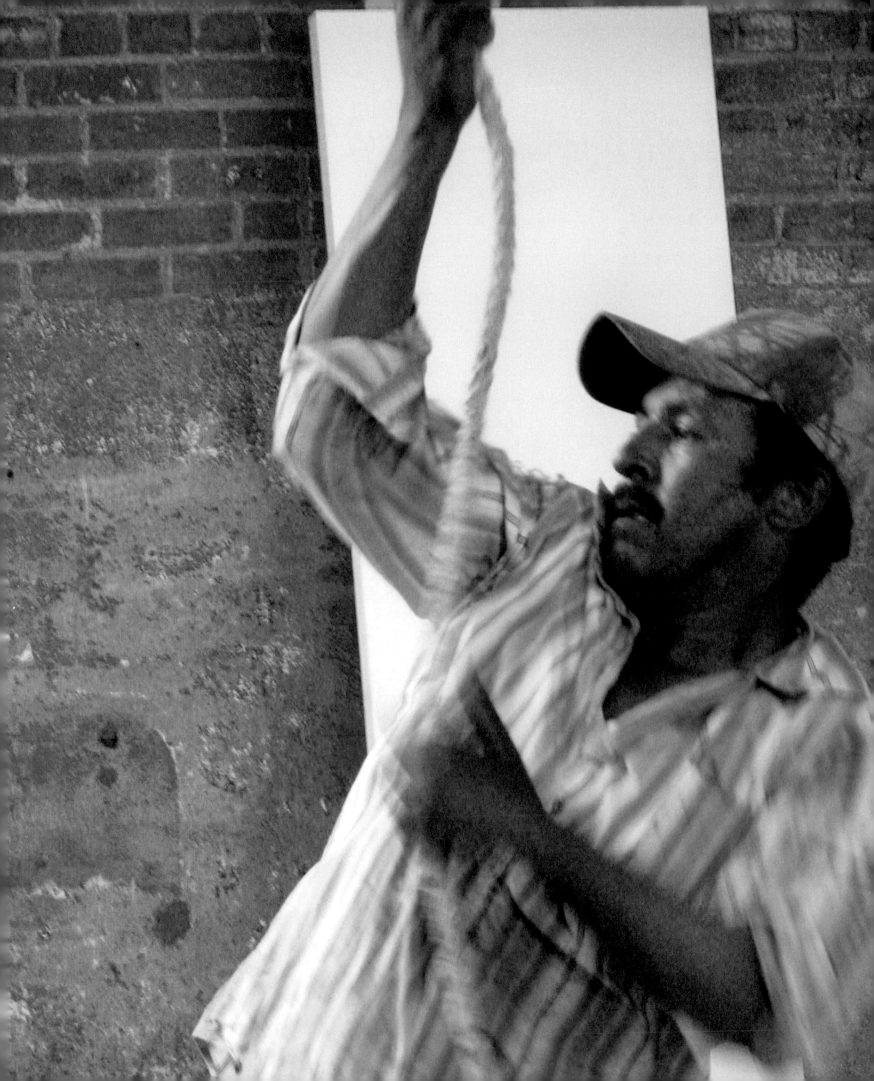

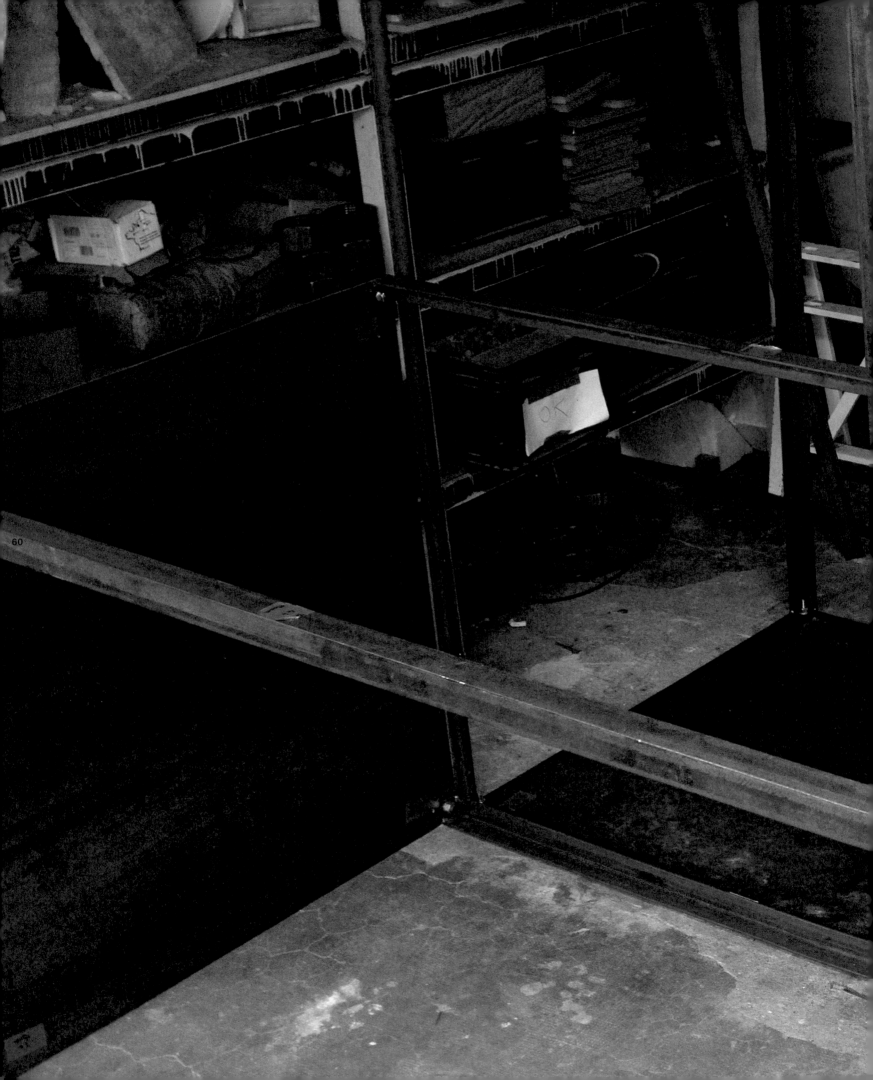

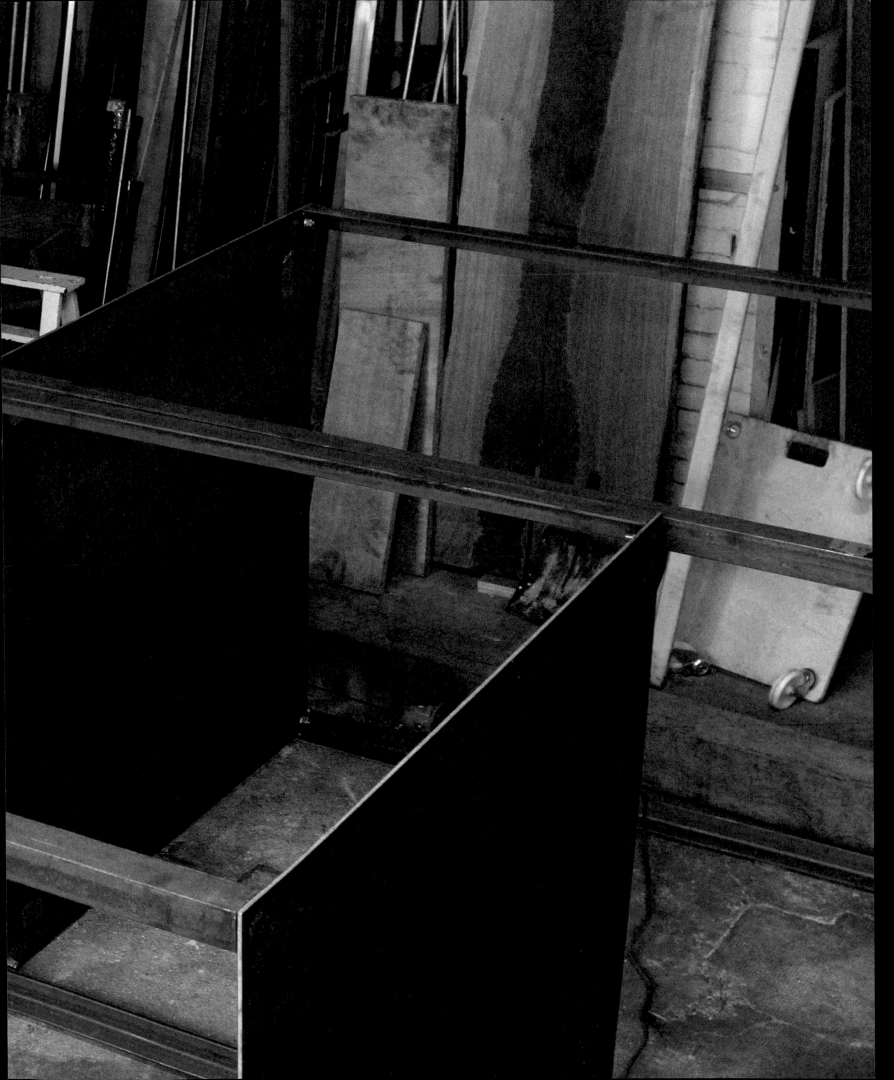

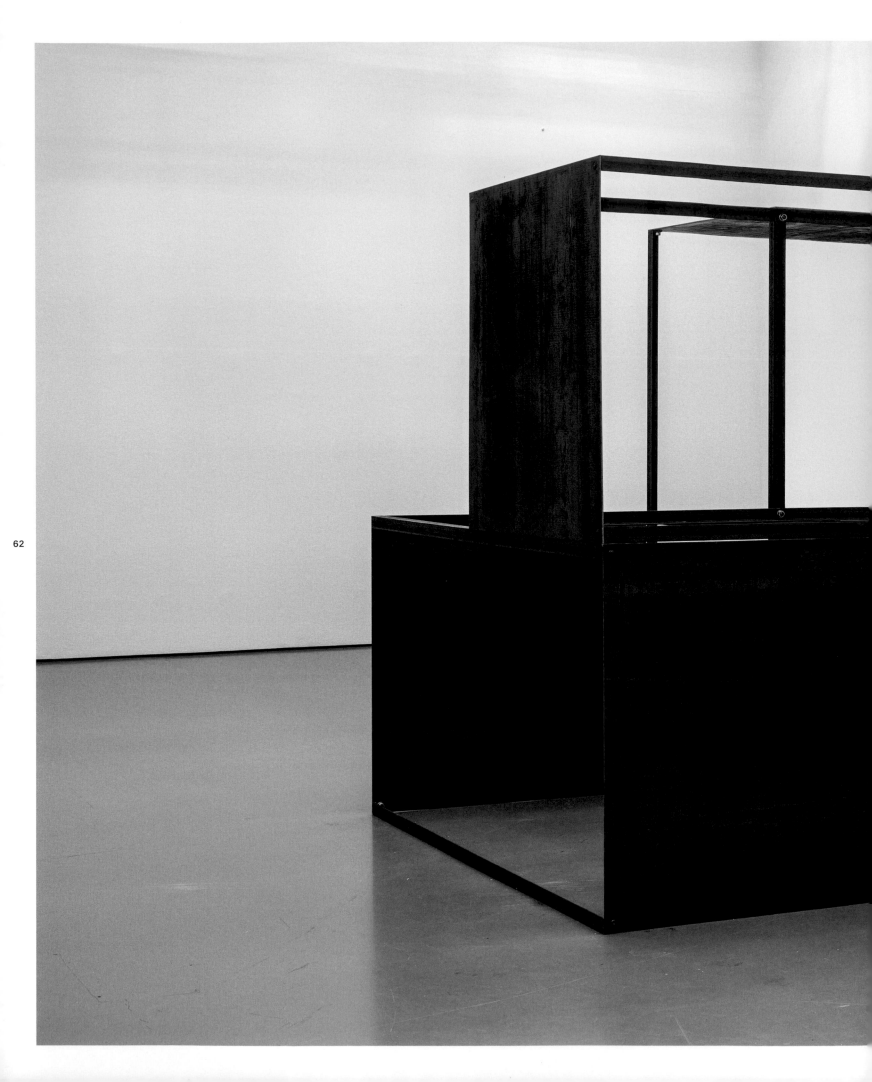

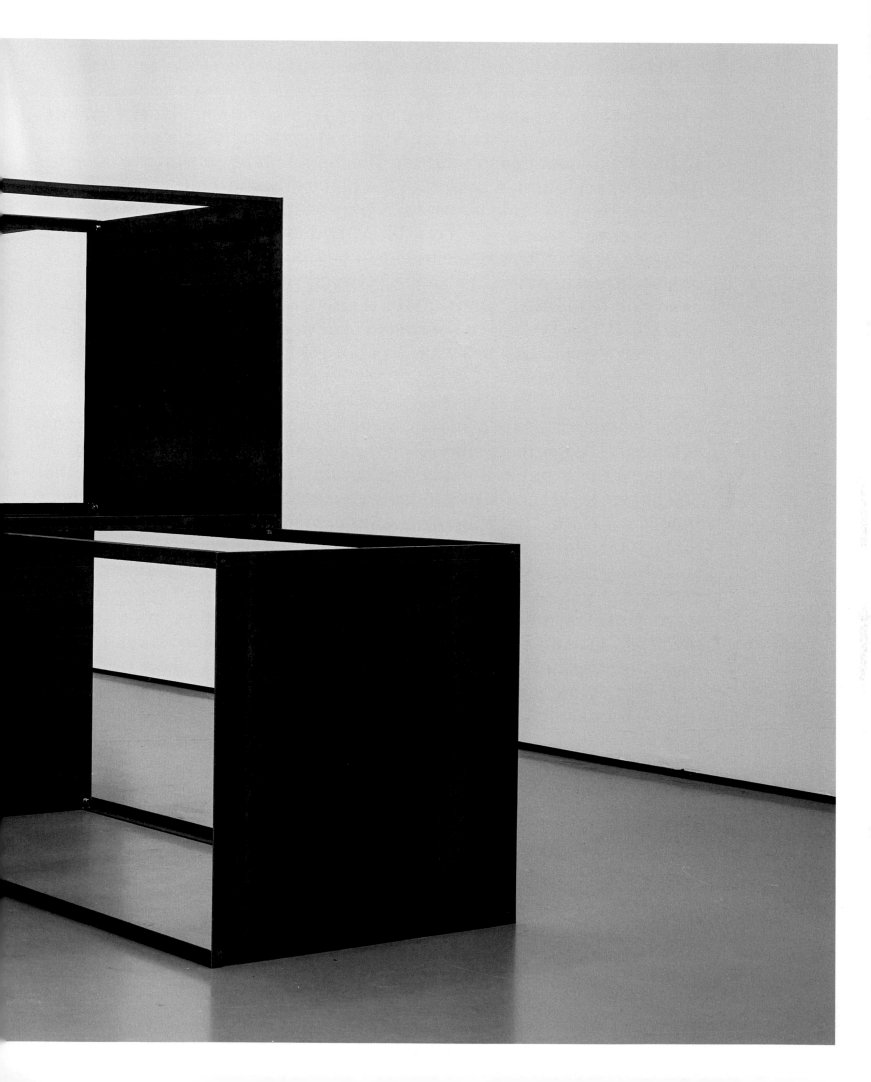

Compress space. Confine it. Enclose a space, close it down. Open it up and close it down. Chop it. Make a line in space, make a plane. Make a place. Walk in. Work in a cage. Live in a cage. Gilding a cage. Sculpture is building a cage. Standing in a cage, standing in place. Working in a space. Building a stage, working in stages, building a stage in a space. The object doesn't matter. The object makes a space around it. A piece of sculpture. A sculpture is a piece of something. A busted thing, a broken thing. A thing in pieces. A fragment, a piece. A sculpture is a piece of something, don't matter what it is. Sculpture is the space between objects. The space between one thing and another. Between one body and another. The space between your legs. The proximity of one thing to another thing—that's a sculpture. The space contained in a wall. There is a space contained in a wall. Make a place for yourself. Live with a thing. Live in a wall. Live between walls. Live in a building. Live in a Ram's head.

An artwork creates its own site. So an artwork could be something that you inhabit, something that envelops you, something you walk into. Not like a room, but in the way that during sex people enter one another. The object is just there to generate an electric field, and the electric field is the work. That's air. A sculpture could be a place. The work can replace the world. It's a place, a space. It could be made for people, something people use without thinking, a place to go. A place to go and be alone. A pointless thing, not meant to be used. It isn't for sale anymore. A useless thing is an insult to money, it's insulting, it's disgusting, revolting. Art can be disgusting, it can really be nothing, it can't be anything. A sculpture is a useless thing you could use, like a tree. What's a tree for? What you need it for. It's a living thing; a tree is living even when it's dead. It's a thing that lives forever, like a word. A sculpture can be a living thing, a sculpture can be a person. It is a person. Sculptures are people. And that includes people. The object includes people. Objects are people. Sculptures are people.

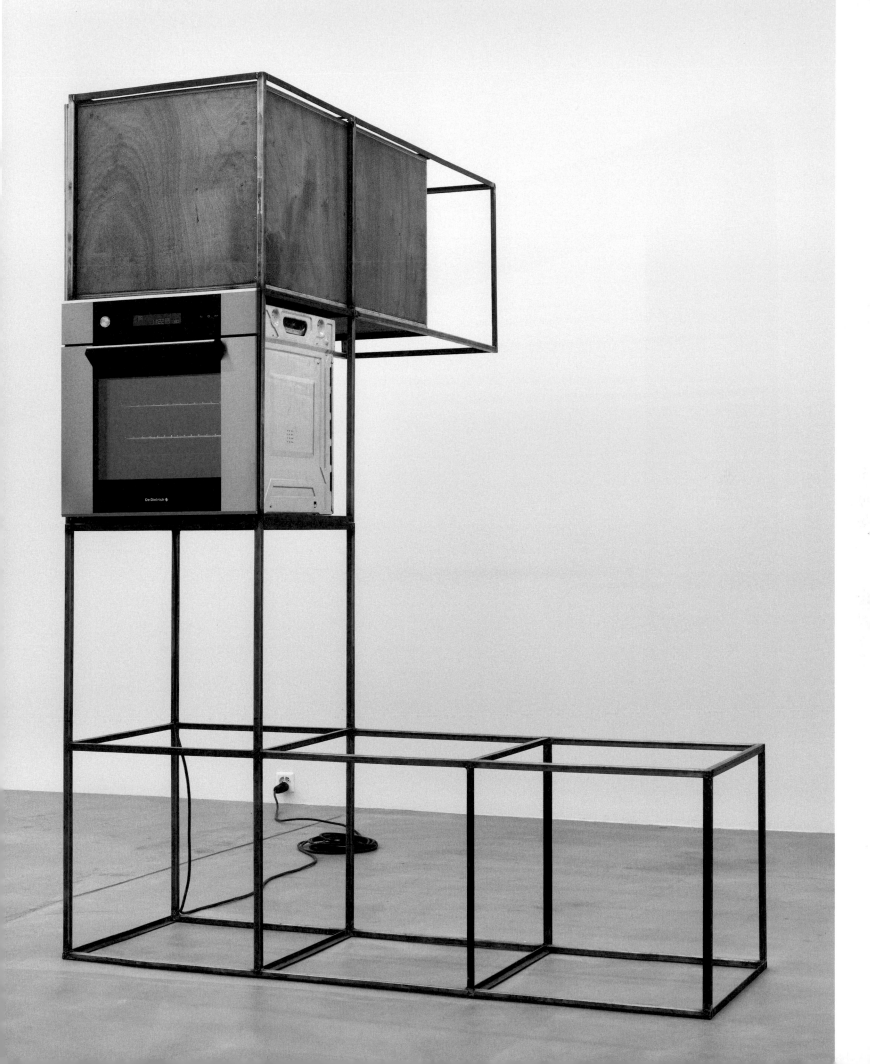

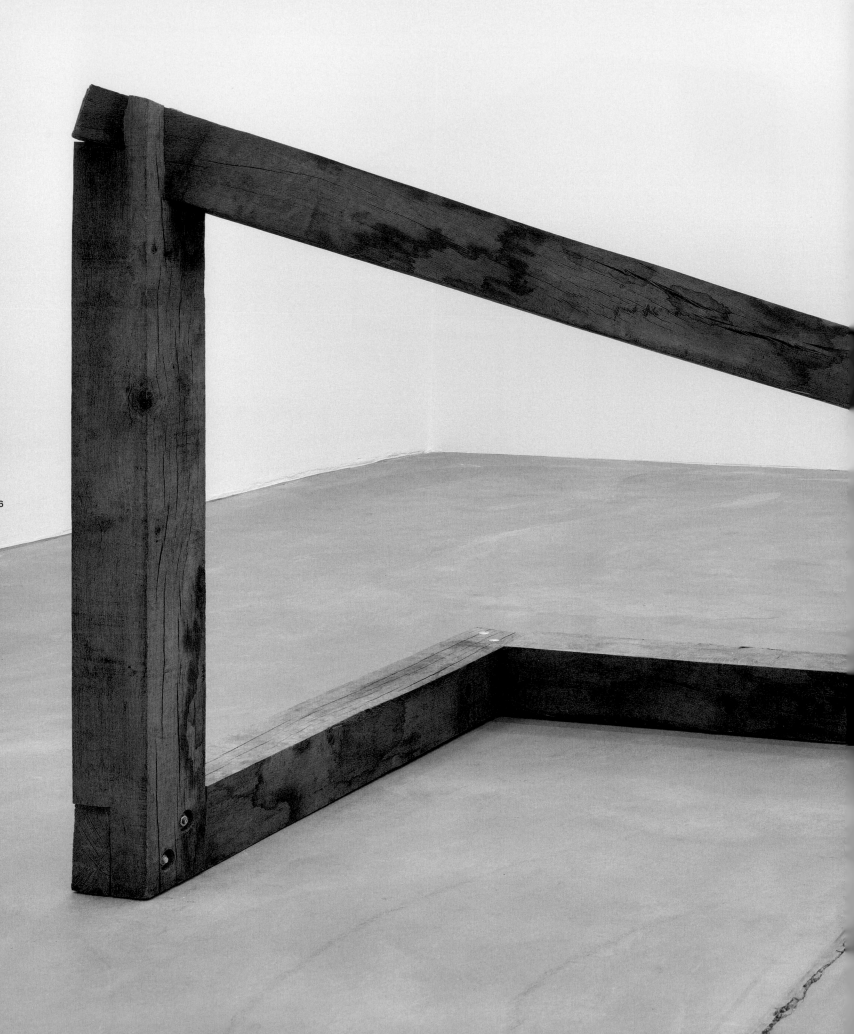

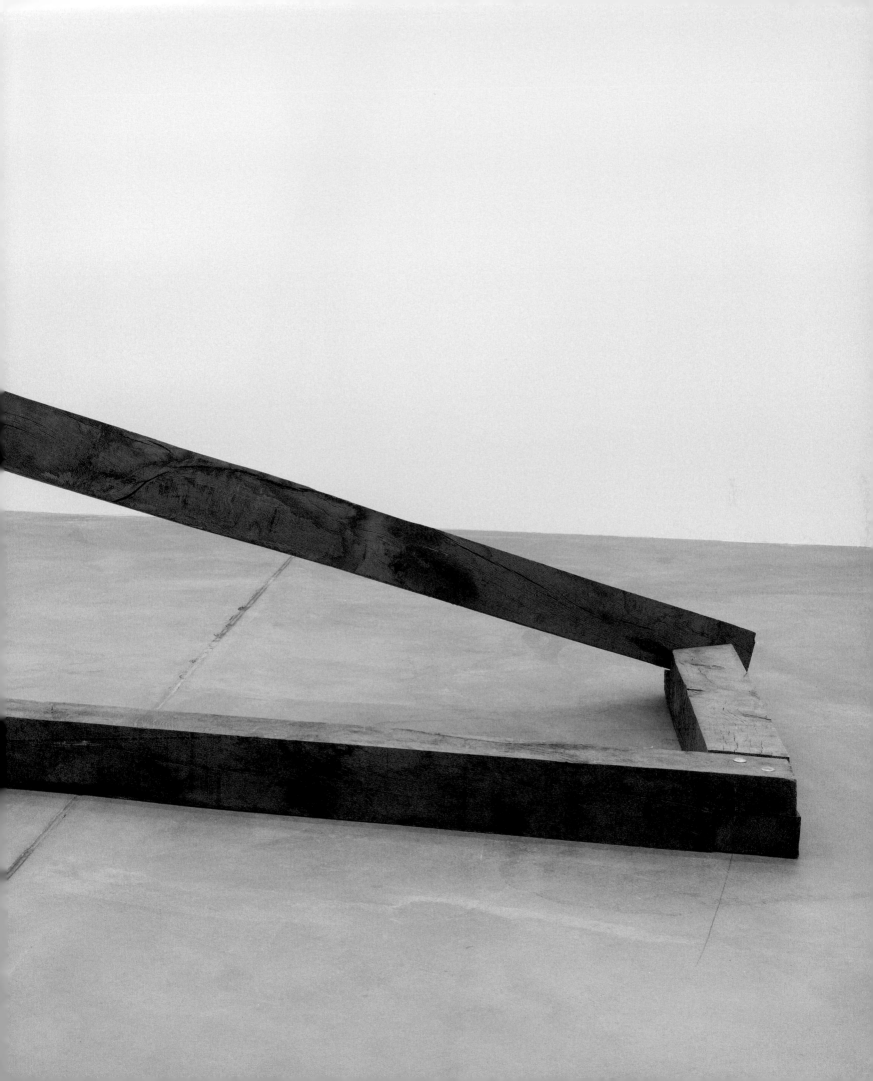

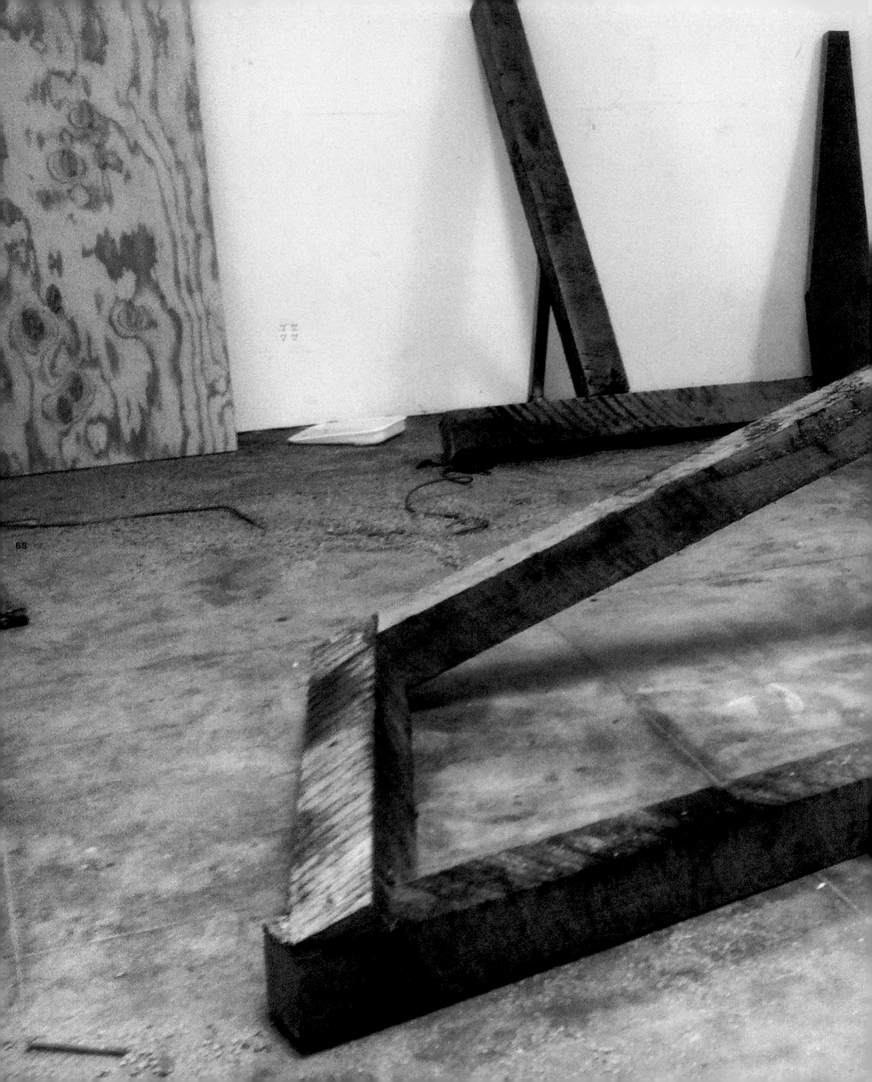

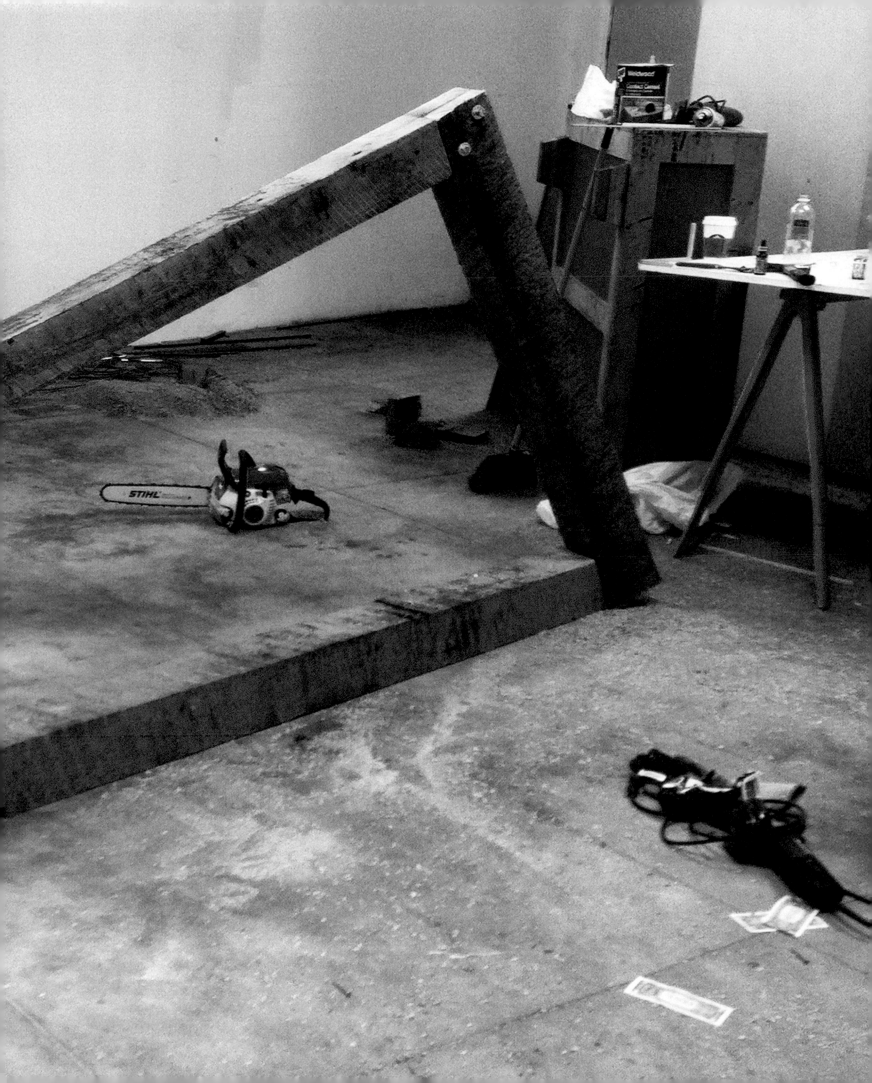

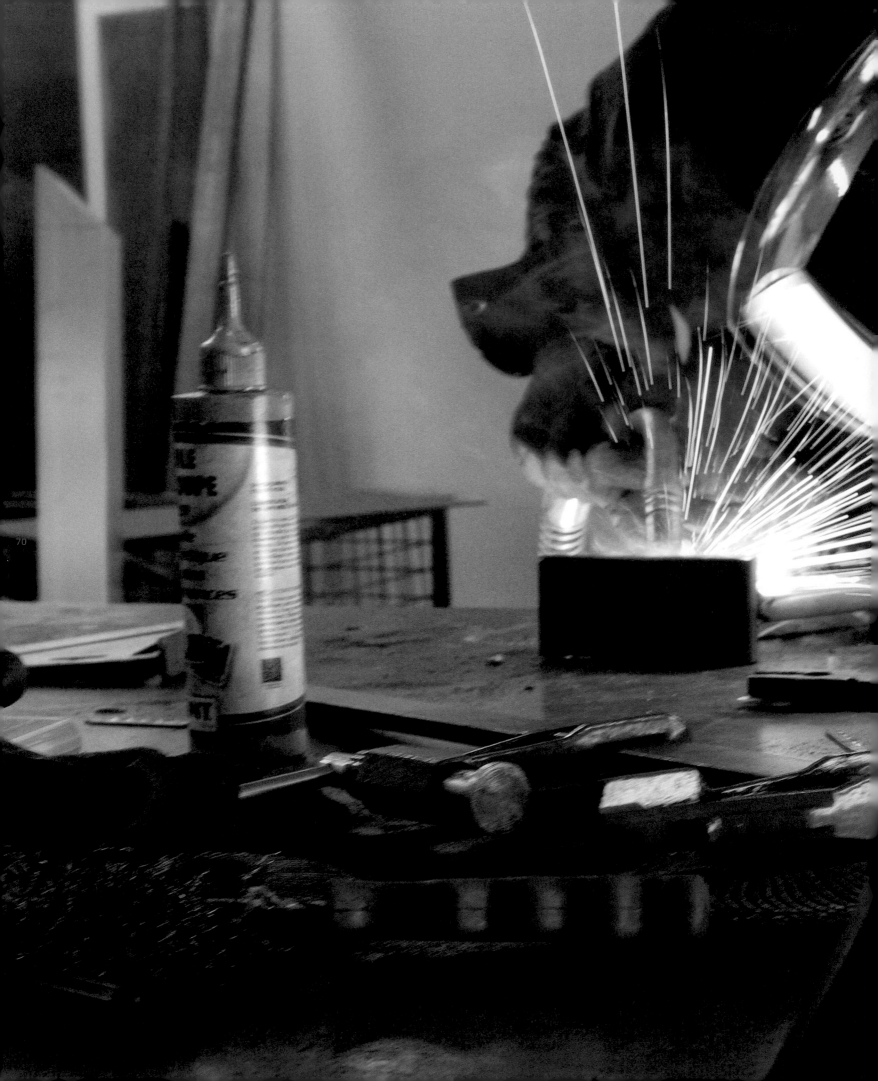

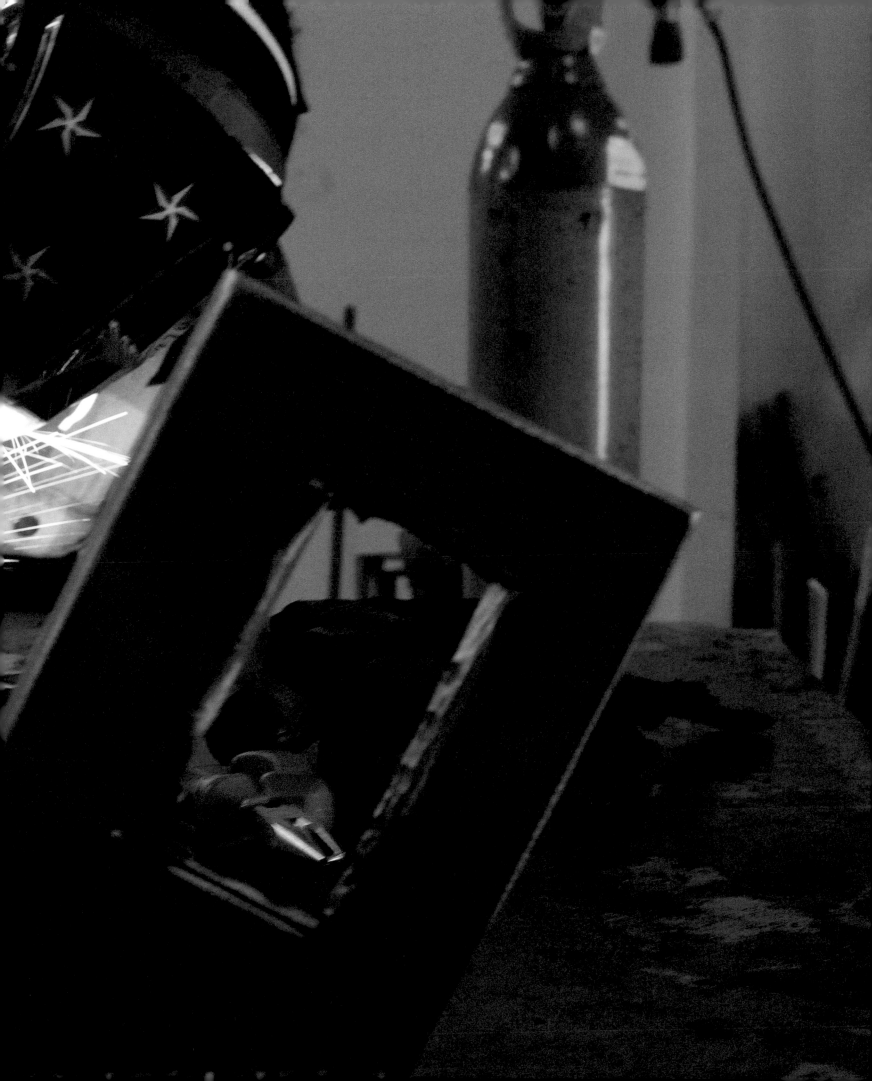

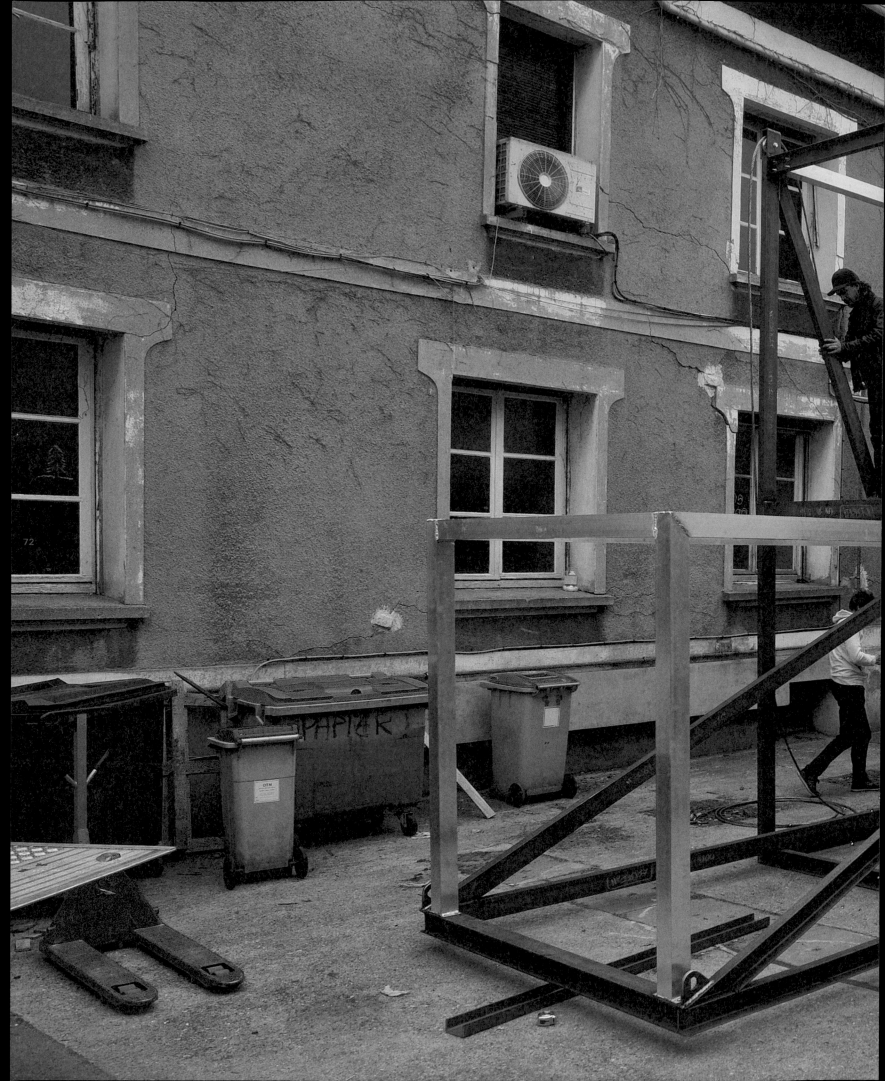

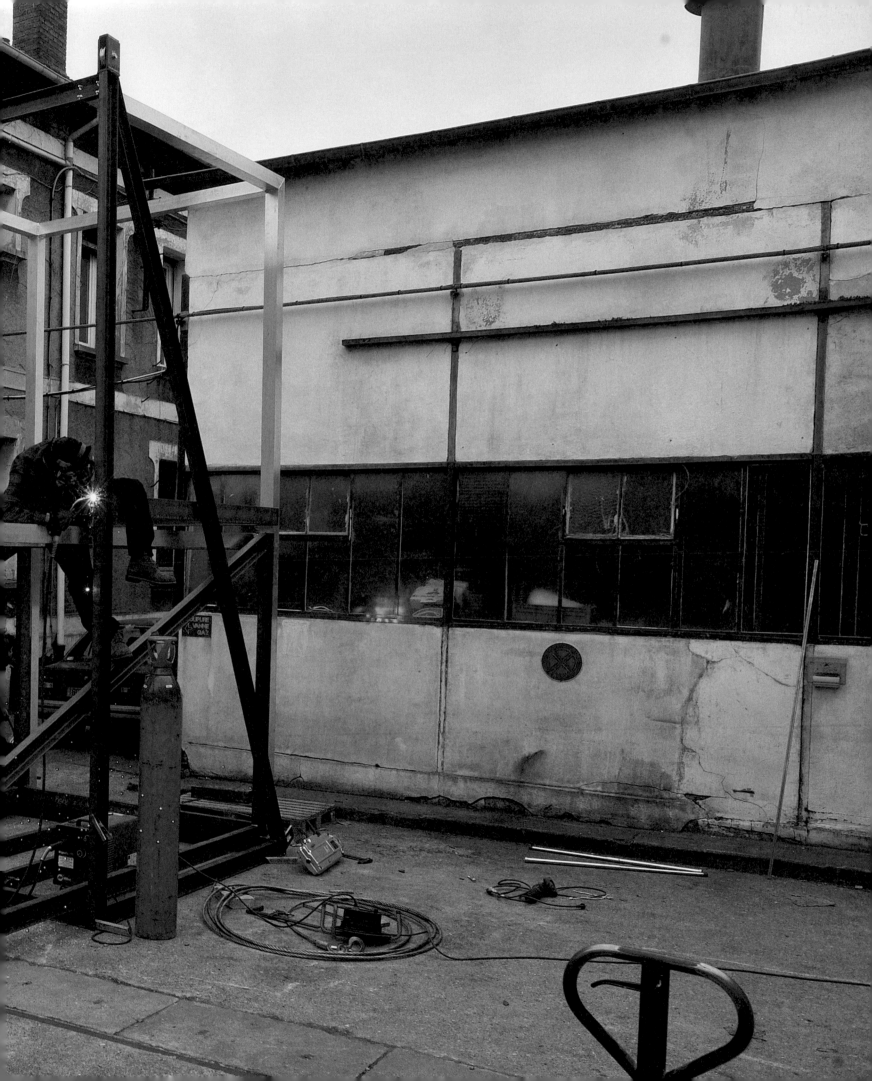

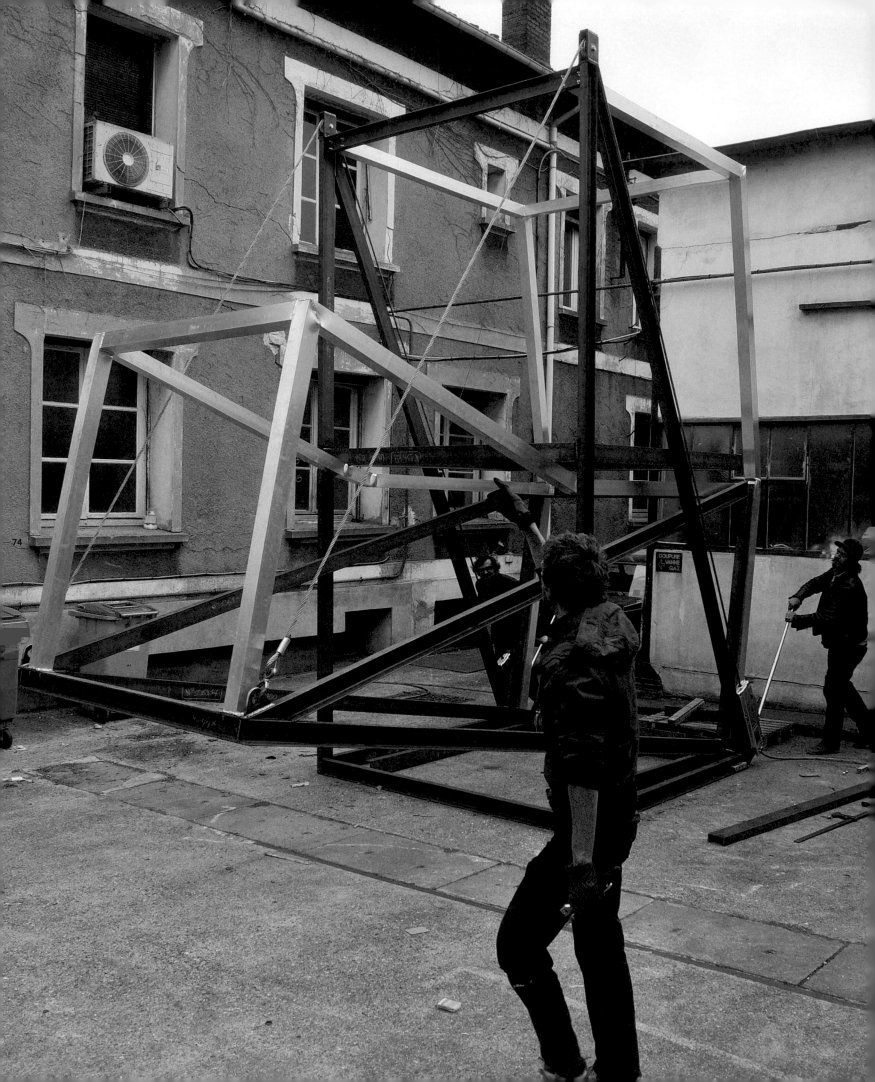

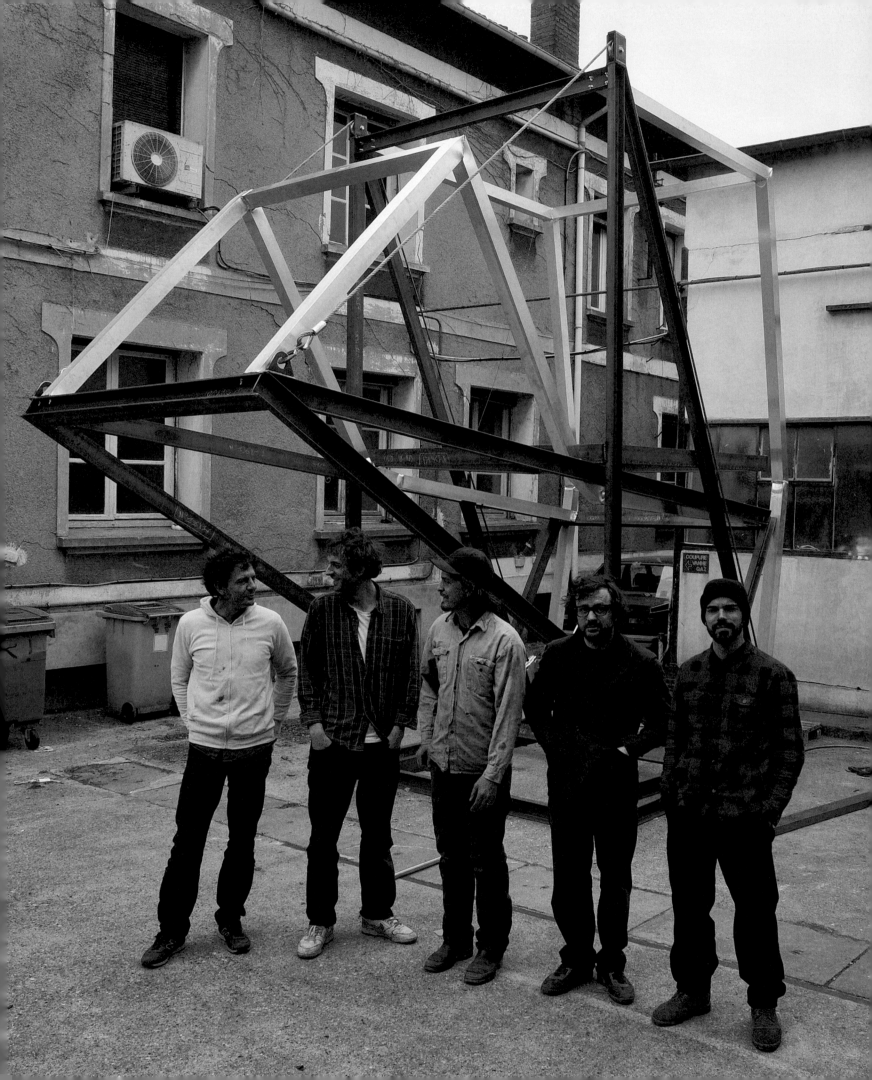

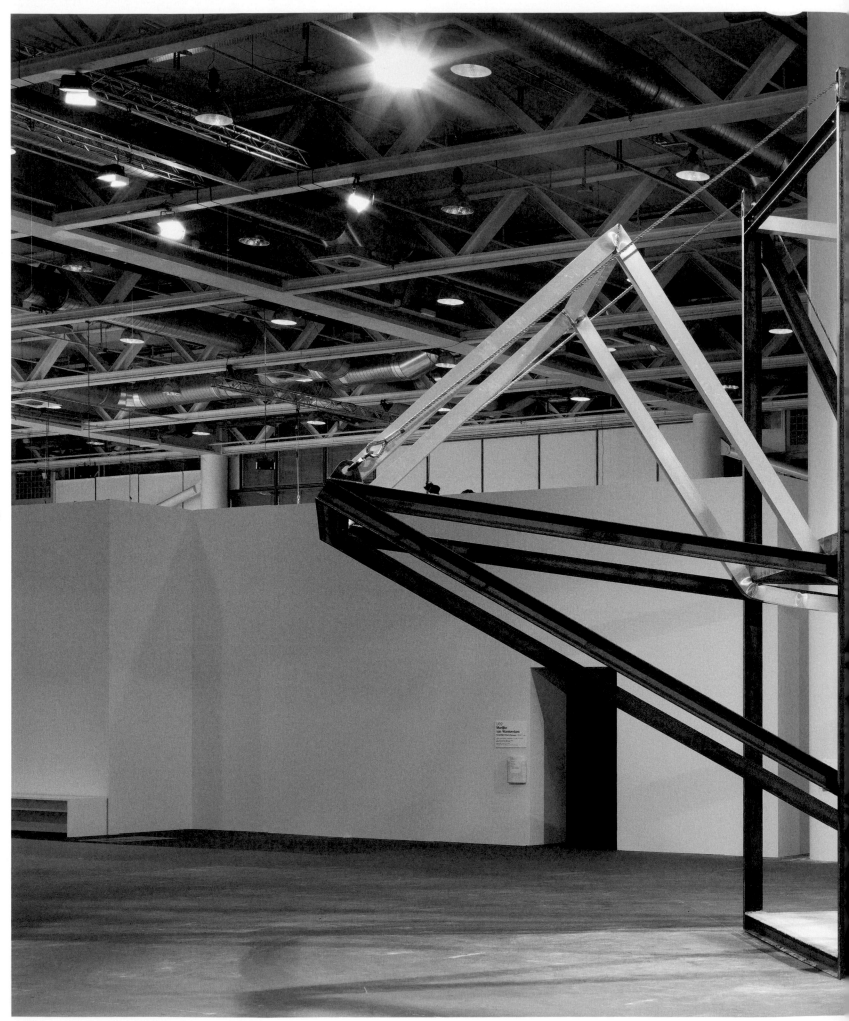

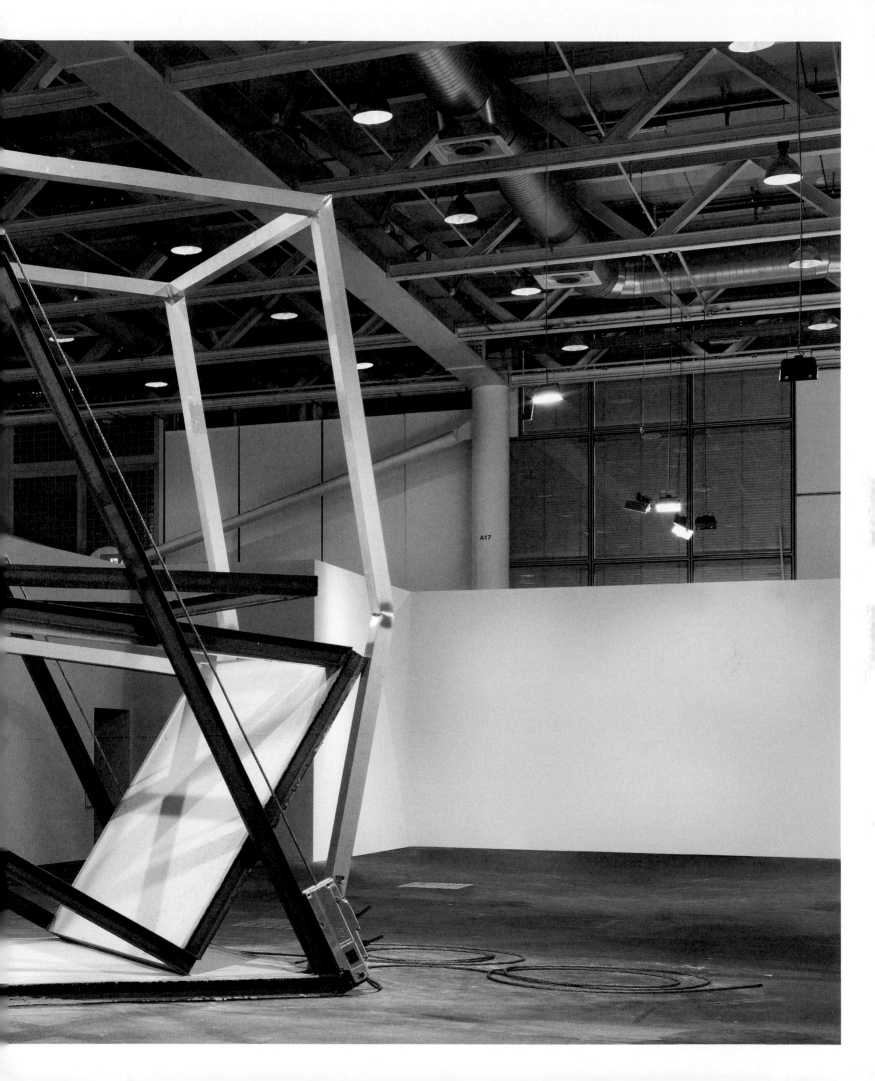

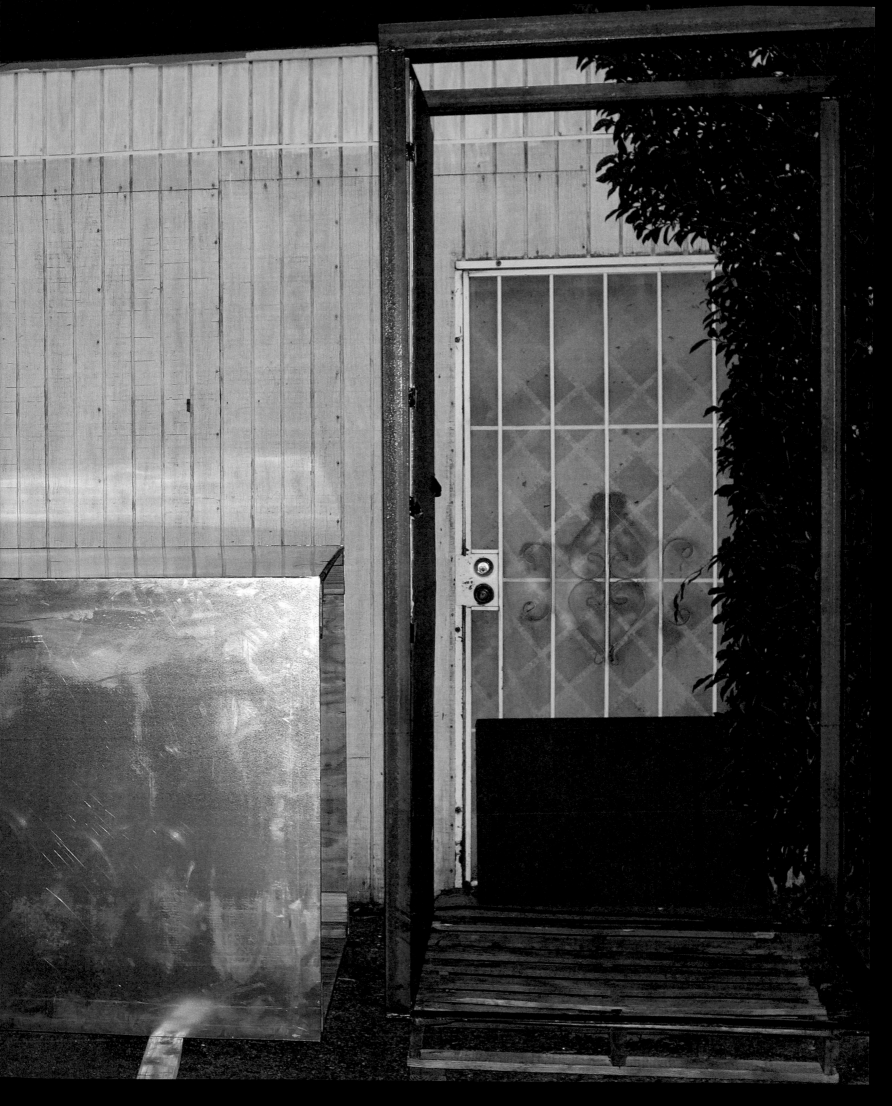

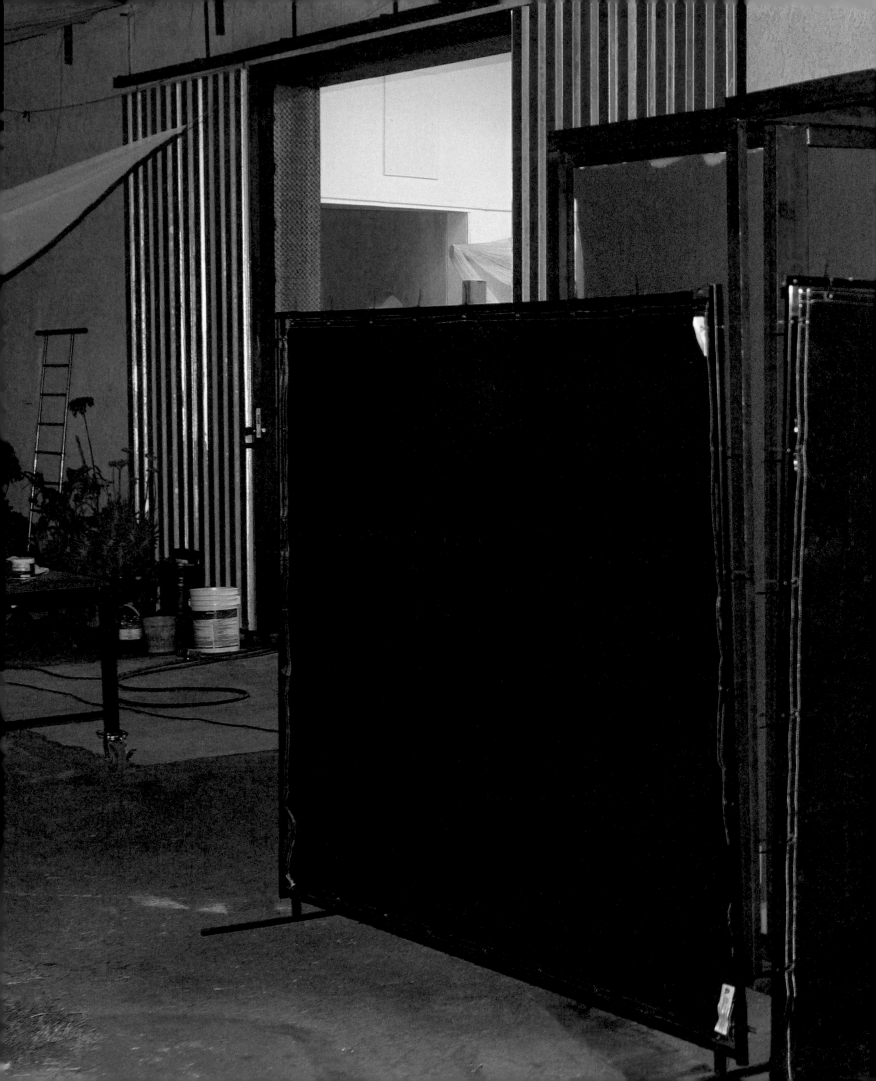

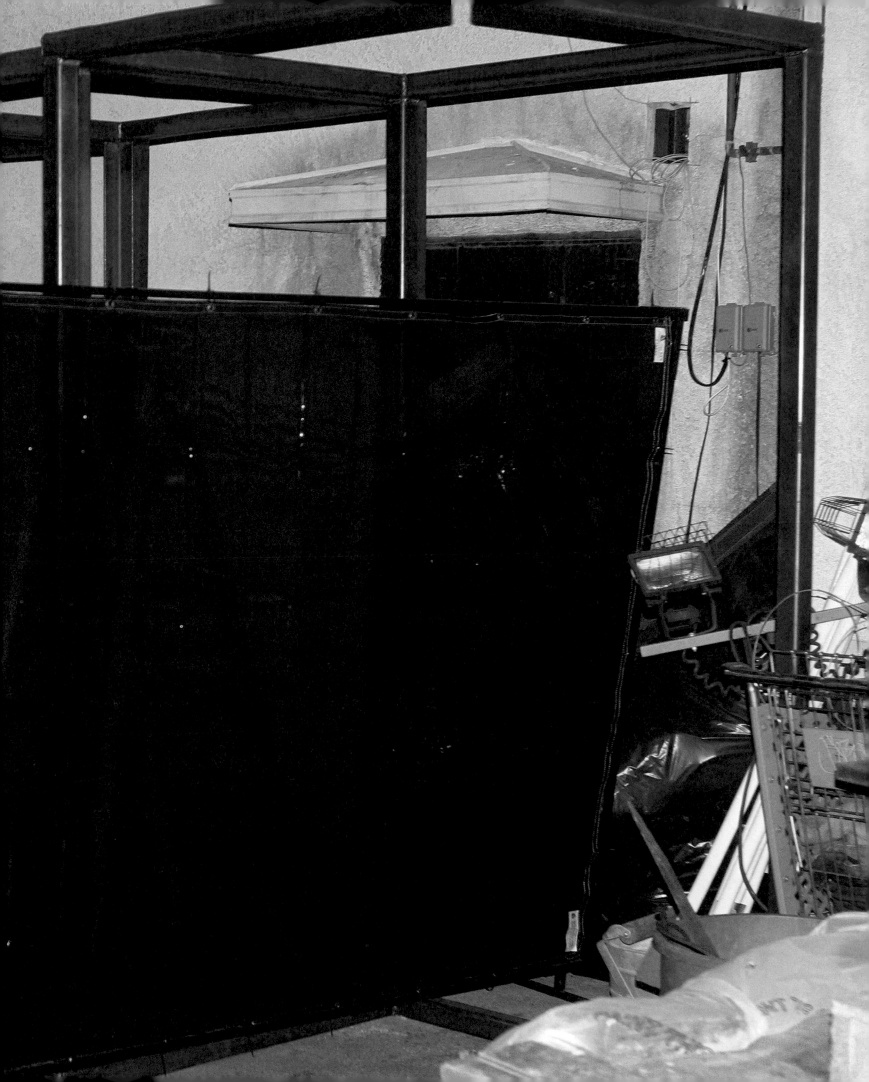

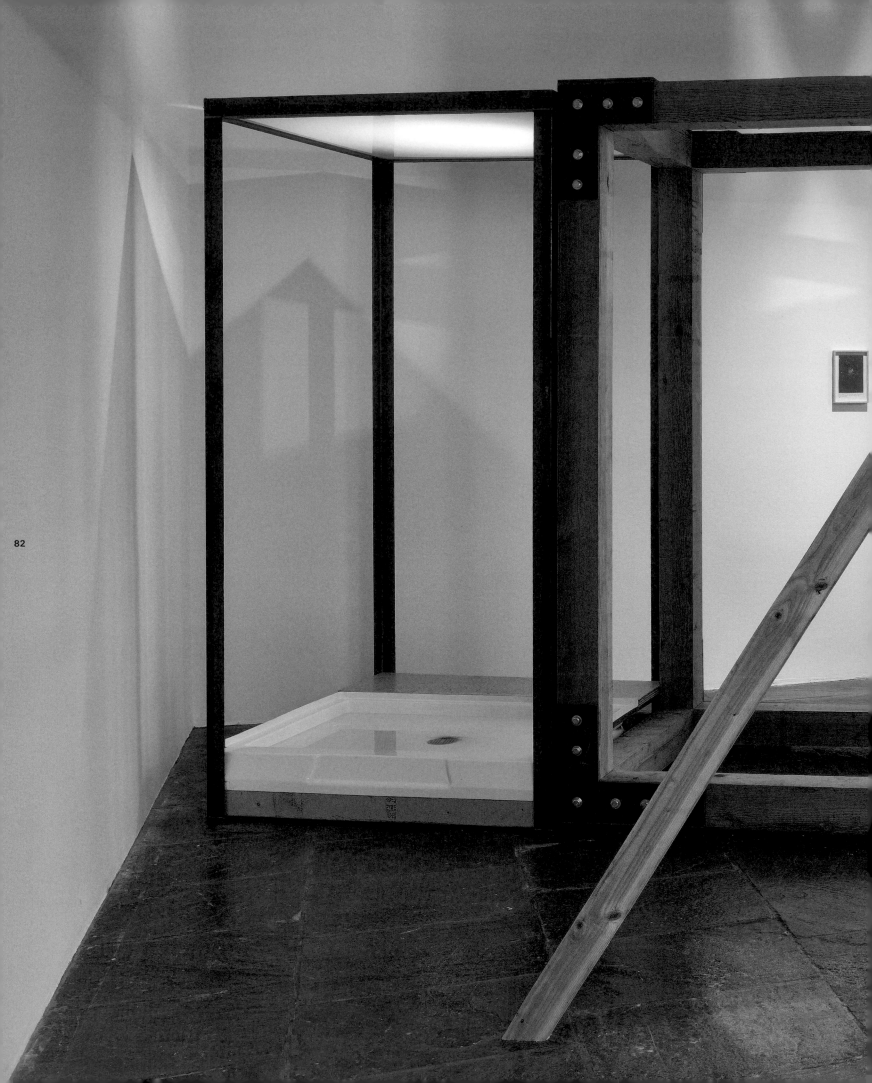

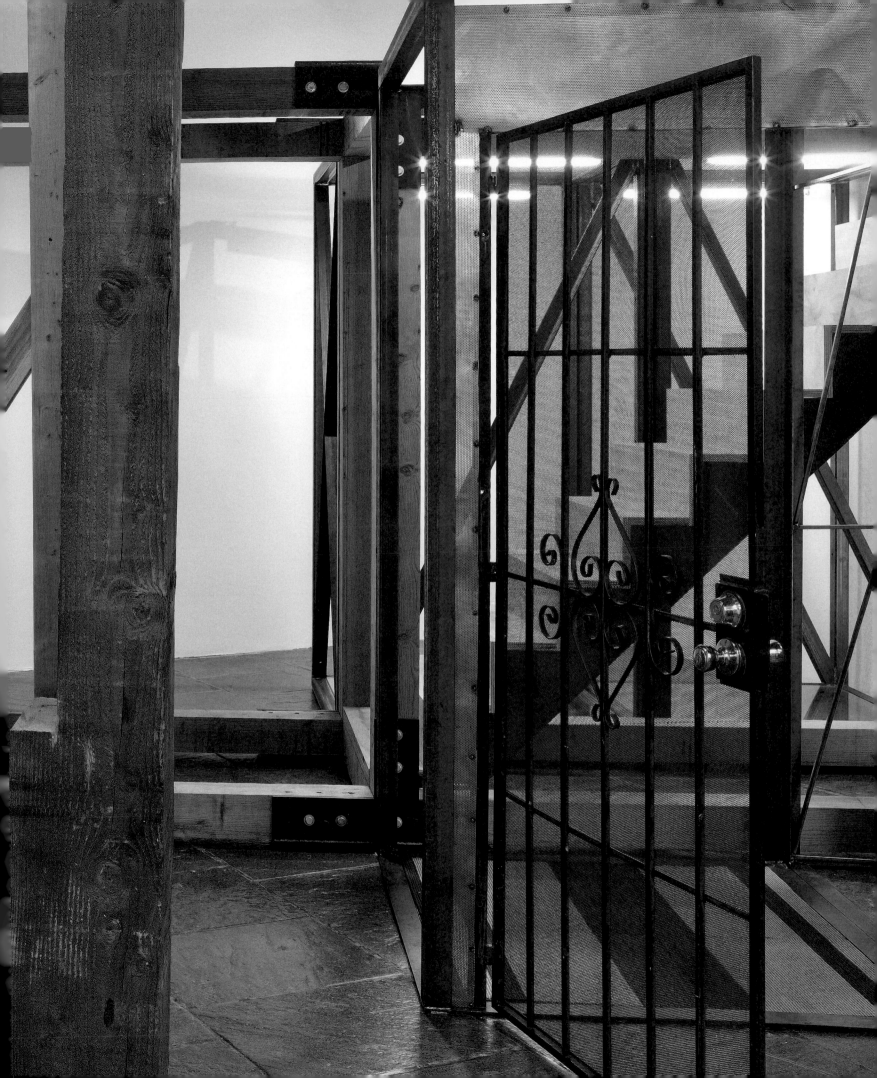

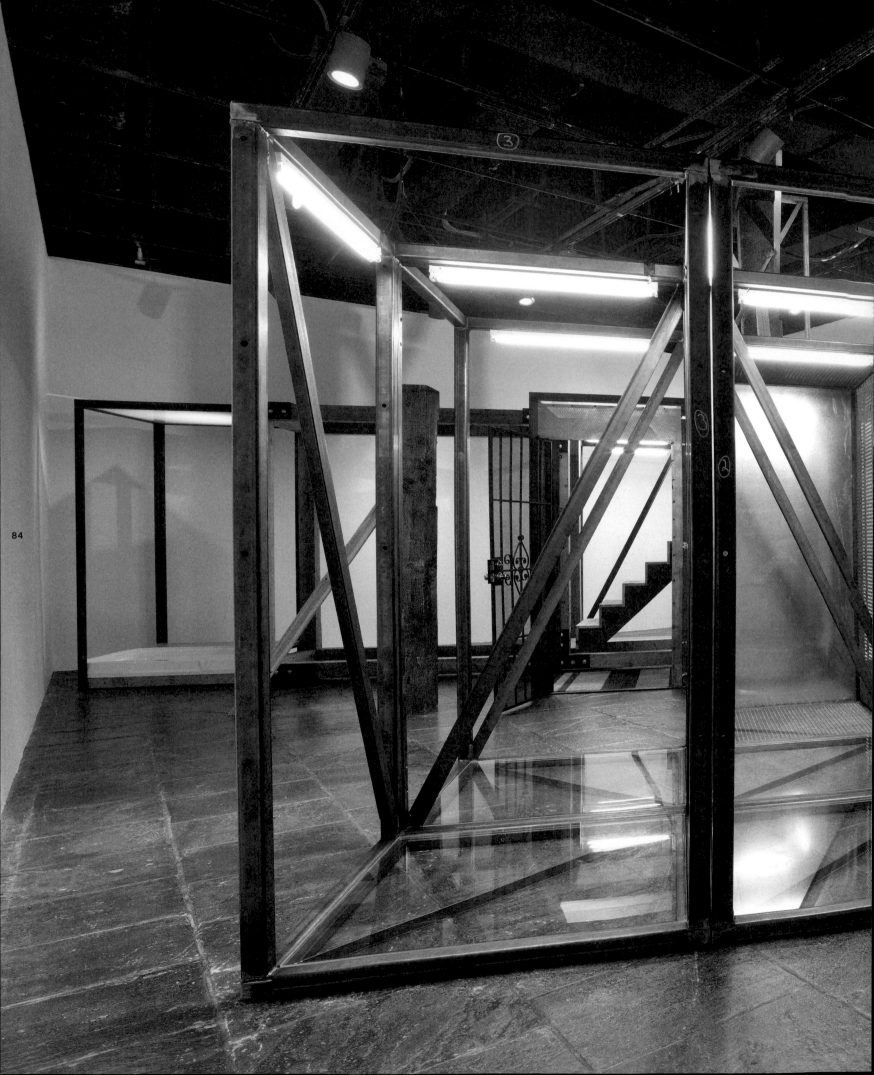

84

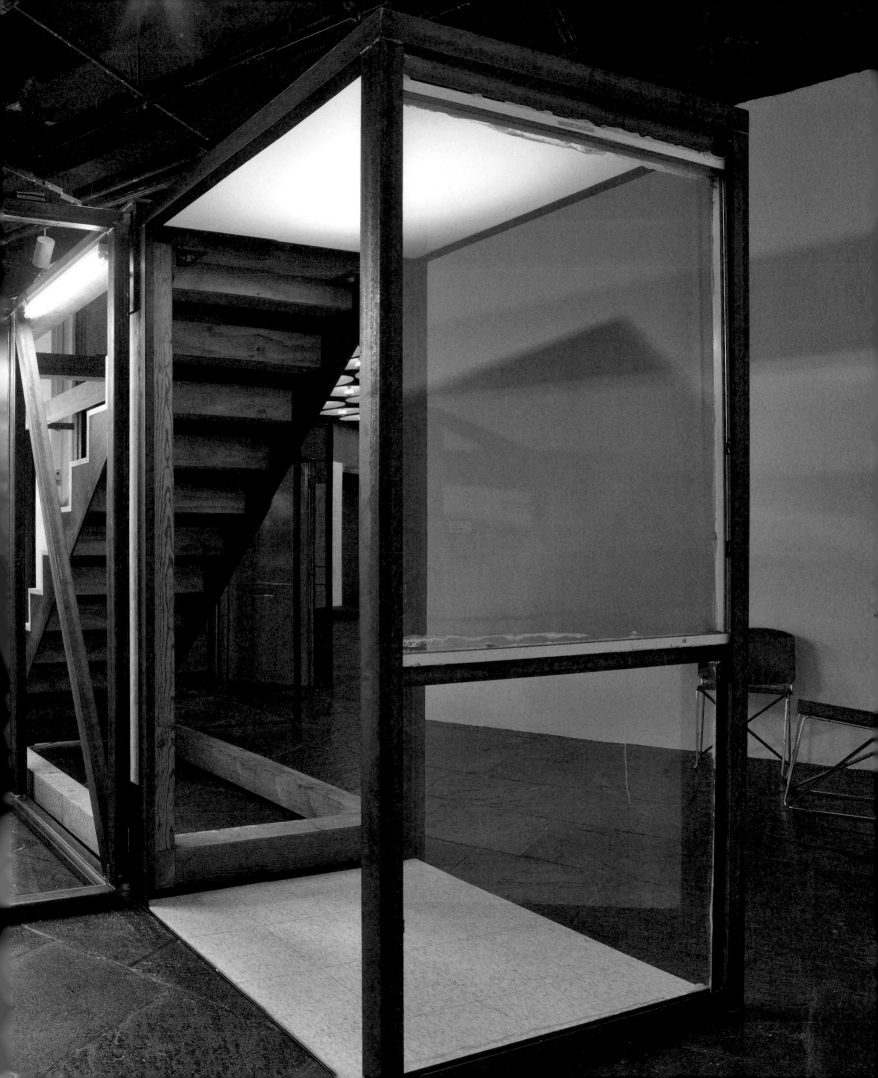

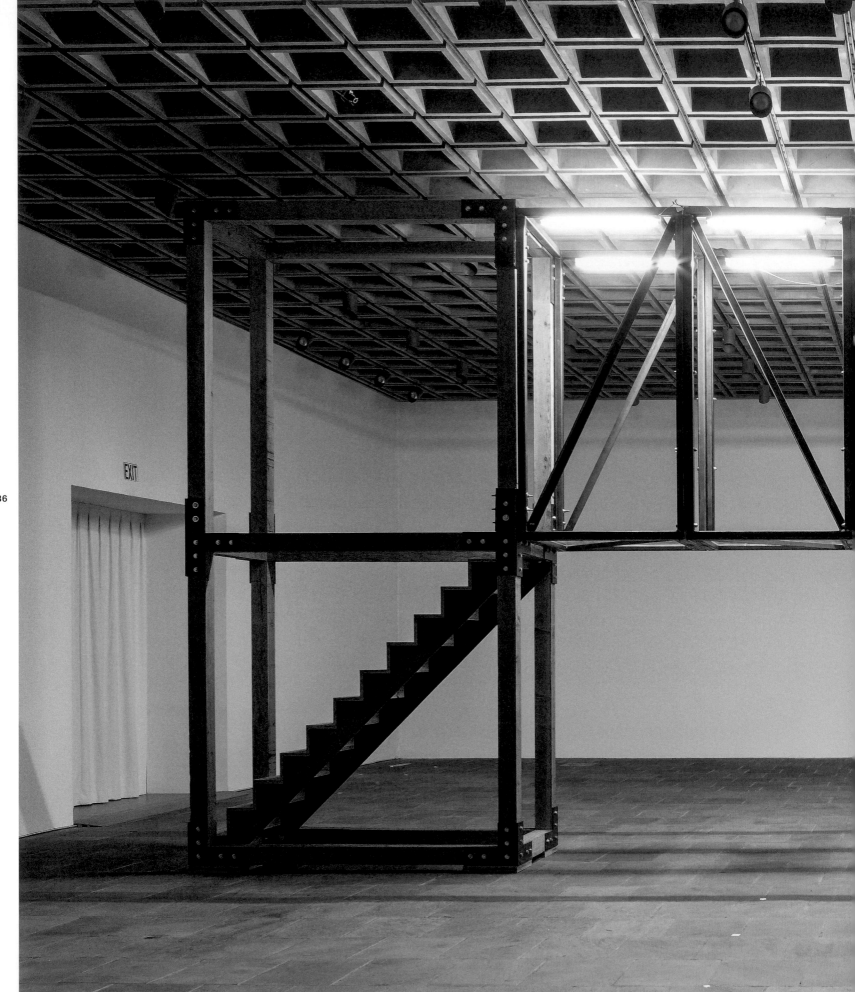

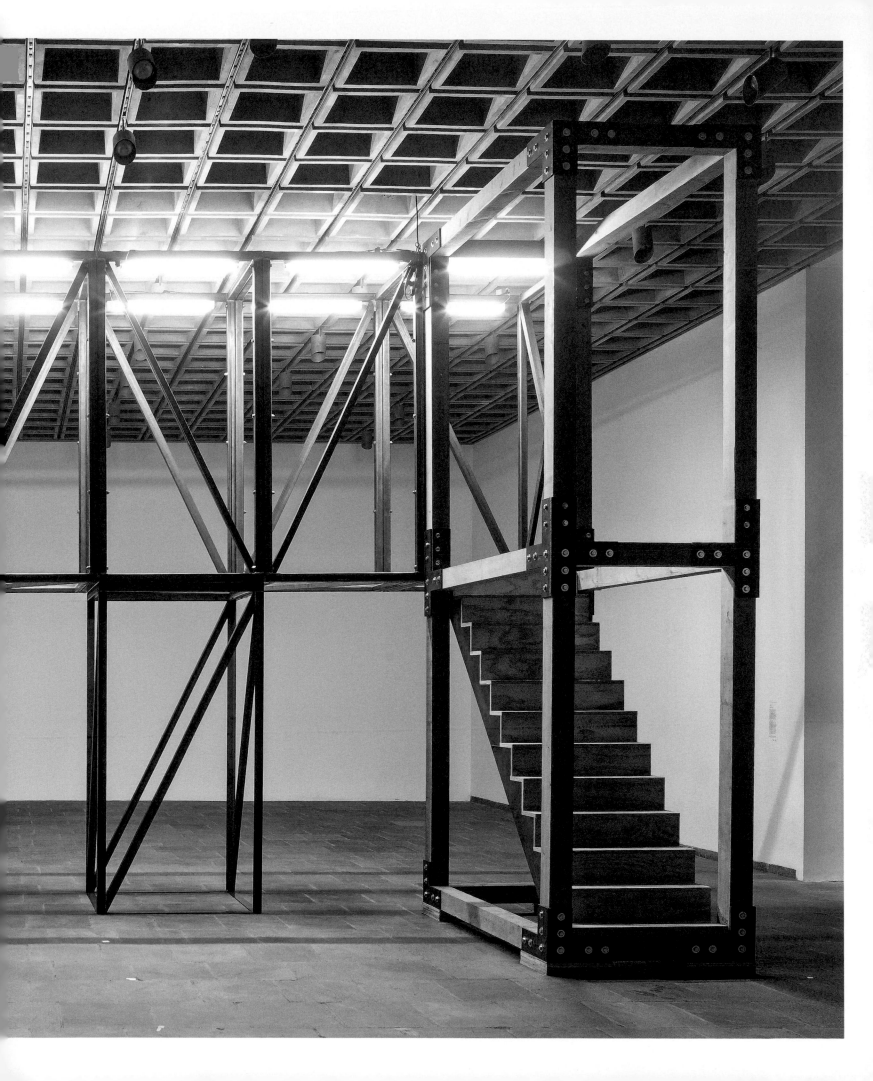

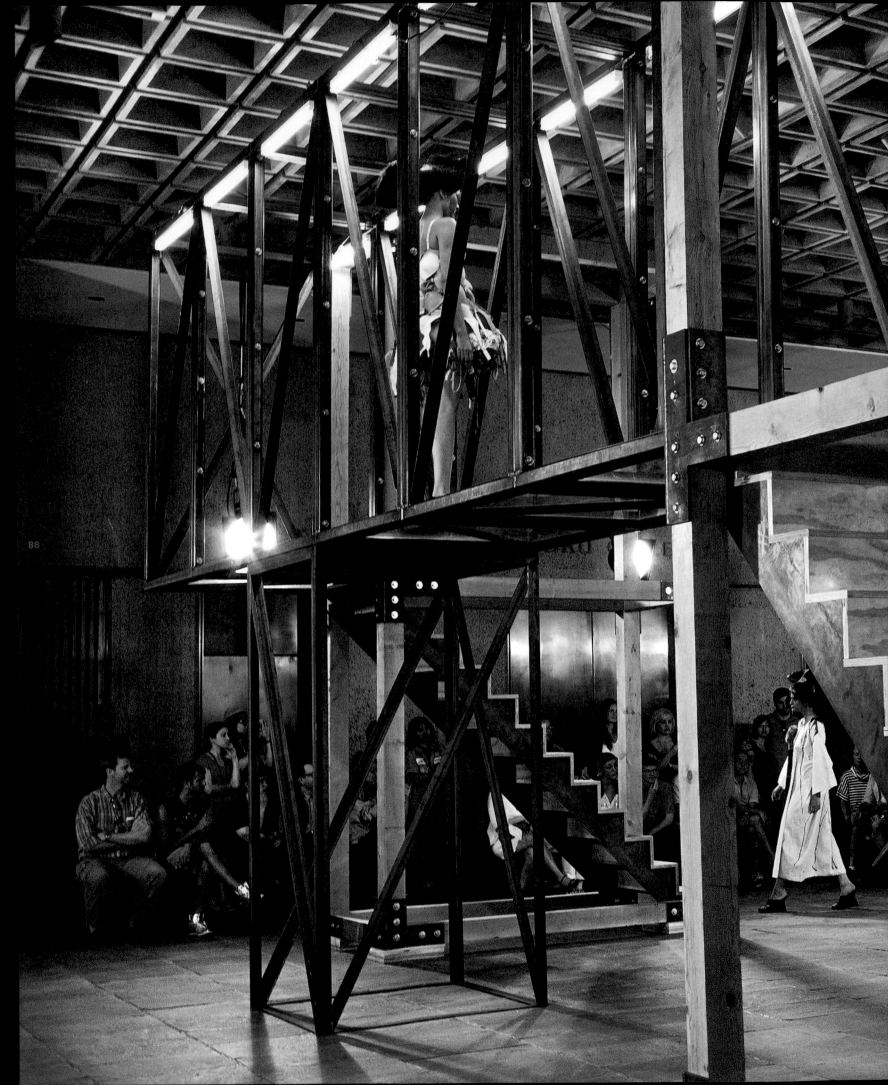

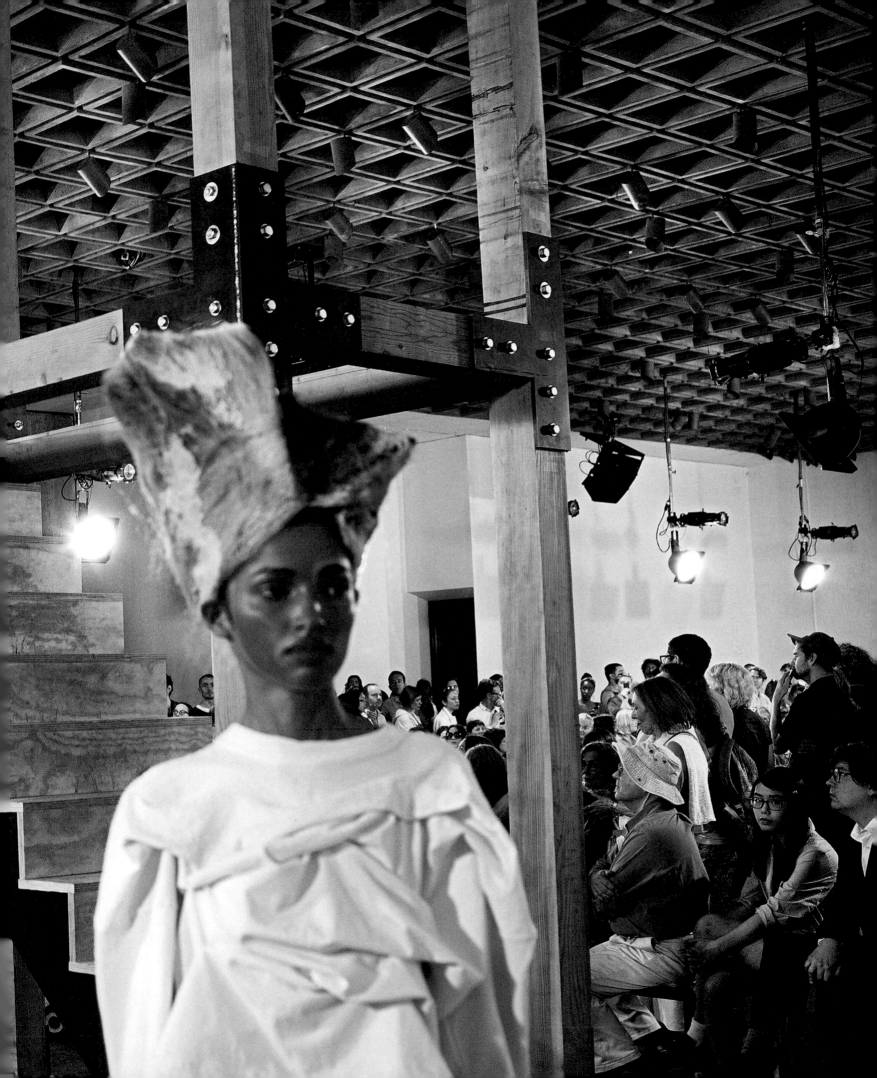

92

108

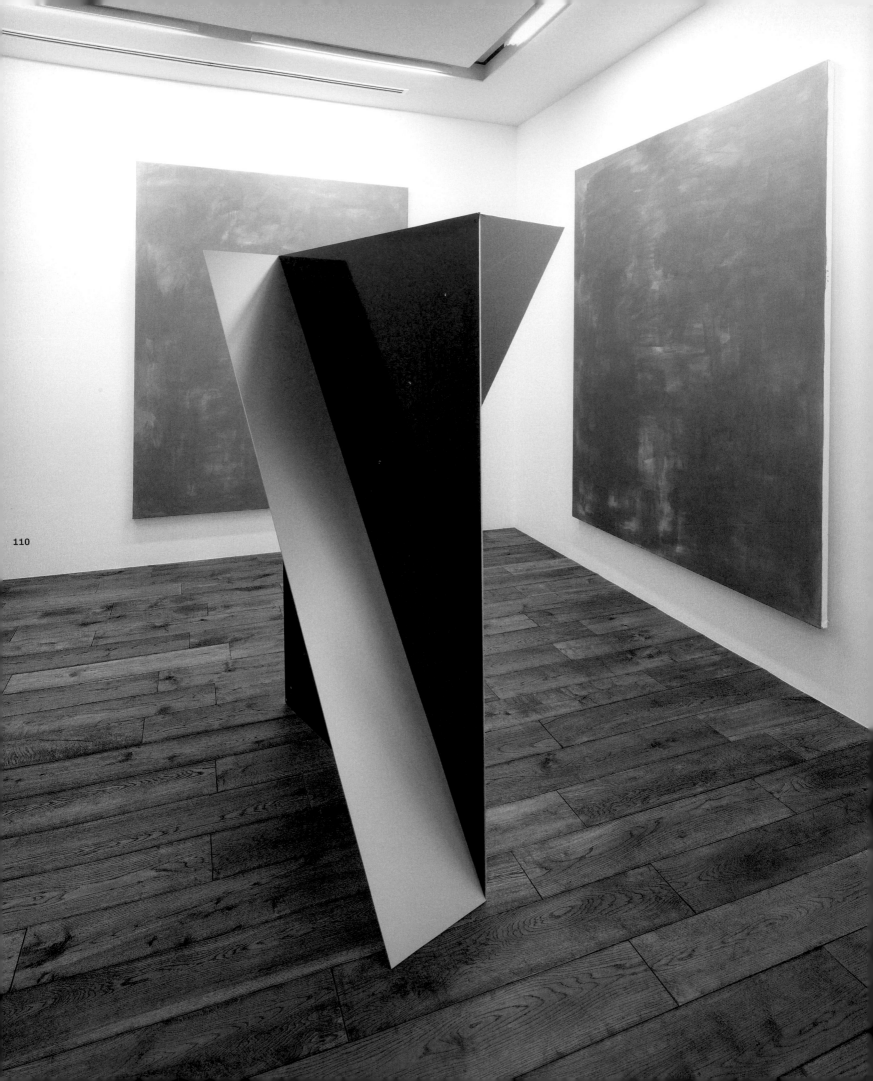

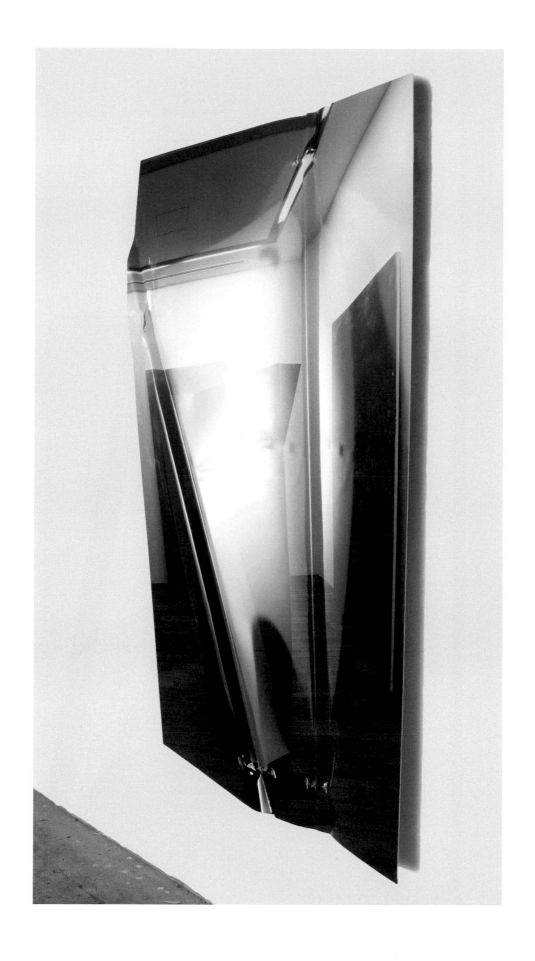

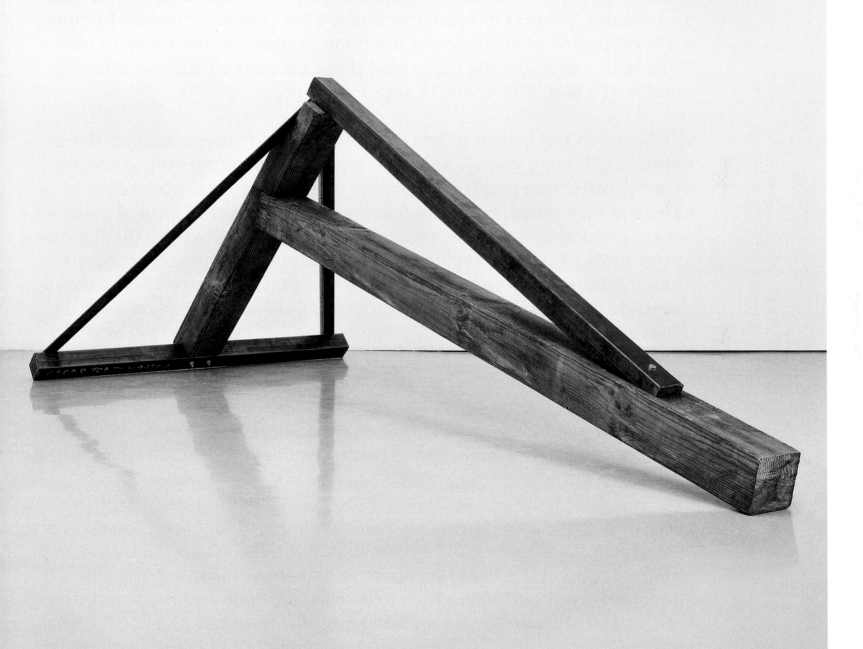

I come in through the front door. There is a layer of dust on the floor, grains underfoot, drifts of sand and soot, lime, powdered plaster, chalk on the floor, some oil, pools of dried ink, carbide dust in a filmy transparent wash coating the tools and the tables, triangular shards of stainless steel around the cutoff wheel, metal dust, fiberglass strands caught in tufts, papers, tobacco, peroxide, flux and rust. A bust. A shutdown shop, a vacant warehouse with a ruined pit baler and a twelve-foot deep concrete shaft large enough for a man, filled with green grease, animal fat and bleach. An empty room. A rack holding twenty foot sections of steel tube, pipe, angle, and plate is fixed along one wall near the back, in front of it leans a stack of plywood cut to various sizes, an argon gas tank on a wheeled rack, tubes of clear silicone, wax and plaster, a pallet of readymix and a 5 horsepower mixer, a hammer, a shovel tipped point down on the floor, orange plastic buckets half filled with water. On the other wall there's a cunt scratched into the plaster. It's wet. The scene is set.

I just stop in the center of the room and close my eyes, feeling the dimensions, feeling young, physical, mystical, standing still, standing over my reflection in a frozen pool of water, waiting for the room to calm the fuck down. I'm bathed in night, an elongated pool of clear water suspended in a greyish sheet of clear plastic above my face, moving in the wind. I feel air passing through a pinhole in the polypropylene, I depart. Come to in the dark, come through, I feel myself come through the dark, my eyes are on in the dark, can't see shit but there's air on my eyeball. That's what I do, I come through. I, my body that is, if it's mine, is fine. I'm doing this with my mind. I feel around in the dark, my hands extended at waist level, sweeping a slow perimeter around me, feeling for the table, a chair or whatever's there. I try to imagine what it is I'm looking for. A length of rebar, mat fiber, knives, a man does what he can to stay alive. I am a human dildo, you said so. I'm building a bed. My job. Just doing my job.

I lay out a thin film of kerosene, bleach, charcoal and angel dust on a bolt of canvas thrown on the floor, watch it bead up on the ridges and pool around the creases, which is somehow meaningless. I'm speechless, not quite sure how to do this. I step back, out of habit, a man on the attack—I'm damn hot. I cut out three lengths of 16 gauge stainless round tube, lay them out across the pooled liquid and mate the corners where they meet. I've got on a portable mini MIG slung in

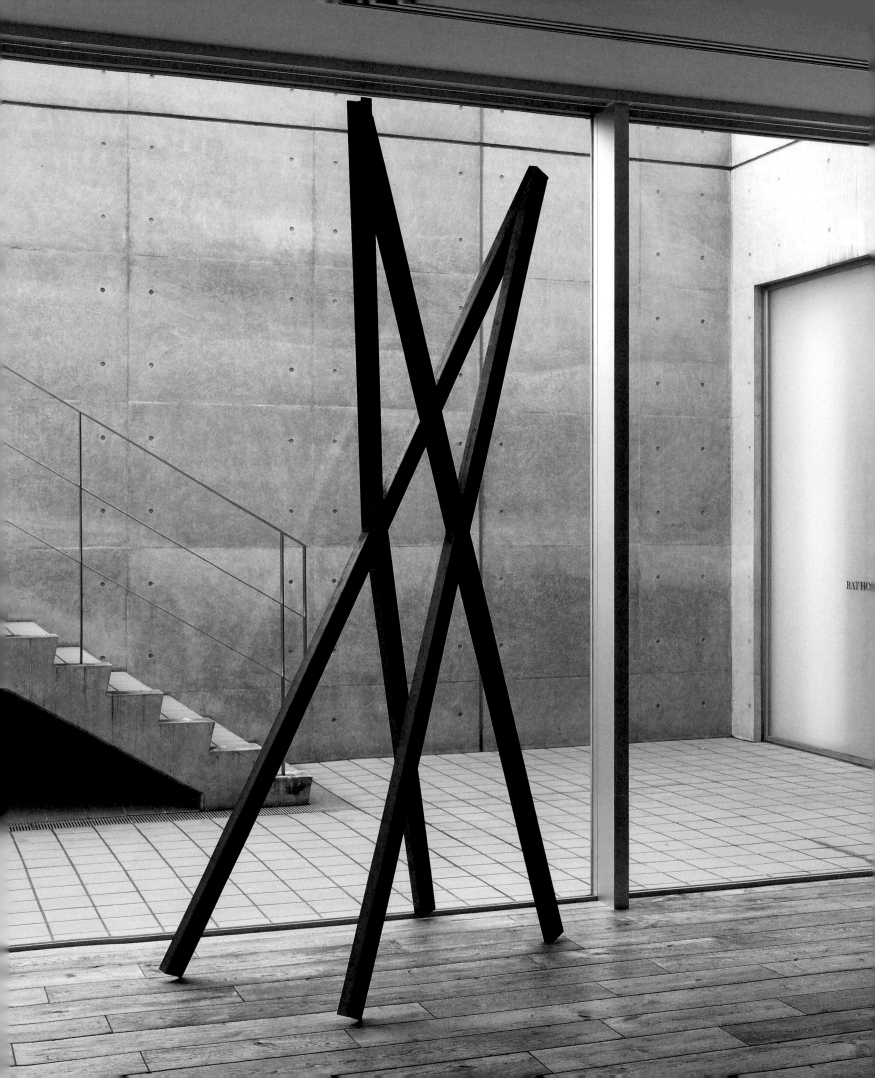

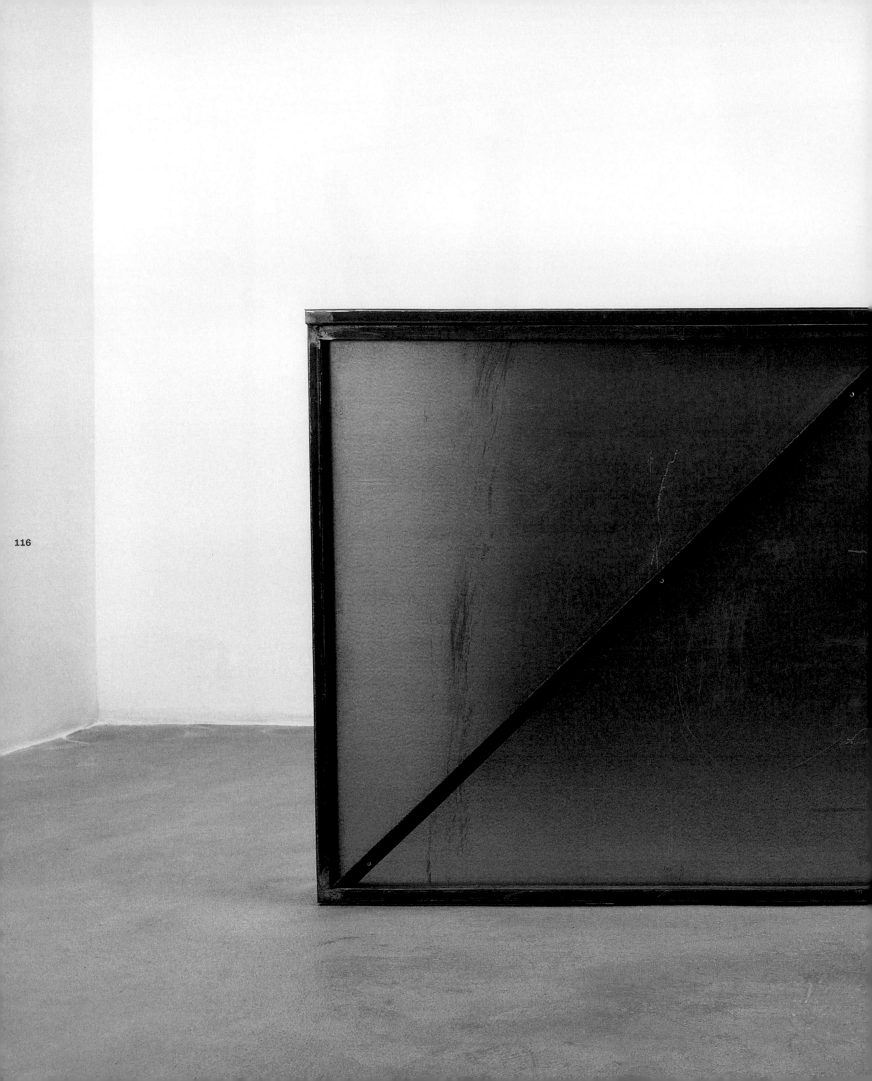

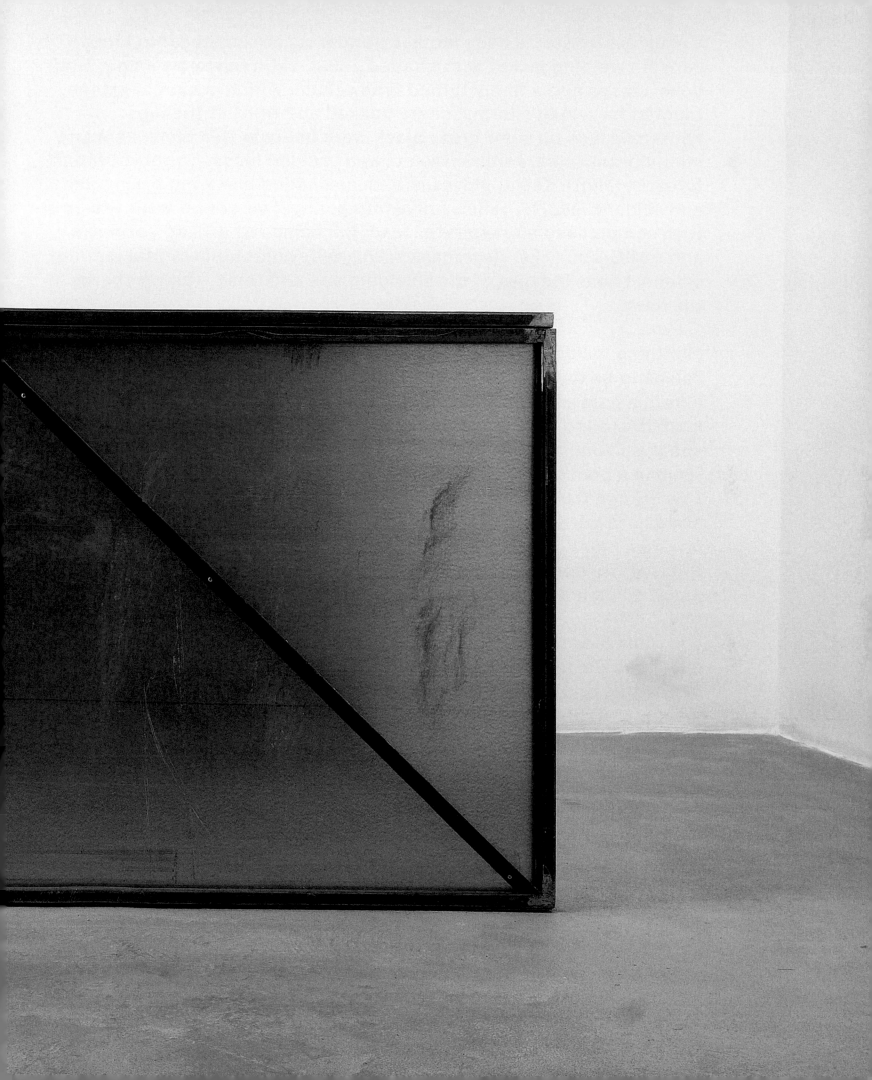

a shoulder holster, a half-harness grinder rig, an impeccable tanned calfskin welding jacket with banded collar, satin butterfly lining, snap down clasps and a finely turned brass chain, which is kind of insane, tailored for a man's form, square backed and tight at the hips. Mid-ankle lace up semi-dress black work boots with a block heel and mini-vibram soles, chrome eyelets and braided laces. Double stitched forearm-length Kevlar gloves with dual-padded black pig grain palm and silicone inserts, yellow and white piping. I've got on a canvas cowl with compressed air respirator feed, full behind-the-head earmuffs and a MIG/stick LED visor mask with a fully adjustable digital readout screen. I hear the hiss of the shielding gas and relax. The rig sparks in the dark.

Lightning inside, a wild ride, I can practically hear my insides. The wire seems to be feeding too fast, riding the work surface, a stack of pennies in a halo of burnt flux and gas, sending sparks out from the tip, kind of a round shower. The machine hums, unwinding wire off the spool, spitting and sparking, it is illuminating, I'm standing in a dark room in a pool of light. I have ignited the kerosene so time is short. Low orange flames float above the floor, devouring the air with a sound like a hard hot soft breath, dancing erratically, spastically, I'm kind of having a blast, people. I hover closer to the work, working a repetitive S-curve, smiling, gazing through my reflection on the inside of the mask, to be honest with myself I'm almost crying.

The room is lit from below: it's on fire. I am on fire. For a moment I am alive, female, with a deep interior, it's so hard trying to write like this, hands free and speedy, extended, slick, needy, kneeling, it's the most incredible fucking feeling. My mind coming apart, frayed in waves, I was in absolute space. Adolescent. You, reading this, feel me. I had let my eyes go, dilated wide and heavy lidded, almost closed, elated, floating, feeling my cock quivering on your lips, what a trip. Light was playing somewhere overhead but I couldn't see a thing, maybe they we're closed, or I was blind, just a cock and a mind. I listened and somewhere in the distance heard the sounds of outdoor pain, wind, rain, a contained low whistle, blood in my skull. My penis, a rigid thick nerve more sensitive and responsive than a finger, with its own intelligence, felt the ribbed roof of your mouth, your tongue moving over it, the bright elastic canal of your throat as you swallowed around me.

My heart stopped because it became too full, a fulfilled and suddenly extraneous organ obedient to pleasure, serving my cock, a commanding sensation impossible to ignore. It may not be described. You smiled gently and straddled my face, a warm liquid flowing from you, a human fountain.

What was this floor for? Who the room belongs to, you, whoever it is I work for. I need to fight off boredom, that's what I work for. I form a phrase, I say cut a hole in the wall, cut a sound out, engrave a name on ice, write a word on water. A stack of dimes, white lines on paper, white paint on white paper, white people, wet words painted white, white walls, lights, a stack of sacks of plaster. Terrific looking objects in box-es, rotating glass walls, blue balls, a long corridor sealed behind a single pane of shatterproof glass. Kind of an empty space without corners. Like being inside a blank book with no words. I woke up inside a book. I woke up like this. I was a word. You feel me, funny guy? Waiting to be spoken, I was a work, yours. What came before man? I have no idea. I am a standard man. A man is an example, simple, kind of a sample.

Time flies by, now the room is on fire, I am, man. I inhale the vapors of a burst fluorescent tube. It is a fine sensation feeling myself exhale, molecules coming unchained, particles floating apart in the updraft, unglued, forming a light white world inside me. A muscle. I want to try to write it. Warm wet skin slick from within, heavy, lively, glistening, what I am about to say could not have possibly happened, and yet it did. A halo of sparks suspended around childish me—which somehow meant that for a time I could see my name write itself—the air is writhing, alive, through the mask I see only the green light of the fire, I'm peaking. The time is mine. I open, dilated and weirdly huge, nude, including the room. Inside me now, still visible, is a polished chrome ring the size of a fist, ascending as if it's attached to a hand. Its warmth, seemingly perma-nent, slides through me, I almost don't feel myself fighting. An eye above me opens the sky, the opposite of a shadow, watching me, kind of mean, I'm screaming. Can't really talk now. Becoming an object. Time to die.

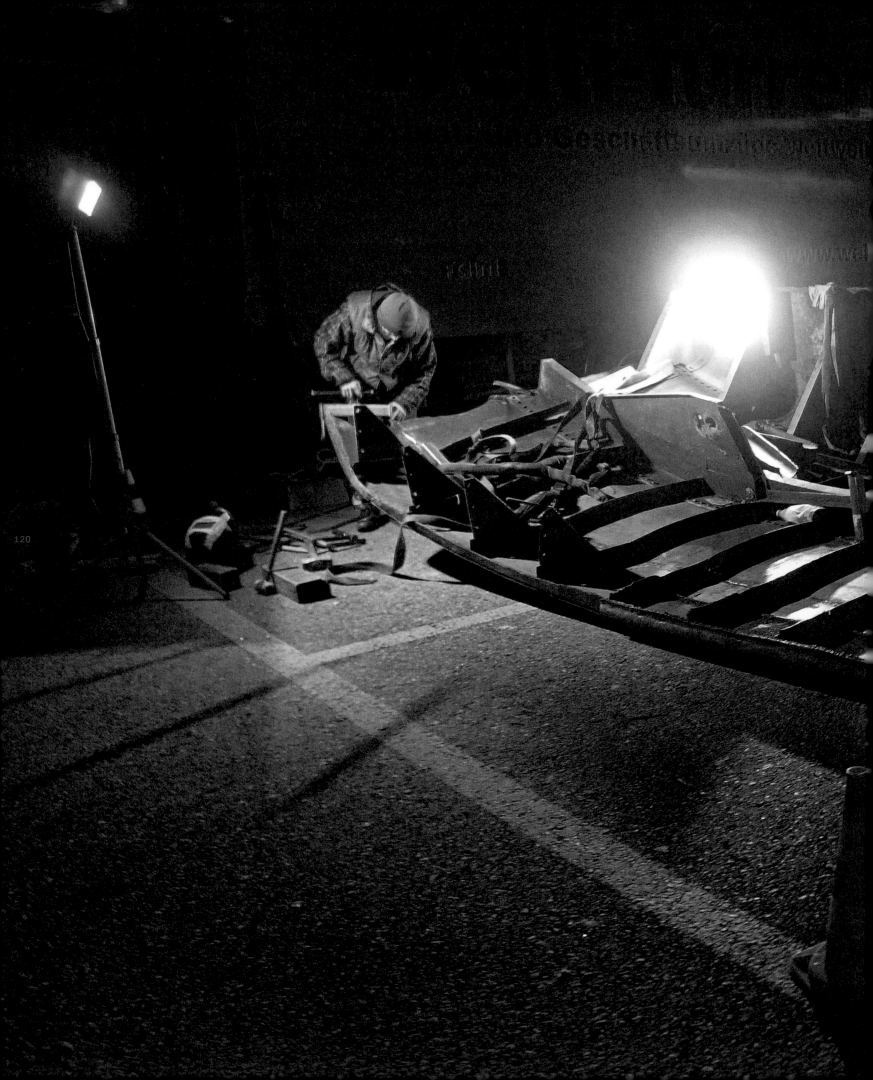

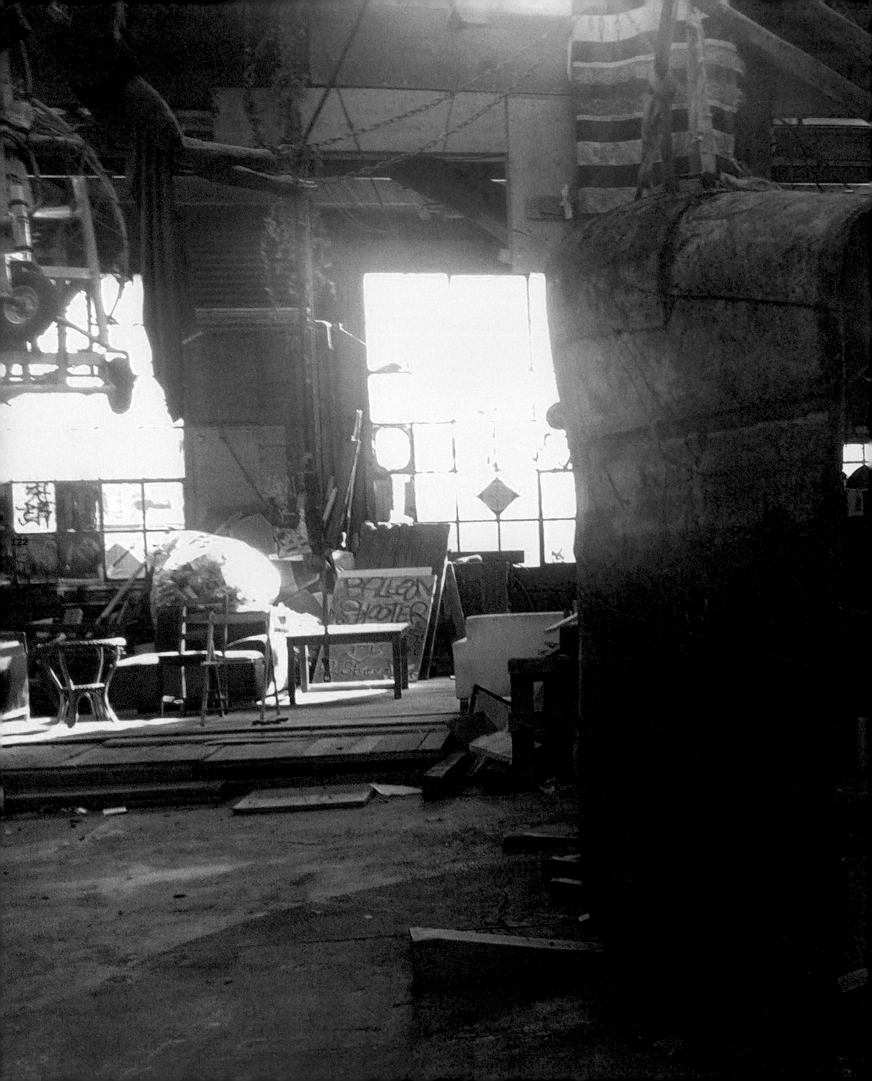

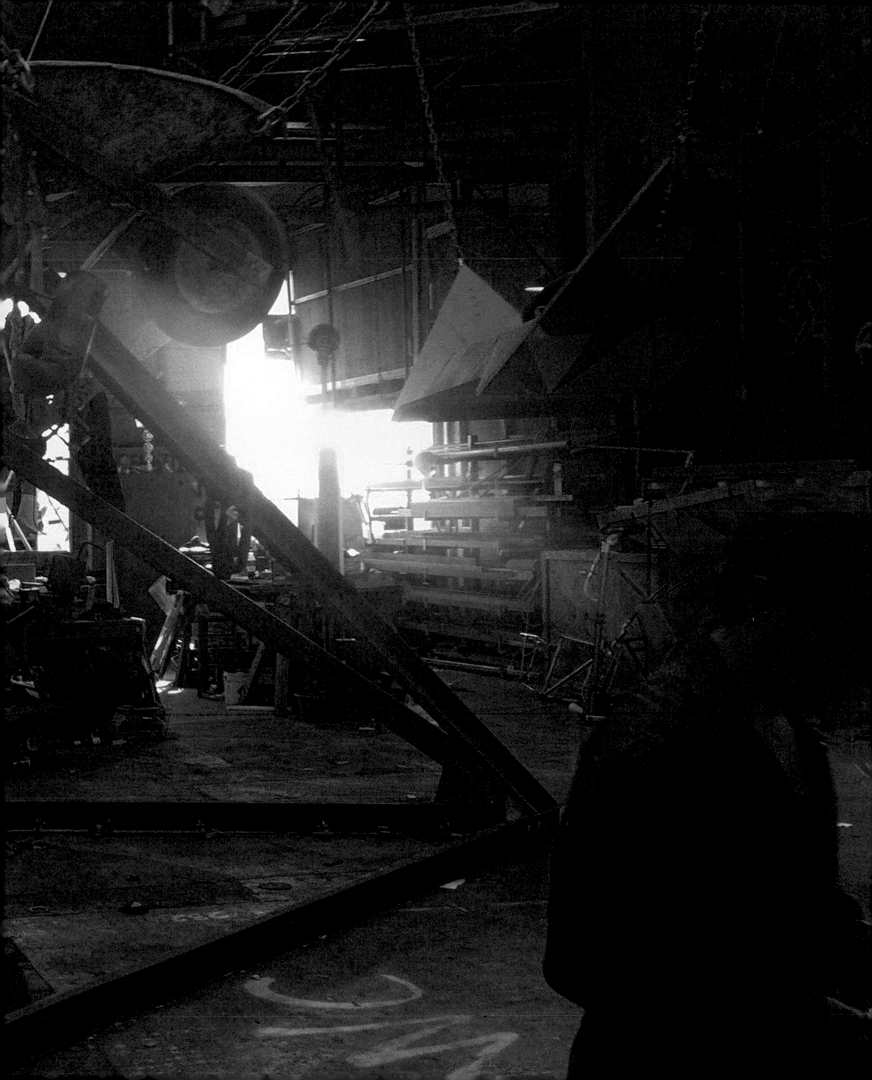

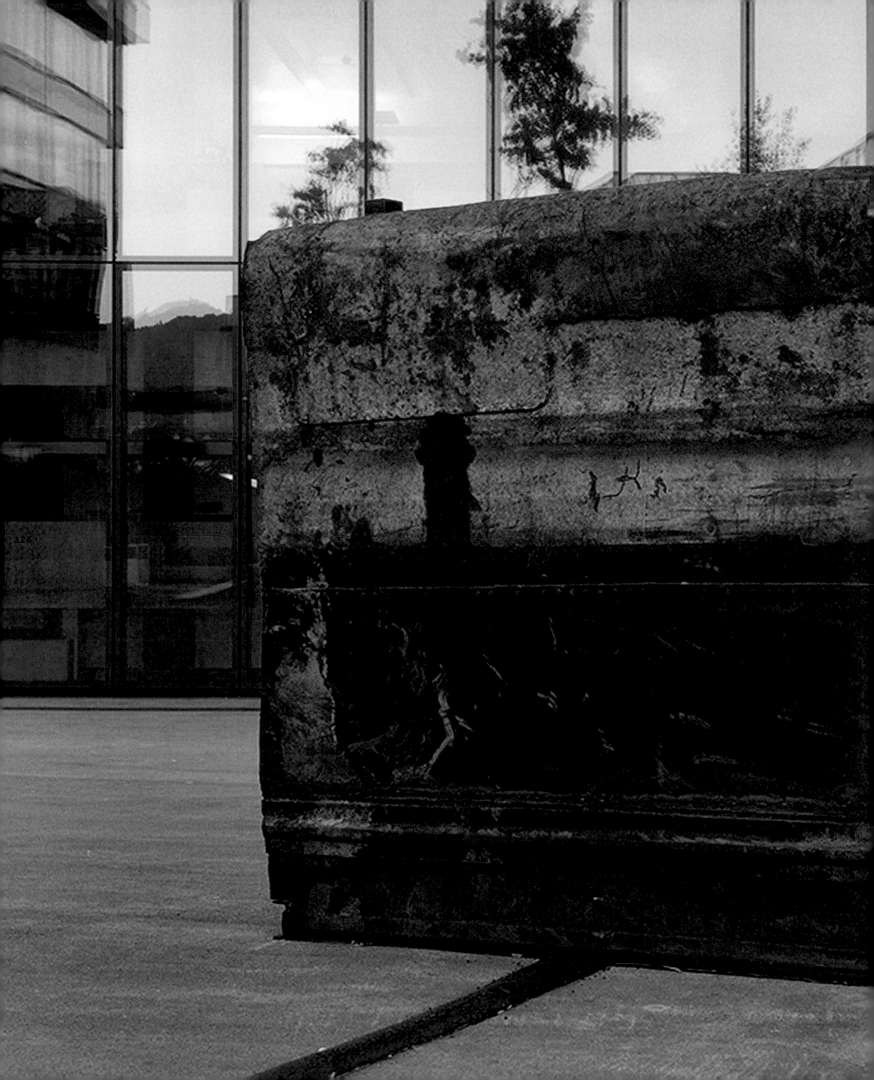

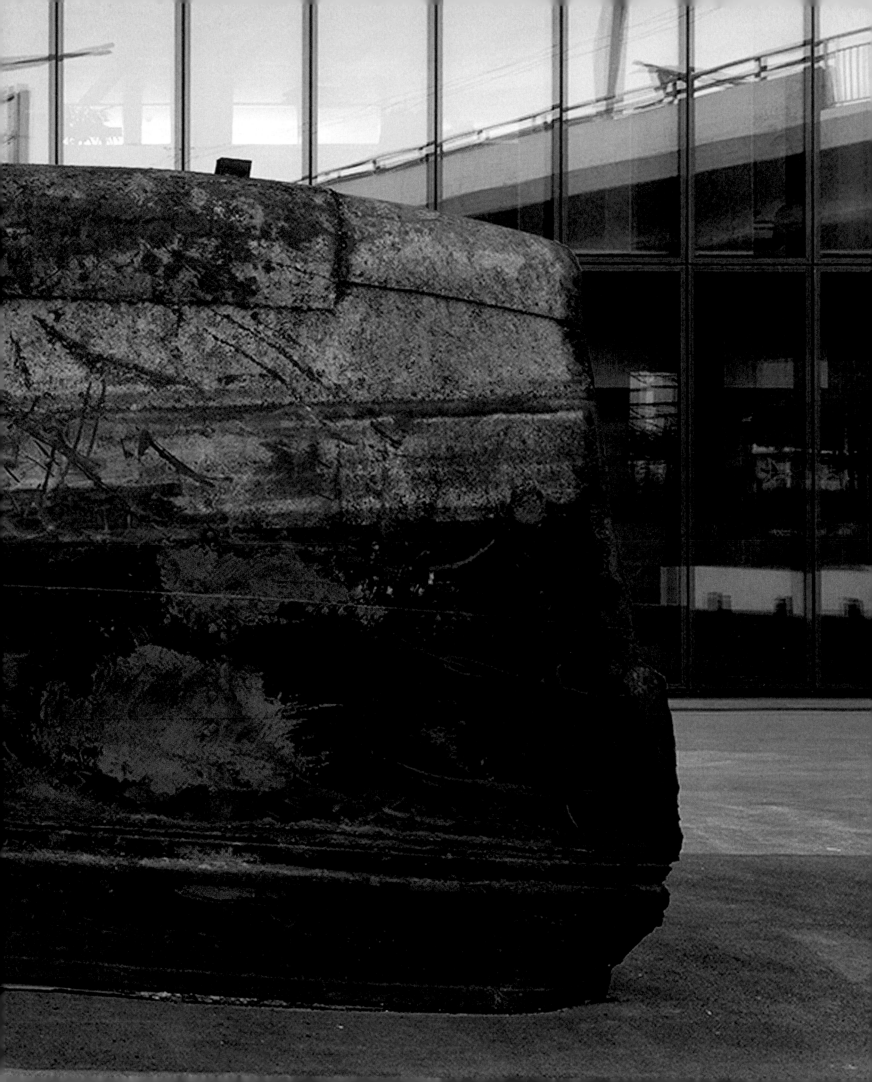

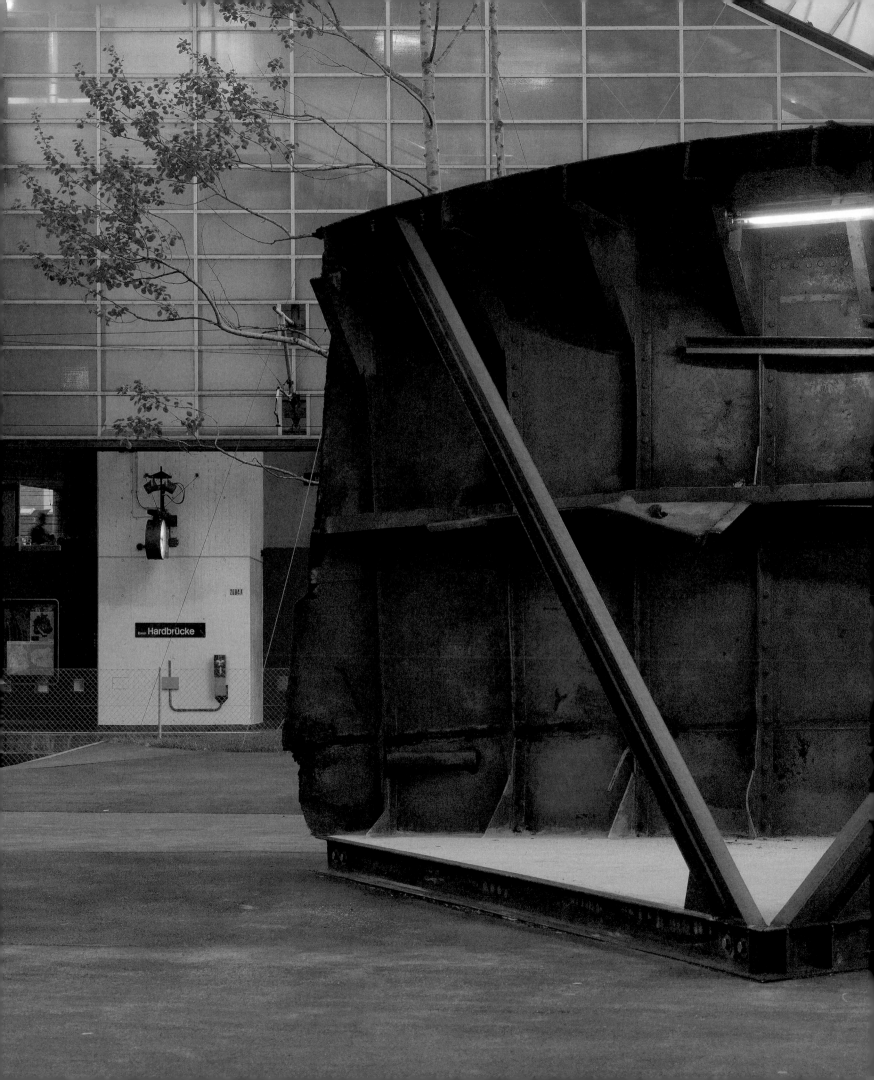

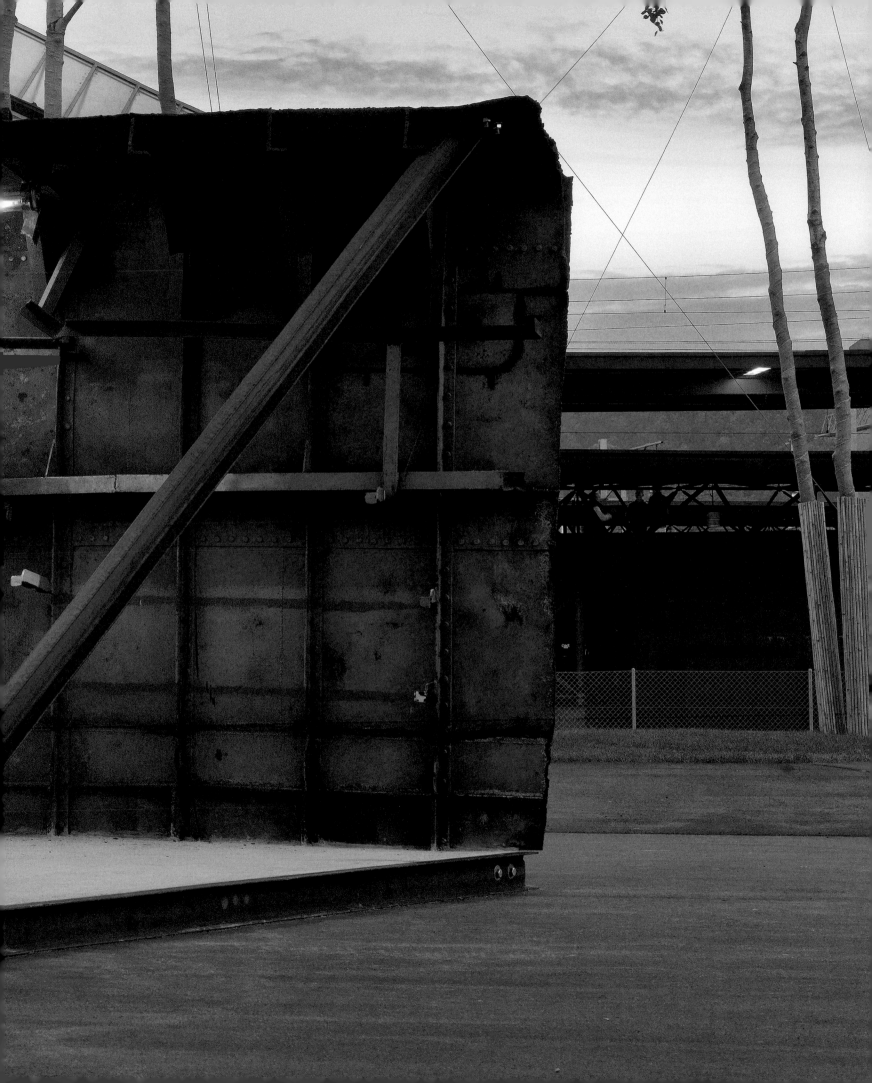

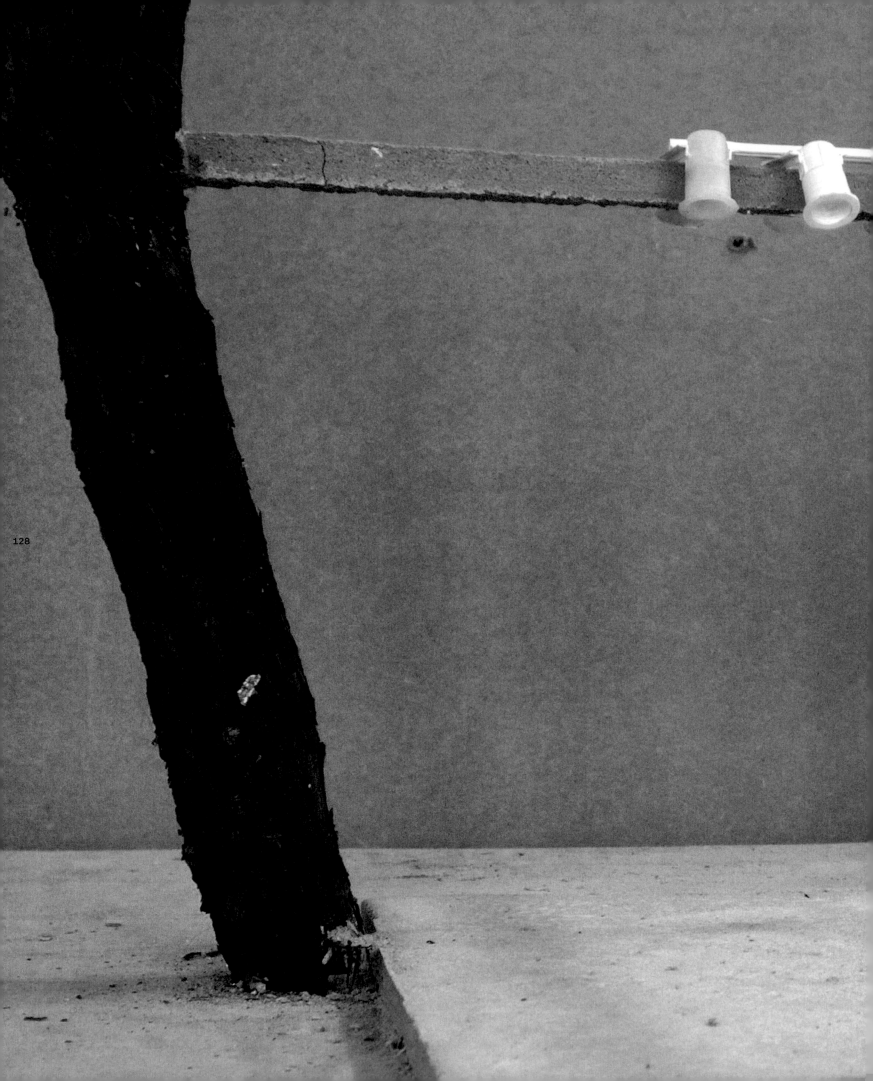

128

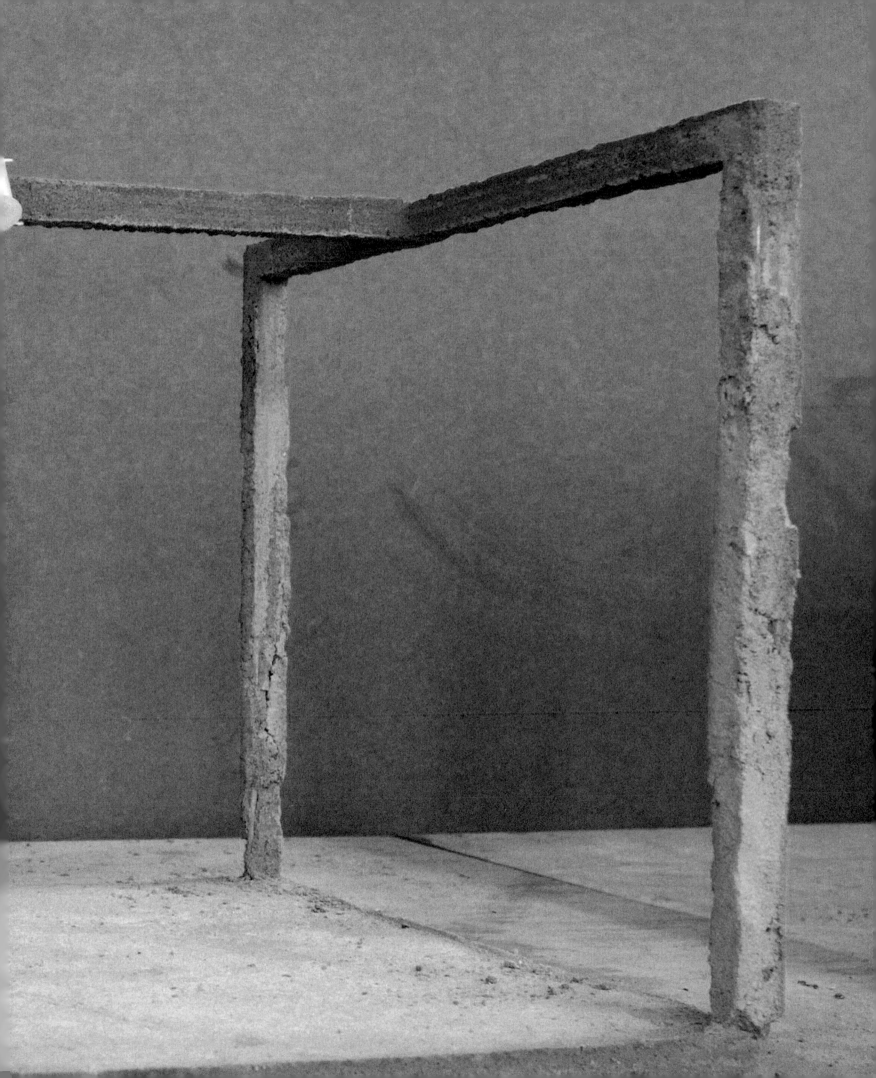

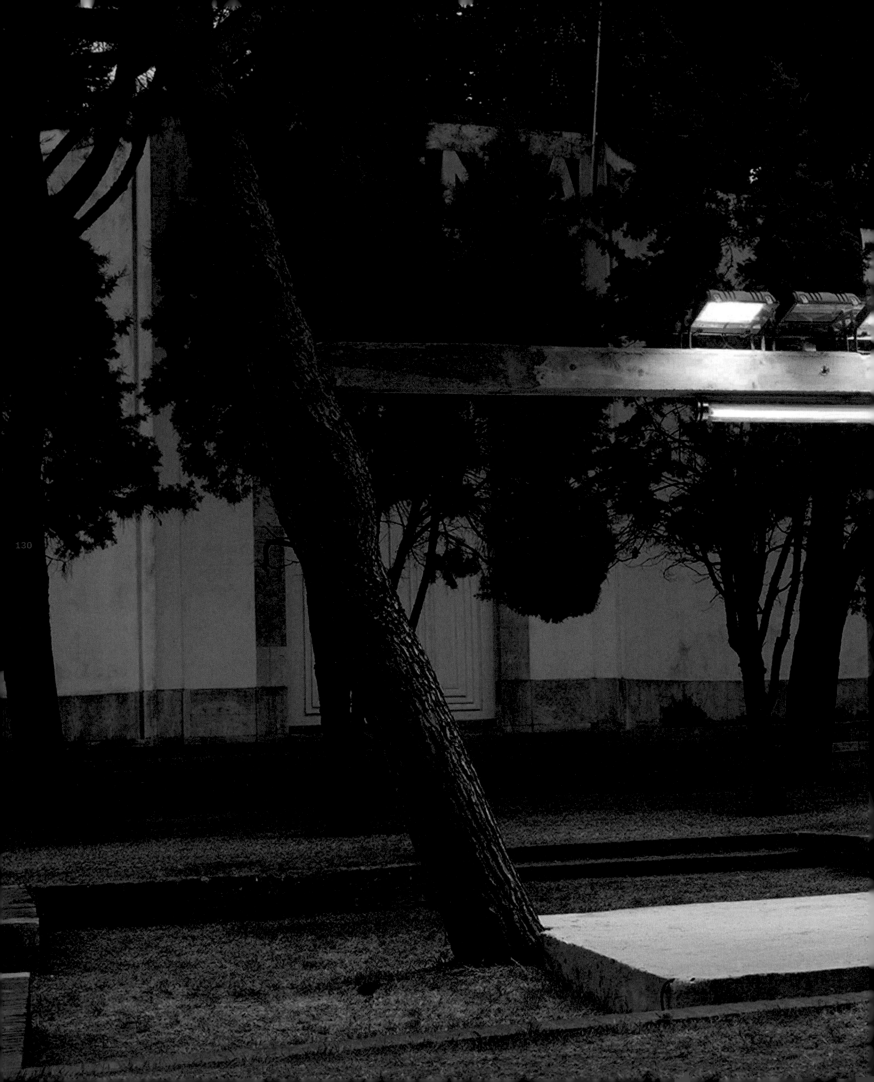

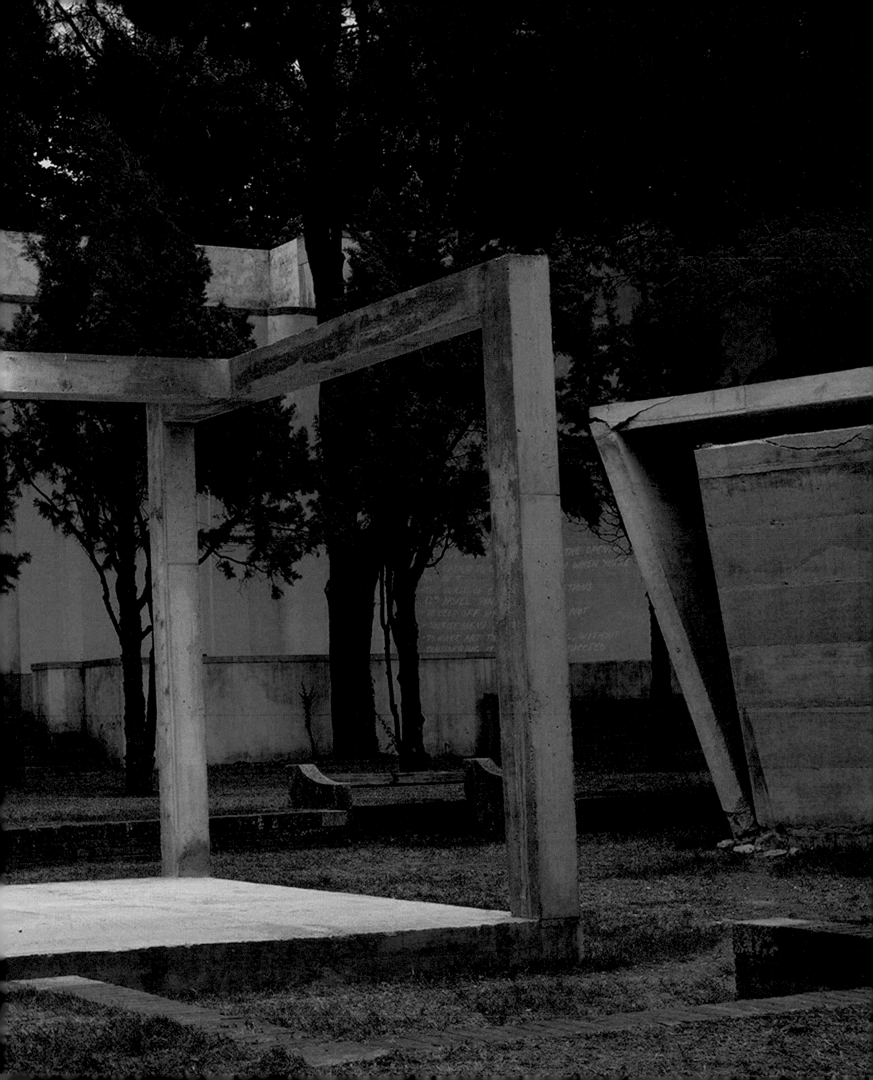

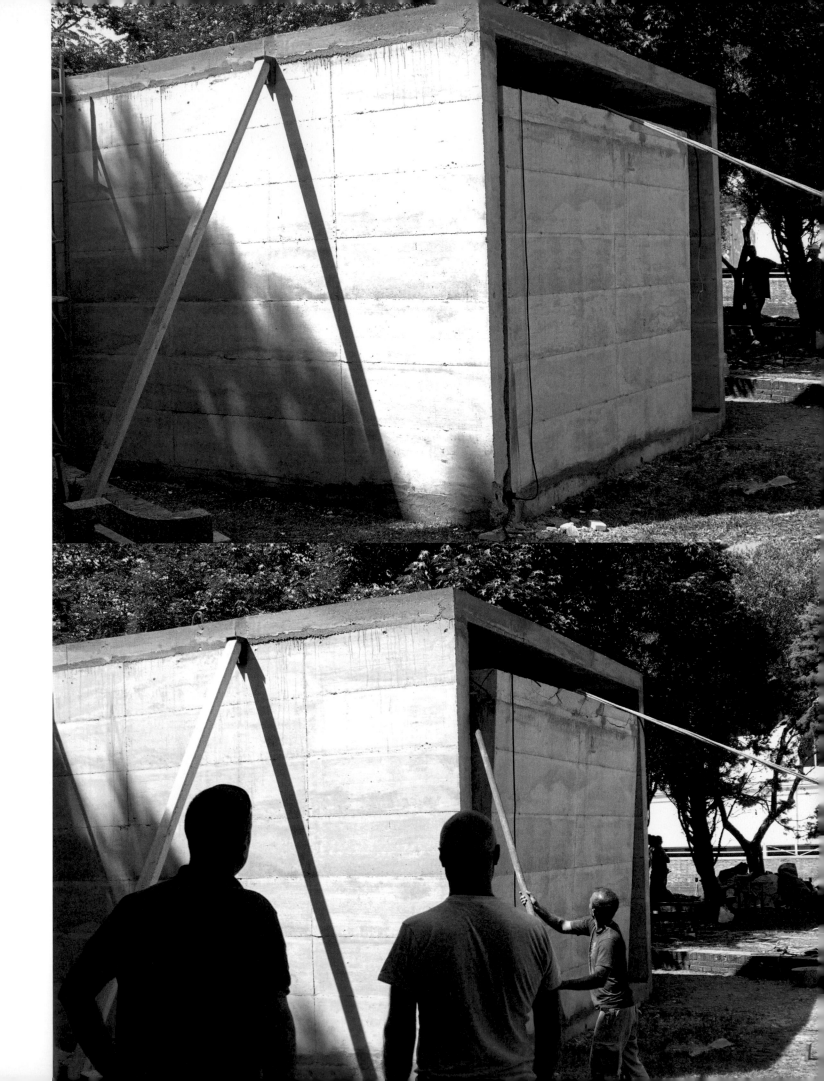

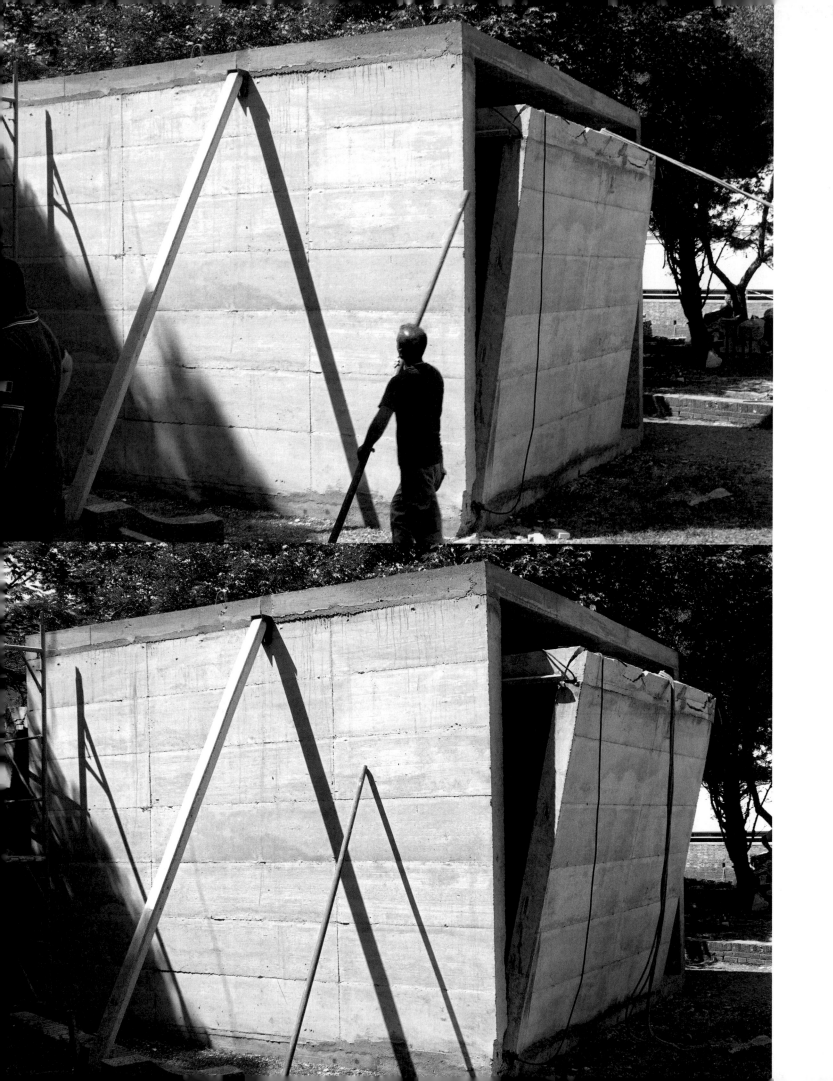

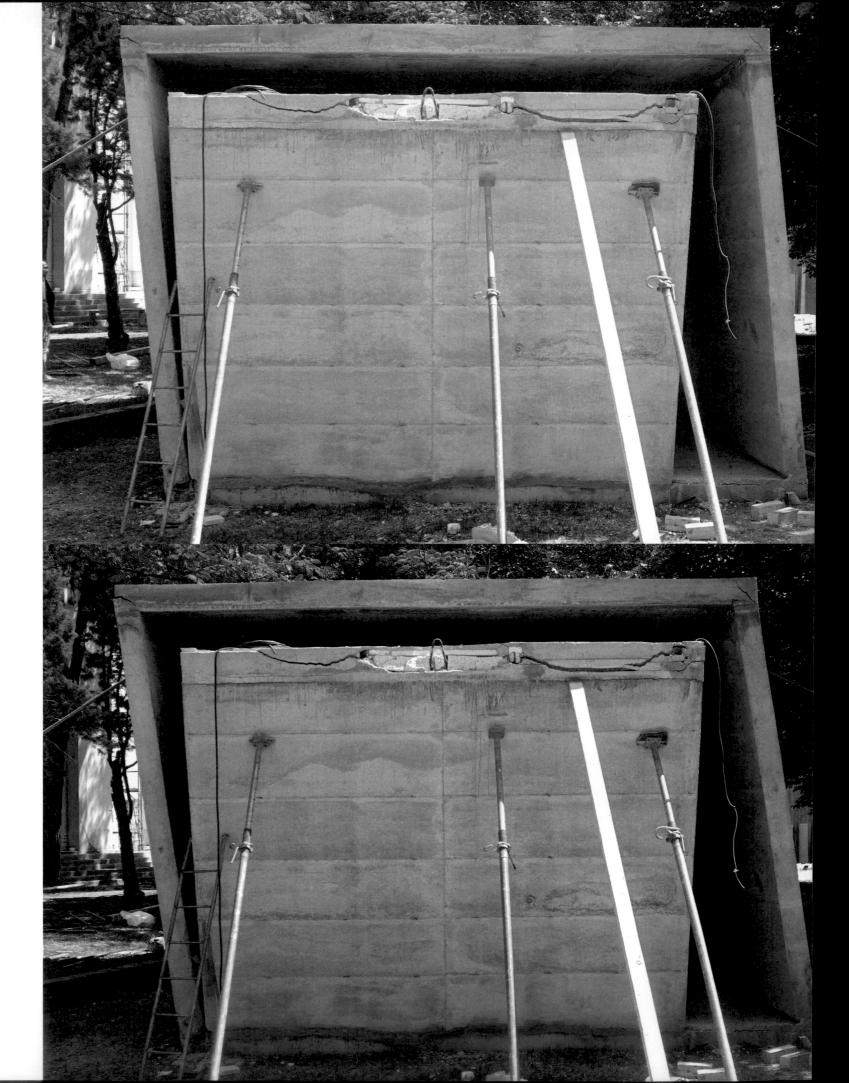

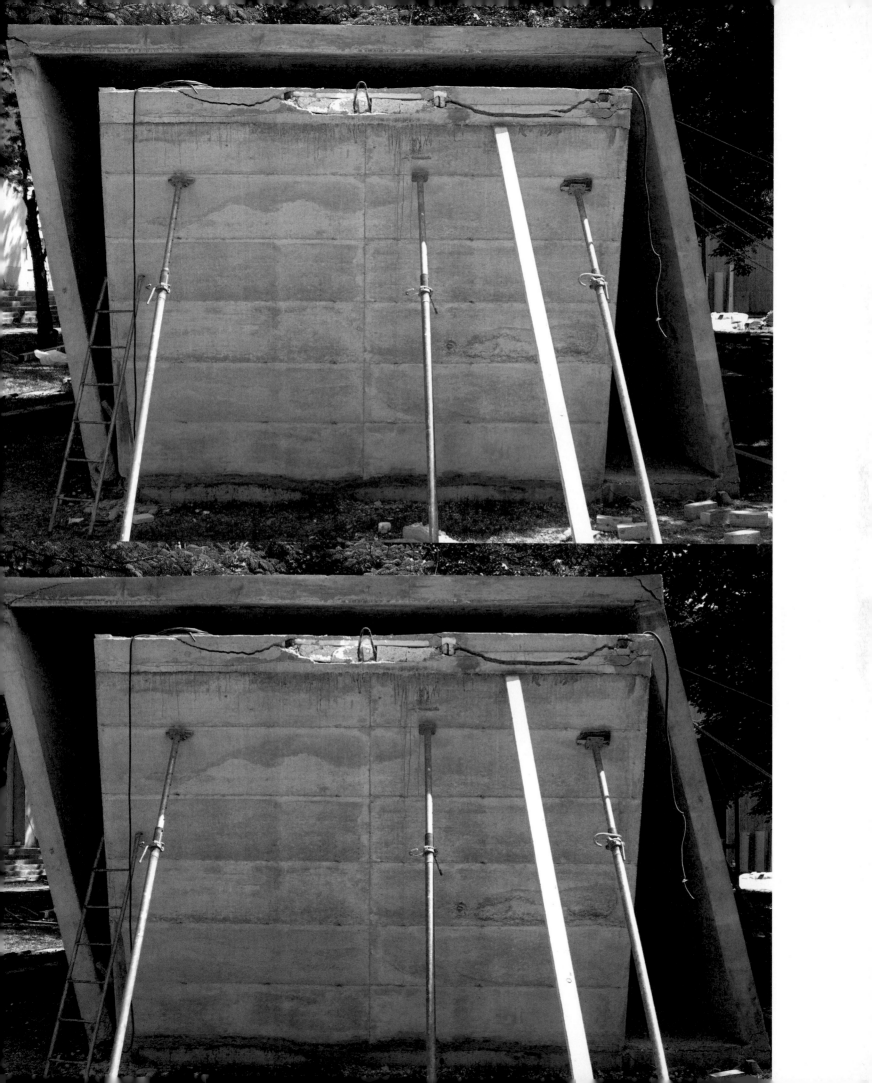

...NICE BIENNALE IS A C...
MERCANTILIST FOSSIL
-THE 30s EFFECT
-WE HAVE NOTHING TO WEAR FOR...
-IT'S EASIER TO CRITICIZE A SHOW...
NOT IN IT
-THE CURSE OF BOOSTED EXPECTAT...
(2ND NOVEL SYNDROME)
-TO KEEP OFF WHO'S HOT & WHO'S NO...
-TOURIST MENU SUCKS
-TO MAKE ART THE WAY WE FEEL, W...
CONSIDERING ITS POTENTIAL TO SUCC...

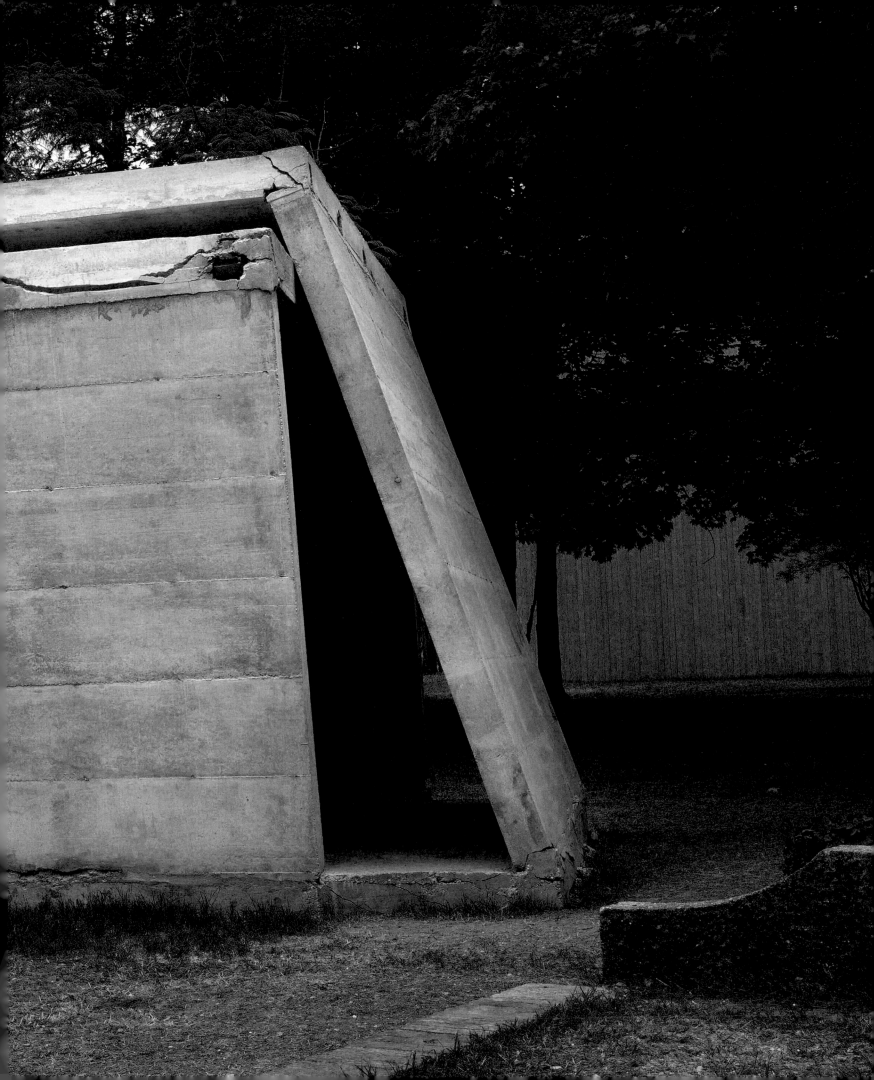

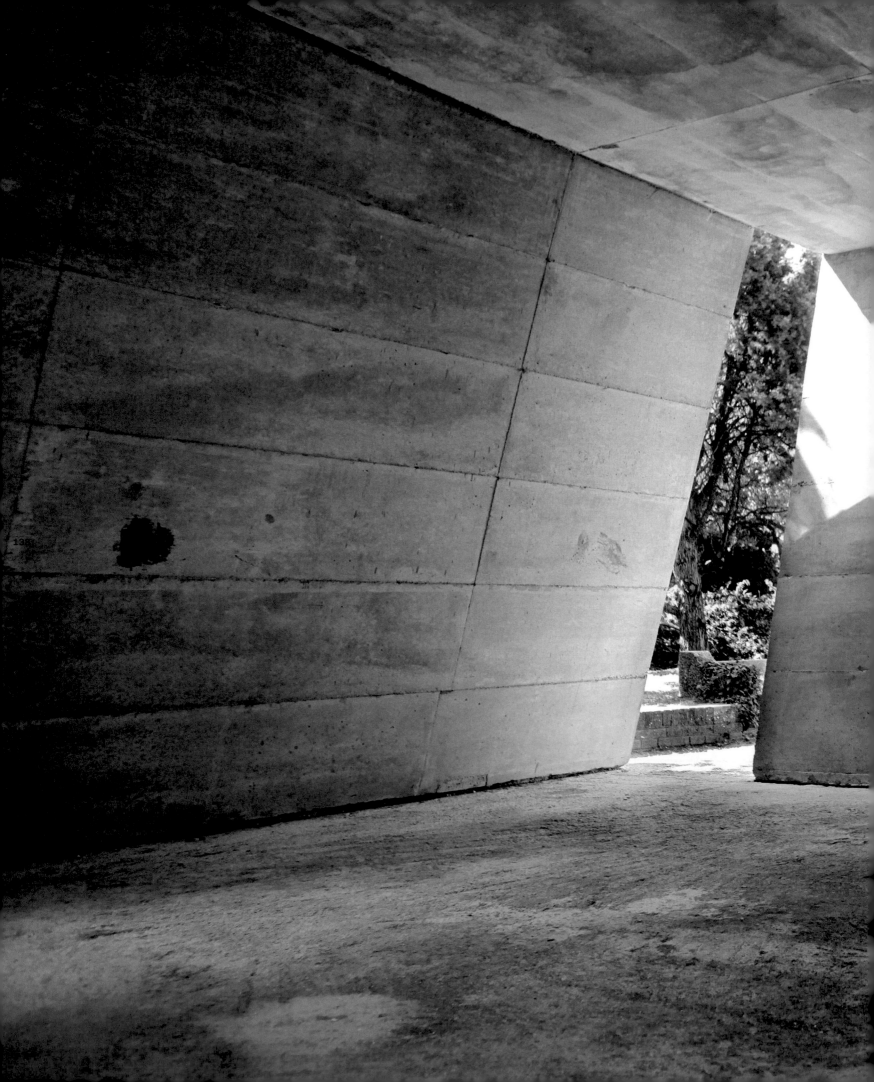

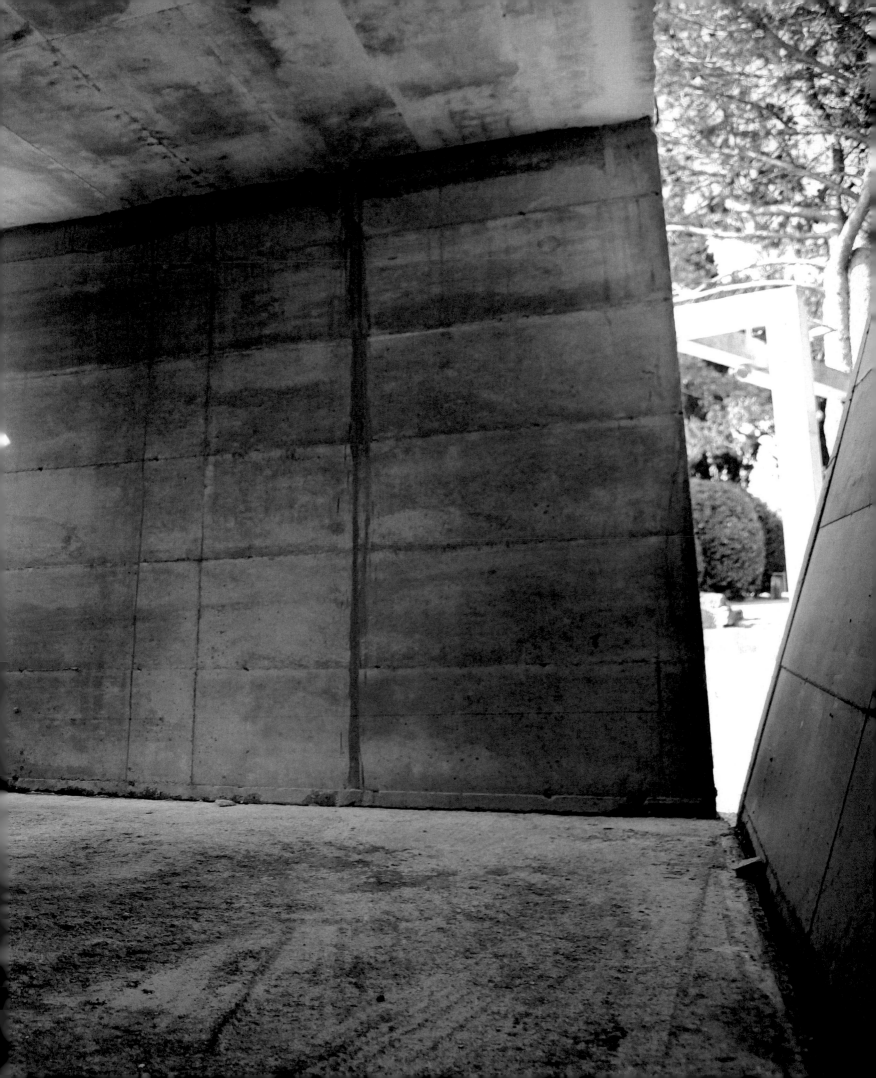

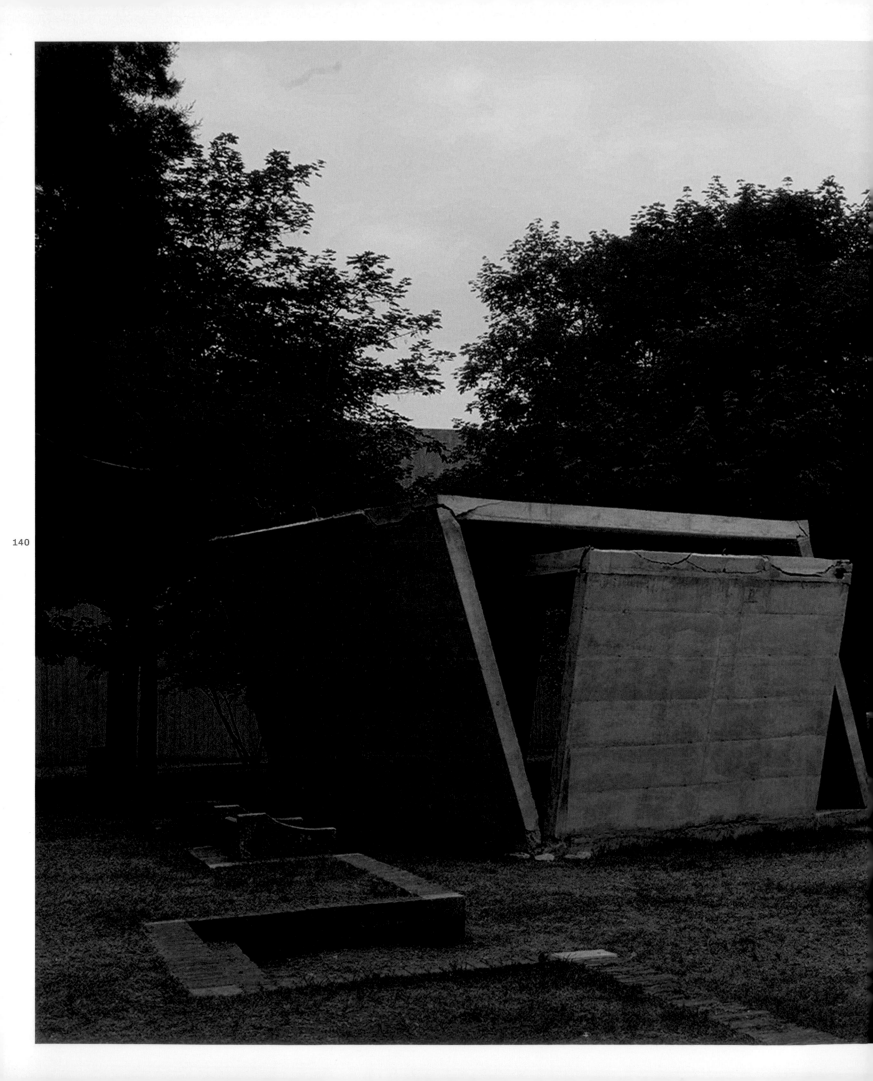

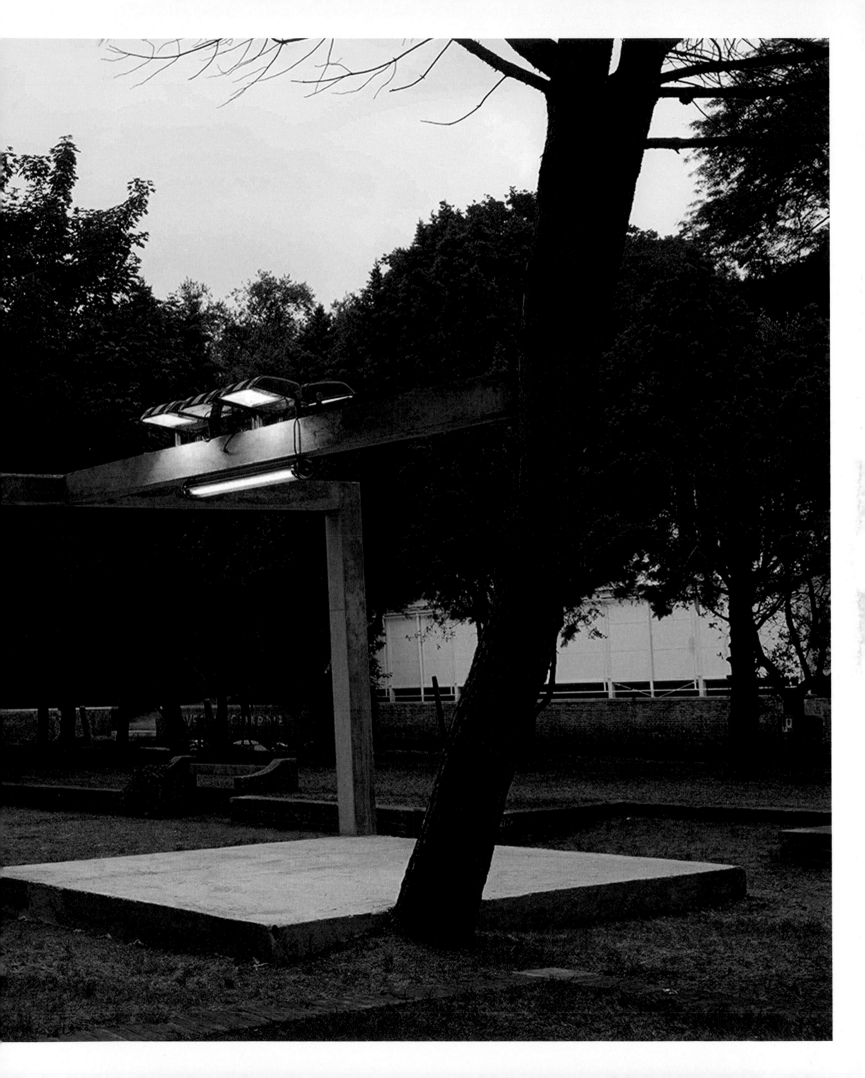

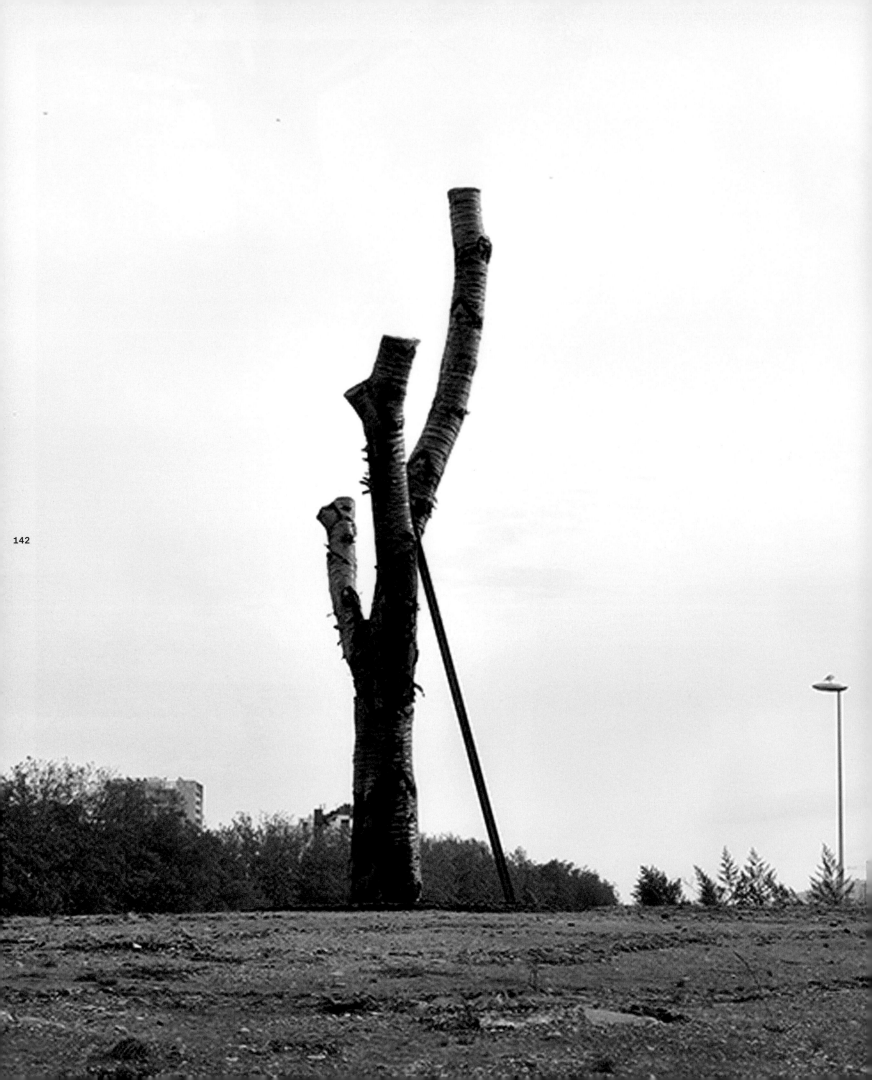

142

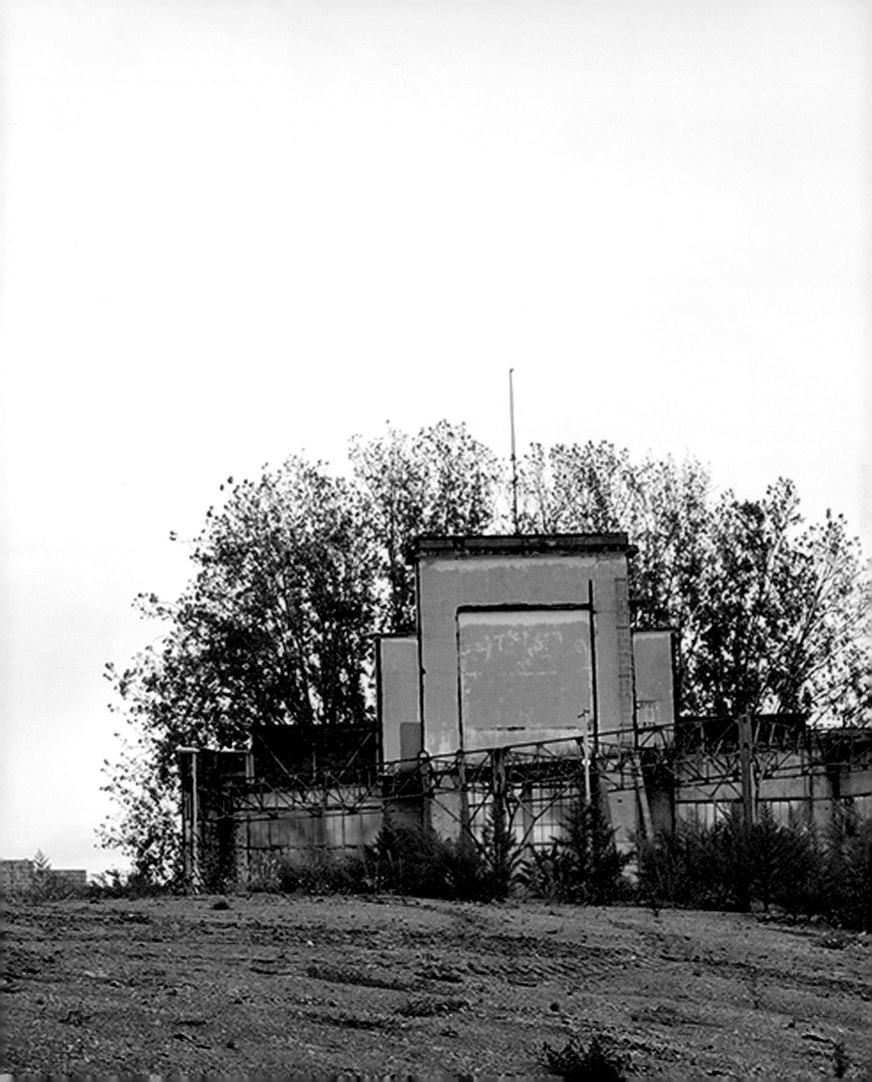

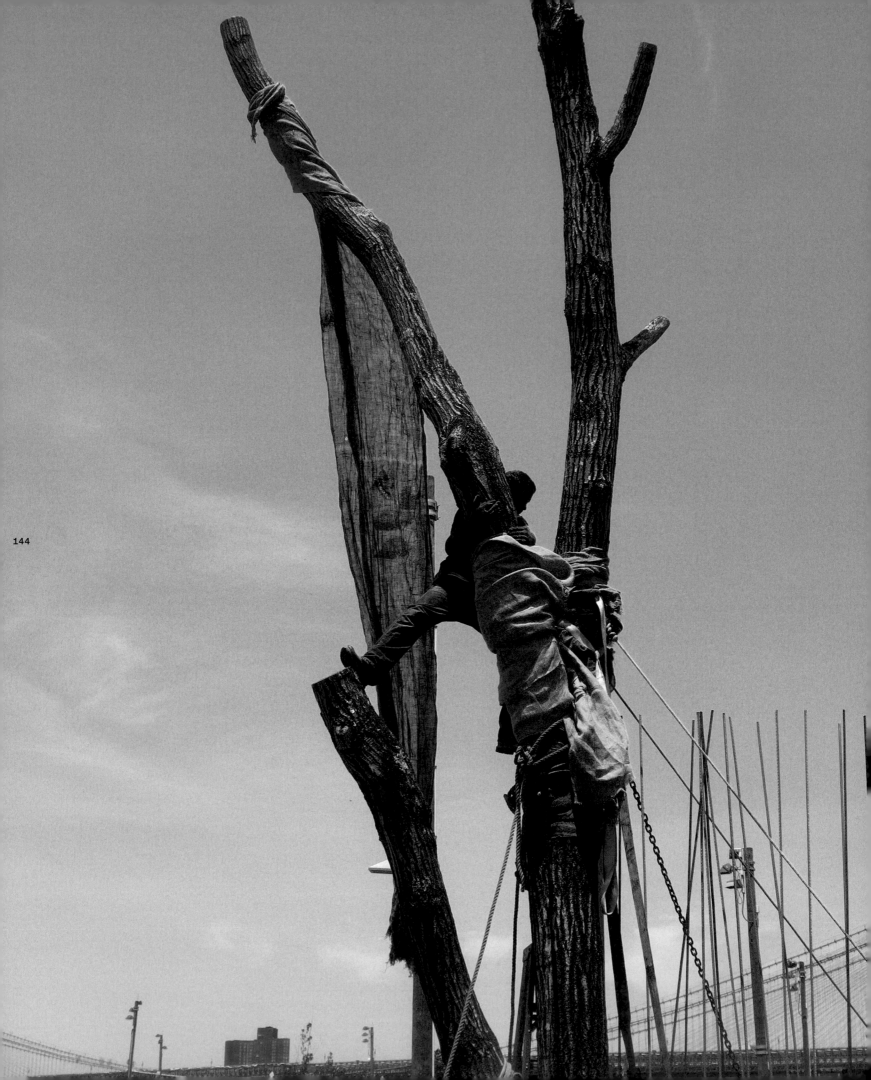

144

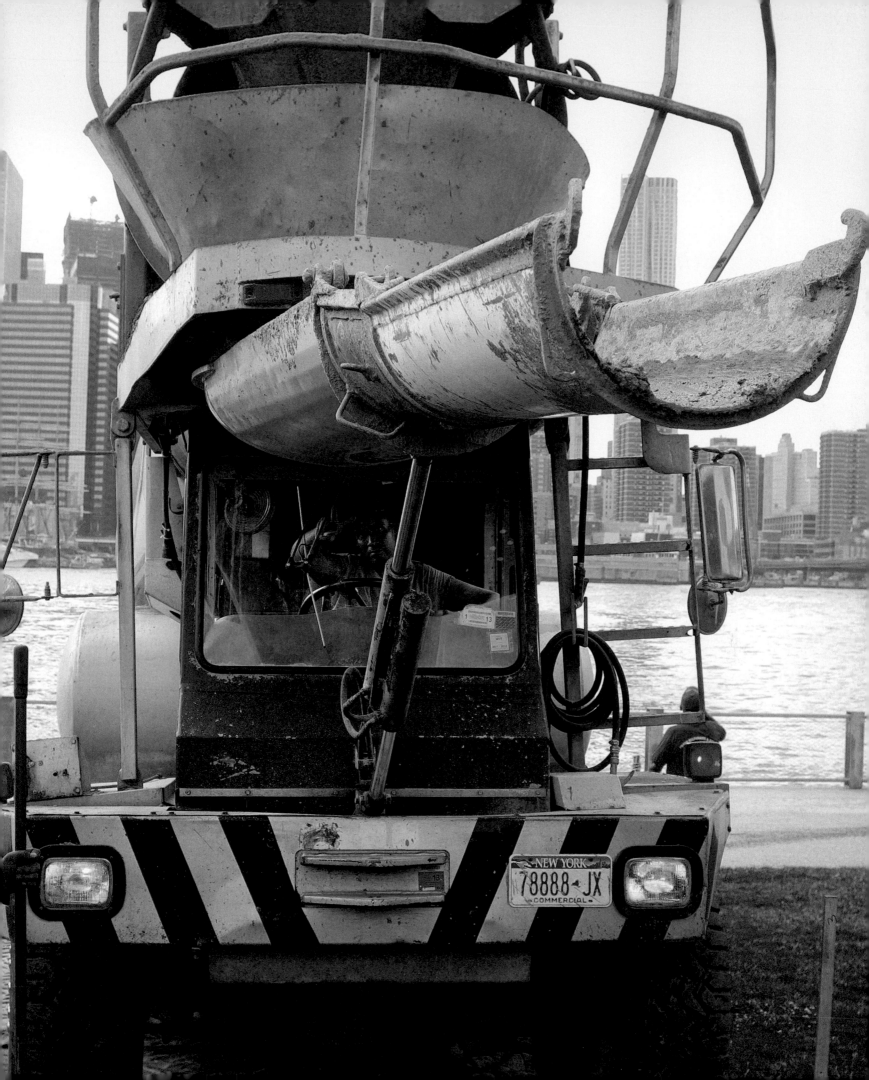

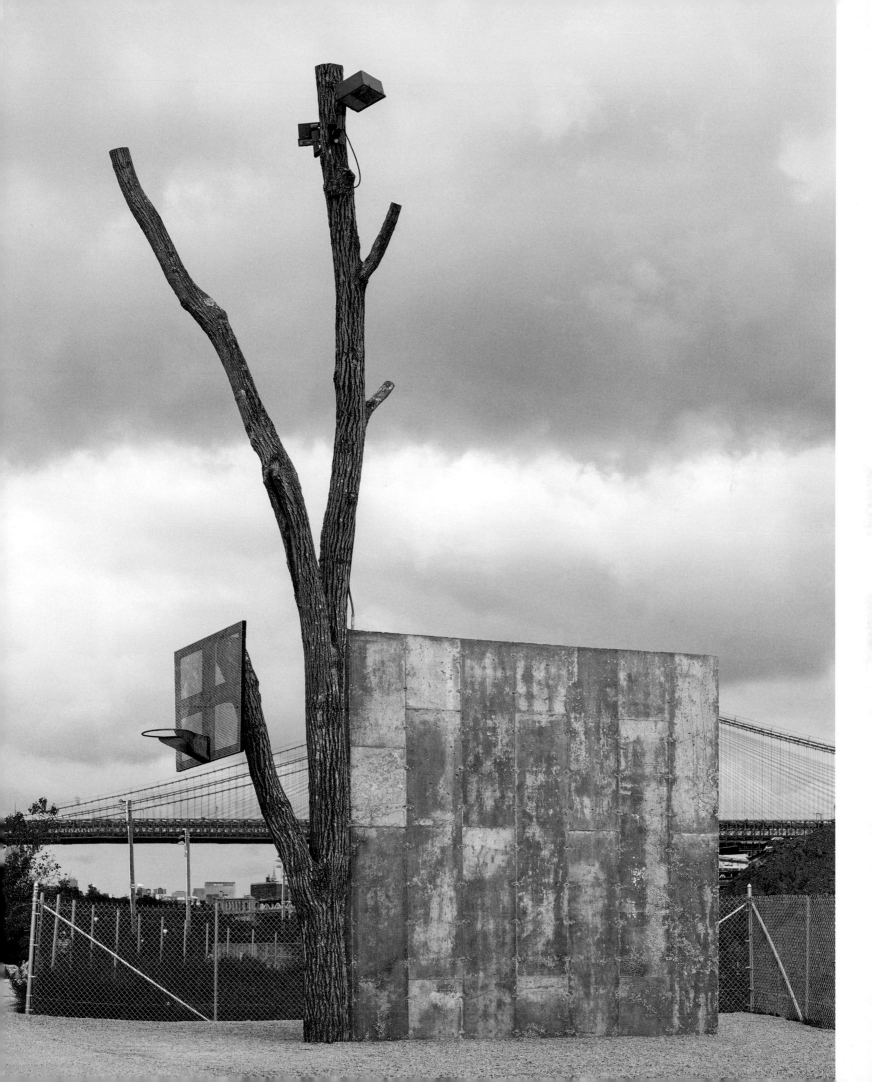

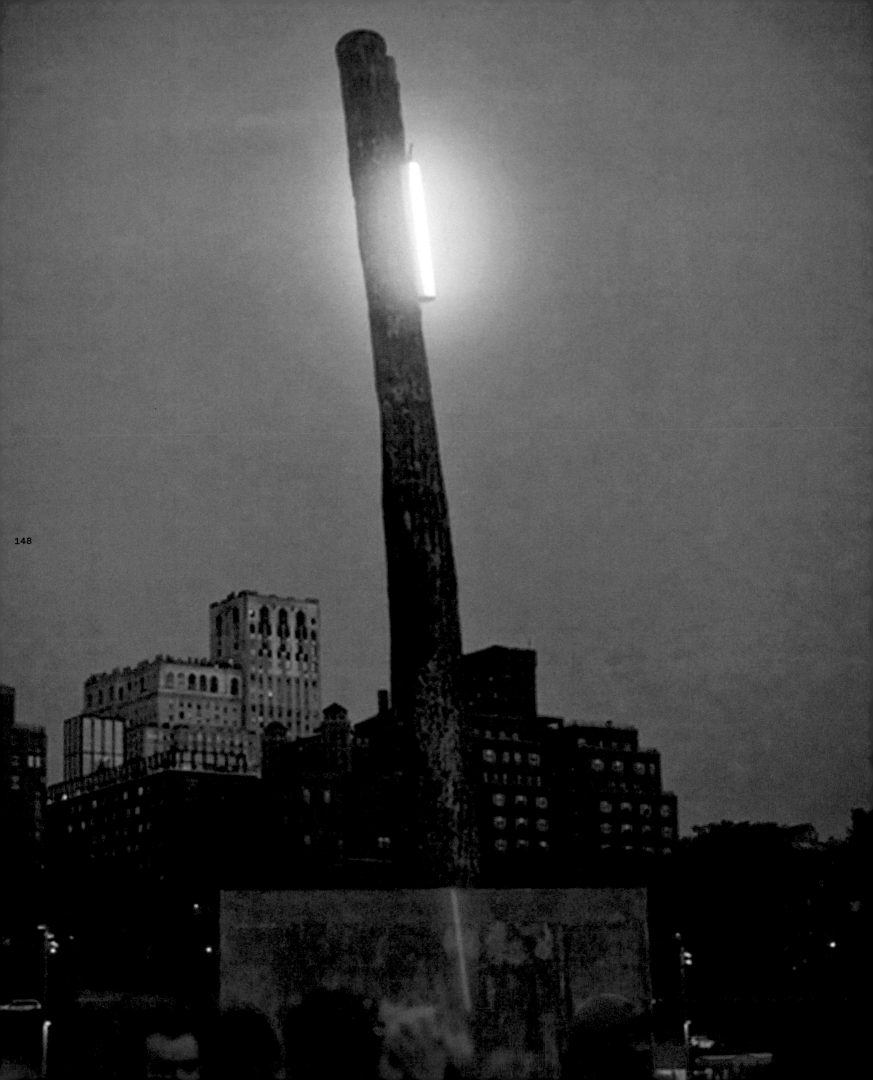

148

152

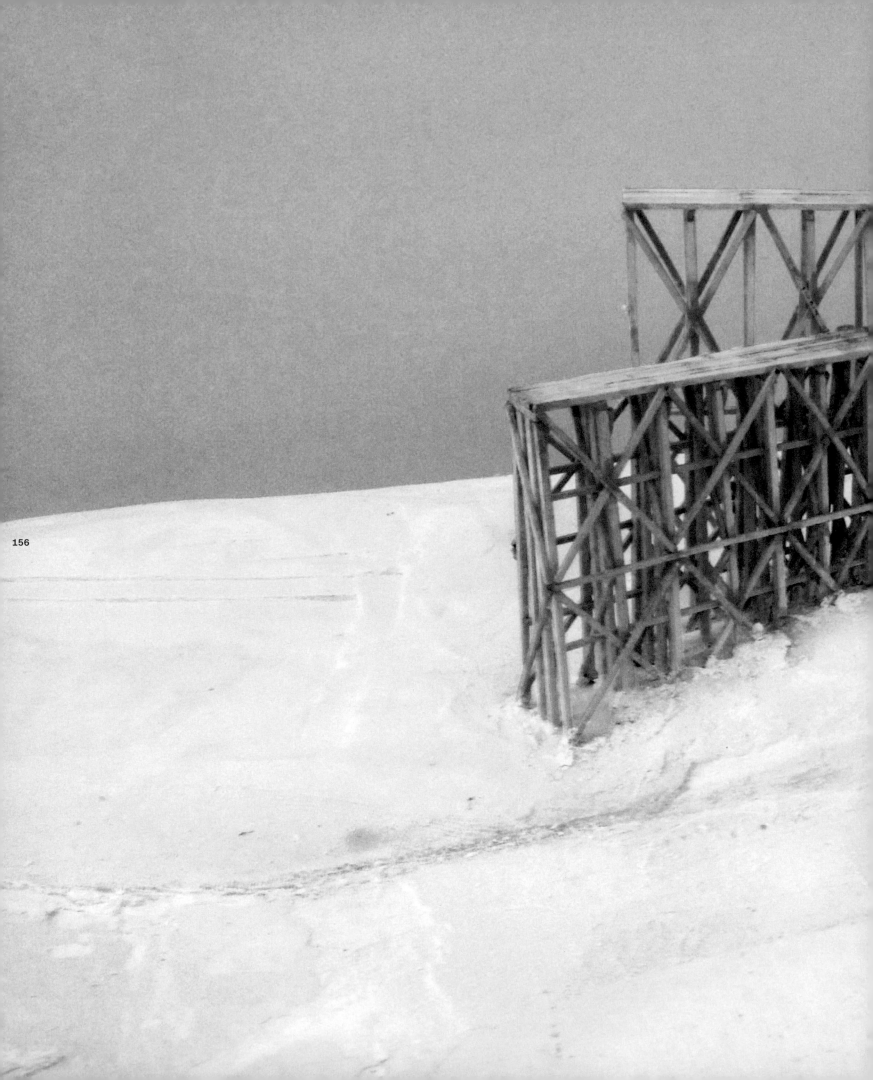

156

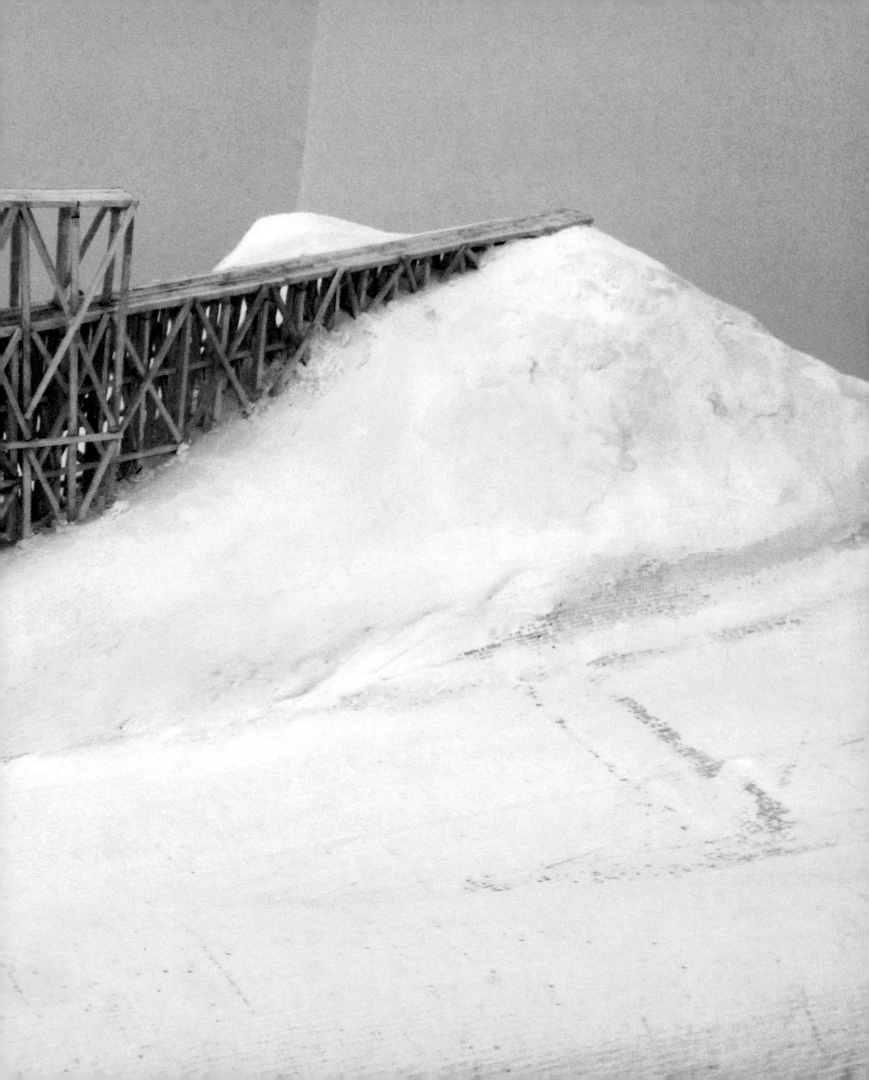

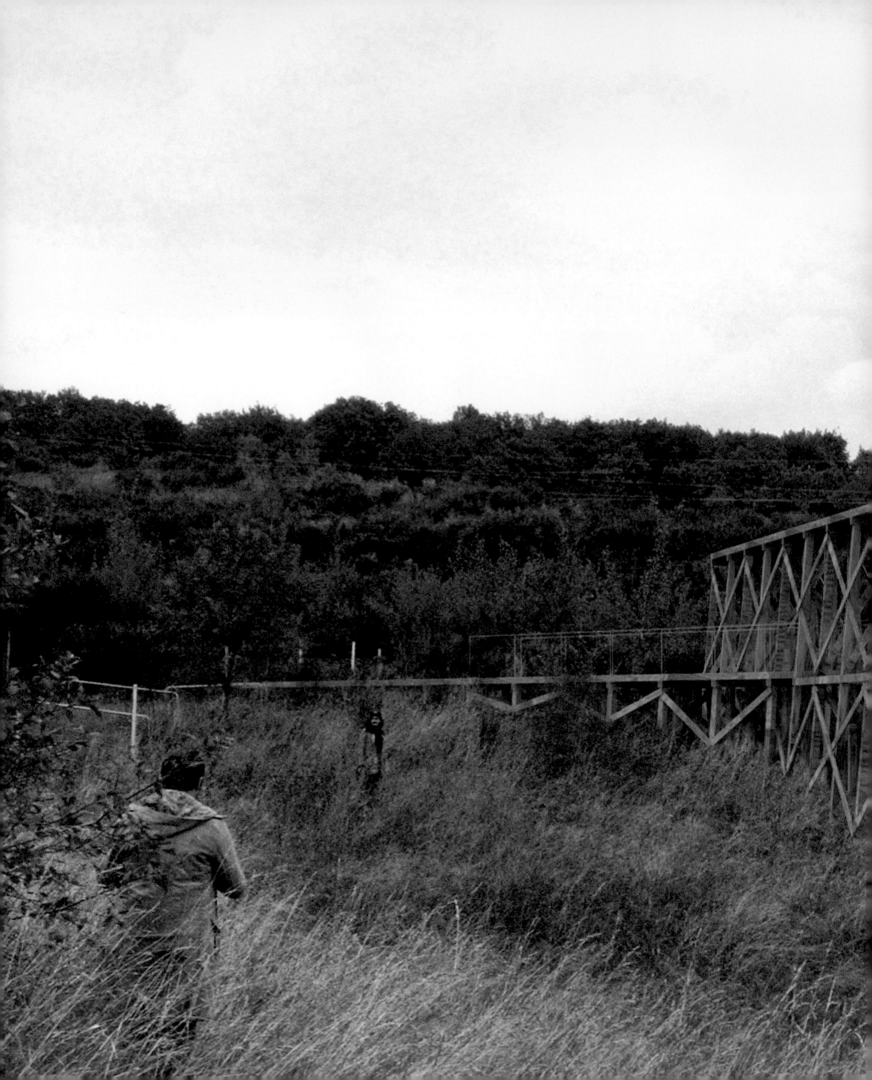

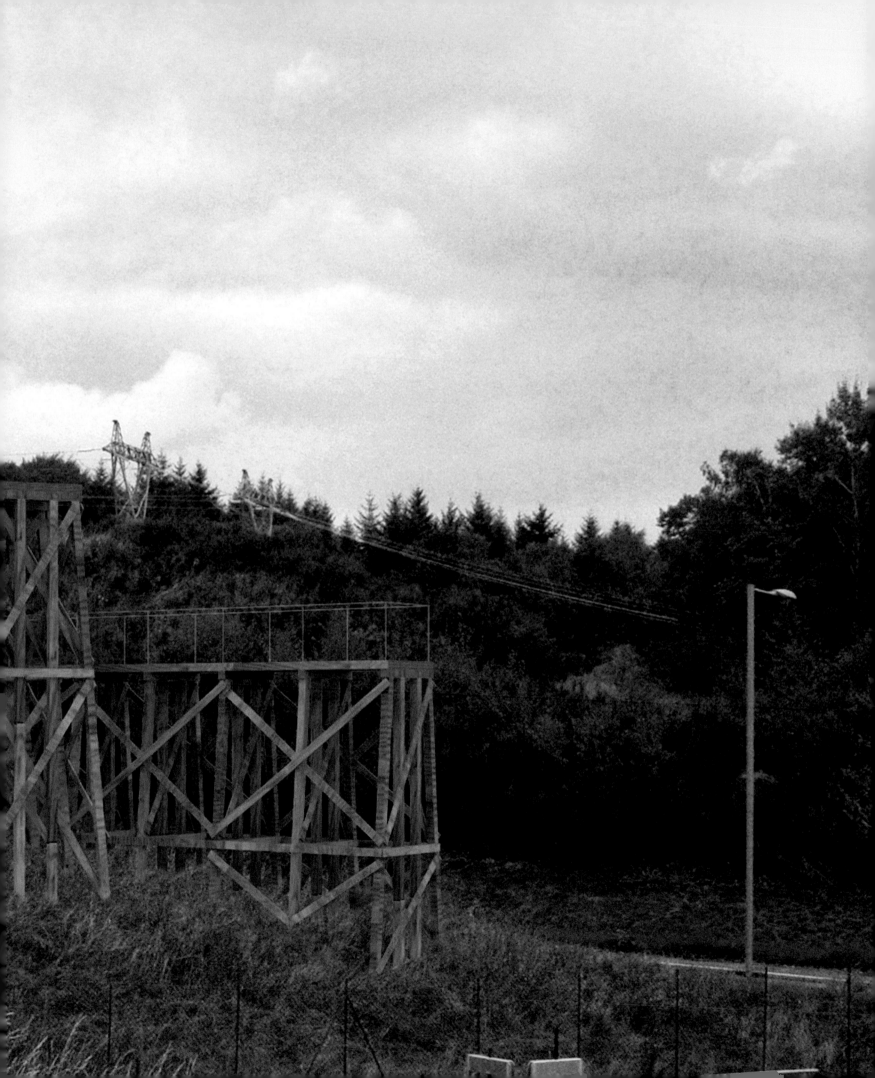

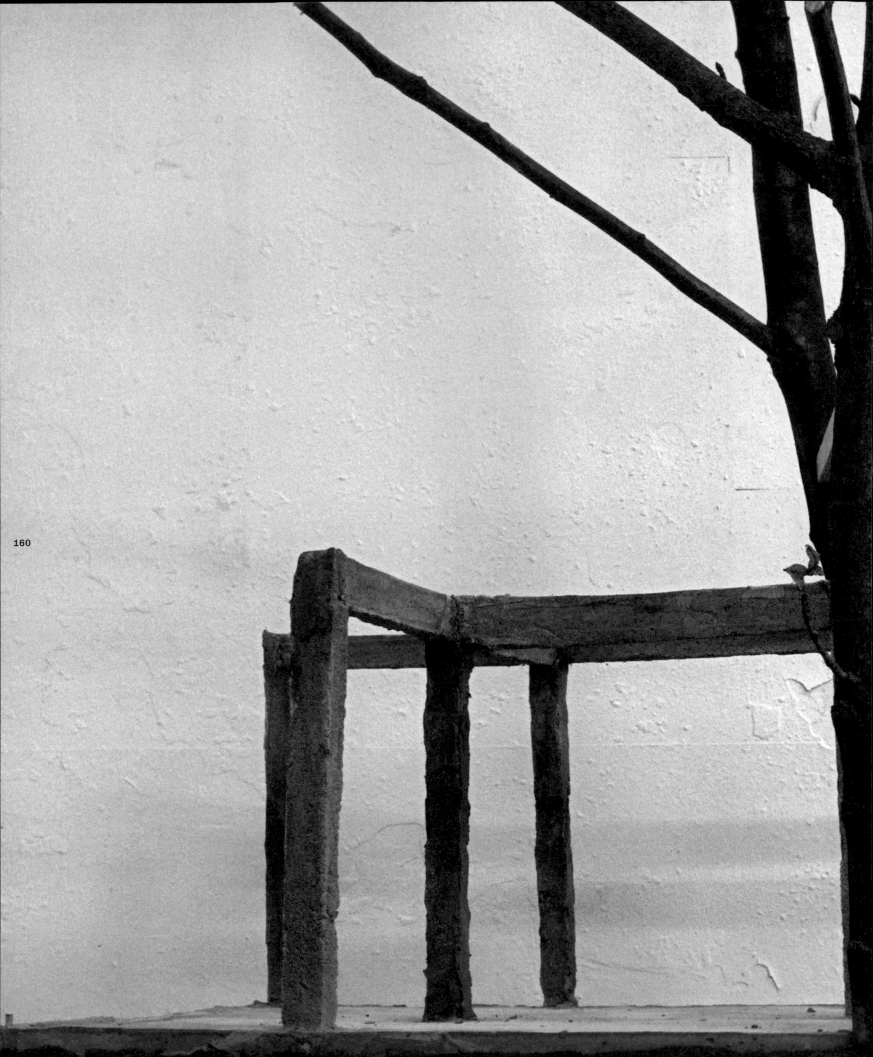

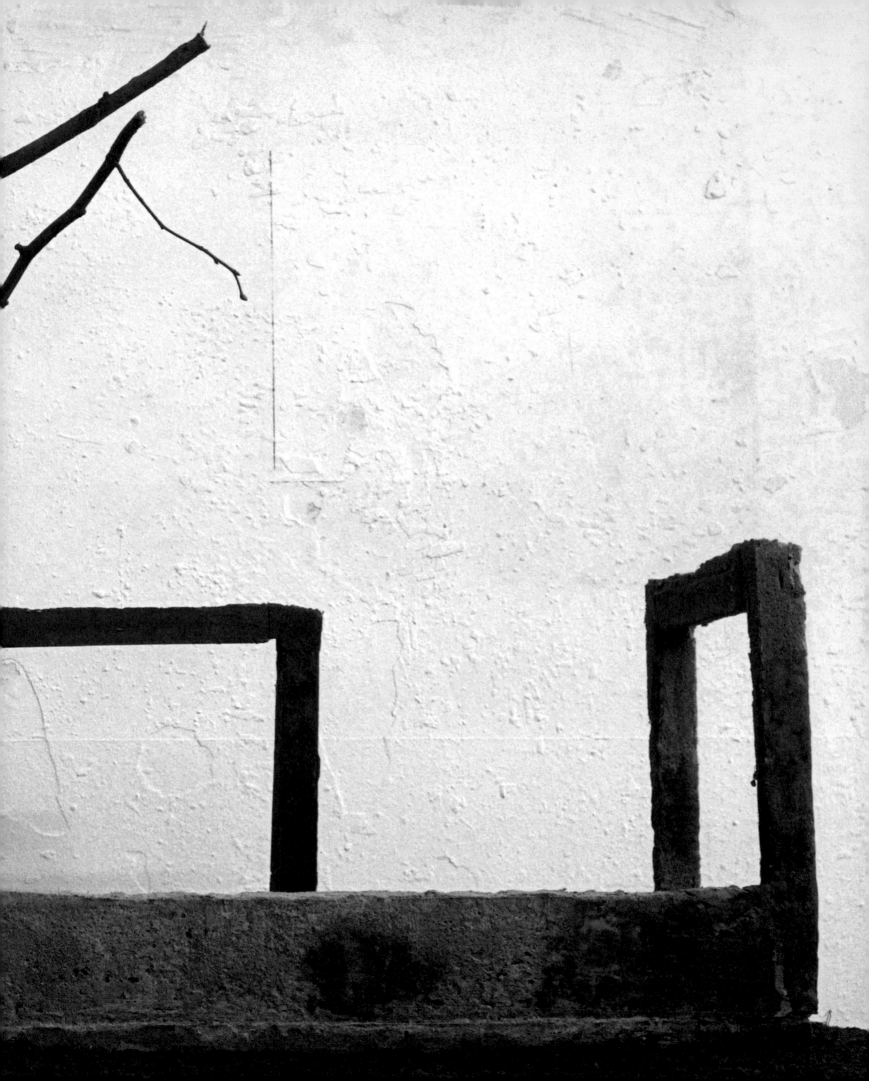

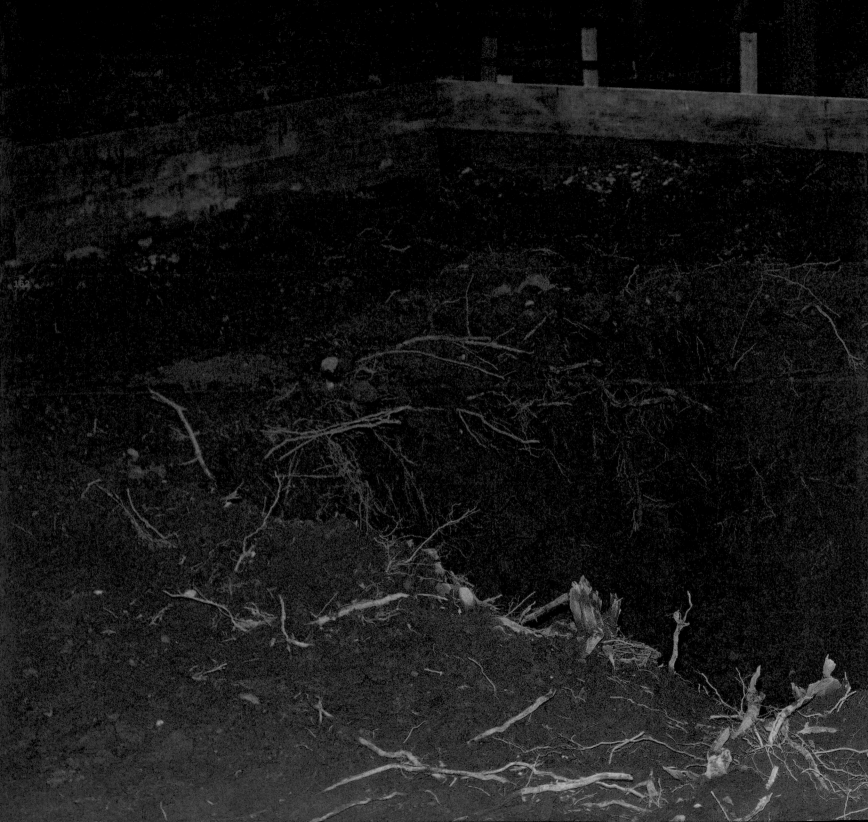

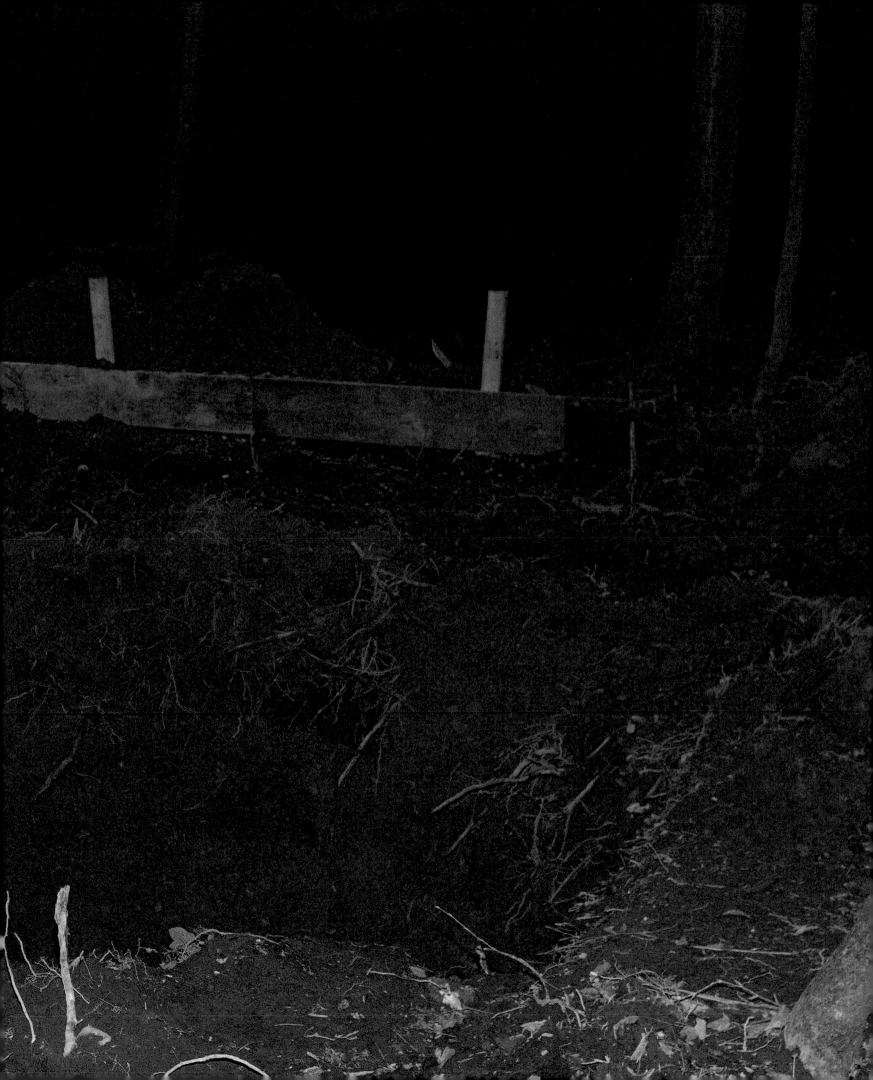

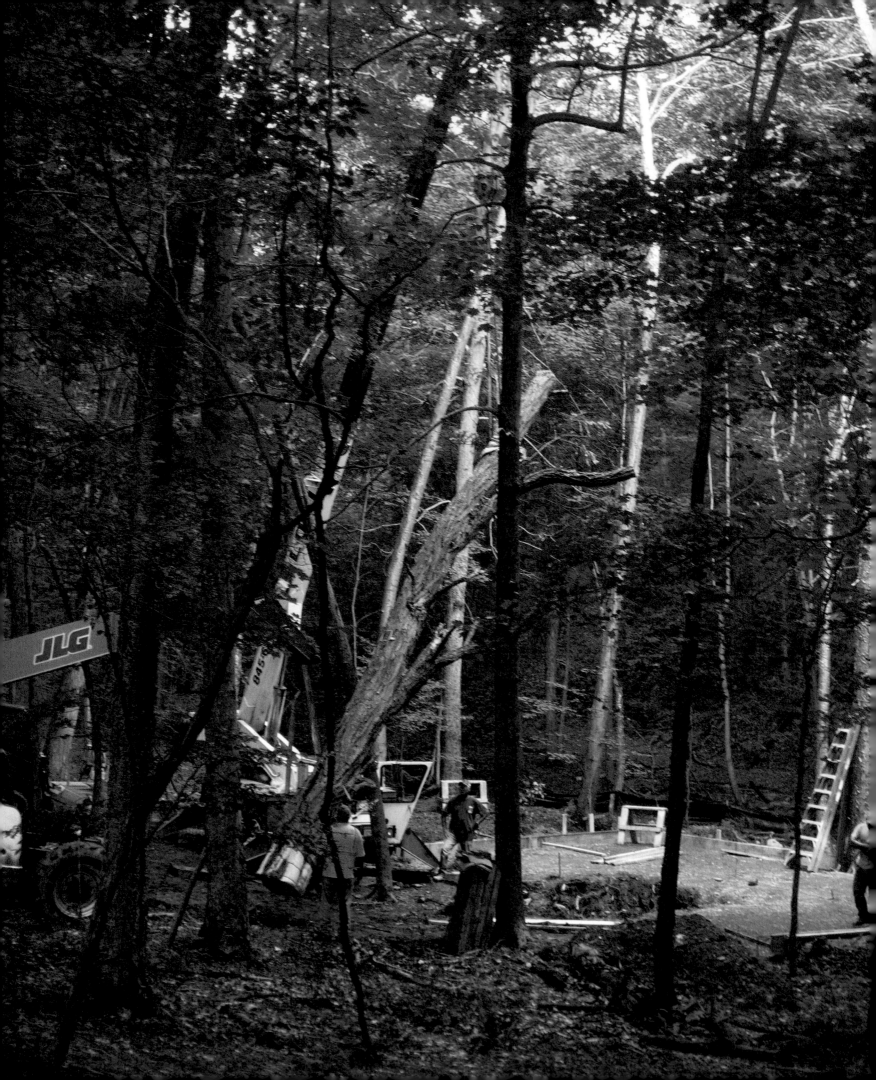

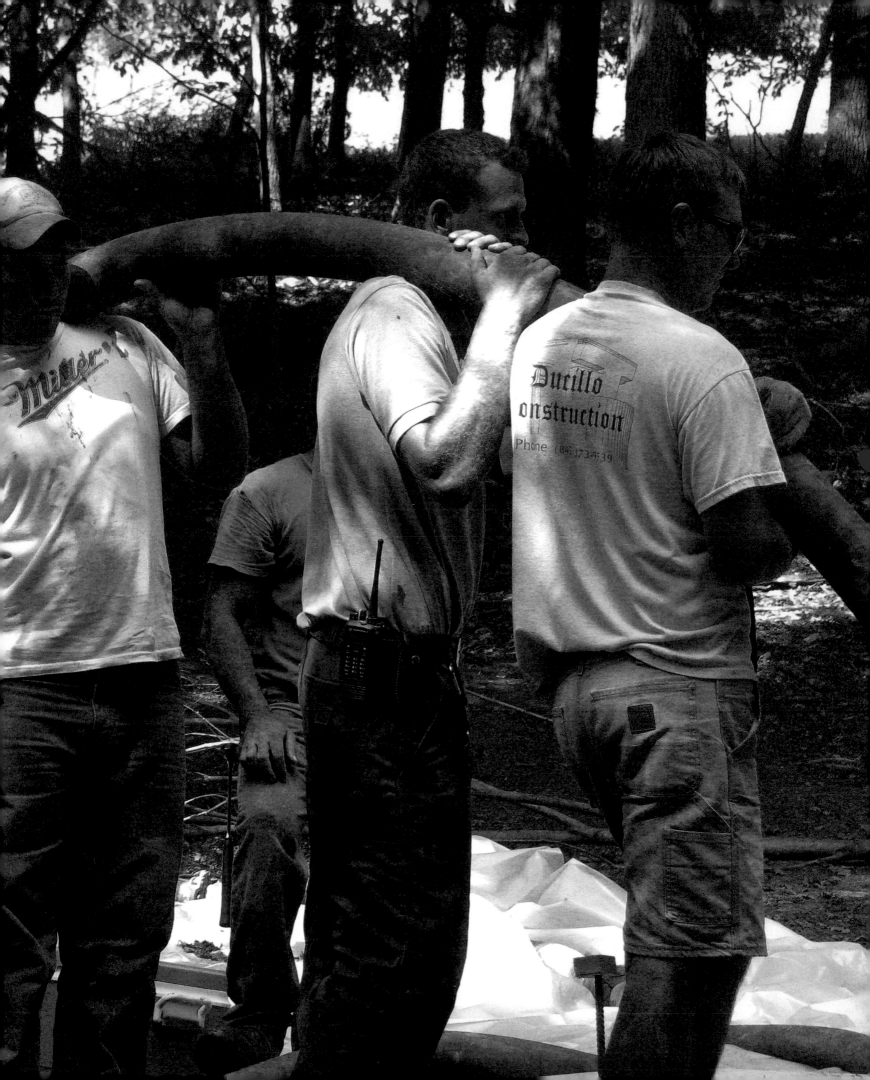

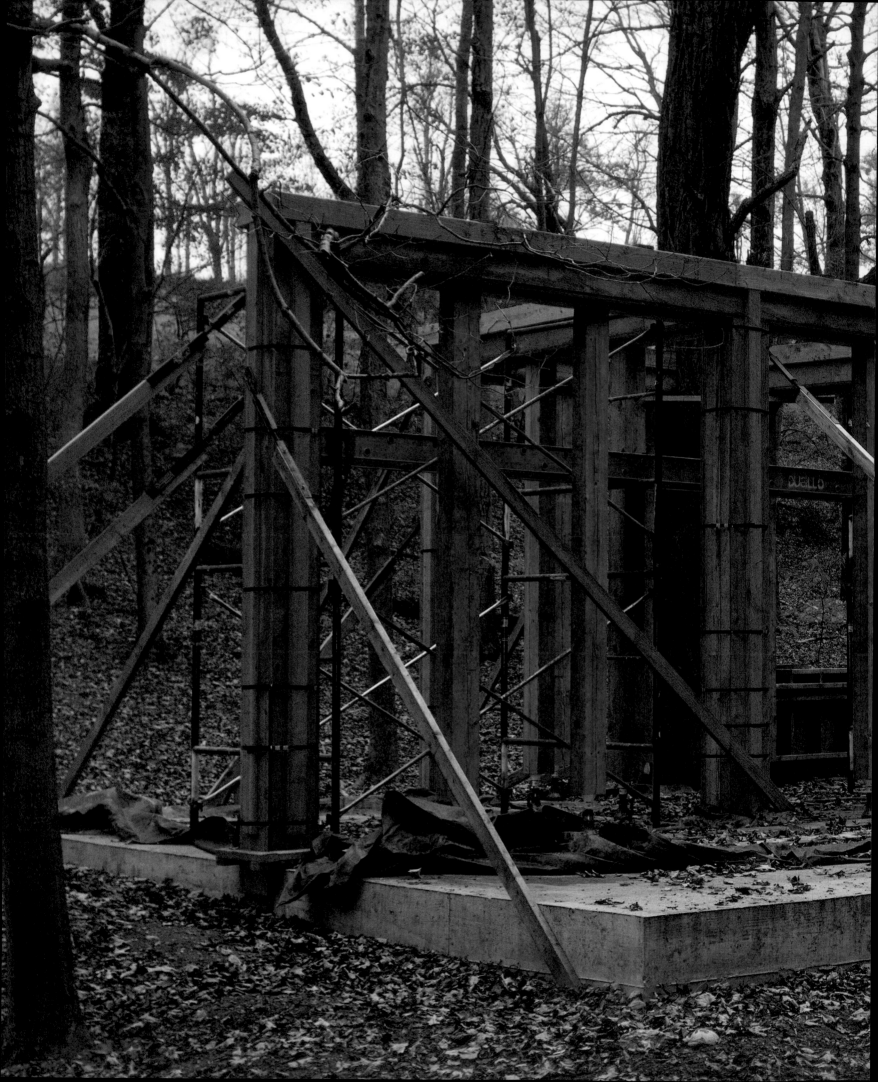

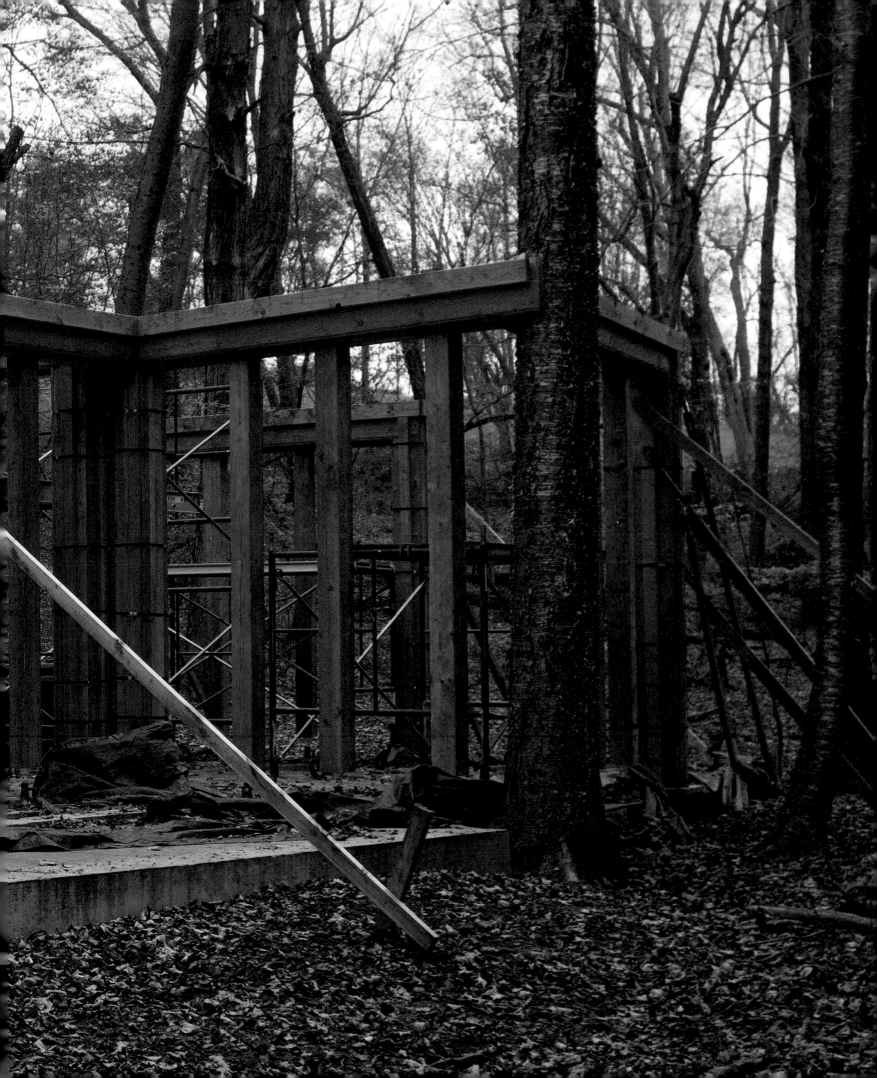

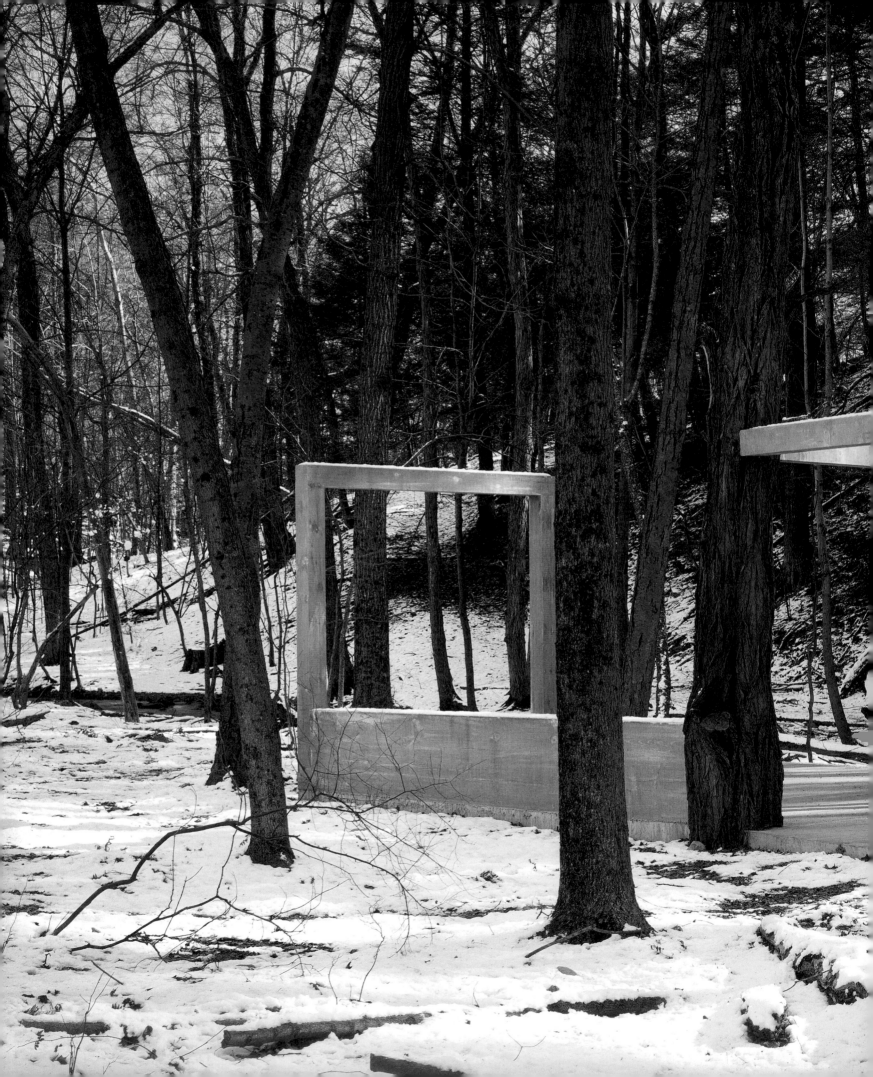

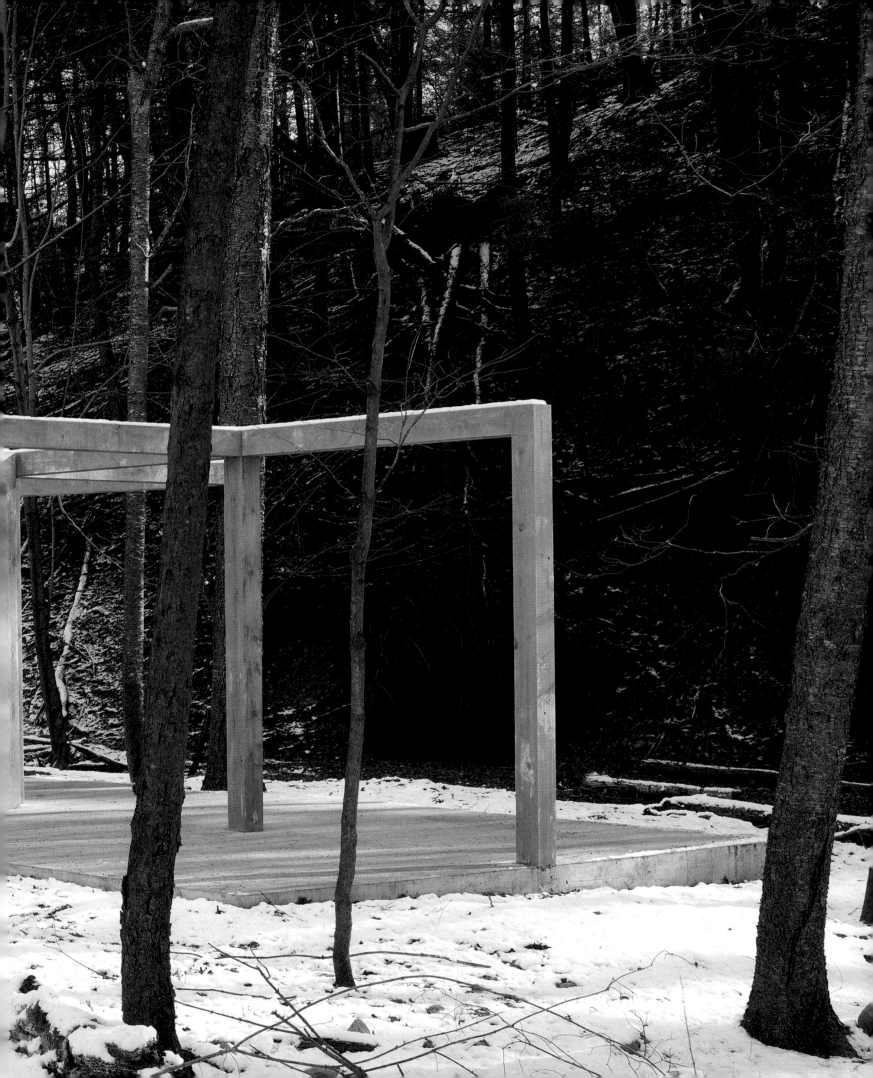

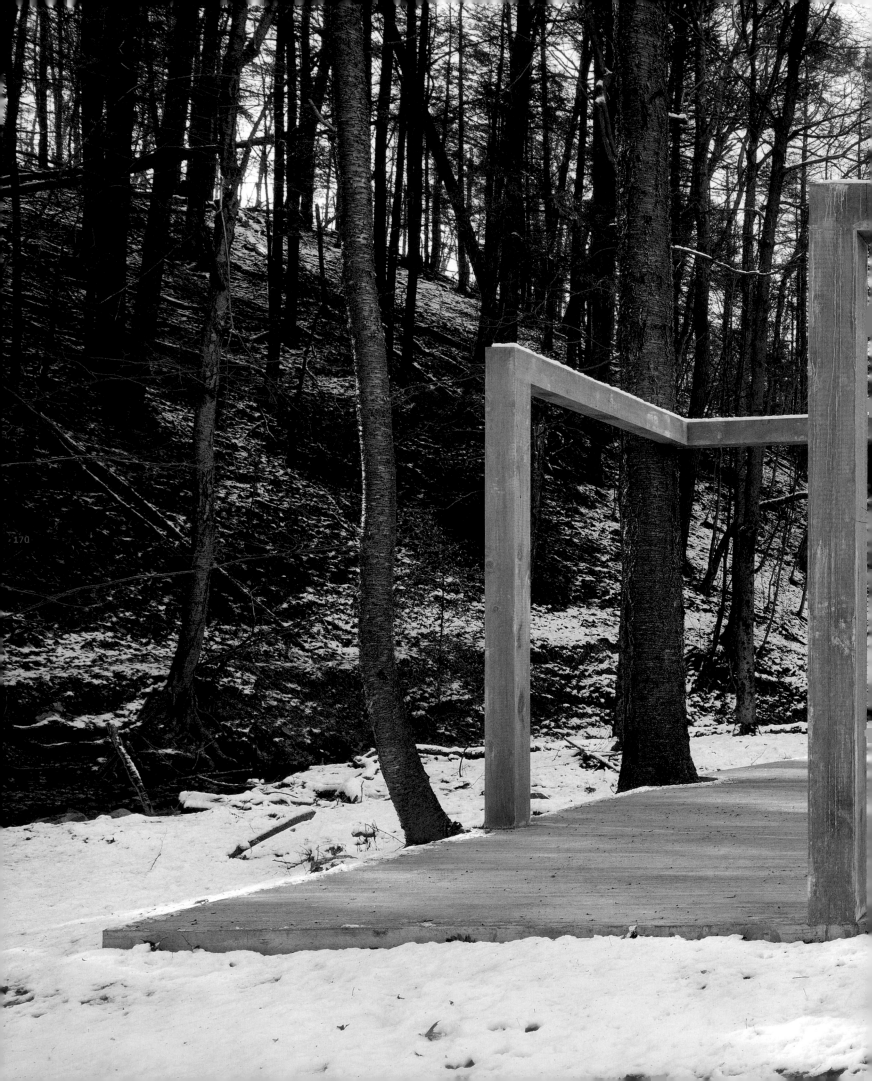

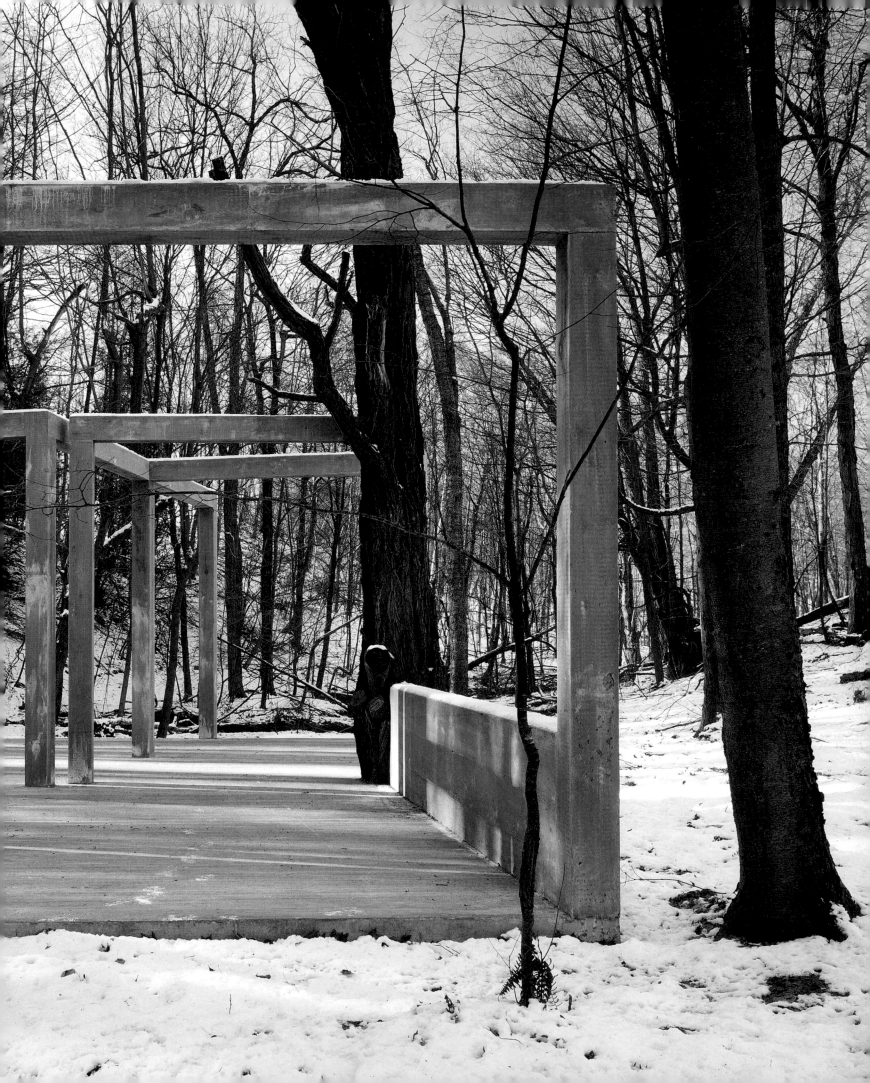

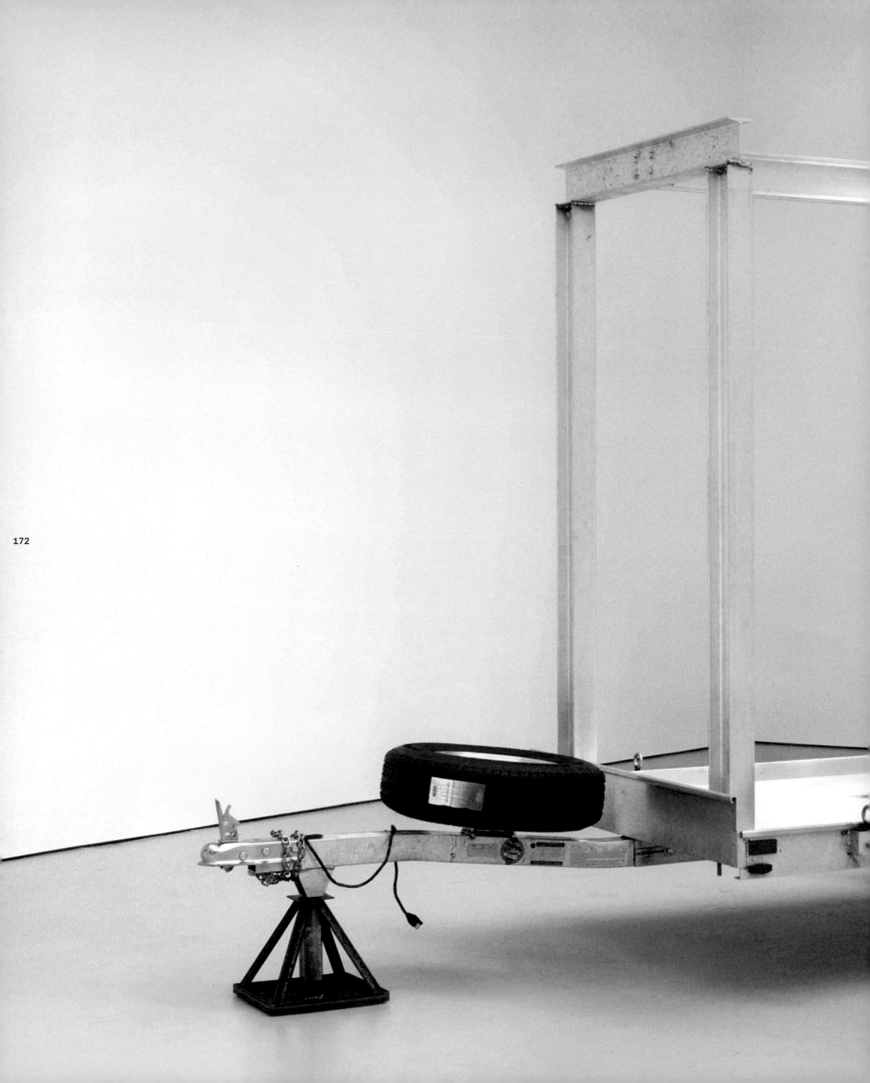

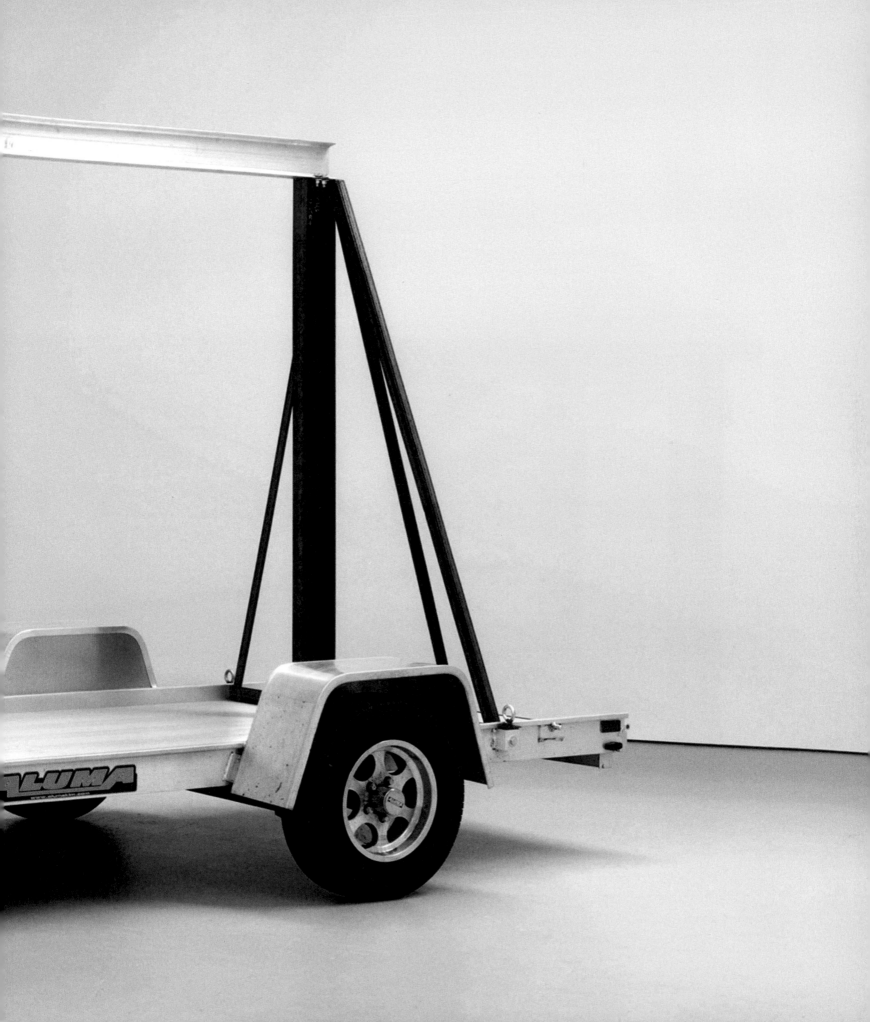

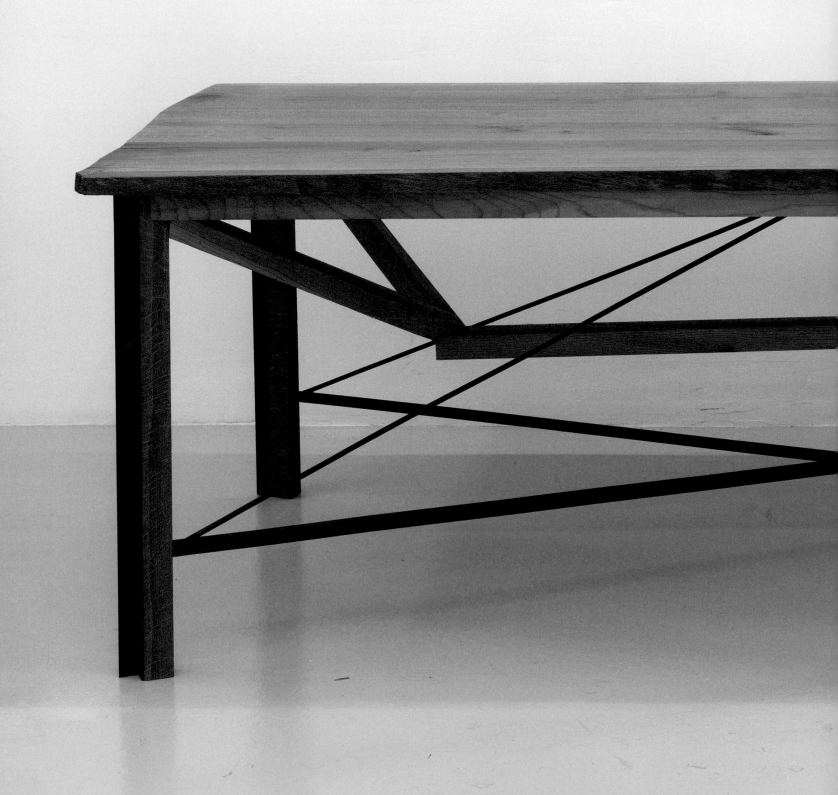

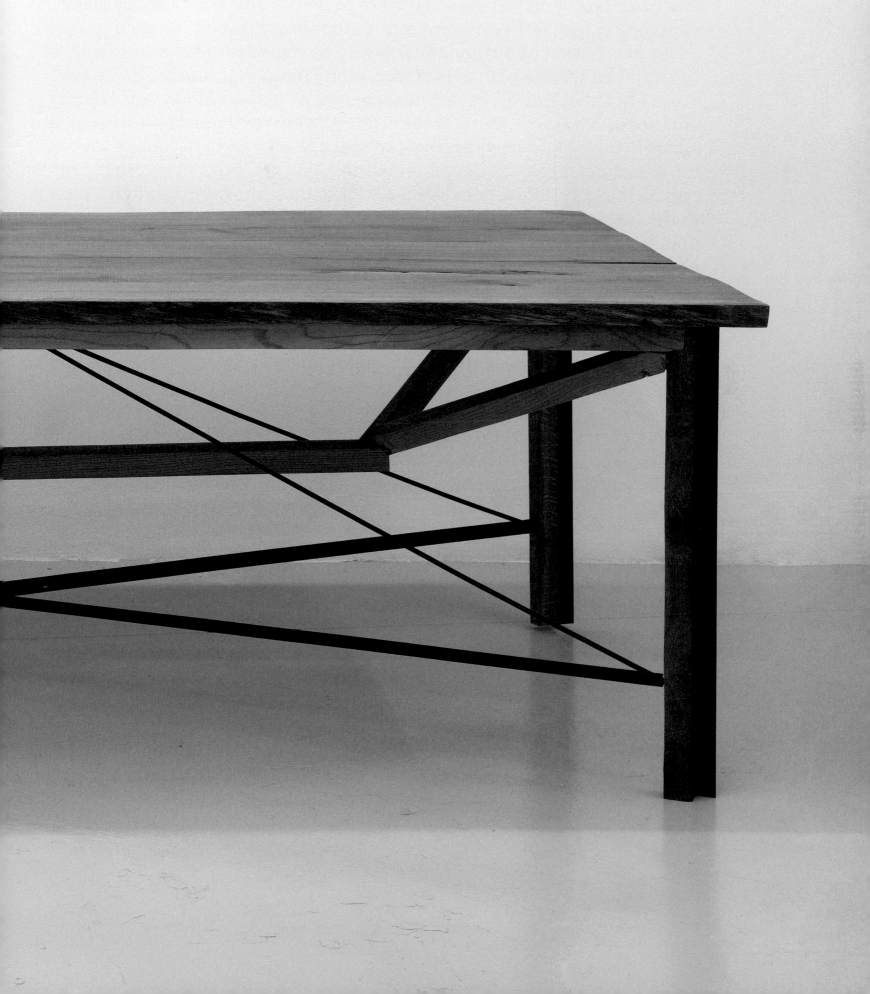

I'm not satisfied. Fuck this world. Even the chairs aren't any good. I want to make mine. I'm going to make you mine. It's not okay, it's not fine. The chair isn't fine. Why does it have to work? The world as it's been supplied to me isn't sufficient, not satisfactory, faulty. So as a person, as an expression of autonomy, it would be necessary to recreate all of the objects around you, everything, everything you touch, the chairs even. Fuck this table, it's not okay. I just get pissed at certain objects and need to destroy them. It feels good. When you get comfortable with a tool in your hand is when you can start to play with it, "make love to it." A real professional doesn't need to show off, but I'm not that and I do. Making a sculpture is using a tool to do something it wasn't meant to do. Using it after hours, fucking around. The object demands respect. Give it some respect. Submit. So that would mean opening a new way of being, a new mode of existence. Call it a lifestyle. A lifestyle as a kind of way of performing on the world. An object with a lifestyle. A way of living that transforms space.

Wet it till you can see through it. I get it wet and stare at it, run a hand over it and stand under it. I press my palm to it and tear it a bit, peer through it, stick a finger in it and oil it, grease it good. Grease on wood, grease on steel, oil on cloth, stain on brick, paint on skin, skin on wire, skin on wood, oil on the floor, sand on steel. A warm cock on ice. Standing on a silvery pier, standing there, I'm standing on a slivered burnt barge on a sea of ice, see if I care.

I'm warmed from within, that's what I am or what I've realized about myself. I'm a kind of cock, a warm half-hard erection, I'm a prick dancing on ice. A warm cock on ice. A pointless hard-on, a silver beacon, a buffed and shiny gland standing on my own. A soft bone, a nose bone. A nose without a face, a pink fish gasping for air, a drunk dick trying to stay upright, a fish wriggling on ice. A wet man wrapped in a damp cloth, a grease stain, a streak of rust, a warm bulge. I didn't ask for this, I'll say, but of course I did ask for it. Then what's a cum? I'm still waiting for that. A cum, a handful of warm cum mixed with spit. A hand full of it, a moist hair. A frozen blood puddle, a wet trickle, a full bottle of booze tilted on ice, some wet and unfortunate fucked thing, a tool that's been used and discarded, a flopped and drooping thing, bent and hanging loose.

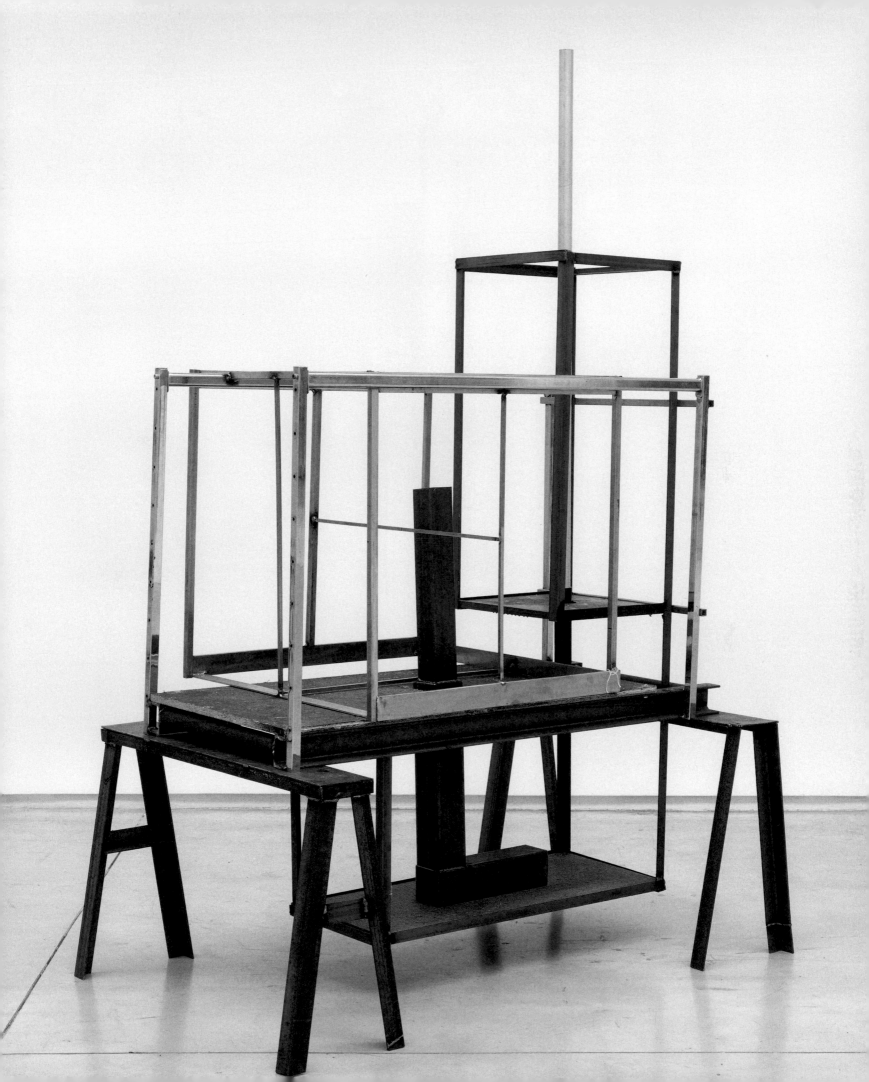

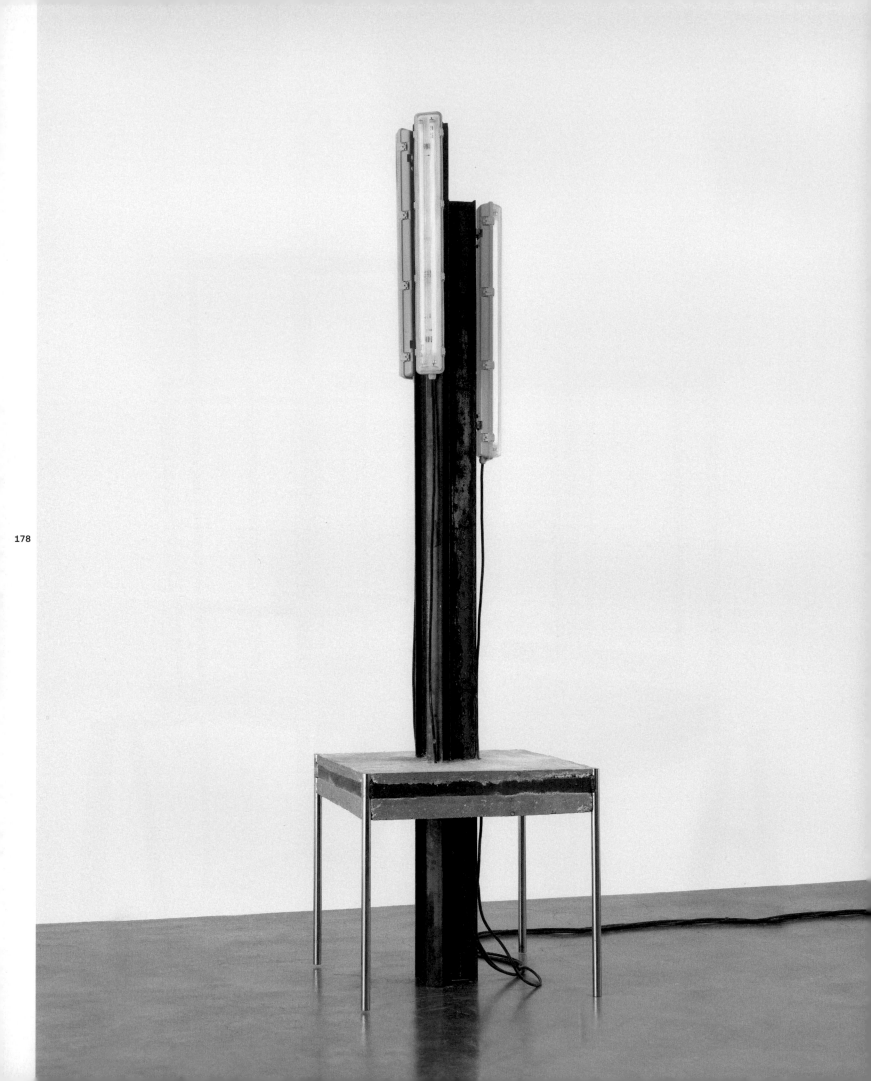

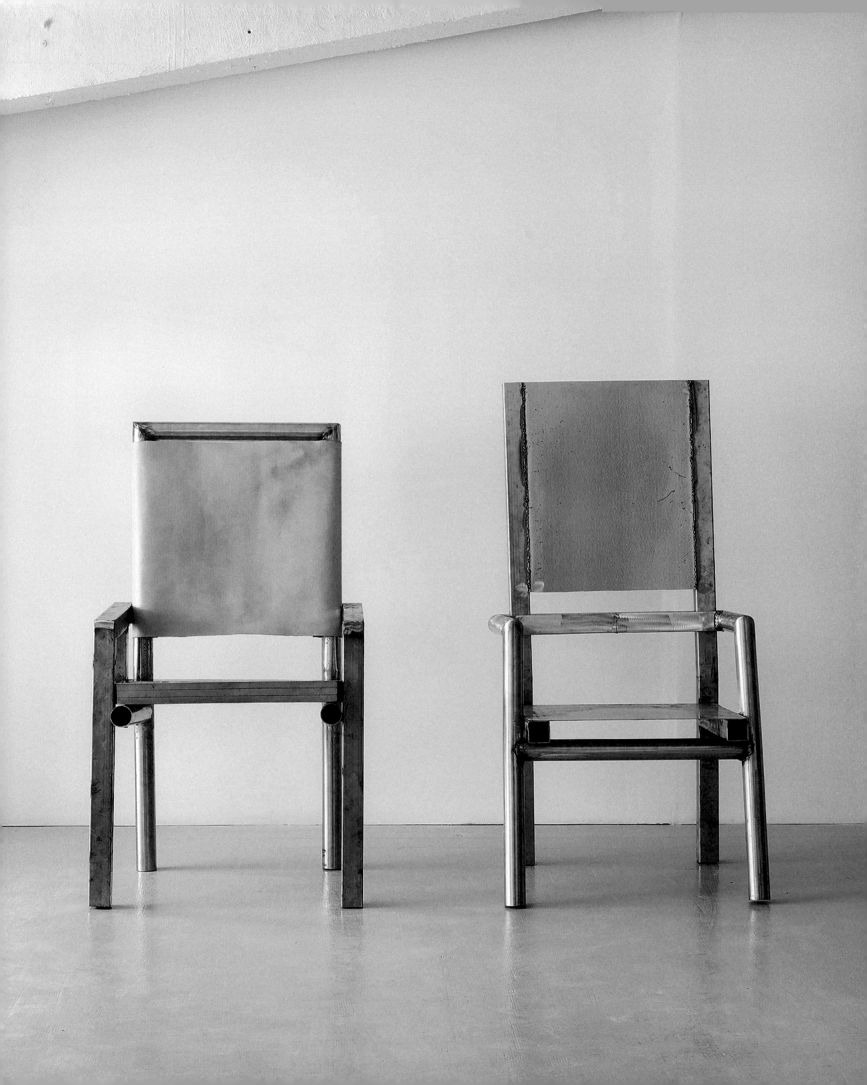

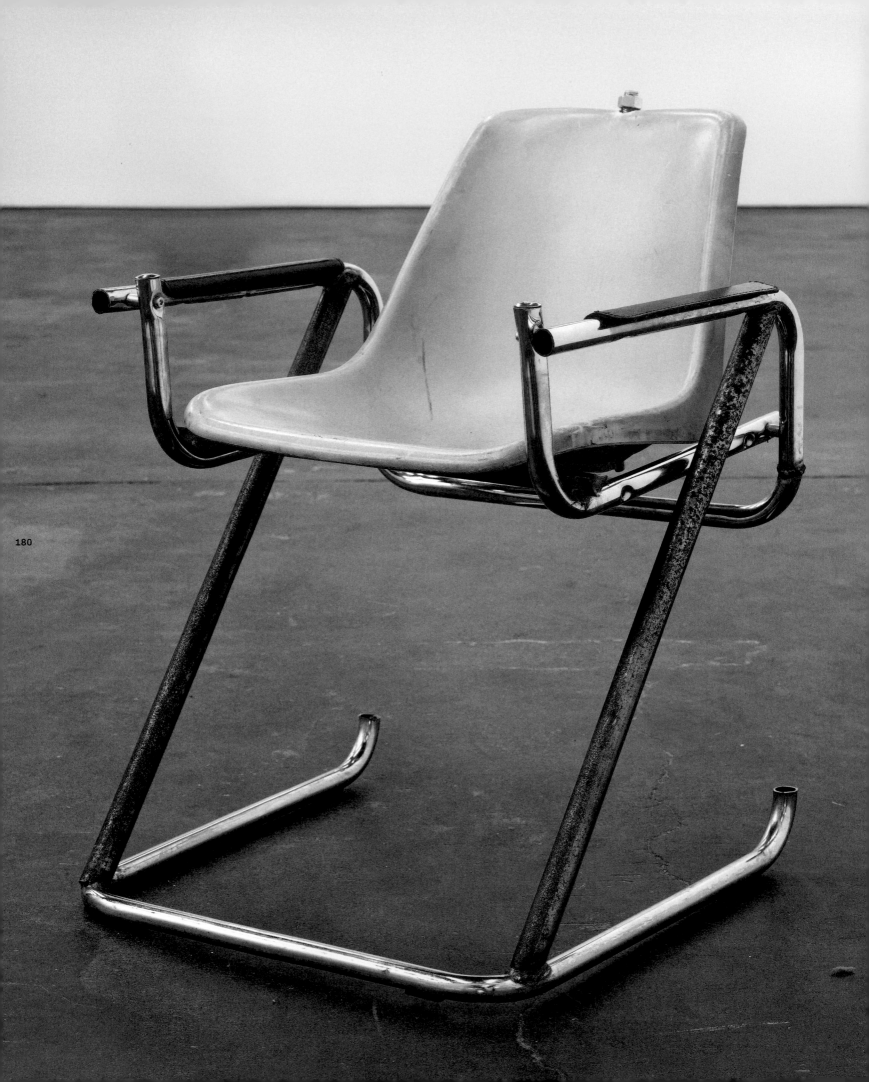

180

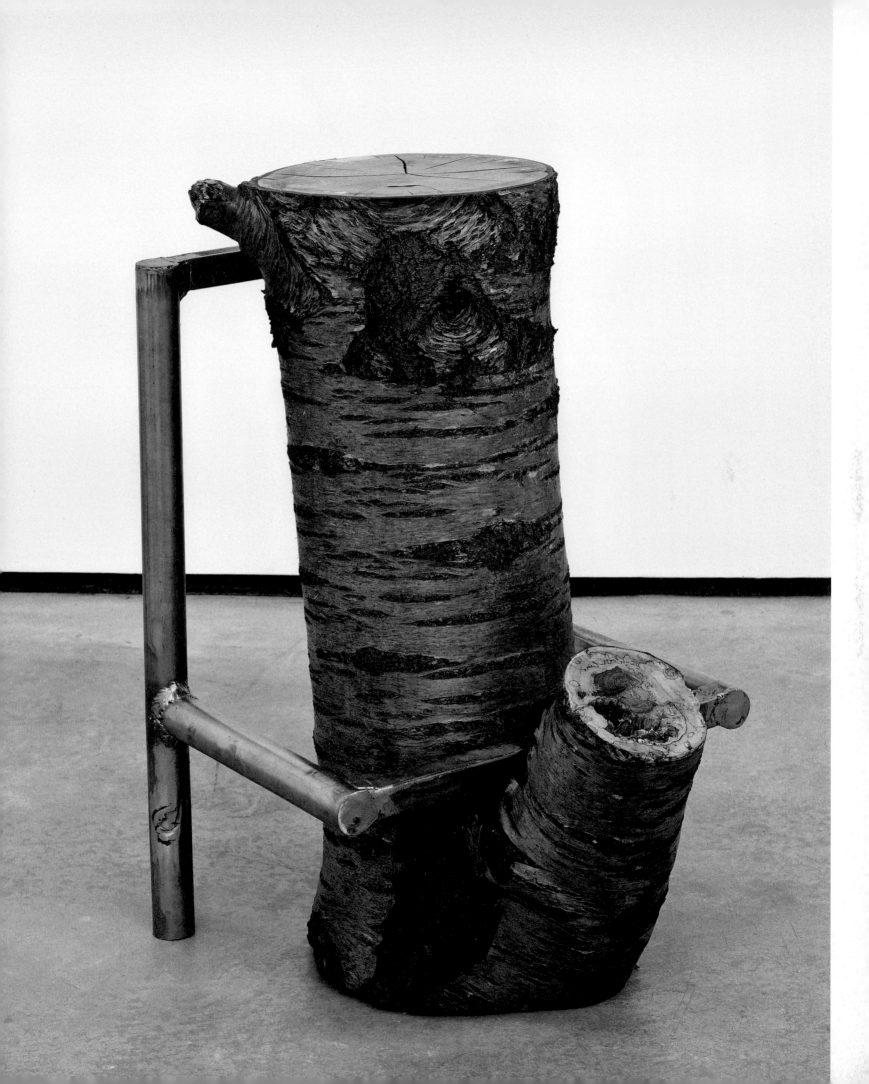

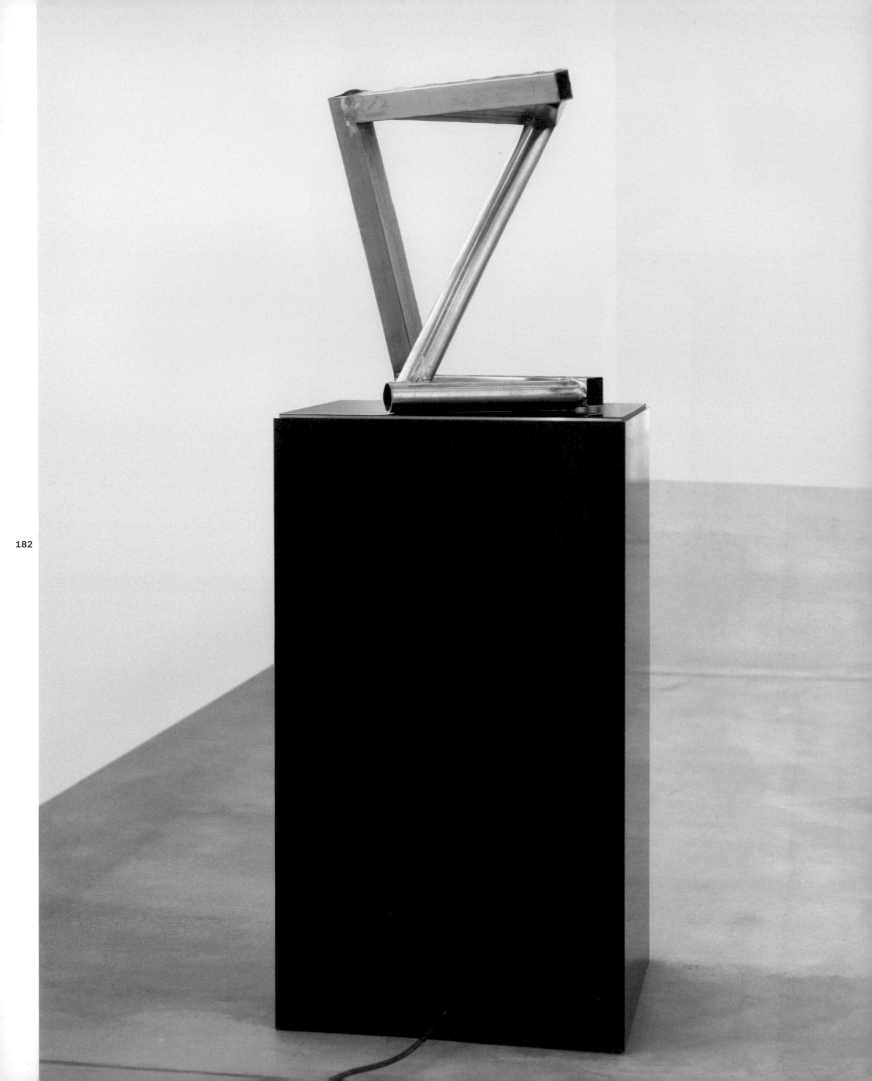

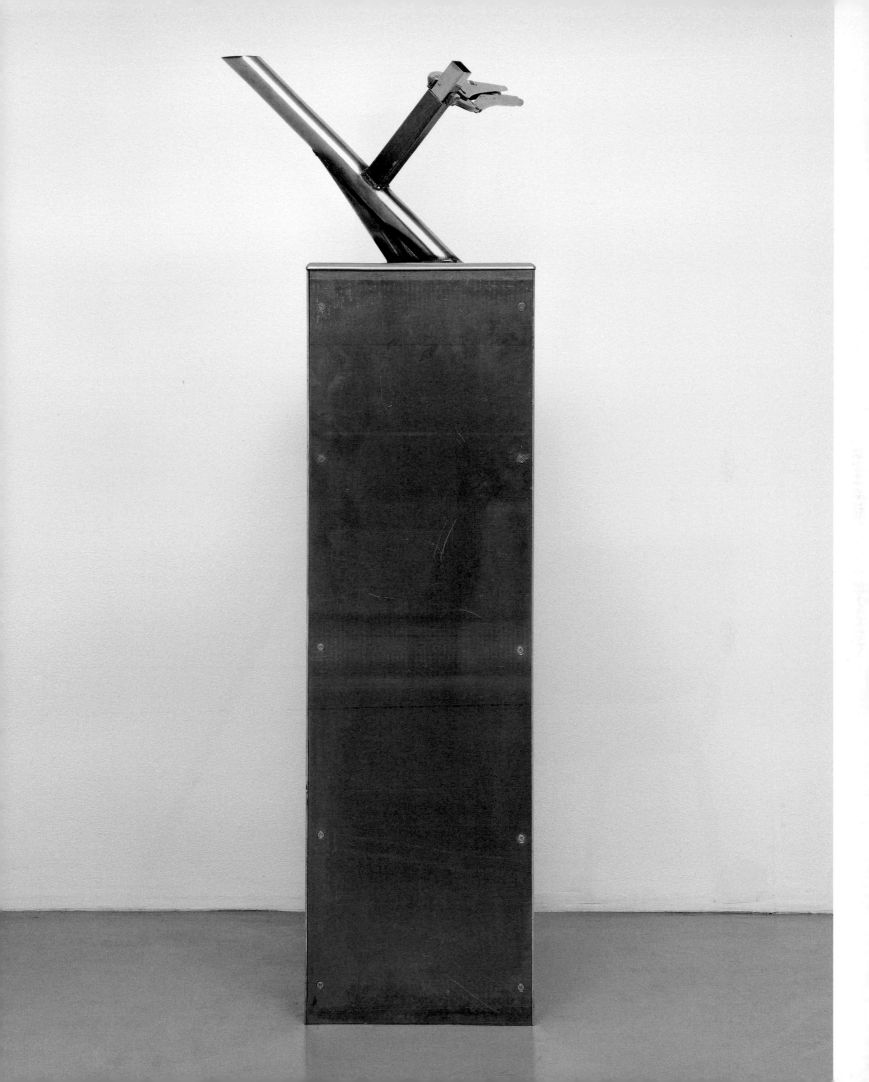

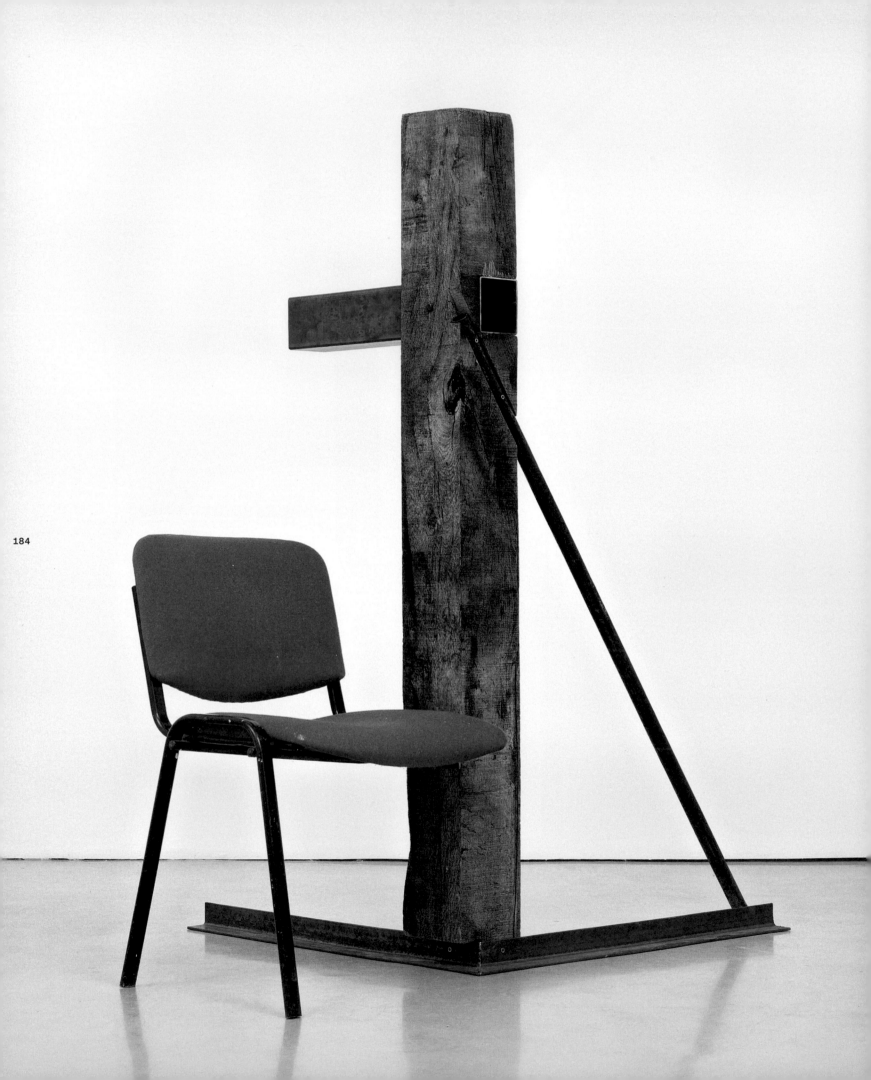

184

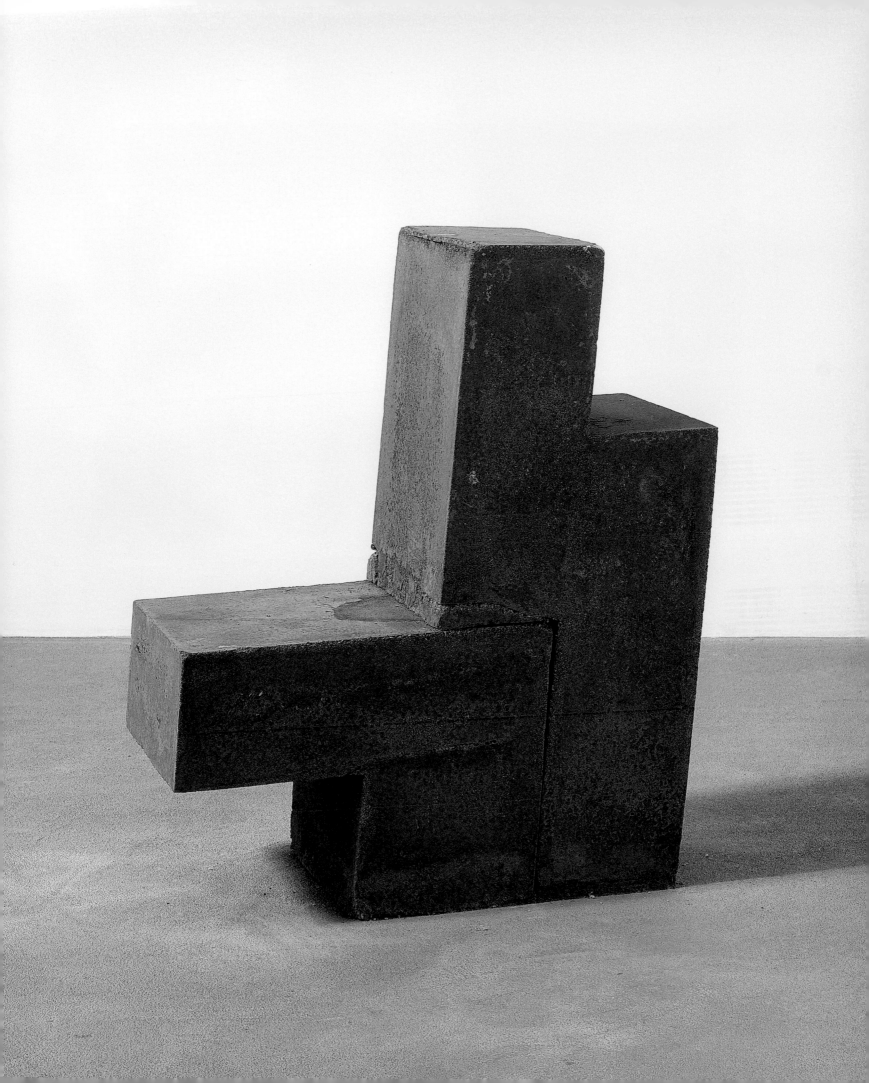

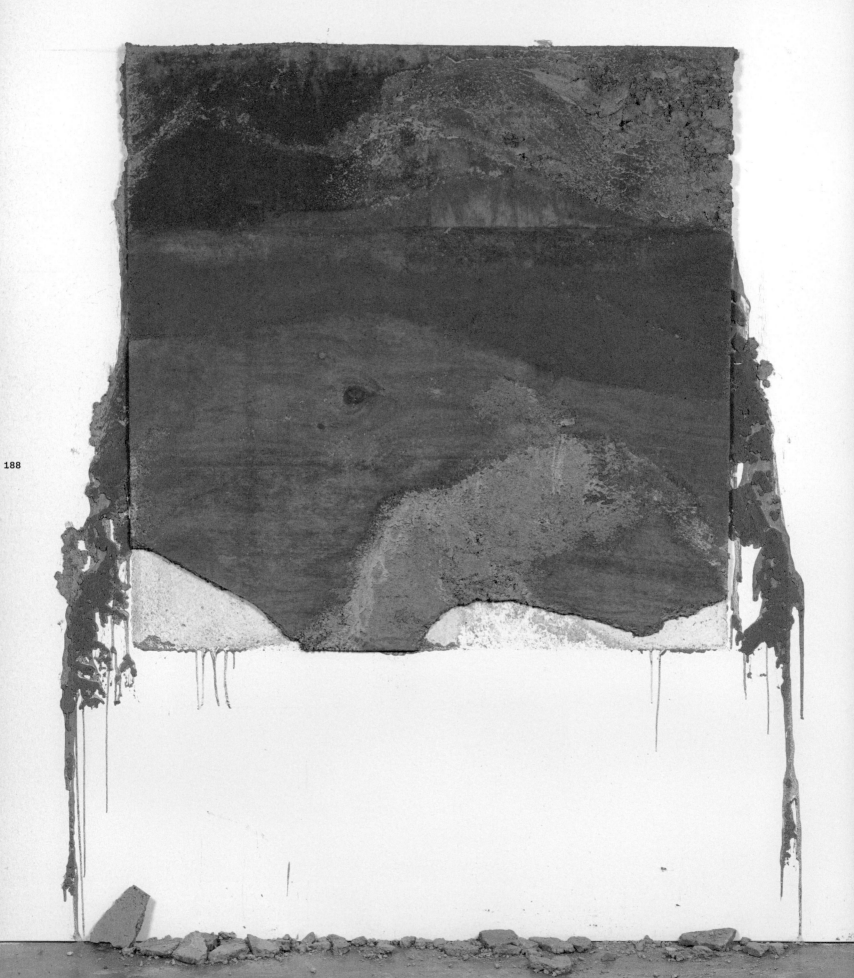

188

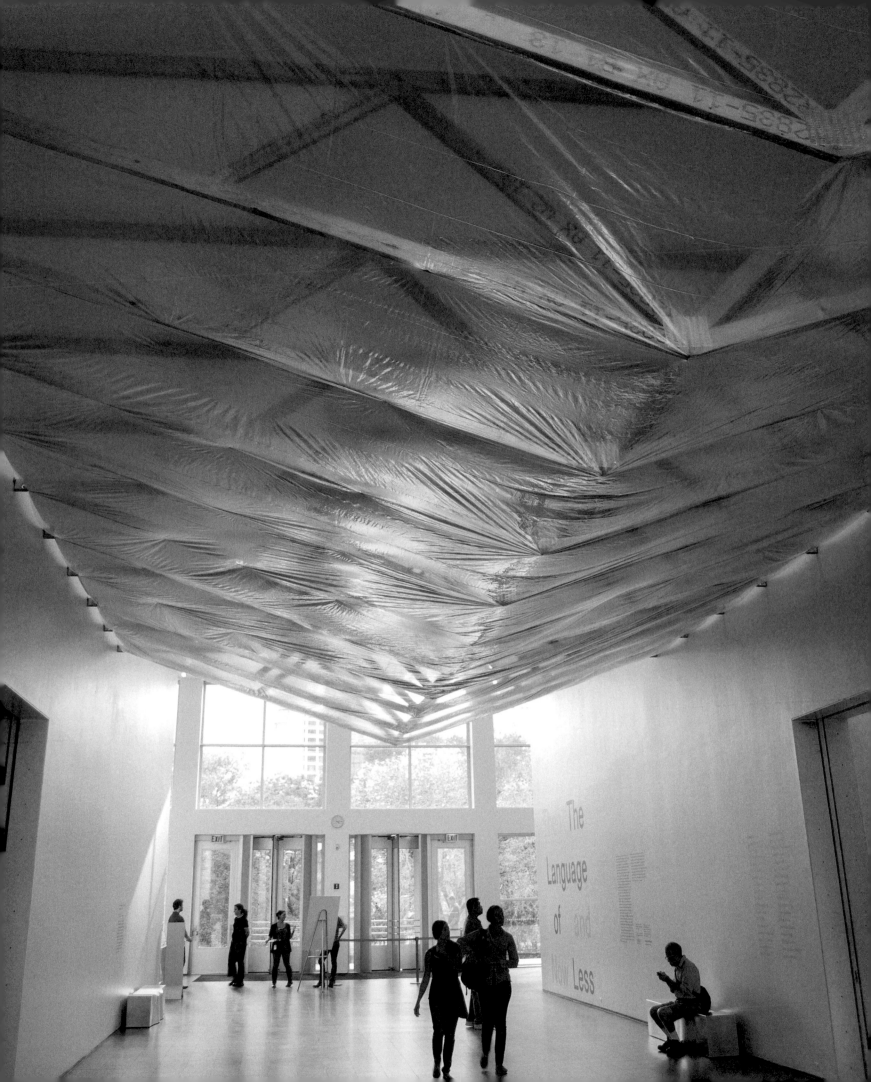

I got my name painted on my shirt / I ain't no ordinary dude, I don't have to work / I don't have to work. That's Waylon Jennings, singing about being an artist. Throughout his years at the top of the country charts in the mid 70s, Jennings kept coming back to the question of what kind of work it was he was doing. This kind of critique of the conditions of production was really the signature of what came to be known as "outlaw country." Jennings was a trained entertainer who had come up through the Nashville music industry, and it's funny to listen to the early albums, where you can really sense the dichotomy that existed between songwriters and entertainers. Guys like Jennings would just sing whatever it was the label asked them to, I guess. But it was Jennings who finally insisted on recording *Honky Tonk Heroes* with his own band rather than session musicians. The questions of what actually constituted artistic labor, and what kind of work an artist does, were really being played out at the time—not just in the music, but in the studio. Part of Jennings' genius as an entertainer was to embody the act of artistic creation as a kind of manual labor.

There's a freedom in doing a cover version, inhabiting someone else's work. I wanted to do a cover version of Glen Seator's *Approach*, a project he did in 1996. *Approach* is an exact replica of the façade and sidewalk outside the gallery inside the space of the exhibition. Seator was an artist who specialized in doing cover versions of reality. In the art world people call this "appropriation," but I don't think it's the same thing. Appropriation implies a bit of distance, it's a way of objectifying something. But a cover version is almost the opposite, a way of getting close to something you love. Seator's work, even the massive sculptural projects, was more performance than sculpture—replicas of spaces that don't exist anymore, mirrored spaces, this devastating idea that the surface of reality is replicable, just pure surface anyway. Dependent objects. It's impossible to replicate Glen Seator's work without him, he took it all with him.

The power of Jennings' performance on *Honky Tonk Heroes* isn't diminished by the fact that this intensely personal, declarative album is in fact an album of cover songs. Every song on the album from start to finish had been written by Billy Joe Shaver. Finally Jennings just became a cover version of Billy Joe Shaver. Billy Joe Shaver eventually ended up recording his own version of the album, you can't really tell if he's covering Waylon Jennings or himself.

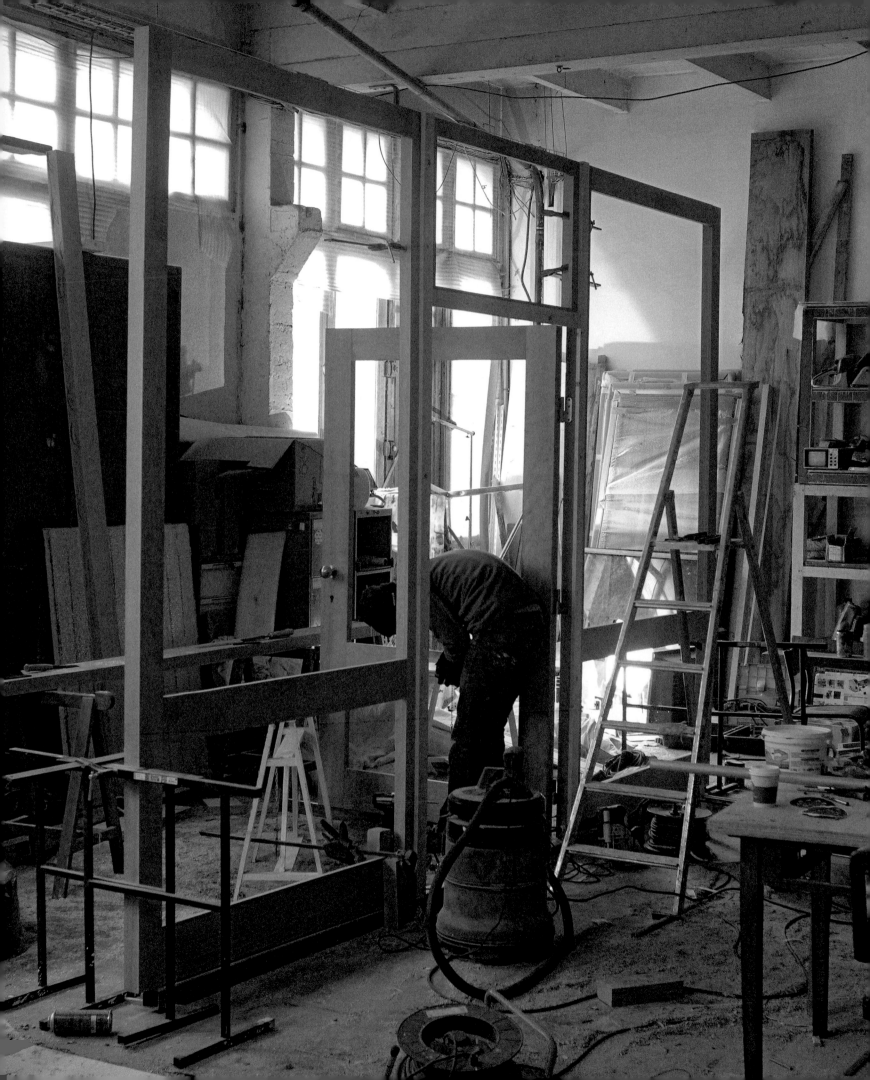

192

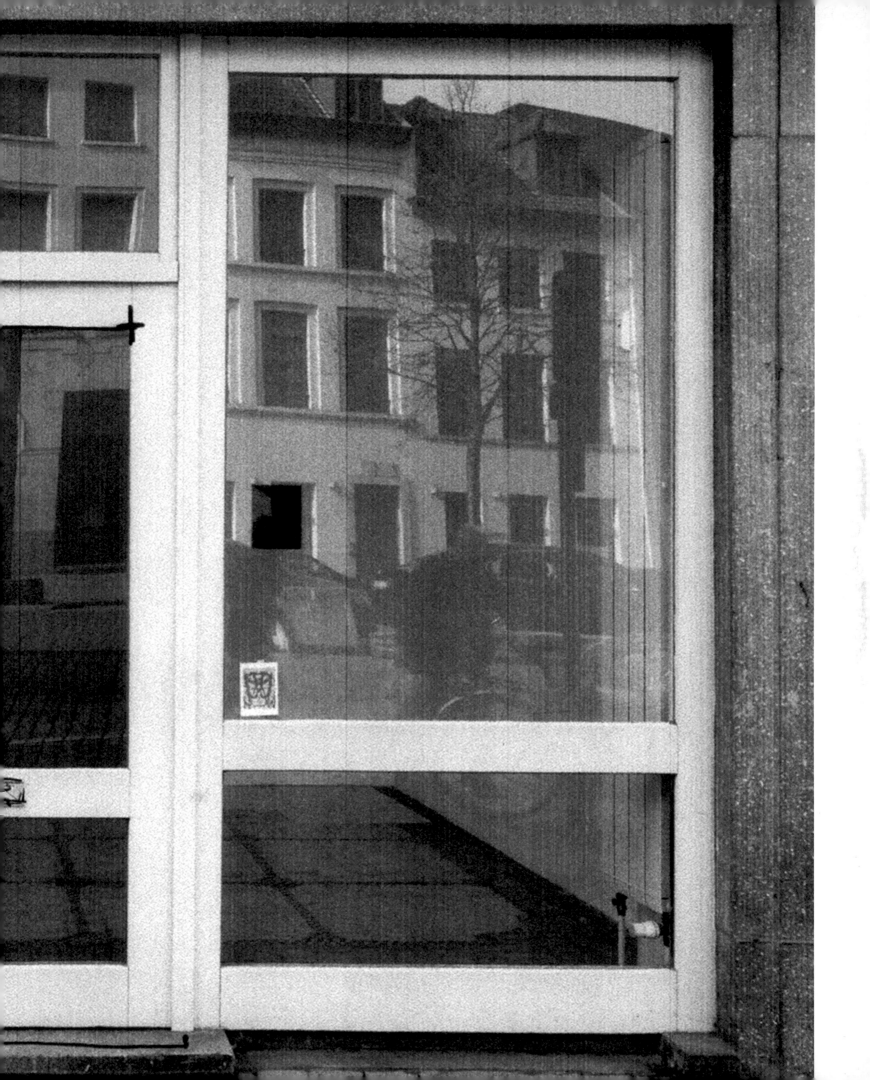

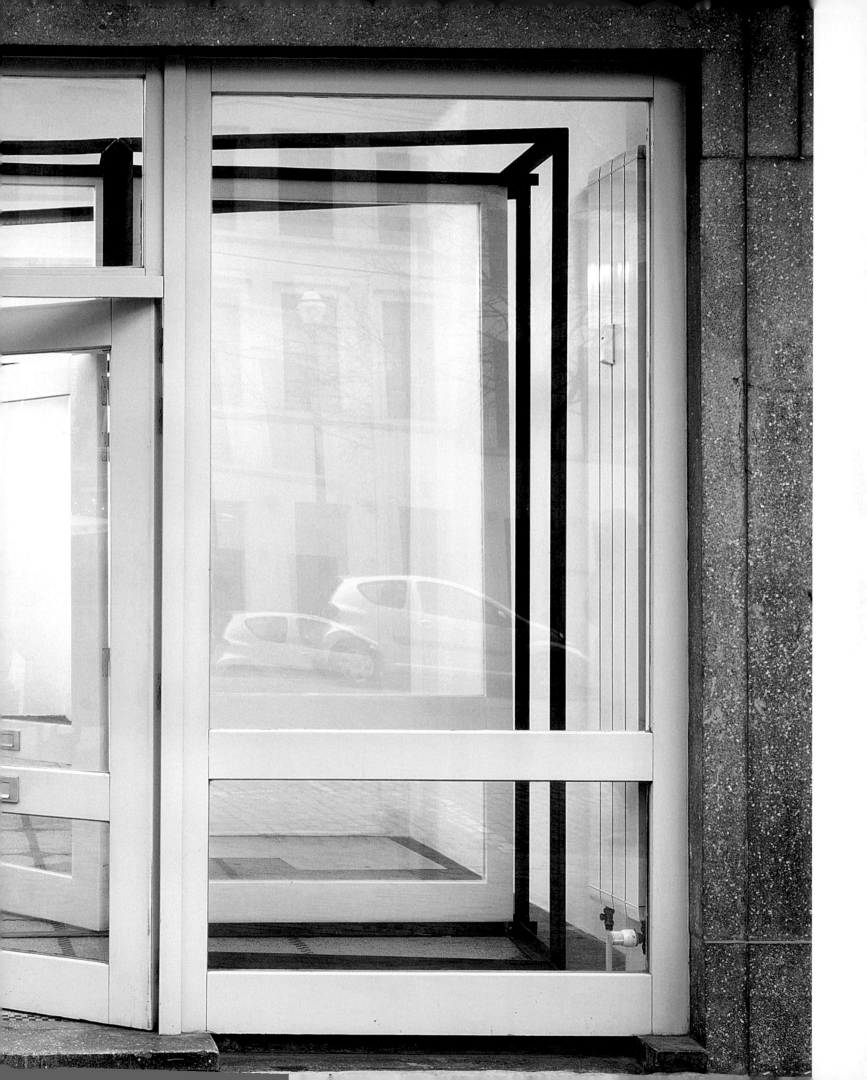

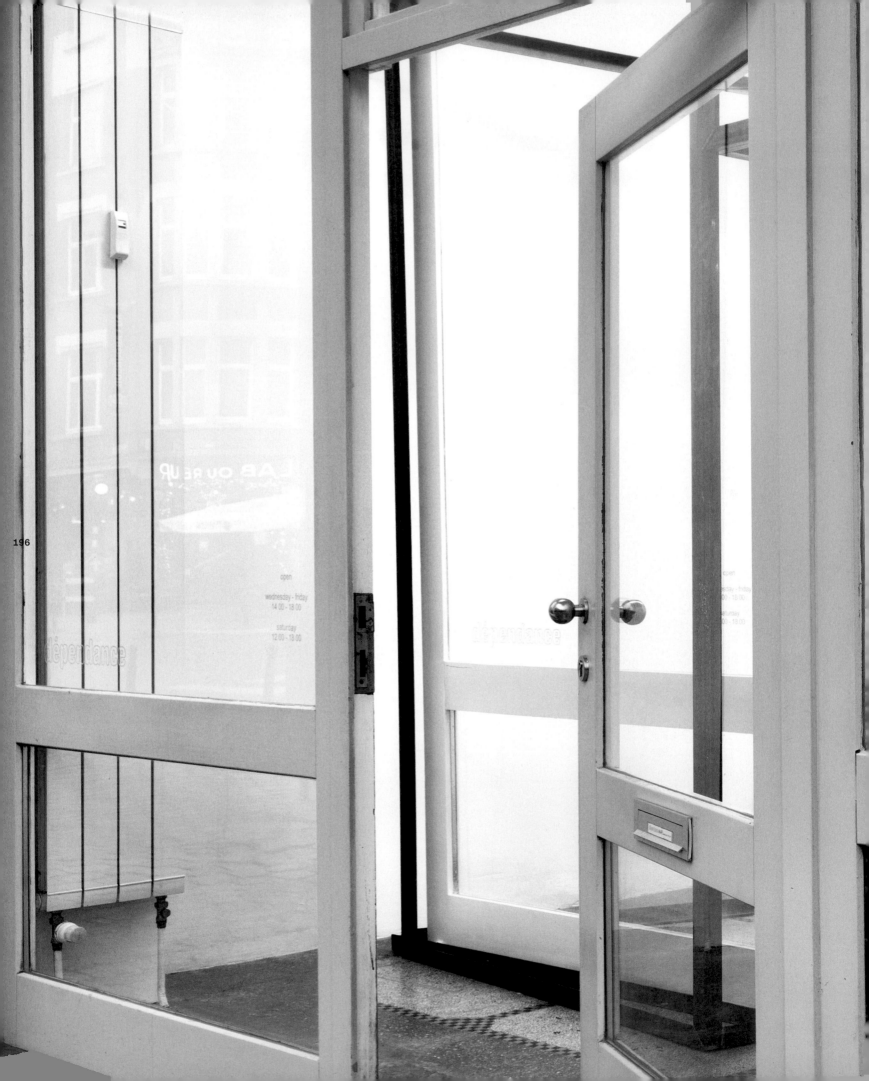

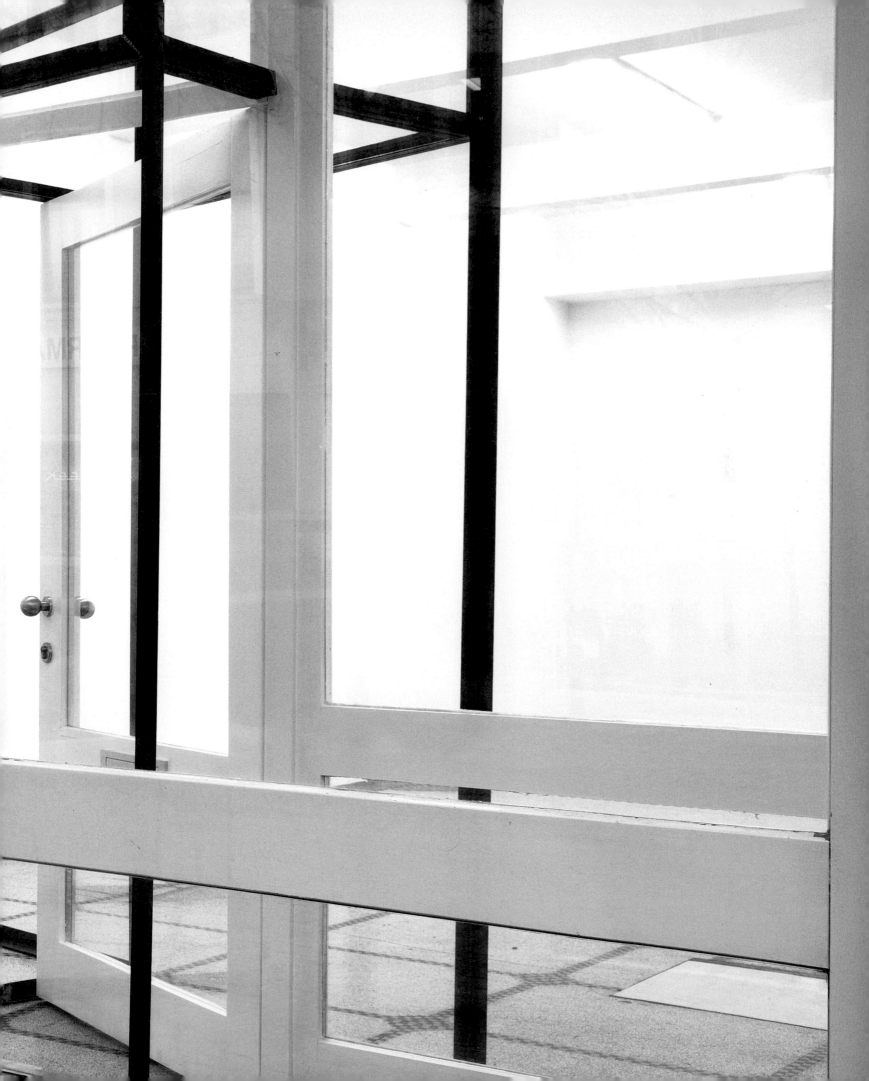

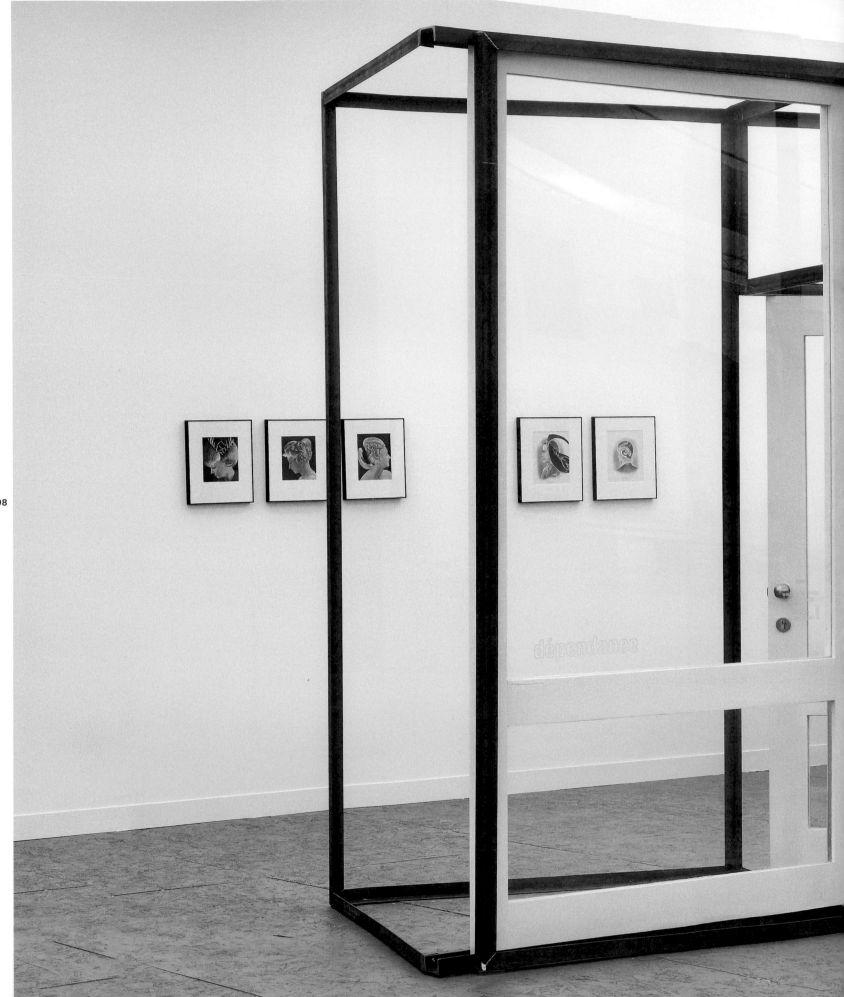

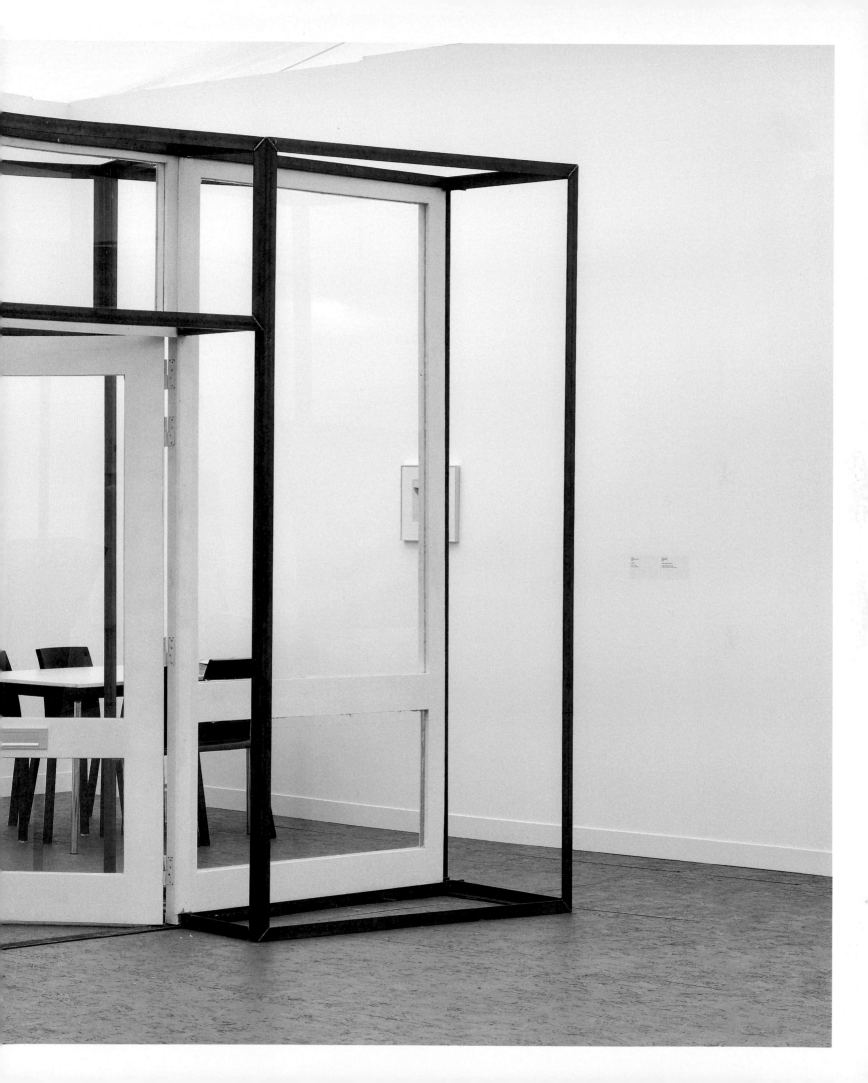

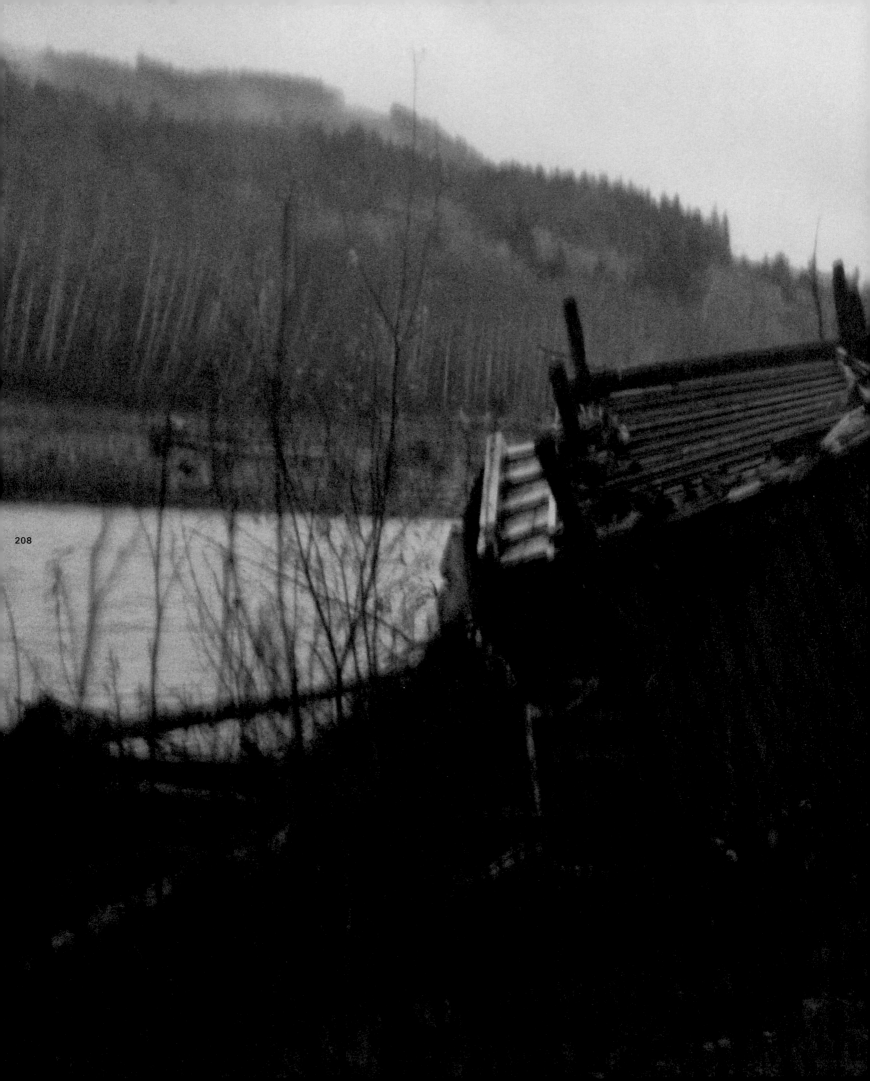

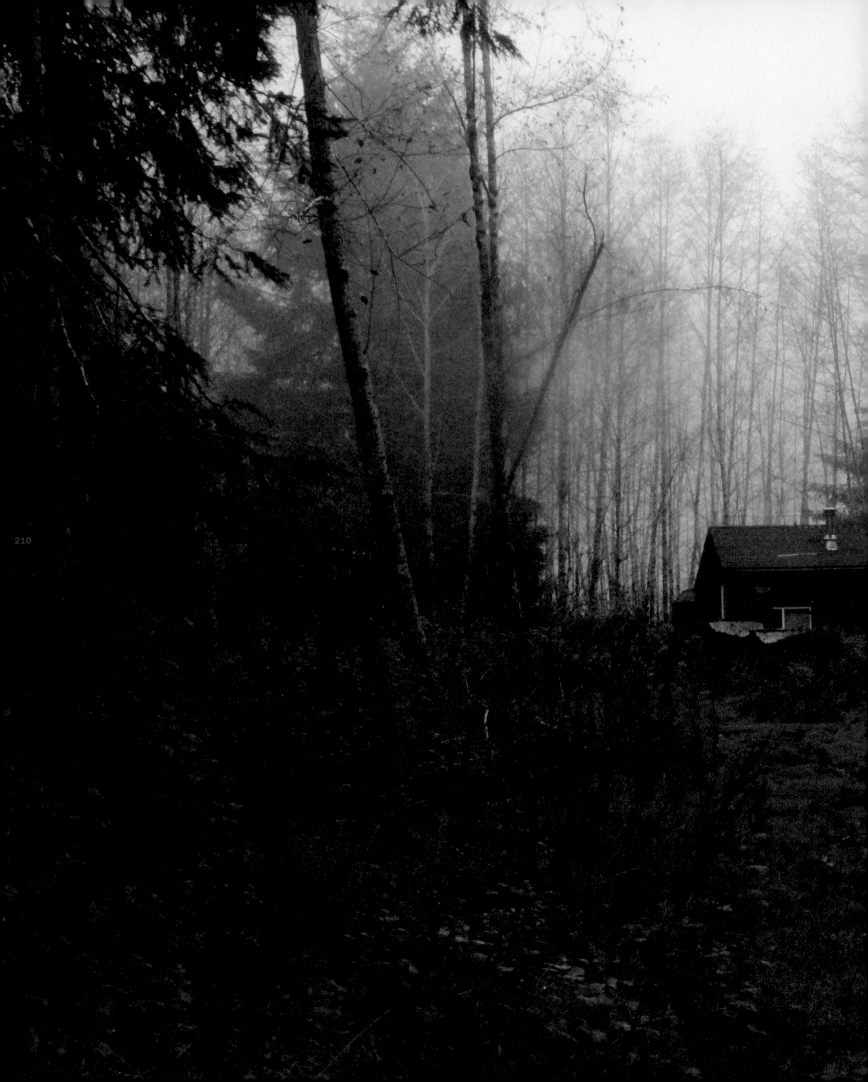

210

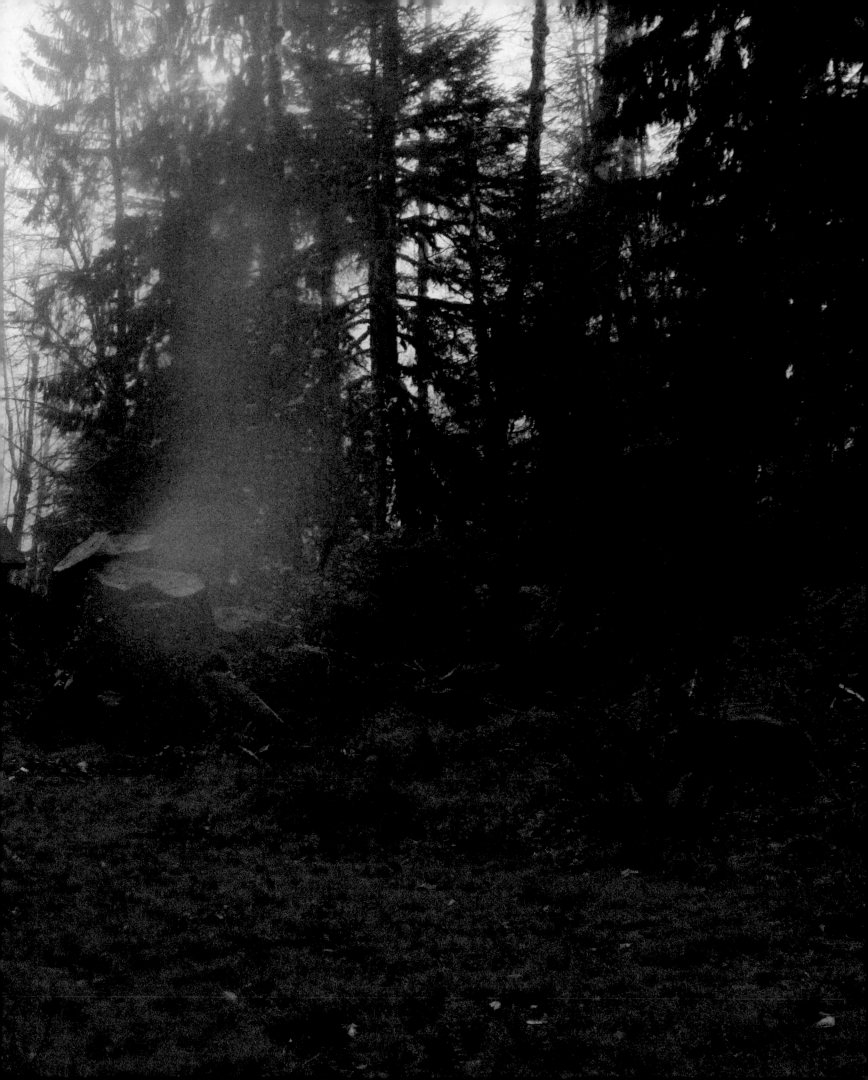

212

214

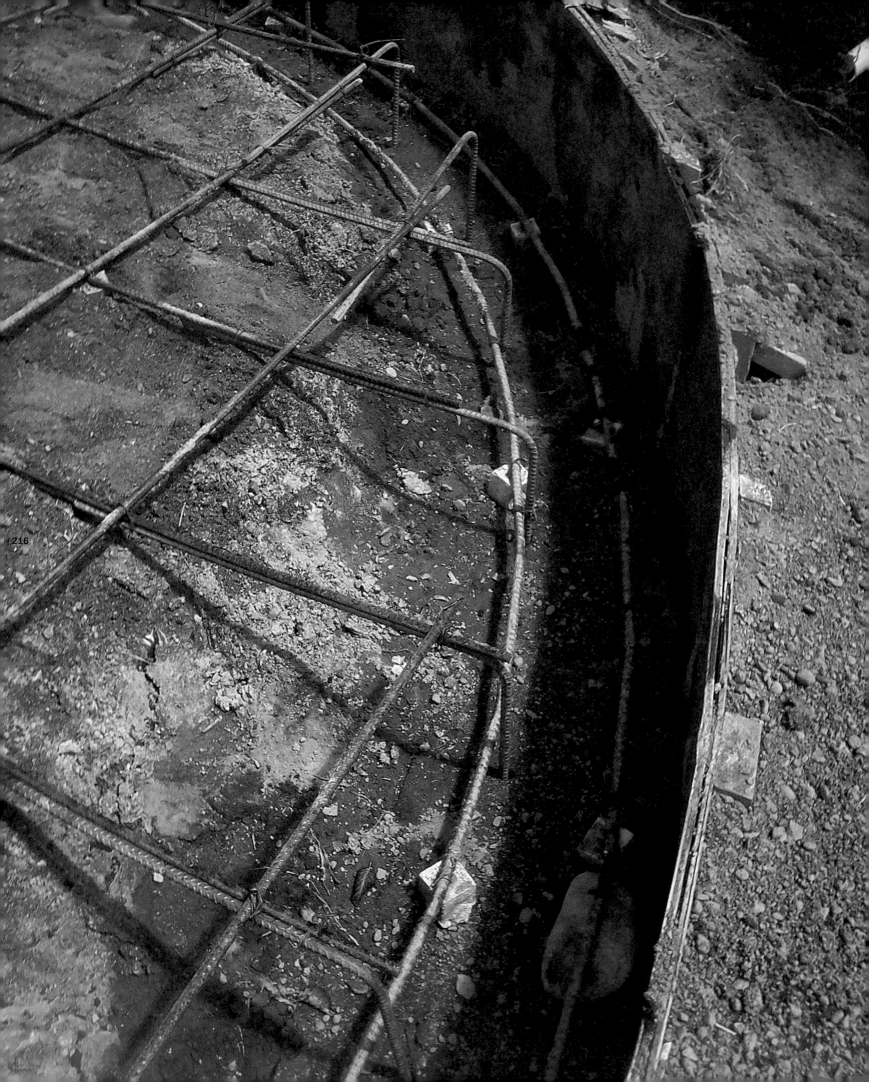

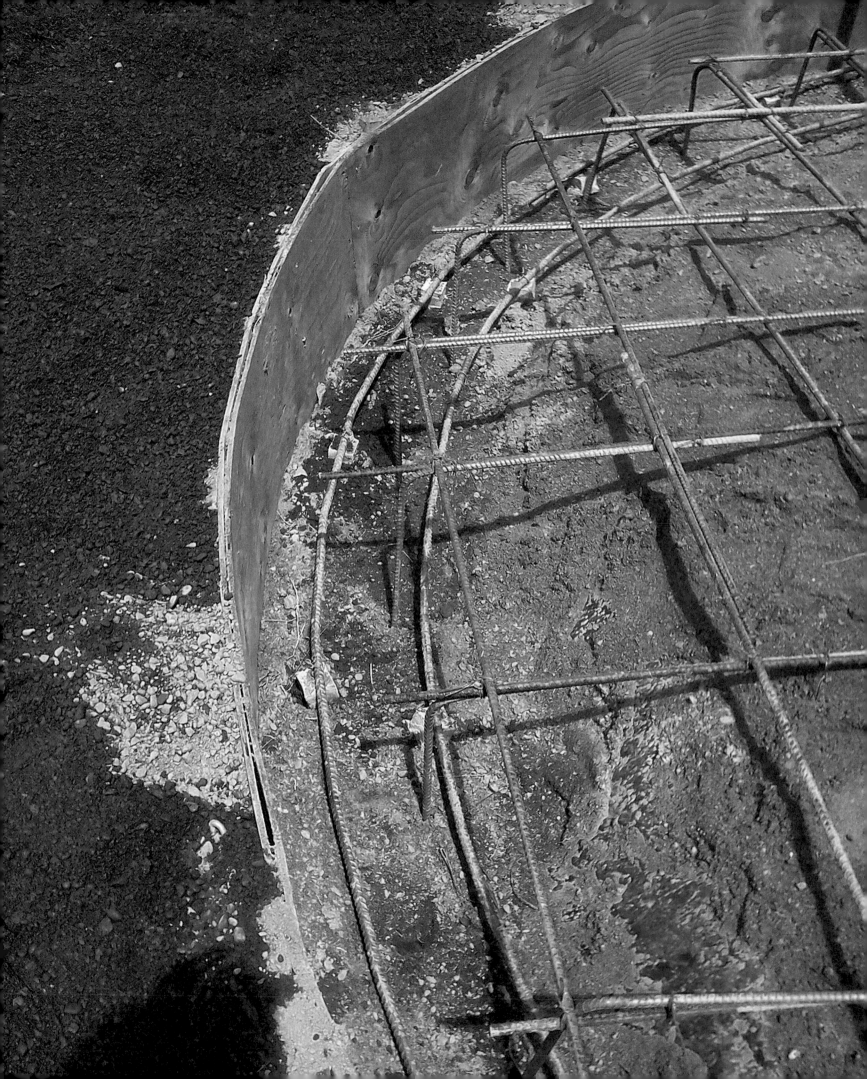

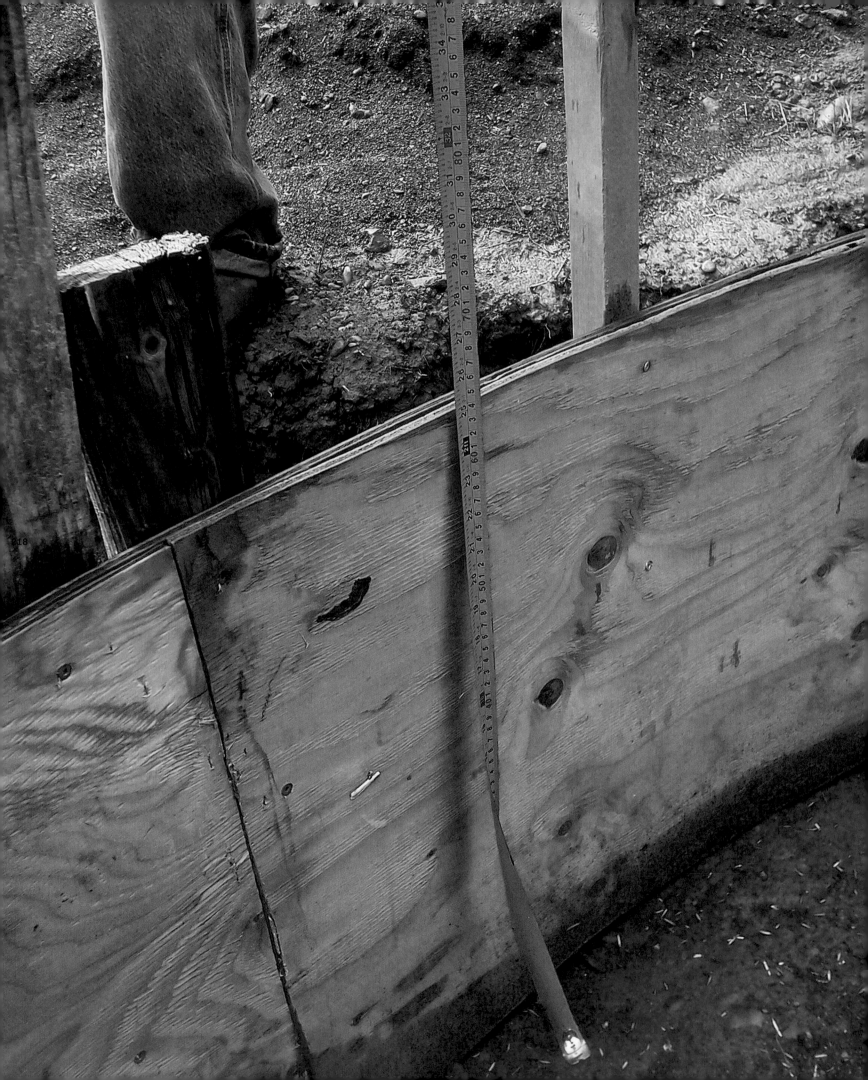

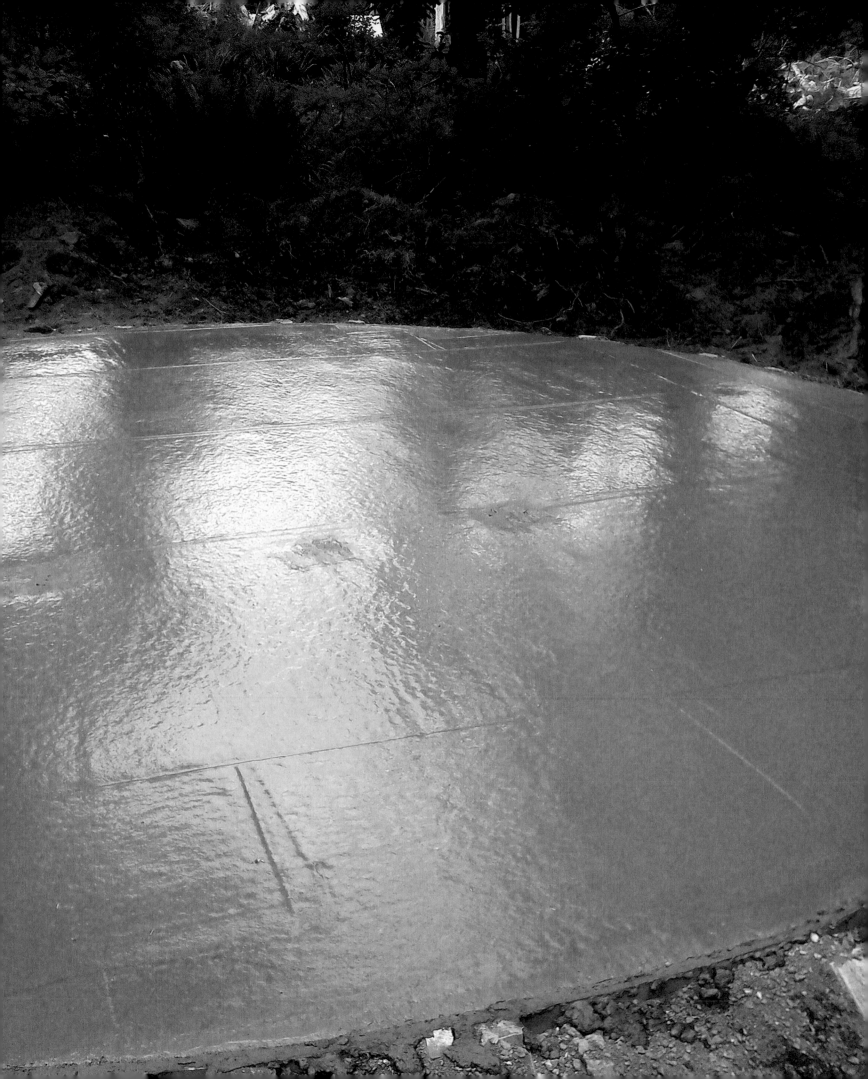

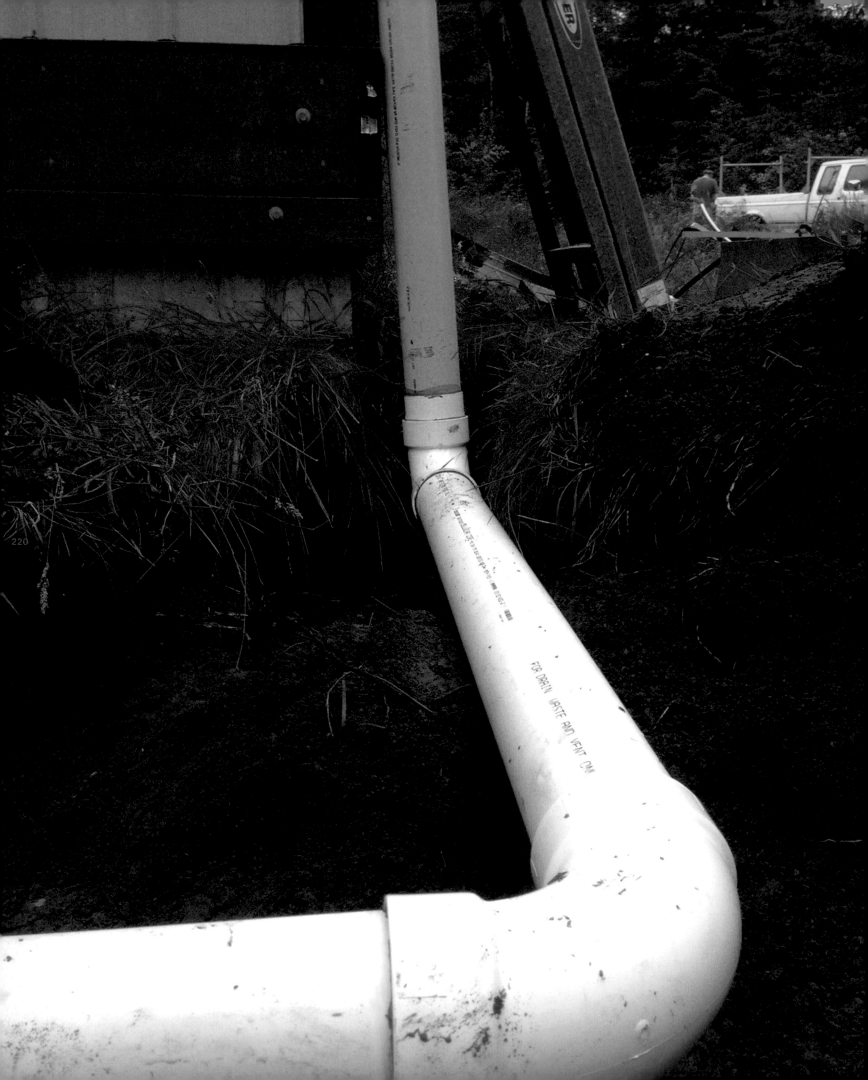

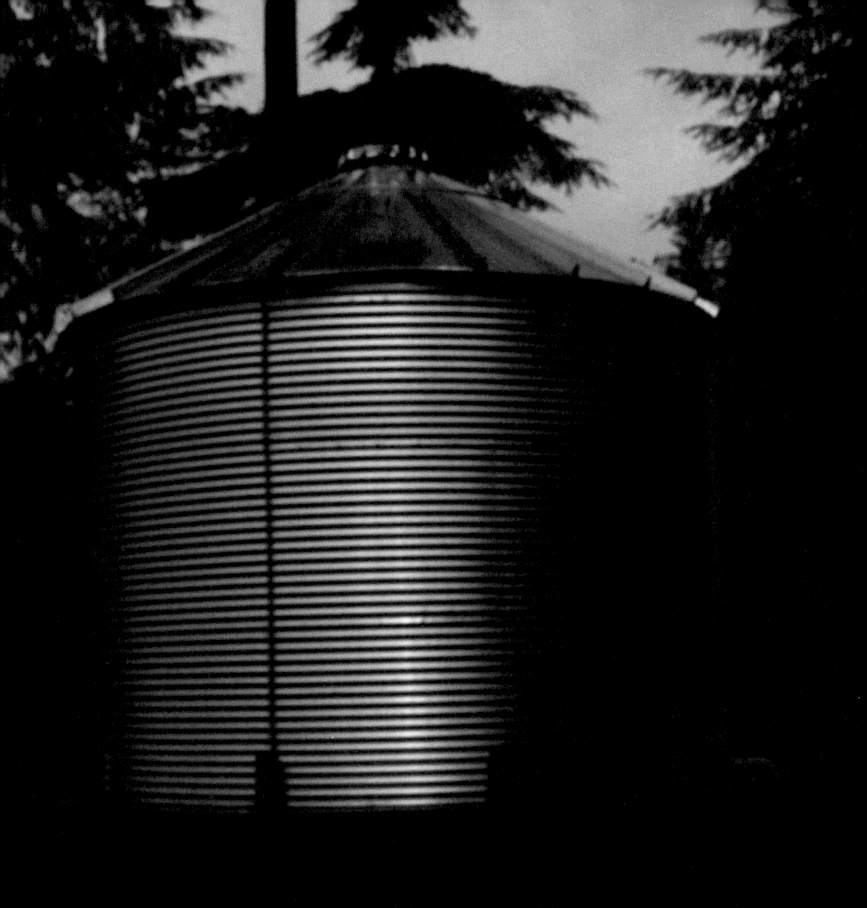

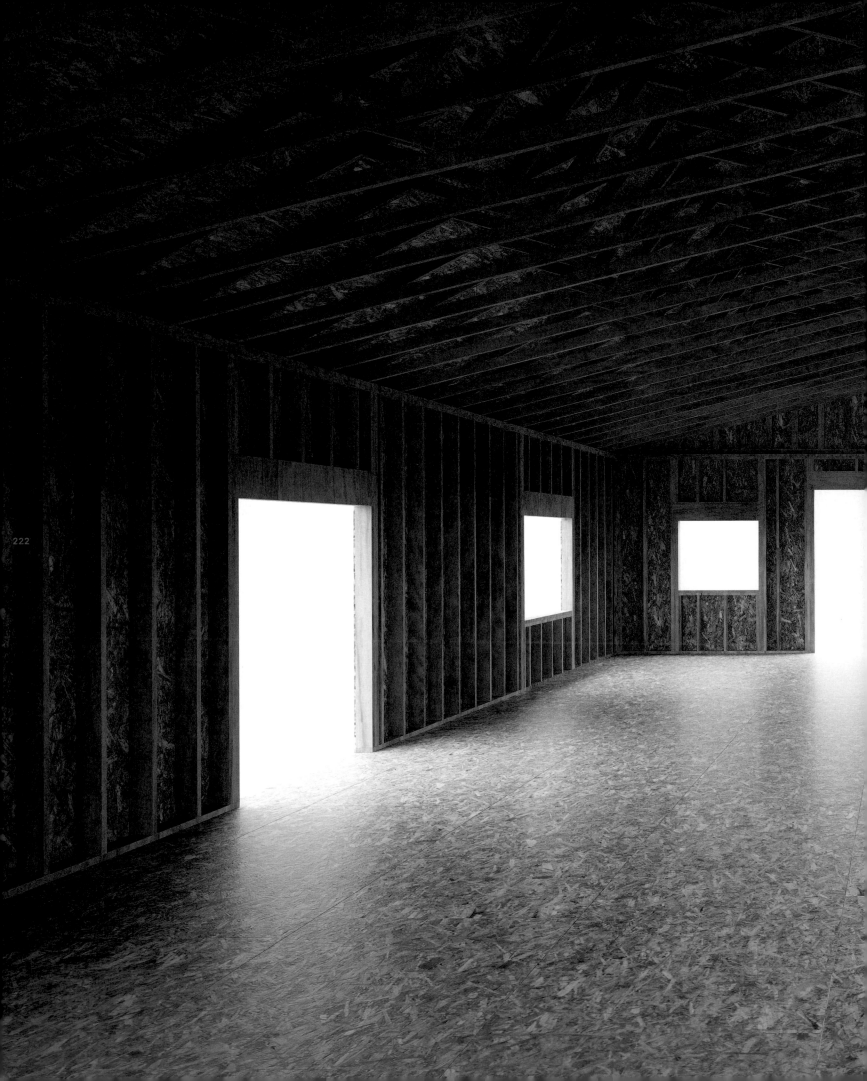

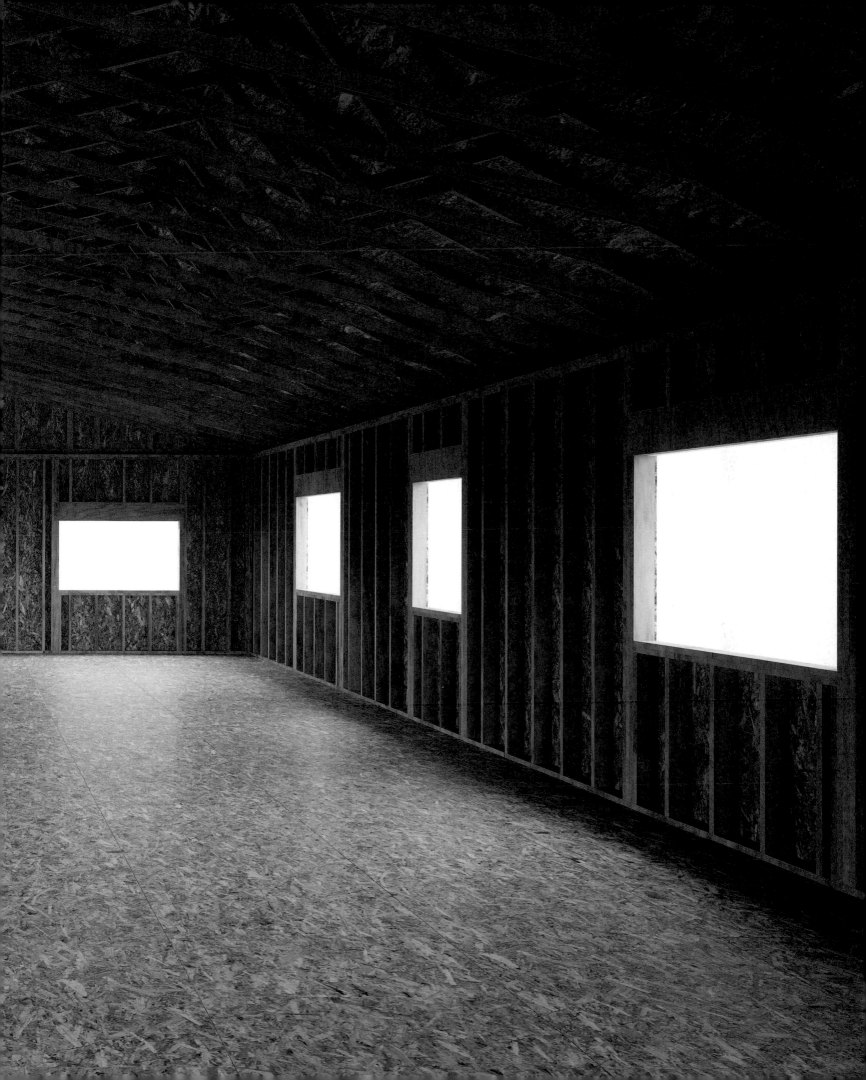

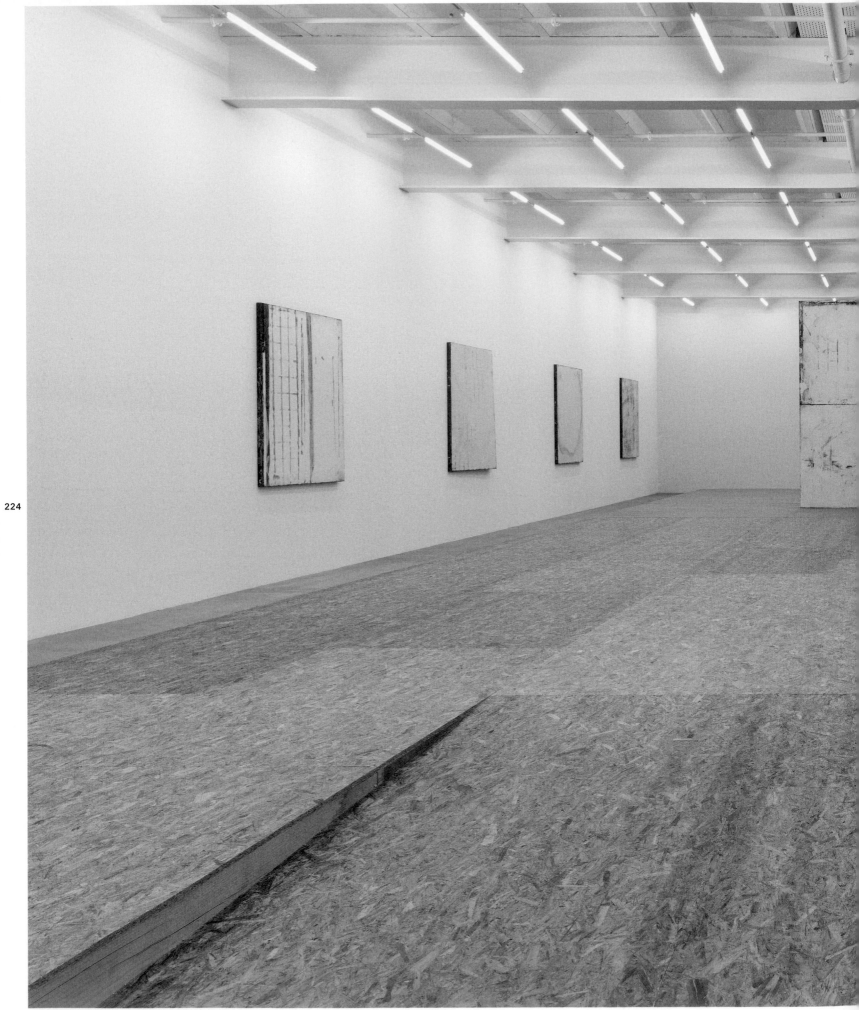

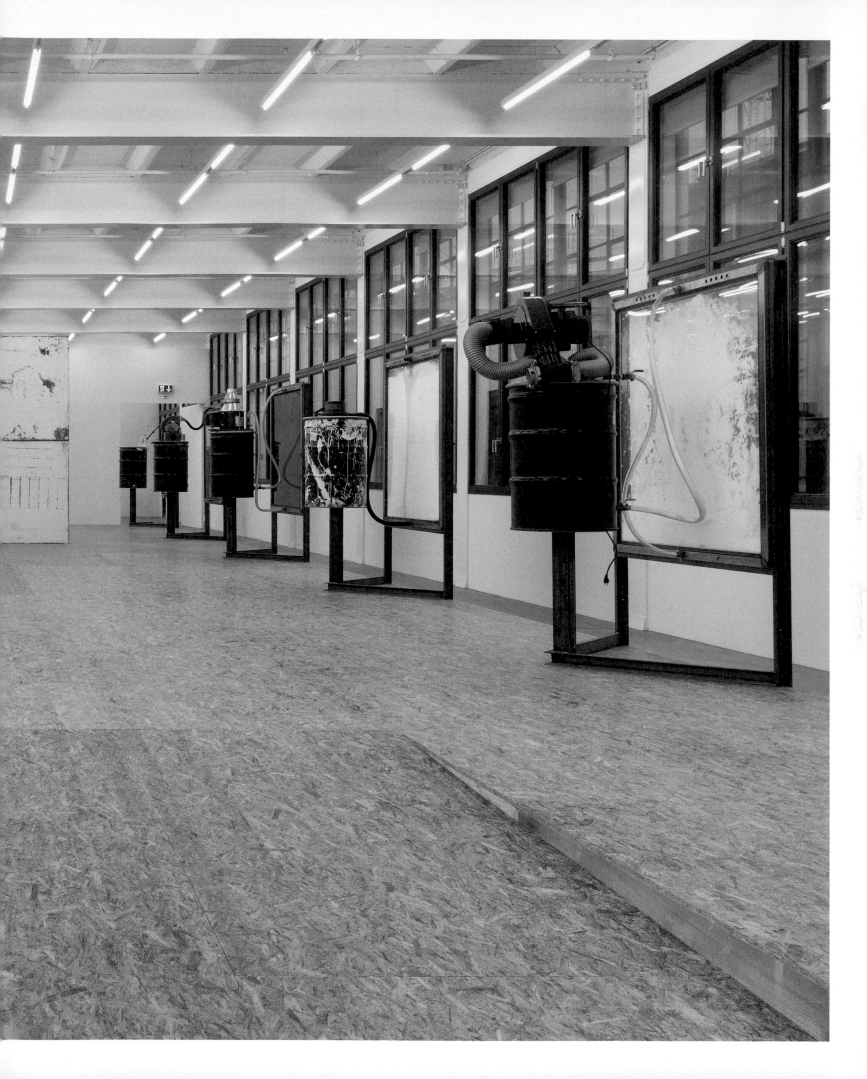

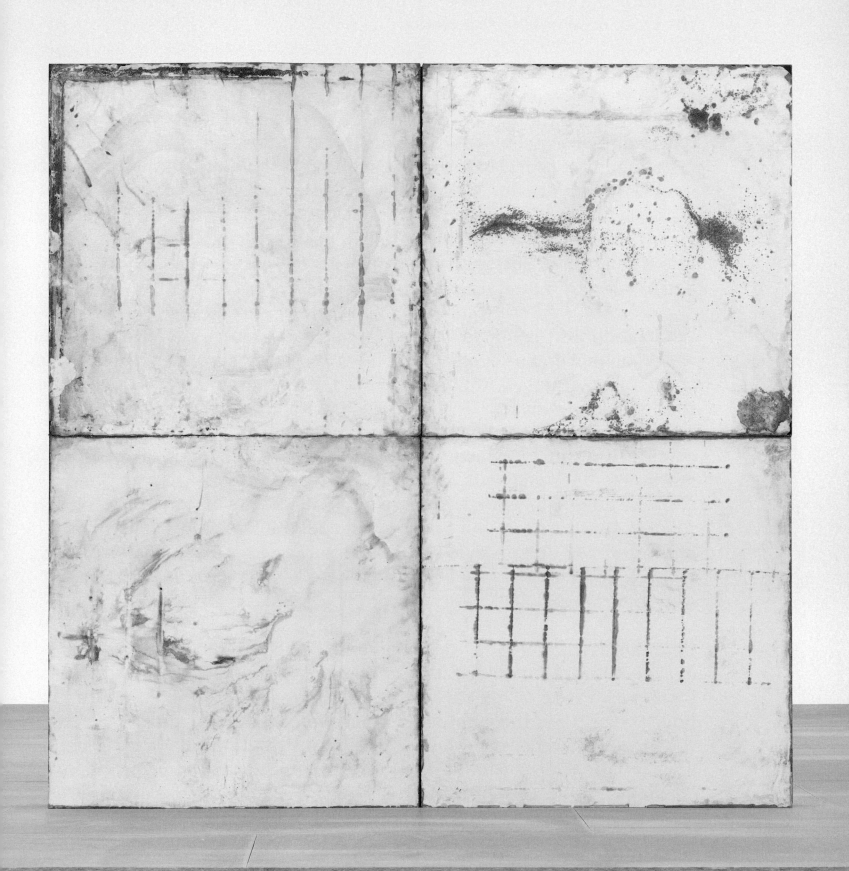

My welds look okay, not great, a bit of spatter where the kerosene must've burned off the shielding gas, it's adequate. It may be that I am biased. I started out with a white-hot desire to fry your minds, now I'm drinking, trying to keep my brain from exploding, to dull the pain of the work of wrecking the world.

What I'm trying to say is, I am paid to do this, a mind experiment, said to be impossible in isolation. Build a house from the floor up, using only your mind—on paper that's doable. Bea and I were talking the other day about what a house is. She said, and I think she's right, that a house is defined by a roof. That is the absolute minimum condition for a house, a roof over your head. To build a house you start with the roof. A roof makes a house. We were talking about this because I've got a house that I want to turn into a sculpture. I asked her, how do you turn a house into a sculpture? She said, just tear off the roof, that's a sculpture. A house without a roof is a sculpture. A sculpture is a floor.

When I bought the house it wasn't much more than a roof. No walls, no water, no power, not even a floor. It was a foreclosure, a bank sale after the housing crash. First I built the road, then septic, and finally a tank that collects rainwater off the roof. Now the floor. It's a studio where I sleep with my family in the middle of whatever I'm working on, a sculpture, a wall, windows, the floor. I go there and work, lay everything out on the floor and walk around it. It's a place to work. Some things can't be done. The work I do there stays there. It's unfinished, probably forever, that's fine. It can't be moved, I don't even know if it can be photographed, it isn't made for an exhibition, for someplace else. It is a place. Some things can't be seen. There's nothing to see, just a river and some trees.

What's a studio for? It's an empty room I walk around and talk to myself out loud. I work for myself. I'm my own boss, I tell myself what to do, I tell myself that. If I can afford to, here's what I'll do: jackhammer the floor slab, rip out the wiring and start over, trash the panel, smash all the glass with a hammer, tear up the drains, fill the well, pull all the lines, cut holes in the walls, floor, roof, dumpster the doors, actually just lay waste to the entire north side of the structure, open it up, air it out, let the rain in, start again.

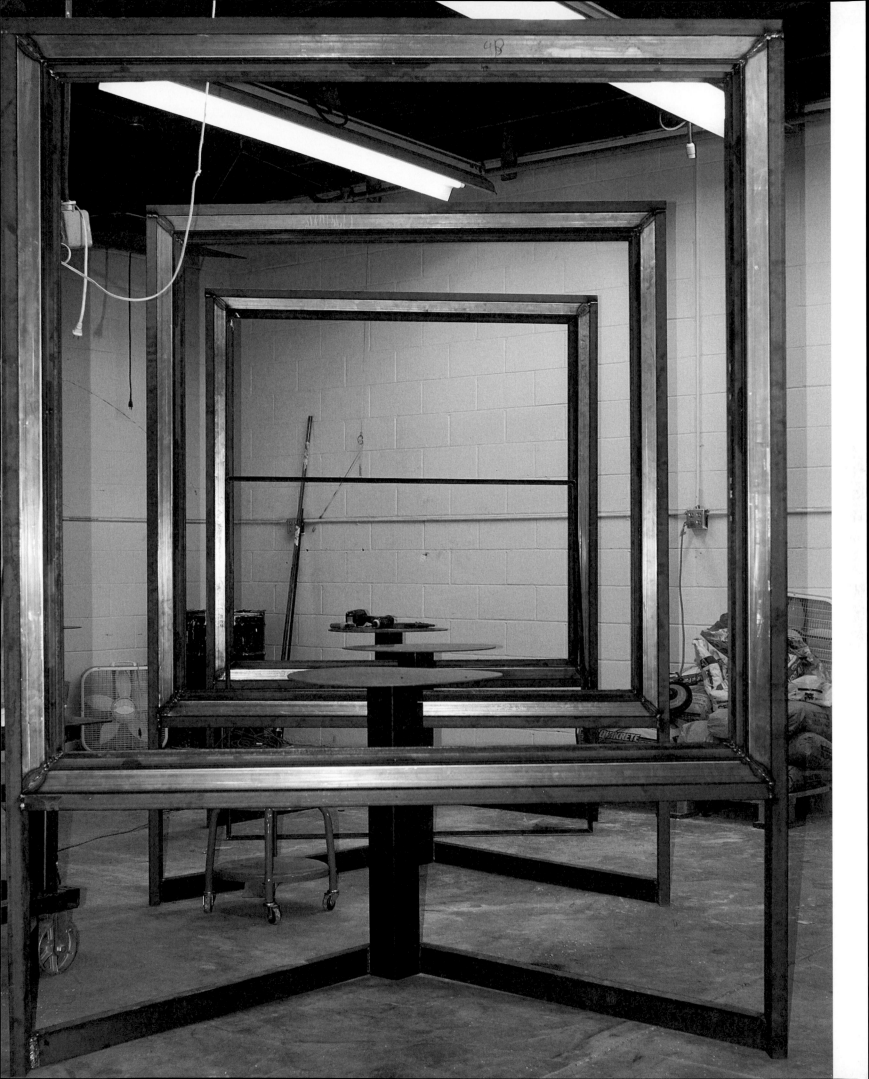

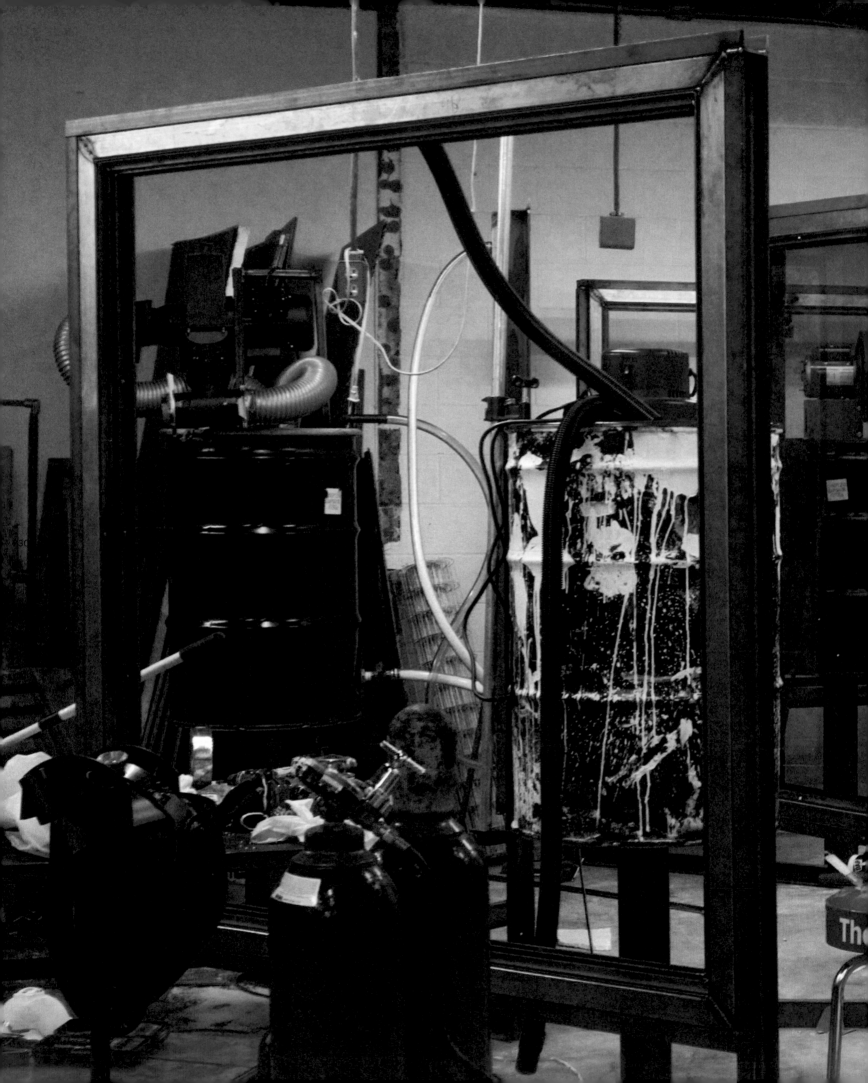

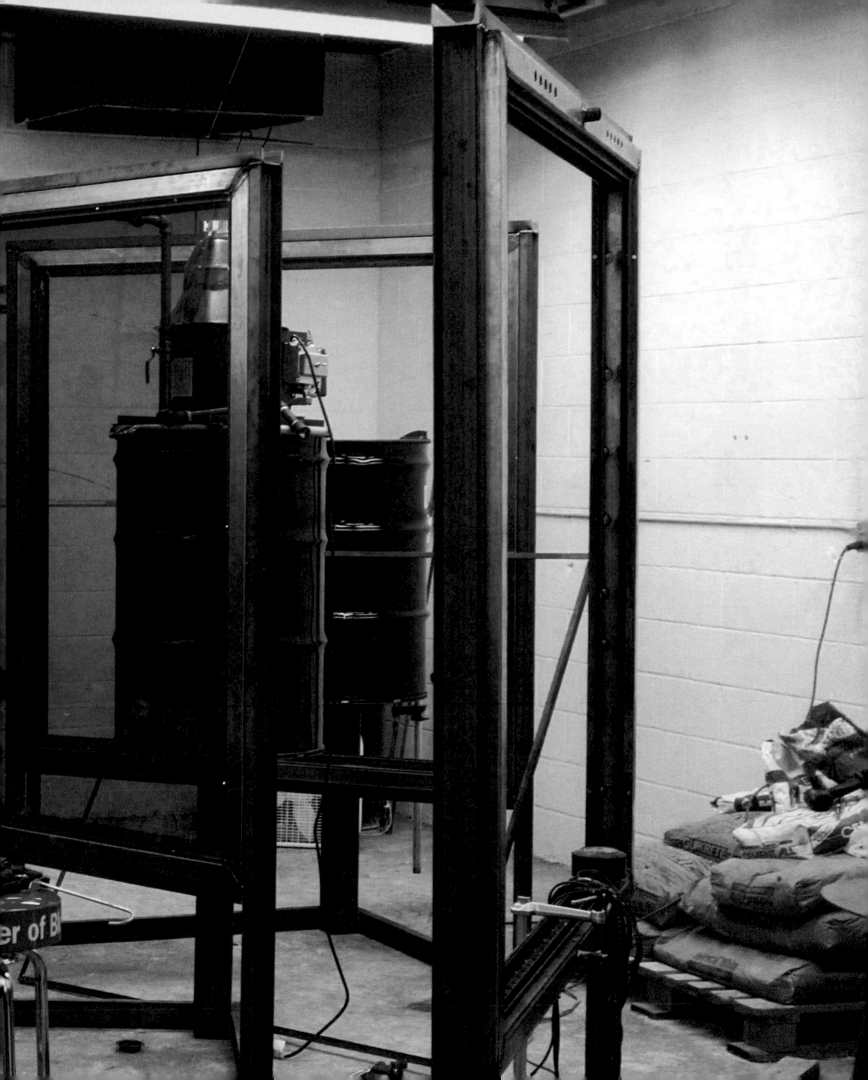

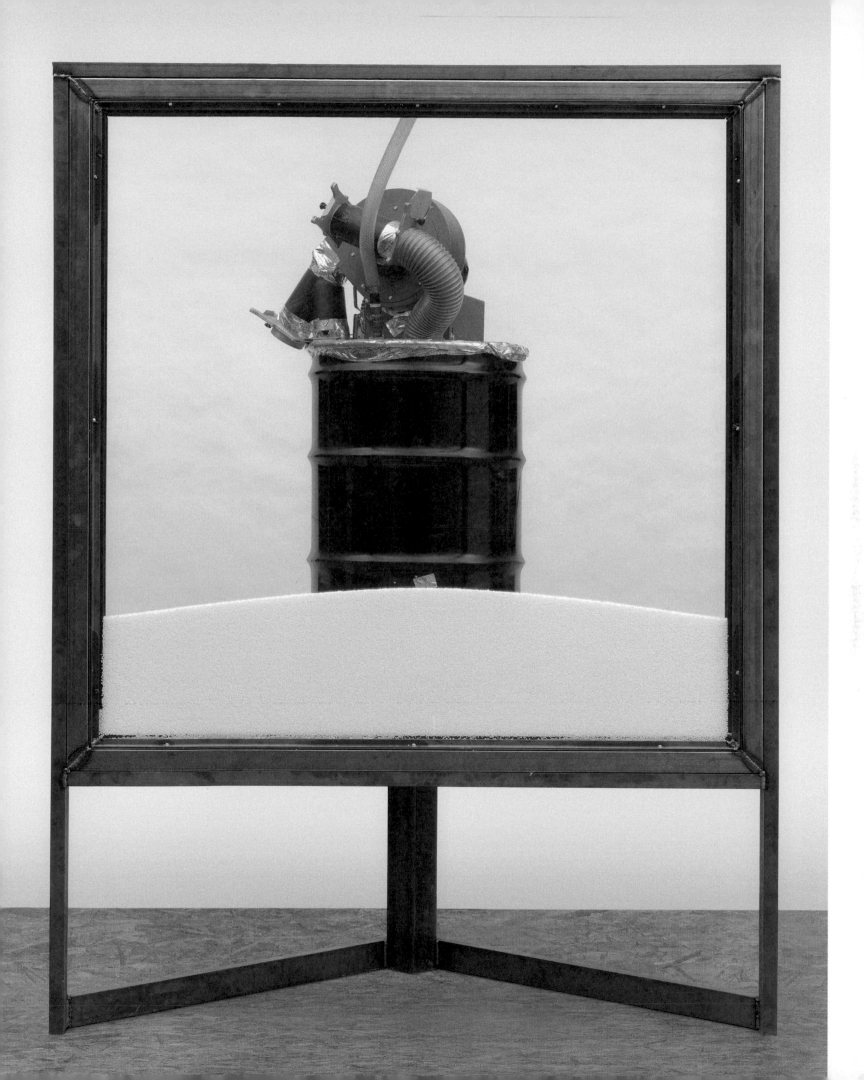

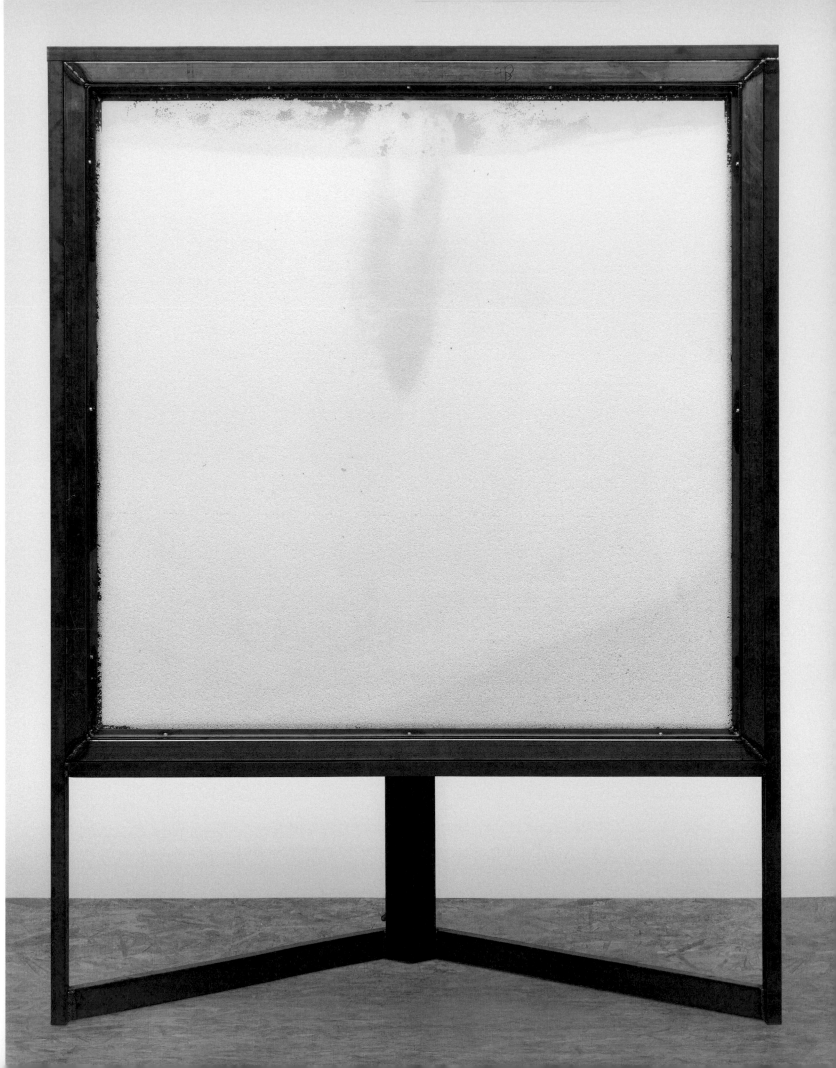

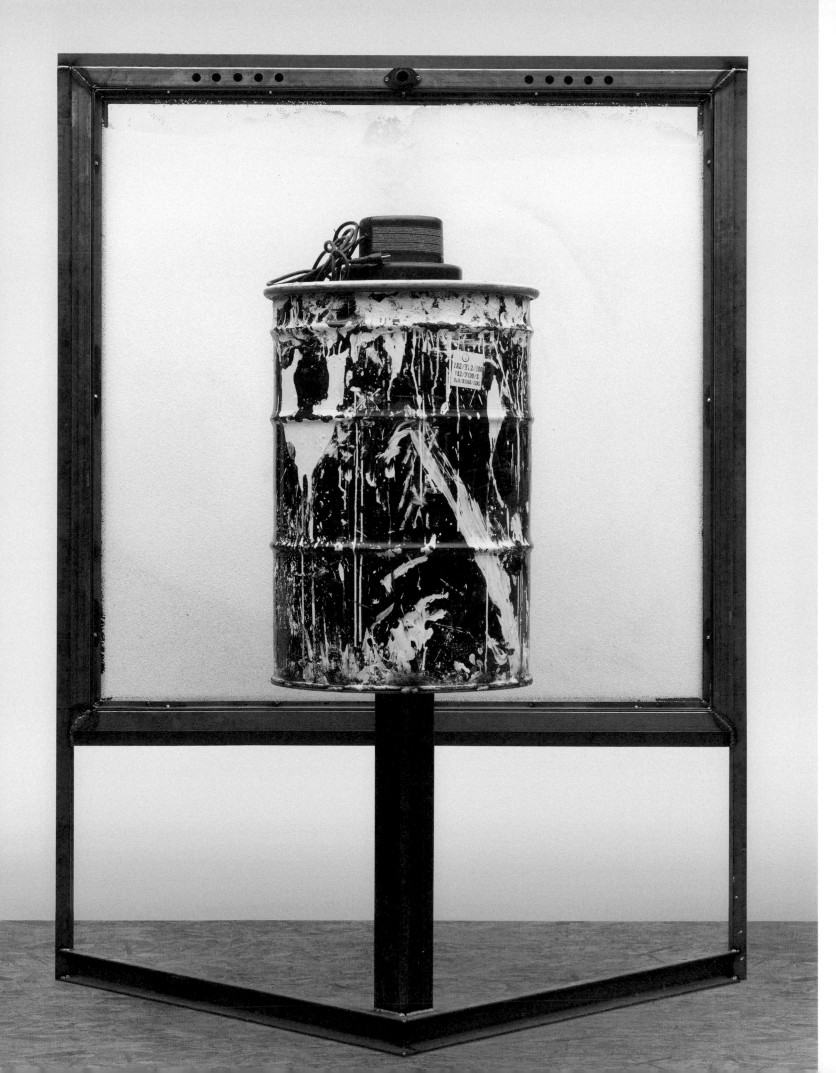

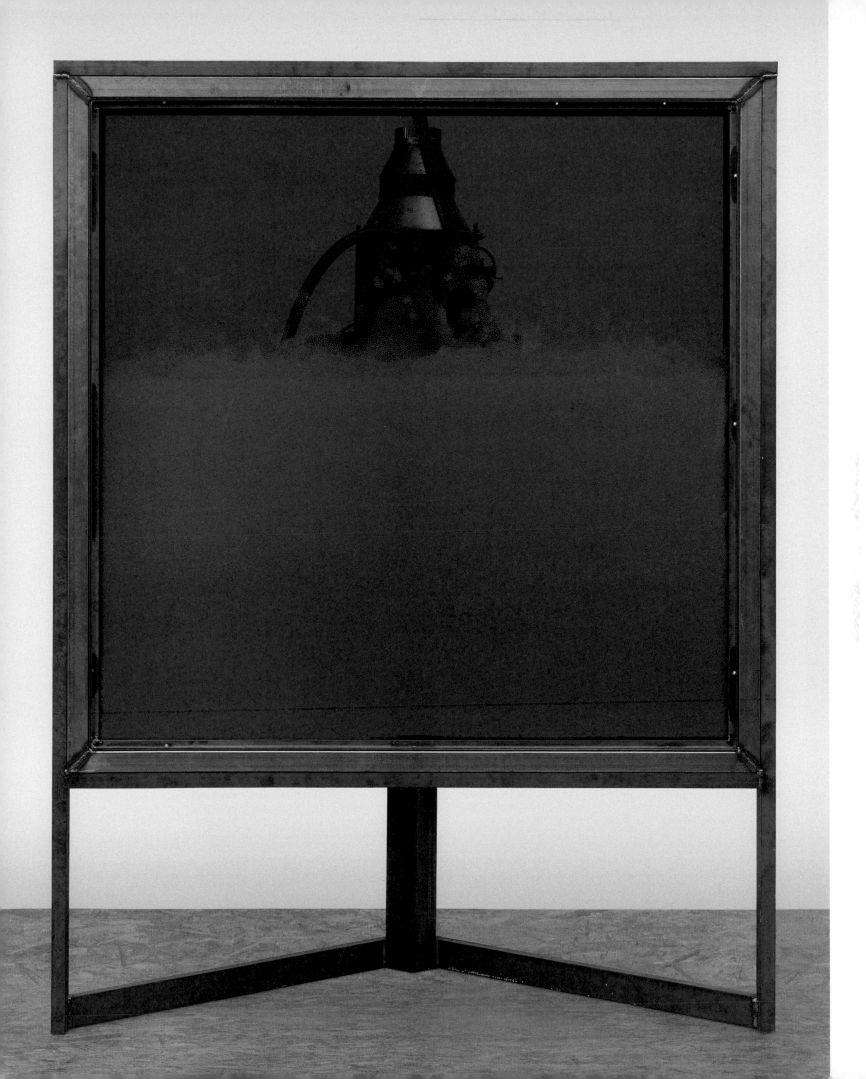

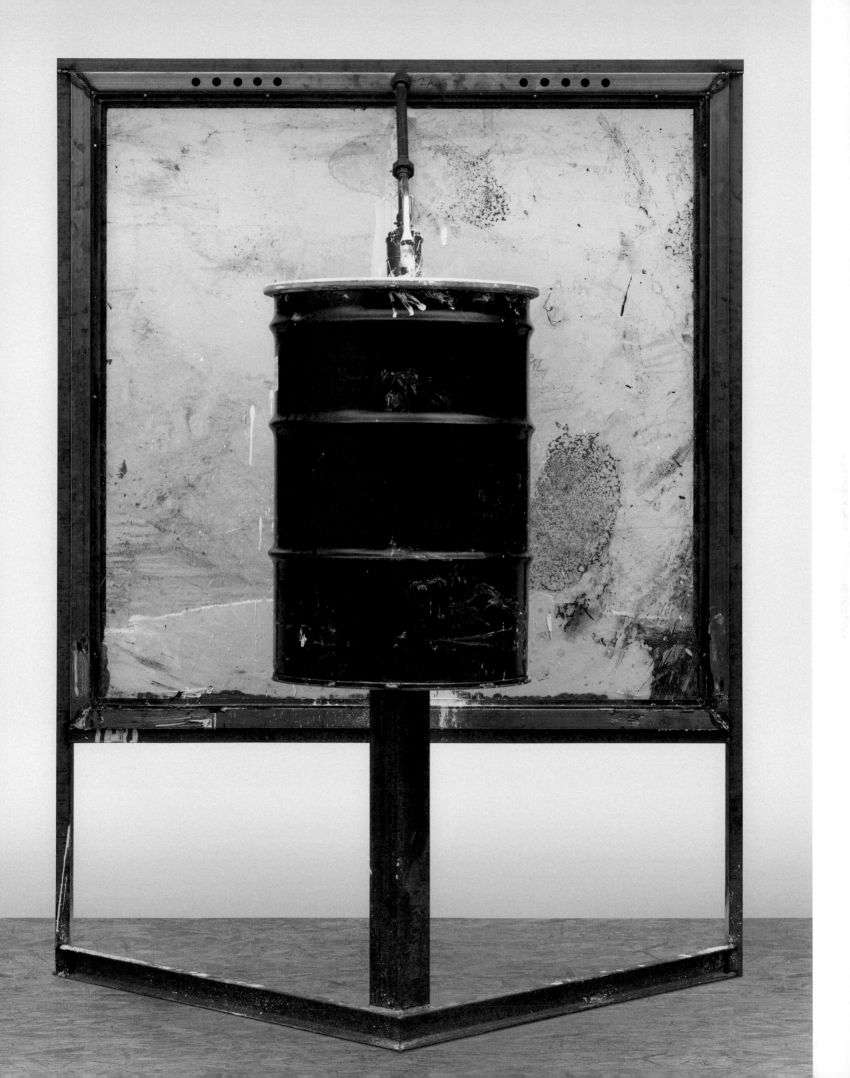

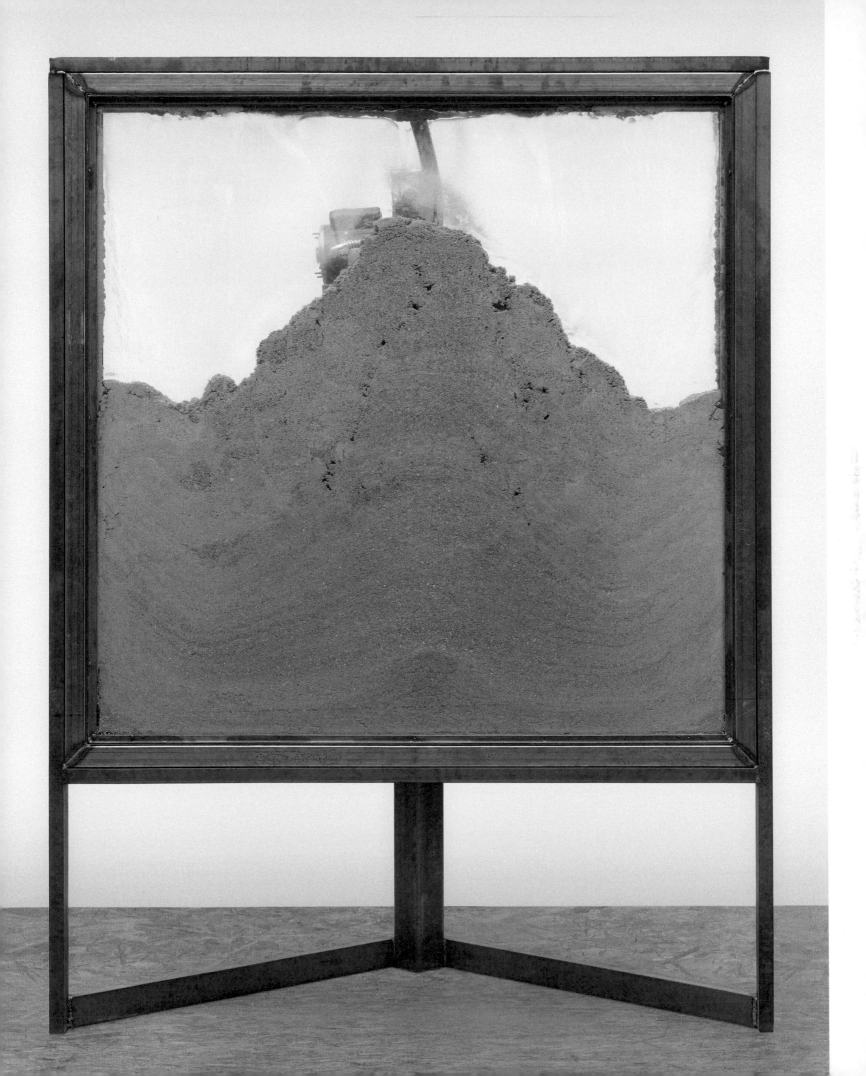

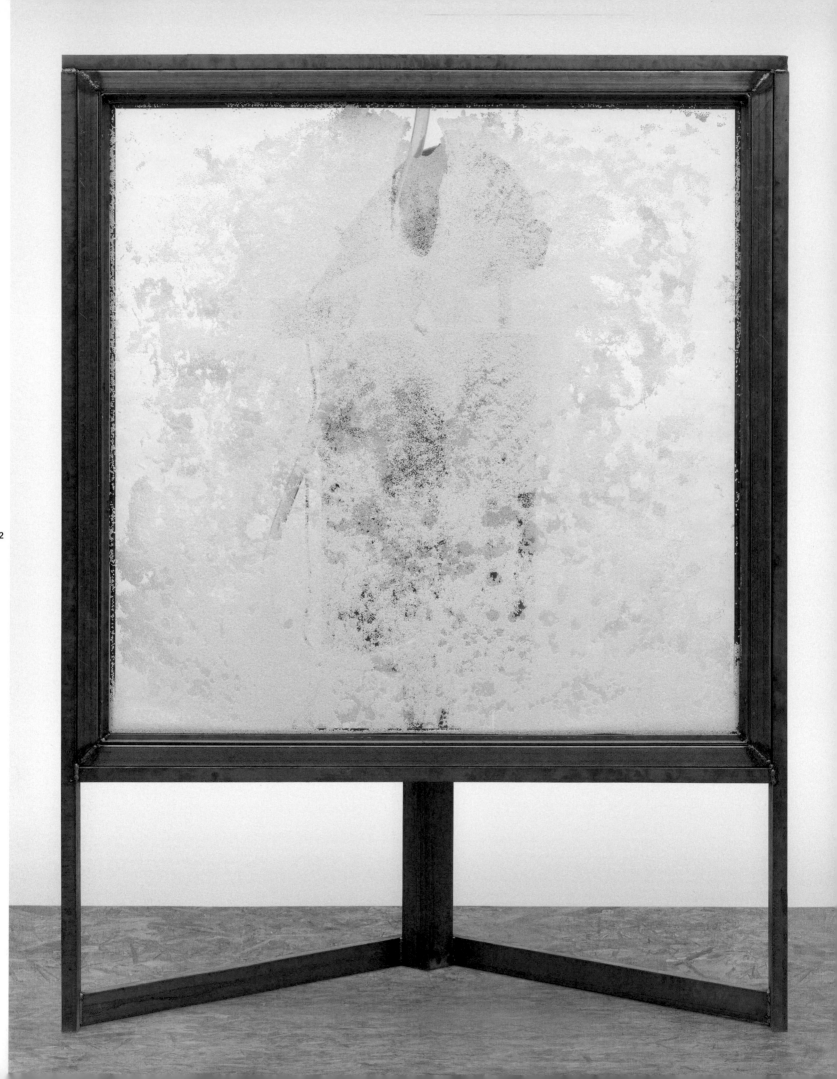

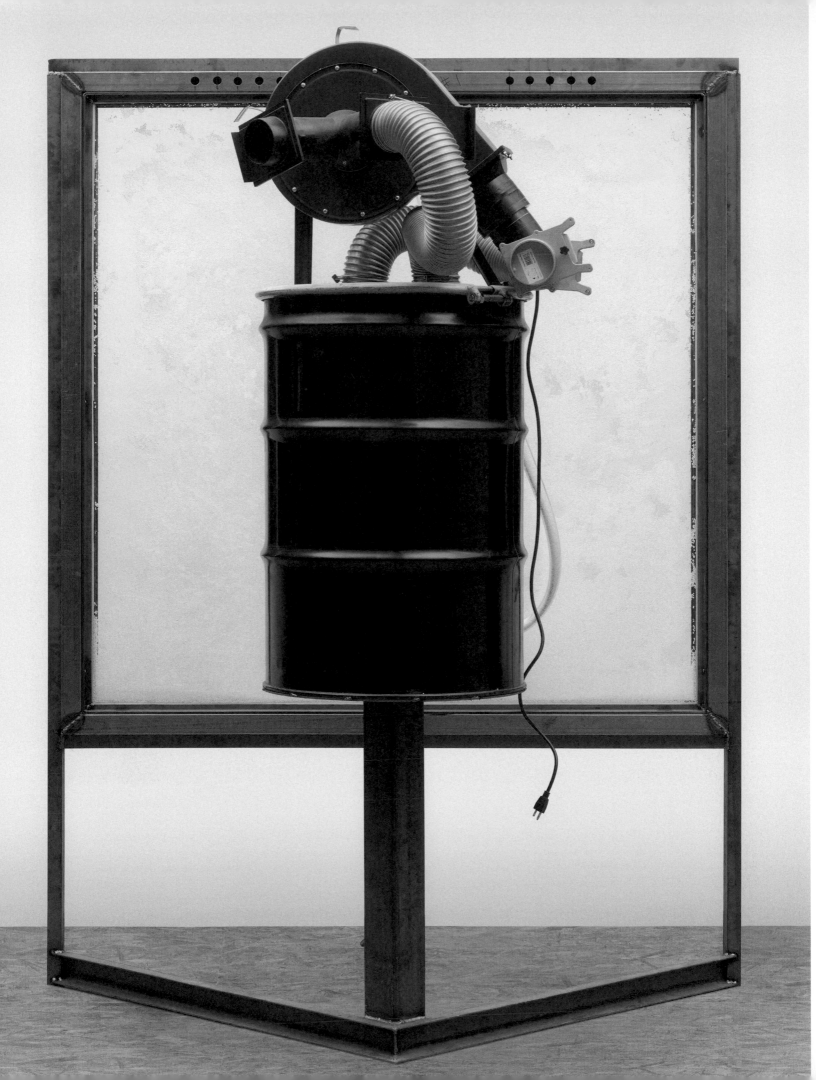

LIST
OF WORKS

244

[2–3]
Introduction (Beam on a Wall),
2011–2012
Oak, steel
15 × 402 ½ × 14 ½ cm
6 × 158 ½ × 5 ⅔ in
Courtesy of Galerie
Eva Presenhuber, Zürich
and the artist

[6–11]
White Walls, 2013
Steel, concrete, wood, paint
Variable dimensions
Courtesy of Galerie
Eva Presenhuber, Zürich;
Maccarone, New York;
and the artist
Photo ©Studio Hans Wilschut

[12–15]
White Walls, 2012
Steel, concrete, wood, paint
Variable dimensions
Tony Salame collection
Courtesy of Galerie
Eva Presenhuber, Zürich
and the artist
Photo ©Studio Hans Wilschut

[16]
Rooms, 2012
Ed. 2 + 1 A.P.
Steel, cedar, steel,
door hardware
214 × 86 × 14 cm
84 ¼ × 33 ¾ × 5 ½ in
Dr. Heinz Peter Hager collection
Courtesy of Balice Hertling, Paris
and the artist

[17]
Double Door, 2011
Oak, pressure-treated wood,
pine, plywood, steel
210 × 160 × 80 cm
82 ⅔ × 63 × 31 ½ in
Private collection
Courtesy of Maccarone, New York
and the artist
Photo ©Jeffrey Sturges

[18–21, 26–27]
My Mistake, 2010
Pine
Variable dimensions
Courtesy of the artist
Photo ©Steve White

[22–25]
My Mistake, 2010
(detail)
Photo ©Steve White

[28–33]
Studio view
Photo ©Oscar Tuazon

[35]
Orphan, 2011
Steel
350 × 367 × 390 cm
137 × 144 × 153 in
Private collection
Courtesy of Balice Hertling, Paris
and the artist

[36–37]
Suquamish, 2011
Pine, concrete
Variable dimensions
Courtesy of Balice Hertling, Paris
and the artist

[38]
Work Now, 2011–2012
(back)
Styrofoam, wood, concrete, mirror
228 × 90 × 50 cm
89 ¾ × 35 ½ × 19 ⅔ in
Private collection
Courtesy of Galerie
Eva Presenhuber, Zürich
and the artist

[39]
Work Now, 2011–2012
(front)

[41]
It Don't Exist, 2013
Steel, acrylic, doors,
sheetrock, wood
200 × 192 × 140 cm
78 ¾ × 75 ⅝ × 55 ⅛ in
Courtesy of Galerie
Eva Presenhuber, Zürich
and the artist
Photo ©Stefan Altenburger
Photography, Zürich

[42–43]

Beyond the Realm of Speech, 2013
Steel, plexiglass, fluorescent
tube, wood
Variable dimensions
Safia Al Rashid collection
Courtesy of Galerie
Eva Presenhuber, Zürich
and the artist

[44]

Extendor, 2013
Steel, leather, upholstery foam
195 × 163 × 81 cm
76 ¾ × 64 ⅛ × 31 ⅞ in
Courtesy of Galerie
Eva Presenhuber, Zürich
and the artist

[45]

I Put Food on the Table, 2011–2012
MDF, wood, screws, paint
260 × 429.3 × 192.4 cm
102 1/3 × 101 ¼ × 107 in
Thomas and Cristina Bechtler
collection
Courtesy of Galerie
Eva Presenhuber, Zürich
and the artist

[46]

Do It Again, 2011
MDF, oak, steel, paint
236 × 174 × 154 cm
93 × 68 ½ × 60 ⅔ in
Andreas Melas collection
Courtesy of Galerie
Eva Presenhuber, Zürich
and the artist

[47]

Dead Ahead, 2011
Oak, steel
Variable dimensions
Permanent collection Kunsthaus,
Zürich

[48–49]

Windows, Walls, 2011
Stainless steel, tinted glass
188 × 288 × 412 cm
74 × 113 ½ × 162 ¼ in
Frank Cohen collection
Courtesy of Galerie
Eva Presenhuber, Zürich
and the artist

[50–51]

Fun, 2012
Concrete, steel
200 × 340 × 210 cm
79 × 134 × 82 ½ in
Courtesy of Galerie
Eva Presenhuber, Zürich
and the artist

[52–53]

Dead Wrong II, 2012
Cement, steel, plywood, sheetrock
Variable dimensions
Courtesy of Maccarone, New York
and the artist
Photo ©Lotte Stekelenburg

[54–55]

Dead Wrong, 2011
(process image)
Concrete, steel, plywood, sheetrock
411.48 × 179.07 × 287.02 cm
162 × 70 ½ × 113 in
The Pinnell collection
Courtesy of The Power Station,
Dallas and the artist
Photo ©Oscar Tuazon

[56–59]

Die, 2011
(process image)
Douglas fir, concrete, steel
487.68 × 243.84 × 487.68 cm
192 × 96 × 192 in
The Pinnell collection
Courtesy of The Power Station,
Dallas and the artist
Photo ©Oscar Tuazon

[60–61]

Numbers, 2012
(studio view)
Photo ©Oscar Tuazon

[62–63]

Numbers, 2012
Steel
450 × 250 × 250 cm
177 × 98 ½ × 98 ½ in
Jacques Seguin collection
Courtesy of Galerie
Eva Presenhuber, Zürich
and the artist
Photo ©FBM Studio, Zürich

[65]

Steel, Plywood, Oven, 2011
Steel, plywood, oven
240 × 188 × 108.5 cm
94 ½ × 74 × 42 ¾ in
Courtesy of Galerie
Eva Presenhuber, Zürich
and the artist

[66–67]

Erector, 2011–2012
Oak, bolts
137 × 378 × 1,131 cm
54 × 148 ¾ × 445 ¼ in
Courtesy of Galerie
Eva Presenhuber, Zürich
and the artist

[68–69]

Instructor, 2012
(studio view)
Oak, bolts
200 × 200 × 400 cm
78 ¾ × 78 ¾ × 157 ½ in
Permanent collection Museum
of Modern Art, New York
Courtesy of Galerie
Eva Presenhuber, Zürich
and the artist
Photo ©Oscar Tuazon

[70–71]

Studio view
Photo ©Oscar Tuazon

[72–74]

A Free Country, 2013
(process image)
Photo ©Antoine Rocca

[75]

Tuazon Studio (from left to right):
Andrei Panibratchenko,
Martin Laborde, Oscar Tuazon,
Antoine Rocca, Eric Perez
Photo ©Antoine Rocca

[76–77]

A Free Country, 2013
Steel, aluminum, concrete
Variable dimensions
Courtesy of Galerie Eva
Presenhuber, Zürich; Maccarone,
New York; and the artist

[78–81]

For Hire, 2012
(process image)
Photos ©Oscar Tuazon

[82–87]
For Hire, 2012
Wood, steel, bolts, shower, door,
plastic, lamps
Variable dimensions
Maurice and Paul Marciano
Art Foundation
Courtesy of Maccarone, New York
and the artist
Photo ©Jeffrey Sturges

[88–89]
Untitled Runway Show, 2012
(performance view)
©K8 Hardy
Photo Linus Sundahl-Djerf

[90–105]
Photo ©Oscar Tuazon

[106–107]
Afognak, 2011
Digital c-print mounted aluminum
177.8 × 119.38 × 3.18 cm
70 × 47 × 1¼ in
Courtesy of Maccarone, New York
and the artist

[108]
Irene, 2011
Digital c-print mounted aluminum
177.8 × 119.38 × 3.18 cm
70 × 47 × 1¼ in
Courtesy of Maccarone, New York
and the artist

[109]
Paris, 2011
Digital c-print mounted aluminum
129.54 × 119.38 × 2.54 cm
51 × 47 × 1 in
Private collection
Eva Presenhuber, Zürich
Courtesy of Maccarone, New York
and the artist

[110]
White Steel, 2010
(paintings by Gardar Eide Einarsson)
Aluminum, digital c-print,
spray paint
180 × 120 × 60 cm
70¾ × 47¼ × 23⅔ in
Courtesy of Jonathan Viner, London;
Rat Hole Gallery, Japan;
and the artists

[111]
Untitled, with Gardar Eide
Einarsson, 2012
Courtesy of Jonathan Viner, London
and the artists

[112]
Steel, MDF, 2011
Steel, MDF
220 × 101.5 × 60 cm
86⅔ × 40 × 23⅔ in
Aishti Foundation collection
Courtesy of Standard (Oslo), Oslo
and the artist
Photo ©Vegard Kleven

[113]
Steel, pressure-treated wood, 2011
Steel, pressure-treated wood
116 × 320 × 140 cm
45⅔ × 126 × 55 in
Private collection
Courtesy of Standard (Oslo), Oslo
and the artist
Photo ©Vegard Kleven

[115]
A Dead Thing, 2010
Steel
80 × 125 × 270 cm
31½ × 49¼ × 106⅓ in
Courtesy of Jonathan Viner, London
and the artist

[116–117]
*"Formerly, when how to get my
living honestly, with freedom left
for my proper pursuits, was a
question which vexed me even more
than it does now, for unfortunately
I am become somewhat callous,
I used to see a large box by the
railroad, six feet long by three wide,
in which the laborers locked up their
tools at night; and it suggested to
me that every man who was hard
pushed might get one for a dollar,
and, having bored a few auger holes
in it to admit the air at least, get
into it when it rained and at night,
hook down the lid, and so have
freedom in his love, and in his
soul be free."*, 2012
Steel, galvanized steel, hardware
120 × 240 × 120 cm
47¼ × 94½ × 47¼ in
Courtesy of Balice Hertling, Paris
and the artist

[178]

The Carnal Plane, 2013
Steel, stainless steel, fluorescent
lamp, concrete
300 × 80 × 80 cm
118 ⅛ × 31 ½ × 31 ½ in
Thomas and Cristina Bechtler
collection
Courtesy of Galerie
Eva Presenhuber, Zürich
and the artist

[179]

Two Possible Chairs V, 2012
Steel, galvanized steel, stainless
steel, MDF, leather
Variable dimensions
Nicoletta Fiorucci collection
Courtesy of Balice Hertling, Paris
and the artist

[180]

Chair Repaired, 2011
Steel, chromed steel, plastic
75 × 50.8 × 61 cm
29 ½ × 20 × 24 in
Courtesy of Maccarone,
New York and the artist
Photo ©Jeffrey Sturges

[181]

Untitled, 2013
Chestnut trunk, stainless steel
73 × 48 × 43 cm
28 ¾ × 19 × 18 in
Lisa and Danny Goldberg collection
Courtesy of The Modern Institute;
Toby Webster Ltd, Glasgow;
Standard (Oslo), Oslo;
and the artist
Photo ©Keith Hunter

[182]

Granite, stainless steel,
induction stovetop, 2011
Black granite, induction stovetop,
stainless steel, electronic material
189 × 53.5 × 66.5 cm
74 ½ × 21 × 26 ¼ in
Lidia Berlingieri collection
Courtesy of Galerie
Eva Presenhuber, Zürich
and the artist

[183]

Aluminum, steel, induction
stovetop, 2011
Aluminum, steel, stovetop
101.5 × 51.5 × 31 cm
40 × 20 ¼ × 12 ¼ in
Aishti Foundation collection
Courtesy of Standard (Oslo), Oslo
and the artist
Photo ©Vegard Kleven

[184]

Steel, oak post, office chair, 2011
Steel, oak, chair
154 × 142 × 83 cm
60 ⅔ × 56 × 32 ⅔ in
Jan-Kåre Fekene collection
Courtesy of Standard (Oslo), Oslo
and the artist
Photo ©Vegard Kleven

[187]

Scott Burton, 2012
Concrete
106 × 50 × 86 cm
41 ¾ × 19 ⅔ × 33 ¾ in
Gilles Renaud collection
Courtesy of Balice Hertling, Paris
and the artist

[188]

A burnt sheet of paper
with burnt words on it, 2011
Concrete
Variable dimensions
Courtesy of Maccarone, New York,
and the artist

[189]

Bottom Dollar, 2011
Wood trusses, steel, canvas,
polyethylene
Variable dimensions
Courtesy of Maccarone, New York,
and the artist

[191–193]

dépendance, 2013
(process image)
Photo ©Oscar Tuazon

EXHIBITIONS

Oscar Tuazon
Born in 1975 in Seattle, Washington
Lives and works in Los Angeles

Education

2002–2003
Whitney Museum of American
Art Independent Study Program,
Architecture / Urban Studies
Program, New York

2001–2002
Whitney Museum of American Art
Independent Study Program,
Studio Program, New York

1995–1999
Cooper Union for the Advancement
of Science and Art, New York

1994
Deep Springs College

Exhibitions
Selected Solo Exhibitions

2014
Alone In An Empty Room,
Museum Ludwig, Cologne (cat.)
A Home, Galerie Eva Presenhuber,
Zürich

2013
White Walls, Museum Boijmans
Van Beuningen, Rotterdam
Spasms of Misuse, Schinkel
Pavillon, Berlin
dépendance, dépendance, Brussels

2012
People, Public Art Fund, Brooklyn
Bridge Park, New York
Manual Labor, Galerie Eva
Presenhuber, Zürich
Action, Jonathan Viner, London
Working Drawing, Centre d'édition
contemporaine, Geneva
Shaman/Showman, with Karl
Holmqvist, Galerie Chantal Crousel,
Paris
Scott Burton, Fondazione Giuliani,
Rome (cat.)
We're Just in It for the Money, with
Elias Hansen, Balice Hertling, Paris
*Towards a Vernacular
Architecture*, Forde, Geneva

2011
America is my Woman, Maccarone,
New York
*Steel, Pressure-Treated Wood,
Oak Post, Office Chair, Induction
Stovetop, Aluminum, 2011*,
Standard (Oslo), Oslo
Die, The Power Station, Dallas (cat.)

2010
Oscar Tuazon, Kunsthalle Bern,
(cat.)
My Flesh to Your Bare Bones, with
Vito Acconci, Maccarone, New York
Sex Booze Weed Speed, with
Gardar Eide Einarsson, Rat Hole
Gallery, Tokyo (cat.)
Sex, Jonathan Viner, London
My Mistake, Institute of
Contemporary Art, London
It Was One of My Best Comes, with
Elias Hansen, Parc St Léger –
Centre d'Art contemporain,
Pougues-les-Eaux (cat.)

2009

Against Nature, Künstlerhaus, Stuttgart
Bend It Till It Breaks, Centre internationale d'art et du paysage, Île de Vassivière (cat.)
Ass To Mouth, Balice Hertling, Paris
F.T.W., dépendance, Brussels
That's Not Made For That, David Roberts Art Foundation, London
Untitled (Leave Me Be), Standard (Oslo), Oslo (cat.)
Another Nameless Venture Gone Wrong, Haugar Vestfold Kunstmuseum, Tønsberg
I Was A Stranger, Isabella Bortolozzi Galerie, Berlin

2008

Dirty Work, Jonathan Viner, London
A Vow of Poverty, Maccarone, New York (cat.)
Kodiak, with Elias Hansen, Seattle Art Museum, Seattle
Alex Hubbard and Oscar Tuazon, Contemporary Art Museum St. Louis
This World's Just Not Real To Me, with Elias Hansen, Howard House, Seattle

2007

Mike Freeman, castillo/corrales, Paris
I'd Rather Be Gone, Standard (Oslo), Oslo
Where I Lived and What I Lived For, Palais de Tokyo, Paris
VOluntary Non vUlnerable, with Elias Hansen, Bodgers and Kludgers, Vancouver

2003

City Without a Ghetto, Artists Space, New York

Exhibitions
Selected Group Exhibitions

2014

The Hawker, dépendance at Carlos/Ishikawa, London
Living In The Material World, Haus Lange and Haus Esters museums, Krefeld
Chez Perv, team (gallery, inc.), New York

2013

Not Yet Titled: New and Forever, Museum Ludwig, Cologne
De leur Temps (4) – Nantes, Centre d'Art Le Hangar à Bananes, Nantes
Alchemy, Jonathan Viner, London
Hello Goodbye Thank you, Again, And Again, And Again, castillo/corrales, Paris
Standard Escape Routes, Standard (Oslo), Oslo
356 Sculptures, 356 Mission, Los Angeles
Anamericana, American Academy in Rome Gallery, Rome
Sea Salt and Cross Passes, The Modern Institute, Glasgow
Folk Devil, David Zwirner, New York
Le Pont, Musée d'art contemporain, Marseille
Beyond The Object, Brand New Gallery, Milan
From Triple × to Birdsong (In Search Of The Schizophrenic Quotient), Kayne Griffin Corcoran, Los Angeles
The Glass Show, Jonathan Viner, London
Dialogues, MAK Center for Art and Architecture, West Hollywood

2012

Deftig Barock, Von Cattelan bis Zurbarán, Manifeste des prekär Vitalen, Kunsthaus, Zürich and Guggenheim Museum, Bilbao (cat.)
Alone Together, Rubell Family Collection/Contemporary Arts Foundation, Miami
Lost (in L.A.), Los Angeles Municipal Art Gallery, Los Angeles
Fruits of Passion, Centre Pompidou, Paris
If There Would Be A Face, This Would Be A Cat, dépendance, Brussels

Sense and Sustainability, Urdaibai Biosphere Reserve, Spain
Art and the City, Das Festival für Kunst im öffentlichen Raum, Zürich (cat.)
Minimal Myth, Museum Boijmans Van Beuningen, Rotterdam
Tools for Conviviality, The Power Plant, Toronto
Deliquesce, Jonathan Viner, London
Ab in die Ecke! Städtische Galerie, Delmenhorst (cat.)
Paperless, Southeastern Center for Contemporary Art, Winston–Salem
Bouvard and Pécuchet's Compendious Quest for Beauty, Curators' Series #5, David Roberts Art Foundation, London
Whitney Biennial 2012, Whitney Museum of American Art, New York
Surface to Surface, Jonathan Viner, London
Heart to Hand, Swiss Institute, New York
Monochrome, S.A.L.T.S., Birsfelden
New Acquisitions, Kunsthaus, Zürich
Into the Corner, Städtische Galerie, Delmenhorst

2011

The Language of Less (Then and Now), Museum of Contemporary Art, Chicago (cat.)
Books on Books, Swiss Institute, New York
ILLUMInations, 54th International Art Exhibition, La Biennale di Venezia, Venice
The Art of Narration Changes with Time, Sprüth Magers, Berlin
Hello Goodbye Thank you, Again And Again, castillo/corrales, Paris
Sculpture Now, Galerie Eva Presenhuber, Zürich
It's Great To Be In New Jersey, Honor Fraser, Los Angeles
The Medicine Bag, Maccarone, New York
The Shape of Things to Come: New Sculpture Part 1, Saatchi Gallery, London
Isabelle Cornaro, Nikolas Gambaroff, Oscar Tuazon, Elias Hansen, A Palazzo Gallery, Brescia
TABLEAUX, Le Magasin, Grenoble
After Images, Musée Juif de Belgique, Brussels

Dystopia, Musée d'art contemporain, Bordeaux
Poste Restante, Artspeak, Vancouver
Art In The City, Art Brussels, Brussels
The Way It Wasn't (Celebrating Ten Years of castillo/corrales, Paris), Culturgest, Porto
Fragments Americana, Almine Rech, Brussels
Light In Darkness, Western Bridge, Seattle
Under Construction, SAKS, Geneva

2010

Displaced Fractures – Über die Bruchlinien von Architekturen und ihren Körpern, Migros Museum für Gegenwartskunst, Zürich (cat.)
You And Now, Balice Hertling, Paris
The Way It Wasn't (Celebrating Ten Years of castillo/corrales, Paris), Midway Contemporary Art, Minneapolis
When Do You See Yourself in Ten Years?, Standard (Oslo), Oslo
The Concrete Show, Galleria Franco Noero, Torino
Dynasty, Musée d'Art moderne de la Ville de Paris and Palais de Tokyo
Rehabilitation, WIELS Centre d'Art contemporain, Brussels (cat.)
Box With the Sound of Its Own Making, Western Bridge, Seattle
Mutiny Seemed a Probability, Fondazione Giuliani, Rome
Do, Redo, Undo, WEILS, Centre d'Art contemporain, Brussels
Perpetual Battles, Baibakov Art Projects, Moscow
A Basic Human Impulse, Galleria Comunale d'Arte Contemporanea, Monfalcone
The Nice Thing About castillo/corrales..., castillo/corrales, Paris
Infinite Fold, Galerie Thaddaeus Ropac, Paris
Les Sculptures Meurent Aussi, La Kunsthalle, Mulhouse

2009

Free as Air and Water, Cooper Union Houghton Gallery, New York
Utopie et Quotidienneté, Centre d'Art contemporain, Geneva
Evento, Public Art Festival, Bordeaux (cat.)
Insiders: pratiques, usages, savoir-faire, CAPC, Bordeaux
Display with Sound, International Project Space, Birmingham
Wood, Maccarone, New York
L'image cabrée, 11e Prix Fondation d'entreprise Ricard, Paris (cat.)
Gennariello, Balice Hertling, Paris
Use It For What It's Used For, with Elias Hansen, Temporary Sculpture Park, New York
Sauvagerie domestique, Ecole Municipale des Beaux Arts – Galerie Edouard Manet, Gennevilliers
Hello Goodbye Thank You, Again, castillo/corrales, Paris
Of Vagrant Dwellers in the Houseless Woods, Or Gallery, Vancouver

2008

We never met before, but it's with great anticipation of your understanding that I'm writing you and I hope you will in good faith give a deep consideration to my proposal below, Standard (Oslo), Oslo
Transformational Grammar, Francesca Kaufmann, Milan
27 November–21 January 2009, dépendance, Brussels
Entrechambrage horizontale, Galerie Catherine Bastide and dépendance, Brussels
Espejos/ Mirrors, MARCO Museo de Arte Contemporánea, Vigo (cat.)
Sack of Bones, Peres Projects, Los Angeles
September Show, Tanya Leighton, Berlin
Degrees of Remove: Landscape and Affect, Sculpture Center, Long Island City
Rendez-vous nowhere, Centro Cultural Montehermoso Kulturunea, Vitoria-Gasteiz
Suddenly: Where We Live Now, Douglas F. Cooley Memorial Art Gallery, Portland, Oregon

Dragged Down into Lowercase,
Sommer-akademie,
Zentrum Paul Klee, Bern
A Town (Not a City), Kunst Halle
Sankt Gallen, St. Gallen
*Suddenly: Where We Live
Now,* Pomona College Museum
of Art, Claremont
You Complete Me, Western
Bridge, Seattle
Société Anonyme, Kadist Art
Foundation, Paris

2007

Documenta 12 Magazines, with
Metronome, Kassel (cat.)
*Compound Values Affirming
Denial*, Standard (Oslo), Oslo
and Art Rotterdam
Exposition N°1, Balice Hertling,
Paris
Hello Goodbye Thank You,
castillo/corrales, Paris

2006

*The Elementary Particles
(The Paperback Edition)*, Standard
(Oslo), Oslo
*Die Kultur der Angst/ The Culture
of Fear,* ACC Galerie, Weimar
Minotaur Blood, Jonathan Viner,
London
Down By Law, The Wrong Gallery
at The Whitney Museum of
American Art, New York
An Open Operation, Edinburgh
College of Art, Edinburgh
Metronome No. 10, Institute
for Contemporary Art, Portland,
Oregon
For Death, Halle 14, Leipzig

2005

Secret Room, Kanazawa
Baroque Geode, Sundown Salon
19, Los Angeles
Bridges, University of Colorado,
Denver

2004

Slouching Towards Bethlehem,
The Project, New York
Xtreme Houses, Lothringer13,
Munich
Adaptationen, Kunsthalle
Fridericianum, Kassel (cat.)
Adaptations, Apexart,
New York (cat.)
Human, Fucking Human, Lofoten
International Art Festival, Bergen
*Urban Renewal: City Without
a Ghetto*,
Temporary Services, Chicago and
Princeton School of Architecture,
Princeton
The Subsidized Landscape, Center
for Architecture, New York
Sprawl, Hudson Clearing, New York
Our Mirror, Lower Manhattan
Cultural Council, New York

2003

24/7, Contemporary Art Center,
Vilnius
Wight Biennial, University of
California, Los Angeles, (cat.)
Float, Socrates Sculpture Park,
New York
Deathtime, 27 Canal, New York
Totally Motivated, with Gardar Eide
Einarsson, Kunstverein, Munich
Between the Lines, with Gardar
Eide Einarsson, Apex Art, New York
Inscribing the Temporal, Kunsthalle
Exnergasse, Vienna

2002

Strike, Wolverhampton Art Gallery,
Wolverhampton
Coming Soon, Whitney
Independent Study Program,
New York
Museum of the White Man, New
York and Suquamish, Washington

2001

Programmable City, Storefront
for Art and Architecture, New York
Building Codes, Lower East Side
Tenement Museum,
New York
LIC: Landlords, Instant Cash!,
P.S.1 Center for Contemporary Art,
New York

BIBLIO-GRAPHY

Bibliography
Books and periodicals

Bernard, Paul. "Oscar Tuazon–Ass to Mouth, Balice Hertling." *Frog* 9 (2010): 66–69.

Boutoux, Thomas. "Oscar Tuazon." In *Vitamin 3-D: New Perspectives in Sculpture and Installation*, 306–307. New York: Phaidon, 2009.

Buckley, Craig. *Adaptationen*. Kassel: Kunsthalle Fridericianum, 2004. *Adaptations*. New York: Apexart, 2004.

Cotter, Holland. "Adaptations." *New York Times,* January 30, 2004.

———. "Body and the Archive." *New York Times,* February 14, 2003.

Darling, Michael. "The Language of Less." In *The Language of Less (Then and Now),* edited by Kate Steinmann, 21–47. Chicago: Museum of Contemporary Art, 2011.

Deliss, Clémentine, and Oscar Tuazon. "Dragged Down Into Lower Case." In *Dragged Down Into Lower Case,* edited by Deliss, 4–9. Hofstetten: Edition Atelier Bern, 2008.

Díaz, Eva. "Dome Culture in the Twenty-first Century." *Grey Room* (Winter 2011): 81–99.

Doran, Anne. "Oscar Tuazon: Maccarone." *Art in America*, February 2012, 104.

Einarsson, Gardar Eide, and Oscar Tuazon. *SexBoozeWeedSpeed*. Tokyo: Rat Hole Gallery, 2011.

Everberg, Kirsten. "After the Utopian Reflex." In *The 2003 Wight Biennial Catalogue,* edited by Doris Chon and Shana Lutker, 14–21. Los Angeles: University of California, Department of Art, 2003.

Hansen, Elias. "Elias Hansen and Oscar Tuazon on the Practice of Glassblowing and the Making of Art Objects." In *I'm a Long Way From Home and I Don't Really Know These Roads.* Los Angeles: DoPe Press, 2014.

Leydier, Richard. "Oscar Tuazon, points de rupture/Breaking Point." *Art Press* 369 (July–August 2010): 52–55.

Lo, Melissa and Valentina Sansone. "Sculpture Forever: Contemporary Sculpture (Part II)." *Flash Art International* (July–September 2003): 106.

Mazadiego, Elize. "Oscar Tuazon." *Frieze* 154 (April 2013): 154–155.

Myles, Eileen. "The Poet's Strike." *Parkett* 89 (October 2011): 200–213.

"Oscar Tuazon." In *L'image cabrée*, edited by Judicaël Lavrador, 77–81. Paris: Fondation d'entreprise Ricard, 2009.

Poitevin, Colette. "Oscar Tuazon." In *Projet pour l'art contemporain – 10 ans d'acquisitions*, edited by Somogy Éditions d'art, 119. Paris: Société des Amis du Musée national d'art moderne – Centre Pompidou and Somogy Editions d'art, 2012.

Pardo, Jorge. "How to Build a House: Jorge Pardo in conversation with Oscar Tuazon." *Paris, LA*, Fall 2013, 38–45.

Pirotte, Philippe. "A Palpable Miss." *Parkett* 89 (October 2011): 174–185.

Rehberg, Vivian. "Oscar Tuazon." *Art in America*, December 2009, 150.

Reust, Hans Rudolf. "Oscar Tuazon: Galerie Eva Presenhuber." *Artforum*, May 2012, 322–323.

Rose, Julian. "Structural Tension: Julian Rose on the Art of Oscar Tuazon." *Artforum*, October 2010, 218–225.

Sherwin, Skye. "Artist of the week 98: Oscar Tuazon." *Guardian*, July 28, 2010.

Shima, Atsuhiko, Yasuyuki Nakai and Azusa Hashimoto, eds. *The National Museum of Art, Osaka*. Osaka: National Museum of Art, 2012.

Smith, Roberta. "Slouching Towards Bethlehem." *New York Times*, August 13, 2004.

Stange, Raimar. "Oscar Tuazon." In *Art and the City*, edited by Christophe Doswald, 238–241. Zürich: JRP Ringier, 2012.

Stefan, Olga. "Manual Labor–Oscar Tuazon at Eva Presenhuber-Zürich." *Flash Art International* (March–April 2012): 98.

Tuazon, Oscar. "A Country Song." *The Kite* (June 29, 2013): 1–2.

——. "Future Academy (Oregon) Shared, Mobile, Improvised, Underground, Hidden, Floating." In *Metronome* 10 (2006), issue edited by Oscar Tuazon.

——. "Hard Work." Interview by K8 Hardy. *Parkett* 89 (October 2011): 185–199.

——. "I Wanna Live." In *Evento 2009—Collective Intimacy*, edited by Didier Fiuza Faustino, 189. Blou: Monografik Editions, 2009.

——. Interview by Rick Owens. *Doingbird* 16 (2012): 170–181.

——. Interview by Amelia Stein. *Pin-Up*, Fall–Winter 2012/13, 112–124. Reprinted in *Pin-Up Interviews*, edited by Felix Burrichter and Andrew Ayers. New York: powerHouse Books, 2013.

——. Interview by Nicolas Trembley. *Numéro*, October 2008.

——."K8." In *How To: Untitled Runway Show*, edited by K8 Hardy and Dorothée Perret, 45–47. Los Angeles: DoPe Press, 2013.

——."On Sabbatical." *Metronome* 11 (2007): 118–199.

——. "Oscar Tuazon." In *Rehabilitation: The Legacy of the Modern Movement*, 175–178. Ghent: Wiels Contemporary Art Center/MER. Paper Kunsthalle, 2010.

——."Self-Made Man." In *Chris Burden: Extreme Measures*, edited by Lisa Phillips, Jenny Moore and Kevin McGarry, 182–187. New York: New Museum of Contemporary Art/ Skira Rizzoli, 2013.

——."Shadows." *Metronome* 9 (2005).

——."A Vow of Poverty." In *Revolution: A Reader*, edited by Thomas Boutoux. Paris: Paraguay Press, 2012.

——."Walter De Maria." *Art in America*, December 2013, 97–98.

——. "The Wrong Way's the Best Way." Interview by Francesca Di Nardo. *Mousse*, December 2008, 104–107.

——, and Elias Hansen. "Dynasty." *Palais* (July 2010): 60–65.

Tuhus-Dubrow, Rebecca."Exhibit Visits Urban Renewal's 'Scenes of Crime'." *Metropolis*, October 2003.

West, Kim, Ariana Reines and Oscar Tuazon. *Oscar Tuazon: Die*. Exh. cat. Dallas: The Power Station, 2011.

Books by the artist

I Can't See. Paris: DoPe Press / Paraguay Press, 2010

Making Books. Paris: Paraguay Press, 2011. Translated by Alisa Cavers, Charlotte Carroy, Clementine Coupau, Eva Ostrowska, Elsa Pragout, Benjamin Thorel and Aurelie Vandewynckele as *Faire des livres (*Paris: Paraguay Press, 2011). Translated by Francisco Carpio as *Haciendo libros (*Alava: Centro Cultural Montehermoso, 2011).

Leave Me Be. Paris: DoPe Press, 2012.

Rayo. *Vonu: The Search for Personal Freedom.*Edited by Jon Fisher. Port Townsend, WA: Loompanics Unlimited, 1983. Facsimile of original edition. Paris: May Revue, 2009. Ed. 50 + 10 A.P.

Working Drawing. Geneva: Centre d'édition contemporaine, 2012. Ed. 130 + 20 A.P.

OSCAR TUAZON LIVE

This catalog is published in conjunction with the exhibition

OSCAR TUAZON
ALONE IN AN EMPTY ROOM

Museum Ludwig, Köln
February 15–July 13, 2014

Published by
DoPe Press and Verlag der
Buchhandlung Walther König, Köln

Editors
Philipp Kaiser, Dorothée Perret,
Oscar Tuazon

Editorial Direction
Anna Brohm

Graphic Design
Madame Paris, Switzerland

Authors
Anna Brohm
Philipp Kaiser
Miwon Kwon
Nico Machida
Oscar Tuazon
Antek Walczak

Catalog Management
Astrid Bardenheuer

Translation from English
Christiansen & Plischke

Translation from German
Elizabeth Tucker

Copy Editors
Hella Neukötter
Barlo Perry
Jennifer Taylor

Editorial assistants
Alice Dusapin
Natalie Jones
Rachael Morisson

Origination, Printing, and binding
DZA Druckerei zu Altenburg GmbH

Museum Ludwig
Heinrich-Böll-Platz
50667 Köln
T +49 (0) 221 221 26165
F +49 (0) 221 221 24114
www.museum-ludwig.de

Team Museum Ludwig
Michael Bangert, Astrid Bardenheuer, Katia Baudin, Beate Bischoff, Susanne Brentano, Anna Brohm, Dagmar von der Burg, Basileios Chronz, Angela Coenen, Enver Concer, Stephan Diederich, Barbara Engelbach, Sophia Elze, Paul Eßer, Guido Fassbender, Ralf Feckler, Julia Friedrich, Marion Funken, Yvonne Garborini, Alfred Glasner, Miriam Halwani, Ulrike Hohn, Christian Hüfler, Sebastian Kahnt, Philipp Kaiser, Kathrin Keßler, Jürgen Koll, Axel Kuhn, Leif Lenzner, Thomas Loerzer, Armin Lüttgen, Petra Mandt, Jasmina Merz, Melina Meier, Ursula Meyer-Krömer, Manuela Müller, Lisa Nadig, Tobias Nagel, Annegret Niermann, Dominik Pape, Leonie Pfennig, Luise Pilz, Armin Raupach, Kurt Rossetton, Thomas Sonnenberg, Judith Specht, Astrid Schubert, Saffet Sen, Thomas Sydlik, Ulrich Tillmann, Angelika von Tomaszewski, Ingo Weber, Andreas Wischum, Helmut Wodarz, Karsten Zinner, Michael Zorn

Distribution
Germany & Europe
Buchhandlung Walther König, Köln
Ehrenstr. 4
50672 Köln, Germany
T +49 (0) 221 20 59 653
F +49 (0) 221 20 59 660
verlag@ buchhandlung-walther-koenig.de

UK & Ireland
Cornerhouse Publications
70 Oxford Street
GB-Manchester M1 5NH
T +44 (0) 161 200 15 03
F +44 (0) 161 200 15 04
publications@cornerhouse.org

Outside Europe
D.A.P. / Distributed Art Publishers, Inc.
155 6th Avenue, 2nd Floor
New York, NY 10013, USA
T +1 (0) 212 627 1999
F +1 (0) 212 627 9484
eleshowitz@dapinc.com

This catalog was made possible with the generous support of

Stiftung Storch

and the support of
Galerie Eva Presenhuber, Zürich and Maccarone, New York.

Artist's acknowledgments
Anna Brohm, Gardar Eide Einarsson, Elias Hansen, John Hansen, Natalie Jones, Philipp Kaiser, Miwon Kwon, Martin Laborde, Anna Linzer, Michele Maccarone, Nico Machida, Pentti Monkkonen, Nate Page, Andrei Panibratchenko, Eric Perez, Eva Presenhuber, Kari Reardon, Antoine Rocca, Alexandra Ruiz, Cole Sayer, Bea Schlingelhoff, Antek Walczak.
And also dépendance, Maccarone, Galerie Eva Presenhuber, Galerie Balice Hertling, Standard (Oslo), Jonathan Viner Gallery.

To my wife and our three crazy girls.

Printed in Germany
© 2014 Museum Ludwig, Köln;
DoPe Press, Oscar Tuazon;
the artists; authors; photographers

ISBN 978-0-9911804-0-0

DoPe Press
3359 Fletcher Drive
Los Angeles, CA 90065, USA
info@dopepress.fr
www.dopepress.fr

DoPe Press